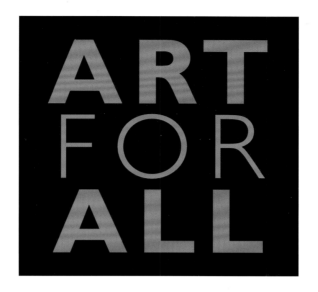

BRITISH POSTERS FOR TRANSPORT

EDITED BY TERI J. EDELSTEIN

WITH ESSAYS BY TERI J. EDELSTEIN, OLIVER GREEN,

NEIL HARRIS, PEYTON SKIPWITH, AND MICHAEL TWYMAN

YALE CENTER FOR BRITISH ART

IN ASSOCIATION WITH

YALE UNIVERSITY PRESS, NEW HAVEN AND LONDON

This publication accompanies the exhibition
Art for All: British Posters for Transport
organized by the Yale Center for British Art

On view at the Yale Center for British Art,
New Haven, from May 27 to August 15, 2010;
at the Musée de l'Imprimerie, Lyon, France,
from October 15, 2010 to February 13, 2011;
and at the The Wolfsonian-Florida International
University, from April 15 to August 14, 2011

Library of Congress Cataloging-in-Publication Data

Art for all : British posters for transport / edited by
Teri J. Edelstein.
 p. cm.
 Issued in connection with an exhibition held
May 27–Aug. 15, 2010, Yale
Center for British Art, New Haven, Connecticut.
 Includes bibliographical references and index.
 ISBN 978-0-300-15297-5 (alk. paper)
 1. Transportation—Posters—Exhibitions. 2. Posters,
British—20th century—Exhibitions. 3. Art and
society—Great Britain—History—20th century—
Exhibitions. I. Edelstein, T. J. II. Yale Center for
British Art.
 NC1849.T7A78 2010
 741.6'7409410747468—dc22
 2009042589

Designed by Susan Marsh
Set in Gill Sans by Tina Henderson
Printed by Conti Tipolcolor SpA, Florence

Frontispiece: Abram Games, *Round London Sightseeing
Tour* (detail), 1971, commissioned by LT, printed by the
Curwen Press, 39 × 25 in. (99.1 × 63.5 cm). Yale Center
for British Art, Gift of Henry S. Hacker, Yale College,
Class of 1965

Page 144: Dorrit Dekk, *We Londoners* (detail), 1961,
commissioned by LT, printed by John Swain and Son,
40 1/16 × 25 1/16 in. (101.8 × 63.7 cm). Yale Center for
British Art, Gift of Henry S. Hacker, Yale College,
Class of 1965

Page 172: Anthony Frederick (Tony) Sarg, *Flying at
Hendon* (detail), 1914, commissioned by UERL, printed
by Johnson, Riddle & Co., 38 3/8 × 23 1/2 in. (97.5 ×
59.7 cm). Yale Center for British Art, Promised gift of
Henry S. Hacker, Yale College, Class of 1965

CONTENTS

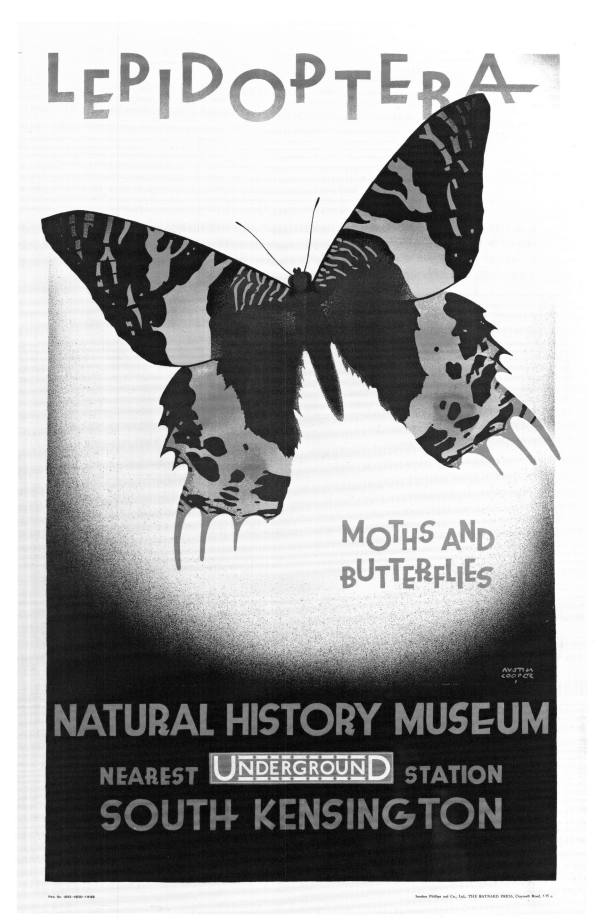

AUSTIN COOPER

Natural History Museum: Lepidoptera, 1928, commissioned by UERL, printed by the Baynard Press, 39¾ x 25 in. (101 x 63.5 cm). Yale Center for British Art, Friends of British Art Fund

DIRECTOR'S FOREWORD

In 1991 Henry S. Hacker (Yale College, Class of 1965) gave twelve Underground posters of the 1950s and 1960s to the Yale Center for British Art, inaugurating its poster collection and initiating one of the most significant and sustained donations to the institution. In the years since that first gift, Henry has given almost two hundred posters, with more promised. The collection now represents the poster art of London's underground and bus system almost from the beginning of Frank Pick's publicity campaign in 1908 through to the 1970s, as well as the poster campaigns of the main British rail lines from their consolidation in 1923 into the Great Western Railway; the London and North Eastern Railway; the London, Midland, and Scottish Railway; and the Southern Railway; to their nationalization as British Railways in 1948. These posters provided the impetus for and form the core of this splendid exhibition; but, as one can see from the checklist of the Center's poster collection at the back of this book, Henry has more recently extended his collecting beyond transport to embrace a broader range of British poster art, adding examples by the Empire Marketing Board, the General Post Office, Wembley Stadium, Shell, and other institutions and commercial enterprises.

Through Henry's generosity and collecting acumen, we are well on our way to creating an important resource for the appreciation and study of British commercial graphic art in the twentieth century. What make this development particularly gratifying and exciting from a scholarly vantage point are the manifold connections between this aspect of twentieth-century art and design and the more traditional arts of the eighteenth and nineteenth centuries that have always been the Center's strength. In the transport post-

ers that are the subject of this exhibition, we can trace patterns of the consumption and production of landscape imagery and the concomitant dynamic between the metropolis and the aesthetic delectation of the British countryside that were taking shape in the art of the Romantic period. Neither are the deployment of national icons and the issues of civic and national identity—so evident in the posters—new; they reflect ongoing debates and preoccupations in British art. To Henry, with his infectious enthusiasm for the subject and his recognition of its scholarly import, we owe the most profound debt of gratitude both for his extraordinary gift to the Center and for this publication and the exhibition to which it speaks, which constitute but one collective outgrowth of that gift.

In pursuing this first project based on the collection, we are beholden to the guest curator, Teri J. Edelstein, for matching Henry's zeal for British transport posters with her own impassioned interest. After many years as a distinguished museum director and professional arts consultant, Teri has returned to the Center, where she once served as Assistant Director for Academic Programs, to reexamine this subject, for which she developed a keen interest in those early years. She has worked with the Center's organizing curator for the exhibition, Scott Wilcox, Chief Curator of Art Collections and Senior Curator of Prints and Drawings, to craft a rich exploration of the cultural and aesthetic importance of British transport art; both are owed thanks for shaping the exhibition and the book with intellectual rigor and creative insight. In editing this volume, Teri has engaged a team of splendid contributors in a collaborative process of exchange that has resulted in a fascinating examination of transport

posters in the larger context of modern design. The Center's Associate Curator and Head of Exhibitions and Publications, Eleanor Hughes, and her colleagues have worked with Teri to manage all the logistical details of the project, in concert with Scott, and with Sally Salvesen, the Center's Publisher with Yale University Press, London. The book designer, Susan Marsh, and exhibition designer, Stephen Saitas, along with the Center's own design team, Lyn Bell Rose and Elena Grossman, have given the publication and the exhibition a power and beauty commensurate with that of the posters themselves.

The exhibition at Yale has been enhanced through generous loans by the London Transport Museum and the National Railway Museum, York; to these institutions we are deeply grateful. We are fortunate to be traveling the exhibition to two esteemed partner institutions. To Alan Marshall, Director, and Bernadette Moglia and Hélène-Sybille Beltran at the Musée de l'Imprimerie in Lyon, France; and to Cathy Leff, Director, and Marianne Lamonica and Lisa Li at the Wolfsonian-Florida International University, we extend our warmest thanks.

Amy Meyers,
Director, Yale Center for British Art

OBSERVATIONS OF A POSTER COLLECTOR

My sense of Paul Mellon is regrettably second-hand and comes from reading his autobiography, augmented by regular visits to the Yale Center for British Art. The Center is Mr. Mellon's crown jewel, certainly among the finest dedicated-purpose museums in the world, which, with typical modesty, he refused to have named after himself. With almost self-deprecation, he described himself as an amateur, a perennial student, an autodidact, and an anachronism, as if something were wrong with those characterizations. In fact, though, these are singular and laudable attributes, and it can be safely said that in the realm of charity, collecting, aesthetics, and vision, Mr. Mellon had few peers.

Mr. Mellon and I shared the Yale experience, albeit a generation apart, and we both maintained a private, yet intense, love of English life. These two factors were central in my decision to establish this collection of British posters from the first half of the twentieth century, and to make the donation to the Yale Center for British Art that forms the core of the current exhibition. I feel myself to be following, in some measure, Paul Mellon's example.

My own personal "Rosebud"—my most vivid early memory—was of a red Dinky Toy: a London double-decker bus given to me by my three Canadian aunts when I was young child. World War II had just ended, and I have retained from that time a sense of the pervasive spirit of comity that existed between Great Britain and the United States because of the victory over the Axis.

Before attending Yale, I was fortunate to be named an English Speaking Union Exchange Scholar, which enabled me to attend Sutton Valence School, an English public school near Maidstone in Kent, for a year. This experience allowed me to gain an appreciation for, and a love of, British design and the country's well-ordered landscape.

Fast forward to the early 1990s in New York, when I first noticed Gail Chisholm's poster gallery in Greenwich Village, where, with her colleague Kiki Werth, she was exhibiting interwar British travel posters. On instinct I bought my first poster, Fred Taylor's *The Road of the Roman*, made for the London and North Eastern Railway. Generally, after that, I bought through dealers, but also at auction, and the collection grew to include a representative sampling of British railway and London Underground posters. Recently, posters depicting products, airlines, the British Empire Exhibition, the Empire Marketing Board, and political subjects have been added. I have made a conscious effort to include multiple works by noted poster artists: there are deep holdings of Spencer Pryse, Tom Purvis, Frank Newbould, and Edward McKnight Kauffer, who are among my favorites.

As I view this collection with a retrospective eye, a number of thoughts emerge. First, the posters present a strong sense of place and movement, which is a means of self-definition. They depict locations, which anchor our existence, while at the same time suggesting how we negotiate time and space by means of transport. The collection, comprising an eclectic range of more than two hundred images, conveys considerable information about the aesthetic, social, and economic issues of the period. It also embraces the concept of the interrelationship of art and commerce, which has always interested me.

I am particularly honored that the Yale Center for British Art has accepted this collection, and that it has chosen to support it by presenting this

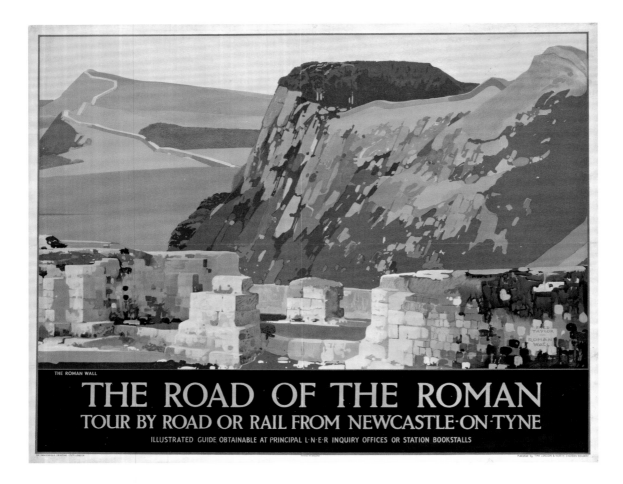

FRED TAYLOR
*The Road of the
Roman—The Roman
Wall*, between 1923 and
1947, commissioned by
LNER, printed by the
Dangerfield Printing Co.,
39 7/8 x 49 7/8 in.
(101.3 x 126.7 cm). Yale
Center for British Art,
Gift of Henry S. Hacker,
Yale College, Class of
1965

exhibition and publishing this magnificent book. I
am grateful to everyone who helped bring them
to fruition. Acknowledgments appear elsewhere
in this volume, but I hope some redundancy will
be tolerated. Thanks go to Teri Edelstein, for her
vision of the collection, for conceptualizing both
the show and the catalogue, and for her tireless
determination in bringing this exhibition about;
Eleanor Hughes, for her efforts connected with
the installation of the exhibition, its travel to
other venues, and production of the publication;
Scott Wilcox, for his stewardship of the collec-
tion and curatorial talent; and Patrick Noon, for
his initial enthusiasm for these works. My pro-

found thanks go to Amy Meyers, for her friendship
and indefatigable support of every aspect of this
project.

The coming to rest of this collection at the
Yale Center for British Art squares directly with
my motives in collecting, namely, that the col-
lection remain intact, that it be accessible to the
general public, and that it be used for scholarly
purposes. These are values Mr. Mellon long cher-
ished and promoted. I hope that he would have
enjoyed this exhibition of posters that speak to
his time and place.

Henry S. Hacker

ACKNOWLEDGMENTS

I have the Yale Center for British Art to thank for both my introduction to and current involvement with British posters. In 1980–81 the Center exhibited *Tom Eckersley: Posters and Other Graphic Work*, which featured his poster *Ceremonial London*, seen in the current exhibition. Thus, at the beginning of my museum career, when I was Assistant Director for Academic Programs at the Center, I met one of the greatest of British poster designers and came to know his work. That experience fostered a career-long appreciation not just of Eckersley's posters but of the works of all the other exceptional artists who have worked in this arena.

It was Andrew Forge, then dean of the School of Art at Yale University, who suggested the Eckersley exhibition to Edmund P. Pillsbury, then director of the Center, and it was realized under Duncan Robinson, his successor. The current director of the Center, Amy Meyers, gave me the extraordinary opportunity to organize this exhibition and create this accompanying volume. Her confidence in the project, expertise, and unstinting support are greatly appreciated.

The catalyst for this exhibition and publication is the magnanimous gift of his British poster collection to the Center by Henry S. Hacker. Getting to know Henry has been one of the great pleasures of this project. I am grateful to him for his generous gift and his intellectual contribution to the realization of this exhibition.

Another joy of this project has been to work again with former colleagues at the Center: Scott Wilcox, Chief Curator of Art Collections and Senior Curator of Prints and Drawings, who has been endlessly supportive as the organizing curator for the exhibition at the Center; Elisabeth Fairman, Senior Curator of Rare Books and Manuscripts, who was tremendously helpful with materials from her collection; Tim Goodhue, Registrar, who superbly handled so many details of the loans and the traveling of the exhibition; Theresa Fairbanks-Harris, Chief Conservator of Paper, who oversaw the conservation work that ensured that the exhibited posters would look their best; Linda Friedlaender, Curator of Education; and Constance Clement, Deputy Director. Beyond those named, it has been a delight to reconnect with other former colleagues at the Center and at Yale. New colleagues at the Center contributed immeasurably as well: Eleanor Hughes, Associate Curator and Head of Exhibitions and Publications, who has coordinated details far too numerous to count and who has been the linchpin of this project; before her, Julia Marciari Alexander, former Associate Director for Exhibitions and Publications; and their colleagues Diane Bowman, Senior Administrative Assistant; Anna Magliaro, who secured the images for this book; and Postdoctoral Research Associates Jo Briggs and Andrea Wolk Rager, who compiled the checklist of posters in the collections of the Center. Many others enabled and ensured the realization of this project in countless ways and have been a pleasure to work with; they include John Monahan and the staff of Prints and Drawings; for the photography of works at the Center, Melissa Fournier, Associate Museum Registrar, Richard Caspole, Photographer, and Kurt Heumiller, Digital Imaging Technician; the installation team under Richard Johnson, Installation Manager; Beth Miller, Associate Director for Advancement and External Affairs, and her colleagues, Amy McDonald, Public Relations and Marketing Manager and Ricardo Sandoval, Public Relations Coordinator, graphic designers Lyn Bell Rose and Elena Grossman, Julienne Richardson,

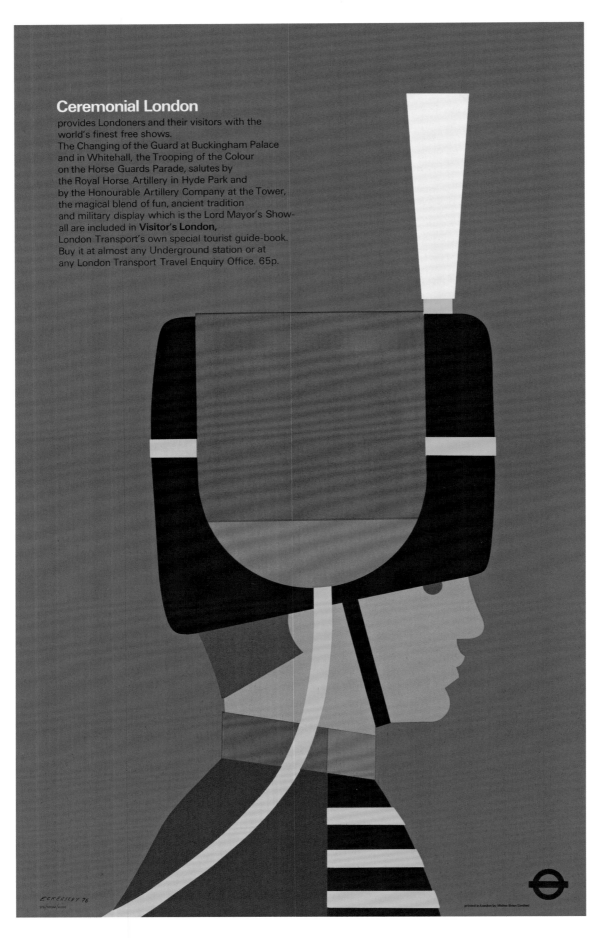

Ceremonial London

provides Londoners and their visitors with the
world's finest free shows.
The Changing of the Guard at Buckingham Palace
and in Whitehall, the Trooping of the Colour
on the Horse Guards Parade, salutes by
the Royal Horse Artillery in Hyde Park and
by the Honourable Artillery Company at the Tower,
the magical blend of fun, ancient tradition
and military display which is the Lord Mayor's Show–
all are included in **Visitor's London,**
London Transport's own special tourist guide-book.
Buy it at almost any Underground station or at
any London Transport Travel Enquiry Office. 65p.

**THOMAS C. (TOM)
ECKERSLEY**

Ceremonial London, 1976,
commissioned by LT,
printed by Walter Brian,
40 x 25 ¹⁄₁₆ in.
(101.6 x 63.7 cm). Yale
Center for British Art,
Friends of British Art
Fund

Special Events Coordinator, and Senior Administrative Assistant Amelia Toensmeier; Martina Droth, Head of Research and Education, and her colleagues Lisa Ford, Associate Head of Research, Cyra Levenson, Associate Curator of Education, Jennifer Kowitt, Assistant Curator of Education, Jane Nowosadko, Manager of Programs; and Lizbeth O'Connor of the Museum Shop. To all of them, and indeed to everyone at the Center, I extend my sincere thanks.

While the physical presence of the posters constitutes the heart of the exhibition, the accompanying book is its lasting legacy. My fellow authors—Oliver Green, former Head Curator and Research Fellow of the London Transport Museum; Neil Harris, Preston and Sterling Morton Professor of History and Art History, Emeritus, the University of Chicago; Peyton Skipwith, prolific historian of British art; and Michael Twyman, Professor Emeritus of Typography & Graphic Communication at the University of Reading—have done much more than contribute their insightful essays to the publication. They have enriched the project in a variety of ways: its organization, its intellectual grounding, and its reach. In addition, each of them has given me extensive advice on myriad subjects. I am grateful to them for everything they have done. I hope I may be permitted to give extra kudos to Oliver. The volume's physical realization depended on the talents of Sally Salvesen, our tireless publisher at Yale University Press, London; the manuscript editor, Eve Sinaiko; and Susan Marsh, our superb designer. The installation of the exhibition also owes a great deal to Stephen Saitas, the exhibition designer. My thanks to them all.

At the London Transport Museum, Sam Mullins, Director, Oliver Green and David Bownes, former and current Head Curator, and Claire Dobbins and their staff have been extremely generous. So too has been the National Railway Museum, York, its former director Andrew J. Scott, current director Steve Davies, and curator Edward Bartholomew. My research would not have been possible without their advice and use of their extensive libraries and archives. Special thanks are also due to Emma Theophilus-Wright, archivist for Transport for London, and her staff; Helen Kent, Caroline Warhurst, and the staff of the library of the London Transport Museum; and Beverly Cole, John Clark, and the staff of the National Railway Museum Library. To the staff of the following institutions, who are too numerous to name, I am exceedingly grateful: the British Library; the National Art Library at the Victoria and Albert Museum; the New York Public Library; the Regenstein Library at the University of Chicago; the Ryerson Library of the Art Institute of Chicago; the Science and Society Picture Library, London; and the Tate Archive.

My research for this exhibition was greatly aided by a number of other people—scholars, librarians, friends. Margaret Timmers, former keeper of posters at the Victoria and Albert Museum, must come first for her generous counsel and advice. Space does not permit me to detail the exact contribution of each person below but I hope they all know how materially and significantly they contributed to this project, and I extend my profound thanks to them all: David Alexander, Brian Allen, Jack Brown, Arthur Cohen, Douglas Druick, Dave Gartler, Laura Giles, Eric Gleacher, Paul Hunter, Anna Ivy, Kasha Jenkinson, Susan Lambert, Lesley Martin, Kevin Mulroy, Helena Moore, David Resnicow, Susan Rossen, David Smith, Cynthia Wall, Mary Woolever, and Peter Zegers.

I hope all of those who contributed to this project in so many material ways will indulge me if I single out my husband, Neil Harris. He was my constant advisor, editor, and support. This project would be the poorer without his participation but, more importantly, every day of my life would be the poorer. I send him my love and my thanks.

Teri J. Edelstein

ABBREVIATIONS

BR British Railways
DIA Design and Industries Association
GWR Great Western Railway
IRT Interborough Rapid Transit, New York
LGOC London General Omnibus Company
LMS London, Midland, and Scottish Railway
LNER London and North Eastern Railway
LPTB London Passenger Transport Board
LT London Transport
NER North Eastern Railway
NRM National Railway Museum, York
SR Southern Railway
UERL Underground Electric Railways of
 London
WPA Work Projects Administration, United
 States federal agency, 1935–43, formerly
 Works Progress Administration

A NOTE ON POSTER SIZES

Posters in this period were usually printed in
standardized sizes, to fit into frames in Tube
and railway stations, and on buses and trams
and train cars. Paper, manufactured in standard
dimensions, dictated these formats. The most
common sizes were:

Double royal (40 x 25 in.; 101.6 x 63.6 cm)
Double crown (30 x 20 in.; 76.2 x 50.8 cm)
Quad royal (50 x 40 in.; 127 x 101.6 cm)

BRITISH POSTERS FOR TRANSPORT —

AN INTRODUCTION

TERI J. EDELSTEIN

A movie screen in England, 1927. . . .

In a frenzied scene at the end of a work day, the female employees of a Lancashire mill are changing into their best clothes, trading their clogs worn at work for stylish footwear. They grab the traveling bags they have brought to work and hurriedly exit the room. A last close-up reveals the discarded shoes, left behind along with the boredom of daily life in the town of Hindle. In succession we see the newly donned fashionable shoes running toward a railway station, hands rapidly thrusting fares at the ticket seller and feet briskly moving to the train that will take the women to a week of pleasure. As they rush forward they pass a train guard waving a flag. He gestures backward toward the drudgery of the mill in Hindle and forward to a place of gaiety and abandon.

Beckoning behind the guard is a graphic celebration of their vacation destination: Blackpool, a locale whose diversions contrast so markedly with the mill town. Conductor, poster, and waving flag become a fulcrum of the narrative (Fig. 1). The 1927 silent film *Hindle Wakes* documents both the use of station posters and their appeal to travelers as signifiers of desire. In the words of the poster artist Graham Petrie, railway posters sought to announce the "propinquity of paradise."[1]

Hindle Wakes narrates an affair between a mill hand, Fanny Hawthorn, and the son of the mill owner, Allan Jeffcote.[2] The central part of the story takes place in Blackpool during Wakes Week, when the Lancashire mills shut down completely and the workers received a week's holiday. *London & North Eastern Railway Magazine* discusses Wakes Weeks as a marketing target for the railway: " 'Wakes.'—Lancashire folk are noted as being most enthusiastic holiday-makers, and a campaign has been launched to ensure LNER [London and North Eastern Railway] holiday districts receiving a full share of this traffic."[3] The London, Midland, and Scottish Railway (LMS), the main line serving this route, commissioned Septimus Edwin Scott, around 1930, to depict the attractions of the resort (Fig. 2).

Conquering the public's hearts and minds, not to mention its pocketbooks, was not the only motive for posters. Nor their only effect. Since the appearance of modern posters in the late nineteenth century, arguments had swirled around their social impact and aesthetic meaning. Where once art spoke of authority and religion, the poster "speaks to us only of ourselves, our pleasures, our tastes, our interests, our food, our health, our life," wrote the French critic Maurice Talmeyer in the 1890s. Instead of demanding obedience, respect, self-sacrifice, it whispered, "Amuse yourself, take care of yourself, feed yourself . . . go to the concert, read romances, buy good soup."

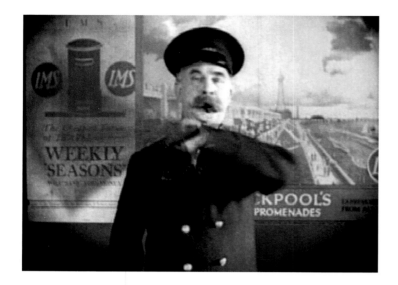

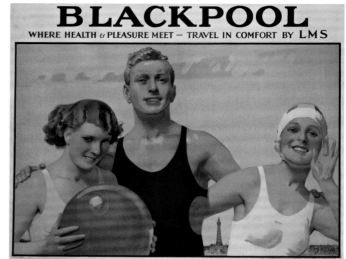

This "agent of perversion" exalted the frivolous, a natural monument to an age of individualism and "excessive egotism," a "chateau of paper," a "cathedral of sensuality."[4] At the same time there were others, like the American Brander Matthews, who argued that "however humble its position," the pictorial poster was taking its place "in the temple of art."[5] "The poor man's picture gallery" was a phrase already being popularized by late nineteenth-century journalists, some of whom argued that this was more than simply an advertising explosion; it was an instrument of modernism, introducing the population to new visual vocabularies. Emphasizing graphic art, Susan Lambert notes, "The 1930s was a period when the link between the fine artist and the commercial artist was at its closest."[6]

Originality, idiosyncrasy, and individuality were hallmarks of early poster design. Artists were, and are, instantly recognizable. The Art Nouveau extravagances of Alphonse Mucha, the radically simplified figures of Henri de Toulouse-Lautrec, the organic complexities of Will Bradley, the spare abstractions of the Beggarstaffs, the collaborators William Nicholson and James Pride, all challenged older graphic conventions, as did the poster designs of their colleagues in Germany, Italy, Austria, and Holland. From the 1890s posters had their connoisseurs and collectors. Exhibitions flourished, while anthologies and magazines in many languages popularized the startling shapes and colors. *Maîtres de l'Affiche* in Paris and *The Poster* in London were among the serials familiarizing artists and lay people alike with the globalizing energy

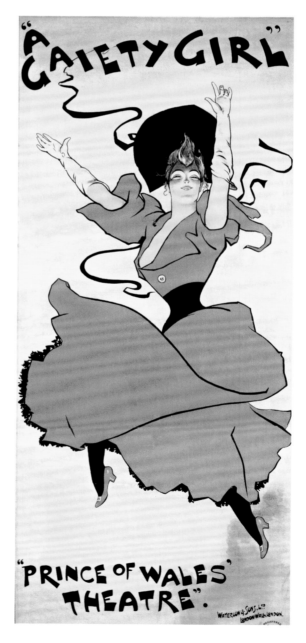

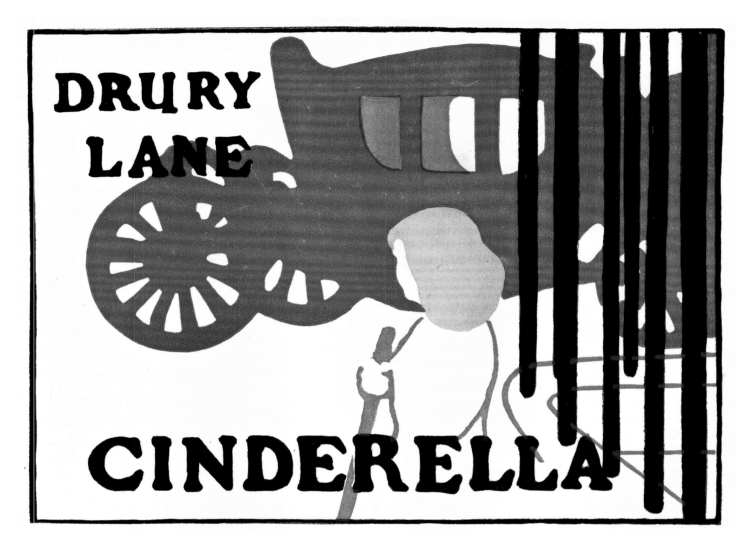

4

THE BEGGARSTAFFS

Cinderella, 1895, opp.
p. 49 of *The Poster* 2
(February 1899).
Courtesy of the Yale
University Library

of the poster revolution. Work opportunities for these early European masters of color lithography transcended geography and nationality. Mucha, a Moravian, worked for French, American, and British clients, for example providing a cover for *The West End Review* that *The Poster* reproduced in 1898. Jules Chéret, the founding master of the French art poster, had studied lithography in England between 1859 and 1866. Dudley Hardy's British theatrical posters, his famous *Gaiety Girl* of 1893 for example, would not have seemed out of place alongside French counterparts for the Folies Bergère (Fig. 3). The Beggarstaffs, on the other hand, favored highly abstracted compositions with flat passages of unmodulated color and an innovative use of the blank paper ground. An 1895 poster for *Cinderella* at the Drury Lane Theatre uses only four colors, all of them applied in pure unmixed form (Fig. 4). These works left an inheritance. Forty years later Austin Cooper,

who designed for many clients, including railway posters for LNER and a series of Underground designs, praised the Beggarstaffs for their "original, daring and highly effective treatment of two-dimensional simplified realism which, to this day, has served as guide and inspiration." [7]

Despite their variety and different stylistic approaches, many of these poster artists, along with contemporaneous architects, furniture designers, ceramicists, glass blowers, jewelers, and iron workers, claimed for themselves a modern or modernist label and identified with the new, the radical, and the audacious. Defining modernism in objective and persuasive ways is one of the most difficult, even maddening tasks an art historian faces, as the claims are so various and the repudiations so swift. Nonetheless, the relationship between British poster art, Underground posters more particularly, and a modernist sensibility must be confronted. Modernism can

variously be defined as a temper, a mood, a series of values, or a set of principles, and individual artists might either be horrified or elated by having the label applied to them. But I would argue that Frank Pick, as patron and taste maker, became for a number of years increasingly sympathetic to principles of fitness, efficiency, abstraction, and austerity that remain today emblems of the modern movement. Modernism, as it was roughly understood at the time of the creation of the posters, is a style of formal innovation that sought originality and embraced abstraction. Seeking to be new, these artists eschewed mimesis and instead referred self-reflexively to their own art. Beyond this, modernism could be said to apply a philosophy advocating the unity of all of the arts. In addition, for some, modernism held a utopian hope that the arts could transform and reform society.[8] In this context, the status of commercial art was promoted by many as being equal to that of fine art.

As suggested by the title of this book—and the exhibition that it accompanies—Underground posters were promoted as "Art for All," originally the title of an exhibition held in 1949 at the Victoria and Albert Museum and co-organized by the museum and London Transport. The exhibition displayed not the printed posters seen by all, but the original works of art submitted before they were sent on to the printers to be combined with type and made into posters. Thus, the 1949 exhibition's art was seen at the time only by the artist, the Underground staff, and the printers, although the original designs had been created with a mass audience for the finished posters in mind.

Invoking that 1949 phrase, the current exhibition focuses on the posters themselves. In addition to commissions made for the London Underground, it examines posters made for British railway companies between 1923 and 1948. These dates are meaningful. 1923 is the year of creation of four lines, the LNER, LMS, Southern Railway, and Great Western Railway, from a myriad of smaller lines. 1948 saw their merger into British Railways.

Well before the 1949 exhibition, prominent figures in Britain were acknowledging the importance of posters to the public at large and validating their artistic status. Writing in the magazine Commercial Art in 1934, the recently appointed director of the National Gallery, Kenneth Clark, paid his own homage:

In the Renaissance, painting was necessary and popular. It was necessary because certain important beliefs could only be communicated to the mass of the people by painting; and it was popular because it was seen in all public places where people had time to spend. . . . Now the art which we connect with academies and salons, the art of the last 100 years, is neither necessary nor popular. It is a luxury designed to attract a few rich people. . . . Posters are necessary and popular, and in very much the same way. . . . They represent a real effort to communicate an idea or a belief in a memorable way to a mass of people.[9]

The texts in the present catalogue analyze transport posters and their history from a range of perspectives. Given the vigorous debates surrounding the rise of modern posters and the accompanying growth of advertising, the opening essay examines posters for the Underground and British railways from an art-historical perspective and reviews the distinctive contributions of some of the most distinguished British designers.

While artists are credited with authorship, poster creation was truly a collaborative effort. In his 1926 introduction to Posters and Publicity Sydney R. Jones acknowledged the many different participants involved in the process of poster making: "The public, directors of business enterprises, printers, publicity managers and agents, and artists also, have all contributed."[10] Michael Twyman's essay studies the careful collaboration of commissioners, artists, and printers required by the chromolithography process used to print many early twentieth-century posters. Sometimes neglected in accounts of the poster revolution, printers were critically important to the success of the artist's designs.

And so, of course, were the patrons. Many actors play central roles in our story, but the galvanizing agent is Frank Pick. No single essay takes Pick as its subject, because almost every one of them comments, in one way or another, on his importance. Trained as a solicitor and employed by the North Eastern Railway (one of the lines that came to make up the LNER), Frank Pick came to London in 1906 to work for a new company,

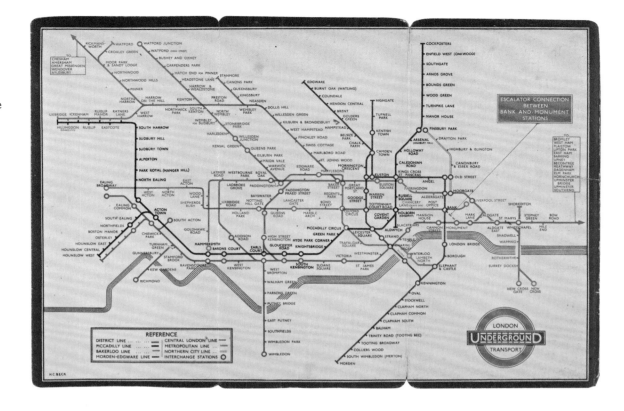

the Underground Electric Railways of London (UERL). The Underground Group, as it was called, amalgamated several rail lines and ran what is now colloquially known as the Tube as well as several tram and bus lines. In 1908 he was appointed Traffic Officer, eventually becoming Managing Director of the Underground Group in 1928 and then Chief Executive of the successor organization, the London Passenger Transport Board (LPTB), known as London Transport, formed in 1933. He retired from London Transport in 1940.

It was in 1908 that Pick initiated the poster campaign, which he monitored closely until his retirement. Created to build traffic in off-peak hours, encourage ridership to new destinations and on new lines, and acquaint Londoners with the novelties and achievements of their transit system, the campaign had as its primary goal, according to Pick, simply to create a positive relationship between the Underground and the passengers. He was responsible for the formation of much of what we know today: in addition to the track and running of the trains that we take for granted, the visual symbols that still represent the system were crafted under his eagle eye. Among them was the distinctive sans serif typeface, which he asked Edward Johnston to design in 1915. At

Pick's behest, in 1918 Johnston also refined the red and blue bull's-eye logo that has become a symbol not simply of the Tube but of London itself. Pick selected the architect Charles Holden to design the now-landmark modernist stations of the 1930s as well as the headquarters building at 55 Broadway in London. The graphic designer Harry Beck created the seminal schematic diagram of the Underground, issued for the first time in 1933, under Pick's direction (Fig. 5). As Neil Harris observes in his essay, Pick's campaigns helped create a civic identity for the city, all the more remarkable when compared with transit efforts elsewhere.

Unsurprisingly, many native experts held British travel posters to be superior to those of every other country, most particularly of the Continent and America. In 1927 *Posters and Publicity* characterized the recent crop of railway posters as so "brilliant" that they "require detailed perusal usually, as for instance when one is waiting for a train" (Figs. 6, 7).[11] Oliver Green details the varied ways in which railway posters were installed by their commissioners, distinctions of display related to size and subjects. He notes, moreover, that the Underground was more systematized in its approach than the main-line railways.

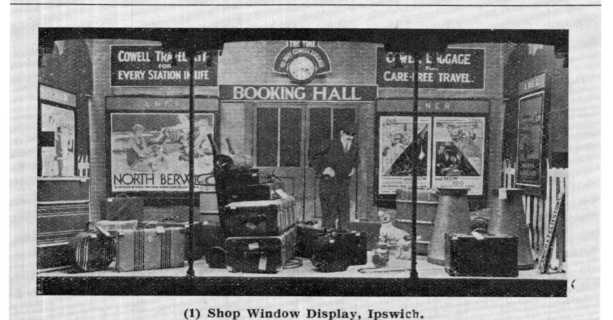

LONDON & NORTH EASTERN RAILWAY MAGAZINE

(1) Shop Window Display, Ipswich.

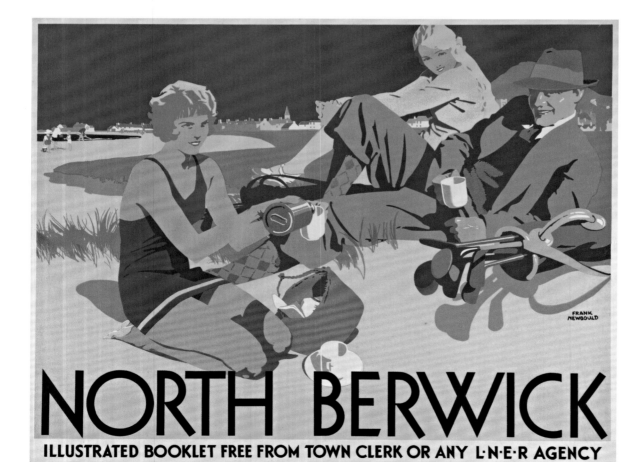

NORTH BERWICK

ILLUSTRATED BOOKLET FREE FROM TOWN CLERK OR ANY L·N·E·R AGENCY

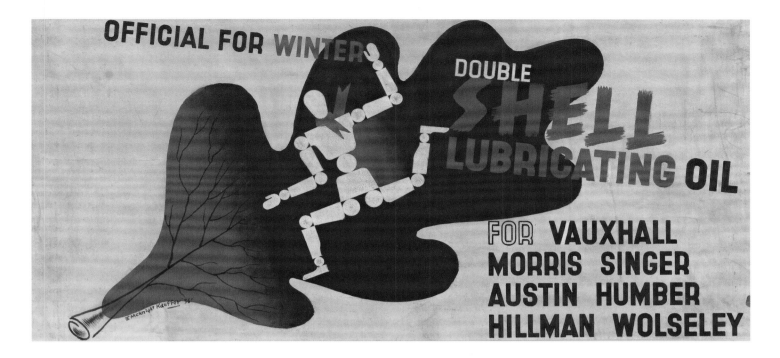

OFFICIAL FOR WINTER
DOUBLE SHELL LUBRICATING OIL
FOR VAUXHALL MORRIS SINGER AUSTIN HUMBER HILLMAN WOLSELEY

8

EDWARD MCKNIGHT KAUFFER

Double Shell Lubricating Oil (maquette), 1936, commissioned by Royal Dutch Shell Co., gouache, image: 10⅜ x 22⅜ in. (26.3 x 56.8 cm). Yale Center for British Art, Gift of Henry S. Hacker, Yale College, Class of 1965

Although the essays in this volume do not extensively examine posters beyond those made for the Underground and the railways, it is interesting to note that some advertisements for other products were created specifically for display in stations and on trains and buses. A label on the back of Edward McKnight Kauffer's maquette *Double Shell Lubricating Oil* (Fig. 8) states that the poster was intended for display in the Underground. *Modern Publicity 1937 and 1938* illustrates the poster *Official for Winter: Single Shell Lubricating Oil* (see Fig. 142) as well as Shell posters by Kraber and the collaborators Thomas C. (Tom) Eckersley and Eric Lombers, with a note that they were used in Tube stations as "reminder advertising."[12] These smaller posters recalled to passengers the extensive pictorial campaign of Shell, seen, for example, on the sides of their trucks.[13]

Apart from their work designing posters for transport, almost all of the artists discussed in this volume worked on other projects and in other media. F. Gregory Brown, who exhibited his landscape paintings at the Royal Academy, worked for most of the rail lines, designed for a number of other clients, such as Bourneville Cocoa and Drury Lane Theatre, did covers for *The Broadcaster,* and won a gold medal for his textiles at the 1925 Exposition des Arts Décoratifs in Paris. Dora M. Batty taught textile design at the Central School of Arts and Crafts beginning

in 1932 and served as head of the department from 1950 to 1958. She also designed extensively for Mac Fisheries and Poole Potteries. Abram Games worked for the General Post Office and Shell, also designing the emblem for the Festival of Britain in 1951. But no artist worked as extensively or as successfully in other media as Edward McKnight Kauffer, whose many book illustrations, magazine advertisements, package labels, textiles, and set designs brought him wide praise. One commentator asserted that he had created public taste instead of merely following it: "There is nothing popular in the ordinary sense about Kauffer's work. It is abstract and 'advanced.' Yet public interest has been roused to a great degree" (Fig. 9).[14] In the introduction to a retrospective exhibition of his posters held at the Museum of Modern Art in New York in 1937, Aldous Huxley stated:

Everywhere his aim is the same: to render the facts of nature in such a way that the rendering shall be, not a copy, but a simplified, formalized and more expressive symbol of the things represented. The aim is common to many of the most interesting and significant contemporary artists. It is McKnight Kauffer's distinction that he was among the first, as he still remains among the best, of the interesting and significant contemporary artists to apply these principles to the design of advertisements.[15]

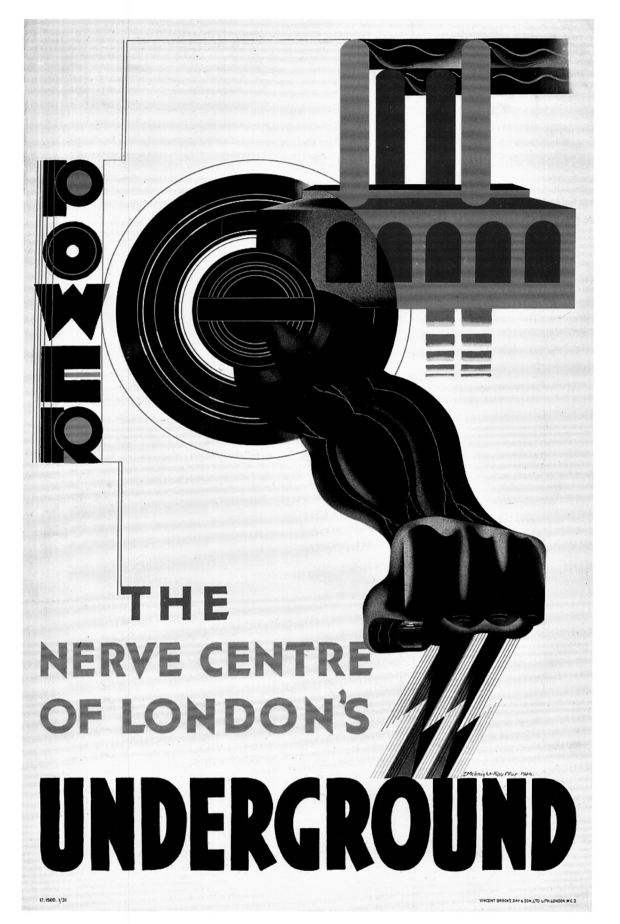

9

EDWARD MCKNIGHT KAUFFER

Power The Nerve Centre of London's Underground, 1931, commissioned by UERL, printed by Vincent Brooks, Day & Son, 40 x 25 in. (101.6 x 63.5 cm). London Transport Museum

MARGARET CALKIN
JAMES

Trooping the Colour,
1932, commissioned
by UERL, printed by
Vincent Brooks, Day
& Son, 12½ x 16 in.
(31.8 x 40.8 cm).
London Transport
Museum

For these reasons Kauffer is the exemplar of the diverse practice of the many artists in this book. Peyton Skipwith's essay examines Kauffer's artistic career, which in turn suggests some of the variety of nontransport projects completed by other artists.

Women were making posters from the earliest days of color lithography, but their presence was unusual. While some women artists worked for the railways as well as other advertisers, it was the Underground that proved to be their most notable patron (Fig. 10). This history and its possible explanations are discussed in chapter six.

In spite of their ephemeral nature, posters are as closely identified with the history of the Underground as its branding and architecture. Pick often voiced the opinion that his main purpose in launching the poster campaign was to create goodwill for the Underground in the face of inevitable problems on the lines; repeating this, one of the staff noted in a memo about the upcoming 1949 *Art for All* exhibition:

To Frank Pick must be ascribed the bold theory that good art is good business, that to insist on the best in posters . . . is not only to give Londoners their just entitlement but to win a rich dividend in the good will of the passenger and in pride of service.[16]

Pick's outlook corresponded with the views of his friend William Crawford, one of England's most successful advertising executives. In 1931 Crawford wrote in *How to Succeed in Advertising*: "The real power of advertising is not to sell goods, but to form habits of thinking. This is rarely understood. . . . It is more important to build goodwill than to sell a great quantity of goods."[17]

The much-lauded reception of the Underground posters inspired the railways to follow suit with the creation of many masterpieces of chromolithography by leading artists, but the railways were more insistent on linking expenditure to economic results. A lead article in the August 1930 issue of the *London & North Eastern Railway Magazine* by the advertising manager, Cecil Dandridge, appears under the title "Is Railway Advertising Justified by Results?" Not surprisingly, given that his job certainly depended on the answer, he feels it is and cites specific statistics to buttress his assertion.[18]

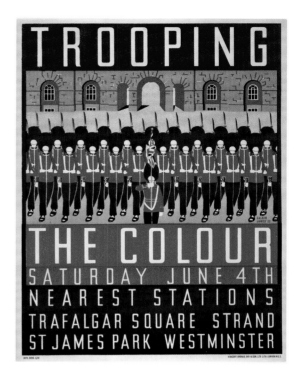

Some have argued that commercial demands actually inspired the artistic achievement of the posters. If art historians trace the roots of modernism in the desire for originality in late eighteenth-century Romanticism and the cult of the genius artist, the magazine *Commercial Art* argued in the 1920s for the imperatives of business: "Union with commerce compels it to be original."[19]

It is important to note that the stated intention of the poster campaign of the Underground was to engender goodwill and encourage ridership, not to promote any particular artistic style or philosophy. At any time, the poster campaign of the Underground encompassed many styles. The 1922 calls to shoppers to venture out in cold weather include both *Winter Sales Are Best Reached by the Underground* by Kauffer (Fig. 11) and *To the Shopping Centres* (Fig. 12) by Agnes Richardson, a children's book illustrator whose style resembled that of Mabel Lucie Attwell. The contrast between Kauffer's highly abstract poster of figures caught in a snowstorm and Richardson's literal depiction of a sweet, rosy-faced child riding on the back of Father Christmas demonstrates the multiple strategies used to reach the largest audience. One poster stretches the aesthetic taste of the audience; the other offers something comfortingly familiar. However, over the course

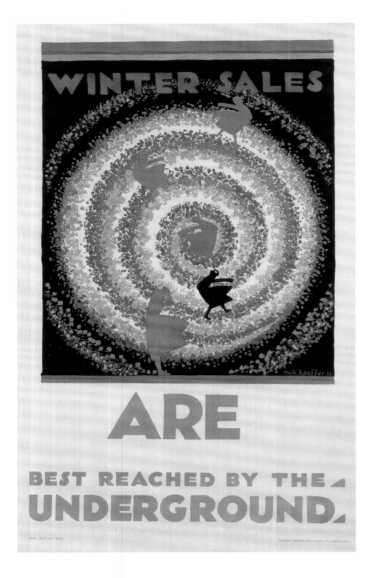

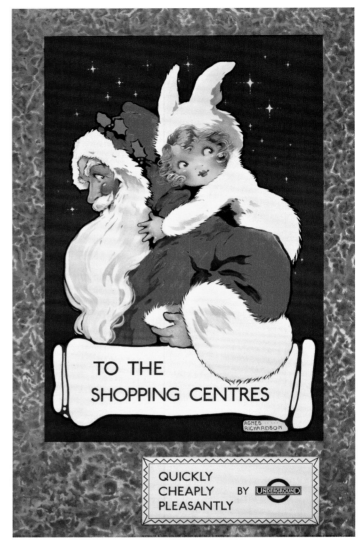

of the 1920s the modernist elements became more pervasive and assertive and by the end of the decade dominated the style of the posters.

No exhaustive database exists for railway posters so it is not possible to make such generalizations for them. But from the available record it is clear that although abstracted compositions were more unusual for the railways, and traditional landscapes predominated, some significant modernist compositions were created. Even conventional landscape posters were often imbued with nonnaturalistic color and simplification of form. The most important artist in this respect was Tom Purvis, whose radical simplifications for LNER echoed and exceeded those of the Beggarstaffs. Some of his posters in the late 1920s and early 1930s of figures in a landscape border on pure abstraction (see Figs. 33, 80). The LNER was the most artistically radical of the lines in its commis-

sions; it had an exclusive railway-poster contract with Austin Cooper as well as Purvis. Another of their artists, Frank Newbould, sometimes created works strongly imbued with a modernist sensibility. They also hired distinguished foreign artists such as Ludwig Hohlwein. Even the conservative rail line, the LMS, occasionally commissioned posters in a powerfully nontraditional style.[20]

No documents have yet come to light to explain definitively why most railway posters tended to be more conventional than their Underground counterparts. Perhaps the commissioners and those at the head of the companies felt that their audience was more comfortable with and responsive to traditional compositions. Perhaps a William Teasdale or a Cecil Dandridge, who successively commissioned posters for LNER, and their colleagues did not share the taste, or enjoy the personal power, of the Underground's Frank

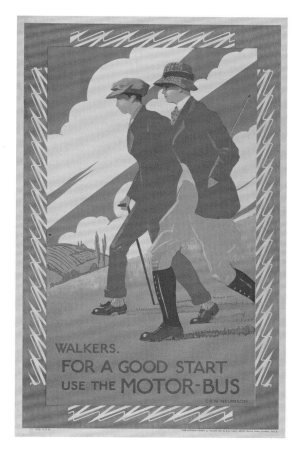

Pick. Perhaps the fact that many railway posters were done in cooperation with local councils for tourist destinations meant that works approved by committee needed to please the largest number of people.

It is also important to note that despite the strong modernist elements in many Underground and some railway posters, none of them equals the daring compositions of avant-garde artists at the time. The colorful, geometricized figural abstractions of David Bomberg and the Vorticist compositions of Percy Wyndham Lewis find no direct parallel in posters, except in rare examples such as a few posters designed by Bomberg himself.[21] Vorticism was a short-lived but influential movement of English avant-garde artists working in 1913–15. Kauffer exhibited with these artists and is sometimes labeled a Vorticist, but his most radical compositions come later than their experiments and, perhaps not surprisingly since most of his output was commissioned by profit-making corporations, never equal the radicalism of their works. When other artists who were members of avant-garde movements designed for the Underground, they tended to

do so later than their revolutionary period and in a less aggressive style. C. R. W. Nevinson's *Walkers, For a Good Start Use the Motor-Bus* of 1921 (Fig. 13) might look startling to a Kensington matron, but its style is less experimental than that of his youth, seen in works like *Returning to the Trenches* of 1915–16. Edward Wadsworth designed for the Underground only in 1936. One of his posters, for the Imperial War Museum, simply reproduces his monumental painting of 1919, *Dazzle Ships in Drydock at Liverpool,* a work that, in the opinion of Charles Harrison, revealed few Vorticist elements.[22] Paul Nash's two posters of collaged urban landscapes were also only done in 1936. However, they display some elements of his Surrealist art of the period.

But even though the most progressive posters do not match the most advanced styles available, their role as disseminators of modernism should not be minimized. A number of contemporaries acknowledged the part played by commercial interests in promoting and legitimating new design standards. In packaging, product design, magazine covers, and newspaper and magazine advertisements, as well as posters, many different corporate clients promoted changing taste along with their own products. Modernist artists, facing skeptical British audiences early in the twentieth century, may well have found their path eased by the willingness of commercial patrons to assume the risks—and reap any rewards—of these commissions.[23]

Such at least was the conclusion in 1942 of the influential historian and cultural critic Nikolaus Pevsner, assessing the Underground campaign. In his opinion, Frank Pick was a vital force in the dissemination of modernism in England in the first part of the twentieth century. Pevsner notes that Fred Taylor and Gregory Brown made excellent posters of the London countryside in a traditional style early in the century and that "Pick might have kept to this type of poster for many years, as the railways did, if his had been exclusively the point of view of the salesman of transport commodities." Instead, Pick sought out young artists with revolutionary methods. In spite of the fact that Pick needed to reach many different kinds and classes of people, Kauffer's daring posters appeared more frequently than those of any other artist. Pevsner concludes, "It can safely be said that no exhibition of modern painting, no lectur-

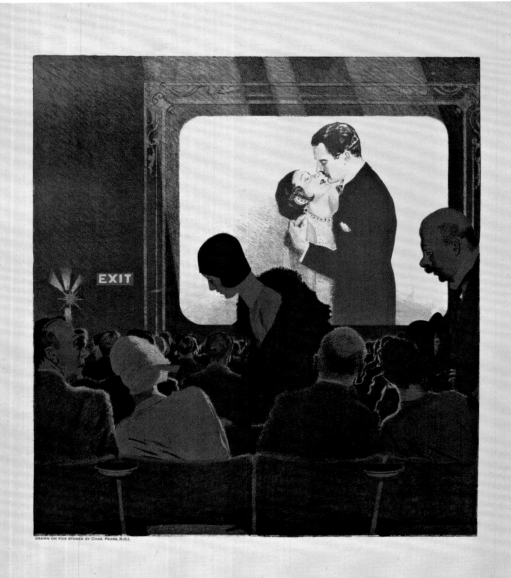

14
CHARLES PEARS
*The Film-Lover Travels
Underground*, 1930,
commissioned by
UERL, printed by
Johnson, Riddle & Co.,
39 ⅛ × 25 in.
(99.4 × 63.5 cm). Yale
Center for British Art,
Gift of Henry S. Hacker,
Yale College, Class of
1965

ing, no school teaching can have had anything like so wide an effect on the educatable masses as the unceasing production and display of L.P.T.B. [London Passenger Transport Board] posters over the years 1930–1940."[24]

Having begun with a film, it seems only proper to end with another cinematic reference, Charles Pears's *The Film-Lover Travels Underground* of 1930

(Fig. 14). The stylishly dressed tardy couple making their way to their seats after the film has begun may be a witty inside reference to the delays on the lines that Frank Pick acknowledged as inevitable. If so, they and countless others have been amply compensated for their inconvenience by the opportunity to enjoy the posters created for British transport.

1. Graham Petrie, "The Art of the Poster," letter to the editor, *The Times*, issue 43561, January 29, 1924, 8, col. E.

2. *Hindle Wakes*, released in 1927, directed by Maurice Elvey and produced by Elvey in conjunction with Victor Saville, based on the 1912 play by William Stanley Houghton, cinematography by Jack E. Cox and William Shenton, produced by A. S. Bromhead and Gaumont-British. The film displays a poster for the LMS (London, Midland, and Scottish Railway) and includes LMS flyers for Blackpool being distributed to workers.

3. Cecil Dandridge, "Advertising Notes," *London & North Eastern Railway Magazine* 19, no. 6 (June 1929): 314. See also 23, no. 6 (June 1933): 292: "A special advertising campaign is being conducted in Lancashire with the object of attracting holiday makers to LNER territory, particularly during the Wakes periods," and 24, no. 7 (July 1934): 375. The railways also promoted the attractions: "All over the north the phrase '*Blackpool for the Illuminations*' has been in evidence, and . . . it is estimated that some 250,000 handbills and 1,250 posters have been issued in the famous Lancashire Resort." Cecil Dandridge, "Advertising Notes," *London & North Eastern Railway Magazine* 26, no. 11 (November 1936): 626.

4. Maurice Talmeyer, "The Age of the Poster," *Chautauquan* 24 (January 1897): 462.

5. Brander Matthews, "The Pictorial Poster," *Century* 44 (September 1897): 749.

6. Susan Lambert, "Prints and Book Illustration," *Thirties: British Art and Design before the War*, exh. cat., Hayward Gallery, October 25, 1979–January 13, 1980 (London: Arts Council of Great Britain, 1979), 82.

7. Austin Cooper, *Making a Poster*, How to Do It series (London: The Studio, 1938), 9.

8. For other discussions of modernism see Alan O'Shea, "English Subjects of Modernity," in Mica Nava and Alan O'Shea, eds., *Modern Times: Reflections on a Century of English Modernity* (London: Routledge, 1996), 7–37; and Christopher Wilk, "Introduction: What Was Modernism," in Christopher Wilk, ed., *Modernism: Designing a New World , 1914–1939*, exh. cat. (London: Victoria and Albert Museum, 2006), 11–21.

9. Kenneth Clark, "Painters Turn to Posters," *Commercial Art* 17 (July–December 1934): 65–72. Clark was opening an exhibition of posters for the oil company Shell-Mex.

10. Sydney R. Jones, *Posters and Publicity* (London: The Studio, 1926), 1.

11. John Harrison, *Posters and Publicity* (London: The Studio, 1927), 1.

12. F. A. Mercer and W. Gaunt, eds., *Modern Publicity 1937 and 1938: Commercial Art Annual* (New York: William Rudge; London: The Studio), 21.

13. For a discussion of some aspects of the Shell campaign, see John Hewitt, "The 'Nature' and 'Art' of Shell Advertising in the Early 1930s," *Journal of Design History* 5, no. 2 (1992): 121–39.

14. Harrison, *Posters and Publicity*, 3.

15. Aldous Huxley, "Introduction," *Posters by E. McKnight Kauffer* (New York: Museum of Modern Art, 1937), n.p.

16. Transport for London Archives, LT 371/001, "Art for All exhibition."

17. Sir William Crawford, K.B.E., "How to Succeed in Advertising," in *World's Press News" Library* 2 (1931), 22.

18. Cecil Dandridge, "Is Railway Advertising Justified by Results?" *London & North Eastern Railway Magazine* 20, no.8 (August 1930): 389–90.

19. *Commercial Art* 1, no. 1 (July 1926): 1.

20. For further information on these posters, see John Hewitt, "Posters of Distinction: Art, Advertising, and the London, Midland, and Scottish Railways," *Design Issues* 16, no. 1 (Spring 2000): 16–35.

21. I thank Margaret Timmers for calling to my attention that Bomberg designed a poster for a gallery, *New Art Salon*, ca. 1914–18, for which a design but no printed poster exists and *Cameo Corner*, 1919, for which both the design and the poster exist. All are in the collection of the Victoria and Albert Museum, London.

22. Charles Harrison, *English Art and Modernism, 1900–1939* (New Haven: Yale University Press for the Paul Mellon Centre for Studies in British Art, 1981, repr. 1994), 128–29.

23. For a discussion of this phenomenon in America, see Neil Harris, "Designs on Demand: Art and the Modern Corporation," in *Cultural Excursions: Marketing Appetites and Cultural Tastes in Modern America* (Chicago: University of Chicago Press, 1990), 349–78, 420–31.

24. Nikolaus Pevsner, "Patient Progress: The Life Work of Frank Pick," *Architectural Review* 92 (August 1942), repr. in *Studies in Art, Architecture and Design*, vol. 2 (New York: Walker, 1968), 32.

THE ART OF POSTERS: STRATEGIES AND DEBATES

TERI J. EDELSTEIN

The poster campaigns of the Underground, launched by Frank Pick in 1908, came a generation after the art-poster revolution that engaged Europe and America in the 1890s. While British masters like Dudley Hardy, the Beggarstaffs (William Nicholson and James Pride), and Aubrey Beardsley were among the earlier participants, Pick's patronage dramatically expanded the numbers of prominent British poster artists and enhanced their reputations. More than that, although Pick employed artists working in many styles, he helped introduce a vast audience to the new visual codes associated with modern (or modernist) artists like Edward McKnight Kauffer.[1]

Pick's reputation as a patron, strong in the years when Nikolaus Pevsner was writing and sustained for some time thereafter, has recently gone into something of an eclipse. For whatever reason, his name is barely mentioned in the massive surveys attached to the recent Victoria and Albert exhibitions, *Art Deco 1910–1939* and *Modernism 1914–1939: Designing a New World.*[2] By contrast, an exhibition in 1980 at the Hayward Gallery, *Thirties: British Art and Design Before the War,* granted Pick and London Transport considerable credit for spearheading changes in taste.[3]

Pick did more than promote his own choices. He also inspired the efforts of others who commissioned posters, most particularly the London and North Eastern Railway (LNER), whose publicity was originated by William Teasdale at the time of its 1923 founding. The art critic of *The Evening Post* commented in 1928 that where Pick led, Teasdale followed.[4] The celebrated poster maker Frank Newbould, one of LNER's featured artists, lauded Teasdale for reforming the previous railway practice of using generic posters prepared on spec instead of commissioning posters of particular sites.[5] As early as 1924, a cartoon, "The Poster Age," recorded the shock this provoked. In a booking hall hung with posters by Frank Brangwyn, Fred Taylor, and others, a melancholy porter, new to the job, soliloquizes: "I thought I had got a job on the railway, but I think I have struck a Blinking Art Gallery" (Fig. 15).

A mere twenty years after the launch of the Underground poster campaign, the status of posters as art, in addition to their role in commerce, seemed secure, at least in certain quarters. Not surprisingly, Pick's colleagues applauded his achievements. Introducing the *Design and Industries Association Year-Book* in 1928, Sir Laurence Weaver praised Pick, "who has provided the people of London with a picture gallery as fine in some ways . . . as the Tate or the National and with a much more imposing number of visitors, and who . . . has made possible by enlightened patronage the admirable work of the modern-

ist advertising designers."[6] Tom Purvis, the well-known poster artist, also gave Pick credit in a lecture at the Royal Society of Arts in 1929.[7] An anonymous reviewer in *The Observer,* perhaps more disinterested than Weaver and Purvis, took a similar position, noting that Pick, "by courageously enlisting the services of a small army of distinguished artists" had simultaneously promoted the advantages of the Underground, amused his audience, and provided them with an artistic education. There could be no doubt, the reviewer continued, that these artists were "universally admired."[8] Of course, at the same time, the Underground and other exhibitors in "the Poor Man's Picture Gallery" were displaying their advertising messages to potential clients.

Despite these accolades, however, at this time commissioners, creators, and commentators on the poster still found it necessary to devise defensive strategies of definition and legitimation. Not everyone, apparently, was prepared to acknowledge the poster's status as a work of art. Examining aspects of the early twentieth century debate will reveal the points of the arguments and their merits.

When Sir Laurence Weaver and others proposed that posters rivaled the art to be found in the Tate or the National Gallery, they were elevating them from their common status in the early twentieth century as "the Poor Man's Picture Gallery." This phrase, repeated frequently in the press, signaled both the ubiquity of posters in public spaces and their implied social role as improvers of popular taste.[9] This function provided one source of legitimacy. But embedded in this common formulation was an element of condescension. The status of artists who worked on commercial rather than fine art was unresolved in this period. Many poster makers felt their identity as artists to be unquestionable; others believed themselves to be artists but feared the world did not agree. It was only the rare artist who frankly accepted (and defended) his or her role as an engine of commerce rather than art. Gregory Brown, who was both an exhibitor at the Royal Academy and a poster designer for the Underground, railways, and other commercial clients, framed his commitment to posters as an art form in political terms: "If art is to be a living force, it must break the bounds of the picture frame, it

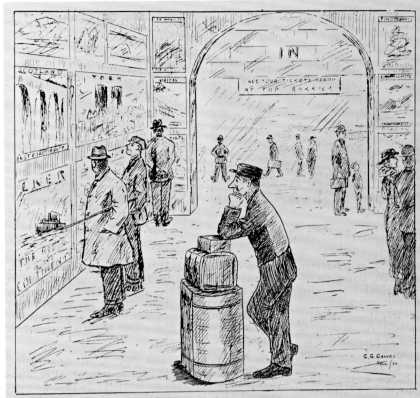

NEW PORTER (soliloquizing): "I thought I had got a job on the railway, but I think I have struck a Blinking Art Gallery."

must reach the things of everyday life. . . . Truly catholic art must apply itself towards improving the lives of people and their surroundings."[10] A few years later he objected to the use of "Art" with a capital "A" as an evaluative term inappropriate to the appreciation of posters: "The word 'Art' is an abomination, so is the word 'Artist,' moreover, they have no meaning." Brown was not simply objecting to the "Art" label but to those posters which simply added type to an existing picture. Posters, he insisted, required their own distinctive and integrated design. "A poster is a design, a picture is a thing to hang on the wall in a frame. There you have it."[11]

One strategy for the advancement of posters as art was the involvement of academic artists of established reputation in promotional campaigns. While some critics found their work admirable, many others objected to posters that were simply reproductions of paintings, usually with text added along the bottom.[12] Held up for special denigration were the posters of the LMS, the London, Midland, and Scottish Railway, which hired the Royal Academician Norman Wilkinson in 1924

15
Cartoon from "The Poster Age," *London & North Eastern Railway Magazine* 14, no. 160 (April 1924): 107. Bodleian Library, University of Oxford

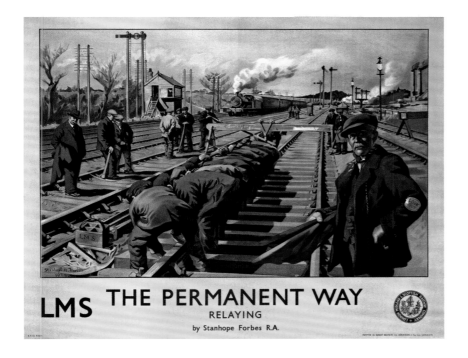

LMS **THE PERMANENT WAY**
RELAYING
by Stanhope Forbes R.A.

16

STANHOPE ALEXANDER FORBES

The Permanent Way Relaying, 1924, commissioned by LMS, printer unknown, 40 × 50 in. (101.6 × 127 cm). National Railway Museum, York

to recruit fellow RAs, like Maurice Grieffenhagen and Stanhope Forbes, to work for the line (Fig. 16).[13] In a 1924 review *Commercial Art* noted the ineffectual nature of these posters: "The railway company who spent so much money on the poster is almost completely forgotten."[14] The following year Percy Bradshaw, an art educator and well-known champion of commercial art, chided the LMS and asked them to "remember that there are many distinguished artists and illustrators whose work might be far more suitable for advertising purposes than a series of characteristic pictures by R.A.s"[15] In March 1929 *The Observer* endorsed this view, arguing that famous members of the Royal Academy had little or no experience designing posters.[16] John Harrison, writing in *Commercial Art* in 1931, concluded, of the LMS campaign, "The results were not very successful."[17]

The LMS might have saved itself such opprobrium if it had consulted a number of poster commentaries that began appearing in print during the mid-1920s. 1924, the launch year for the LMS campaign, also saw publication of *The Art of the Poster*, edited by Kauffer and dedicated to Frank Pick. R. A. Stephens, in his introduction, insisted that the art of poster making differed from the art of painting pictures. "A painting can no more substitute for a poster than a poster can be a painting . . . poster designing [is] an entirely separate branch of art which possesses its own laws

and purposes."[18] A poster demands a summary of facts, quickly grasped. Citing the poster's origins in the signboard, he emphasized the importance of economy and simplicity and the basic geometry of composition. Color as a key element of harmony, accent, and association, and the centrality of the symbol are also noted.

Many of the posters illustrating the section "The Progress of the Poster" came from Kauffer's own extensive collection. He singled out Toulouse-Lautrec, the Beggarstaffs, and the American Edward Penfield as important antecedents of the contemporary poster.[19] In the book's contemporary section Kauffer's own works figure prominently, as well as works by, among others, Maxwell Armfield, Gregory Brown, Frank Newbould, and Frederick Herrick. The principles articulated here were generally accepted by commentators elsewhere. A reviewer of posters in *The Observer* in 1929, who may have heard such ideas at Tom Purvis's lecture at the Royal Society, could repeat as accepted wisdom that the poster "demands extreme simplification, boldness of design, and knowledge of how to obtain the most striking effects with the fewest possible colours."[20]

Other writers on poster theory listed additional requirements. W. G. Raffé initially published "The Elements of a Poster" serially in *Commercial Art* in 1928–29 and gave extensive advice on appropriate form, content, and printing technique. He hoped to "elucidate the components fundamental to all posters. These may be observed within three main groups: artistic factors; emotional-intellectual factors; and scientific factors."[21] In 1933 the poster artist Leonard Richmond edited *The Technique of the Poster*, a practical guide with tips on poster design, including lettering and color, and a compendium of essays by commissioners and executors of posters with anecdotes and some occasional theoretical insights.[22] Its survey of the contemporary poster in England pays particular attention to the posters of the Underground and the rail lines.

Austin Cooper wrote still another text, a treatise for students, in 1938.[23] Cooper, one of the artists retained on commission by the LNER, was also a frequent contributor of posters to many other clients, especially the Underground, creating over fifty posters for them between 1922 and 1944. Summarizing both his knowledge of the

history of posters and his own designing experience over a number of years, he stressed the need to integrate lettering with the poster design. He spoke of the "tiresome conventions" of the average railway poster, with its lettering usually running across the bottom; he urged that type be kept minimal and be an integral part of the composition. Like many, he condemned posters that were mere reproductions of works of art: "I remember seeing an oil painting—an alleged poster."[24]

While not the first to make or exemplify this argument—German artists had been doing so for decades—Cooper supported his theoretical stance in his own work. A 1928 poster for the Natural History Museum, *Natural History Museum: Lepidoptera* (Fig. 17), makes this clear.[25] A monumental, brightly colored butterfly floats on a diagonal against an ivory ground, wings overlapping its Latin name, which is staggered in large, bright pink letters across the top. These catch the viewer's attention and create a sense of movement. The background shades to black, the dominant color of the butterfly, at the bottom of the poster, creating a contrast for the words "Natural History Museum" in large turquoise letters that pick up an accent color of the butterfly. Below that, "Underground" and "South Kensington" are centered and printed in pink. Unlike many artists, who gave the Underground a maquette for the printers of the image only, Cooper's maquette includes the lettering integral to his design.

Perhaps Pick, creator of the poster campaign for the Underground, said it best, in his straightforward way, in a lecture on posters on March 3, 1939, shortly before his retirement from London Transport. The aim of a poster is to accomplish four things:

> *To arrest*
> *To explain*
> *To inform*
> *To suggest.*[26]

Despite, or perhaps because of, the development of advertising, particularly after World War I, the artistic status of poster designers remained a contentious issue. Aided by the growth of specialist agencies, this rapidly expanding industry was demanding broader public attention in Britain; in 1922 a new journal calling itself *Commercial*

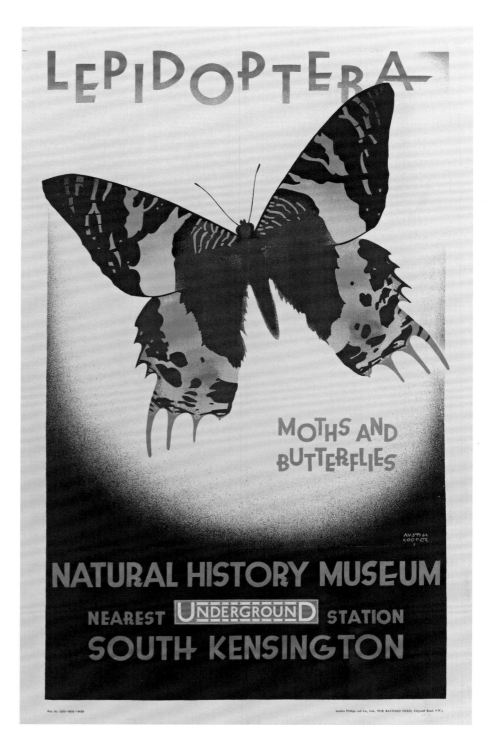

Art appeared, devoted to posters, display, packaging, and advertising. The first page of its first issue asked: "Cannot Art and Commerce be indissolubly united . . . ? . . . Our contention is that its [art's] use in Commerce is constant, immense, and indispensable."[27] Percy Bradshaw titled his 1925 examination of the field *Art in Advertising*.[28] The most common trope invoked to justify the credentials of the commercial artist was that of

the medieval or Renaissance artist. An article in the inaugural issue of *Commercial Art* claimed that the contemporary commercial artist of 1922 was no different than the builder of a Toltec temple or Michelangelo working for a patron—a historical model that was repeated in a subsequent issue as well.[29] "Commercial Art is the legitimate successor to the entirely different but equally commercial art of the Middle Ages, where artists were employed to paint pictures and decorations for the great churches—one *could* say for the purposes of religious propaganda. Then again, they were employed by the great nobles on works of art; one *could* say, here, for *personal* propaganda." Thus Bradshaw introduced the poster artist Purvis as a lecturer to the Royal Society of Arts in 1929.[30] Employing "propaganda," a word that commonly served as shorthand for advertisements and posters in this period, Bradshaw was simply echoing the opening page of Raffé's series of essays.[31]

Continuing prejudice against commercial art in the 1930s stimulated a whole range of scholarly and popular rejoinders. Thus Nikolaus Pevsner declared in *An Enquiry into Industrial Art in England* (1937): "The medieval painter was a craftsman . . . he would not have thought of objecting to the carrying out of orders. . . . Take some of the best commercial artists in London. They . . . design posters, packages and catalogues, the social value of which is higher than . . . any good portrait or landscape . . . while their aesthetic value is certainly not lower."[32] Pevsner thus links the idea of the artist/craftsman to one of social value. In his eyes, the aesthetic purity of Modernism—its cleanness, directness, and precision—was both a social and moral priority.

Two years earlier Anthony Blunt had lamented the secondary status of Kauffer. Reviewing an exhibition of his works at the Lund Humphries Gallery, he sought to raise the perceived lower status of the commercial artist. "Mr. McKnight Kauffer is an artist who makes me resent the division of the arts into major and minor. Since he is . . . an illustrator and a designer of book-covers and posters he must, technically, be classed as minor, but as I looked round the exhibition . . . I was led to think: 'If he is minor, who then is major . . . ?' "[33]

The Underground and the railways, particularly the LNER, worked energetically to position their posters as works of art. Pick was one of those who encouraged the accession and exhibition of posters by museums. As early as 1911, just one year after the Victoria and Albert Museum began actively to collect posters, he initiated an extensive ongoing donation to the museum of posters commissioned for the Underground.[34] Given Pick's lifelong involvement with art education, perhaps his primary motivation was the training of future generations of poster designers by this museum, founded to further such education through its collections and study rooms. But an added benefit might be adduced from the first poster exhibition organized by the curator Martin Hardie in 1920, which was dedicated to Frank Pick of the Underground Electric Railways Company of London, "in honor of his brave and successful effort to link art with commerce" and for "setting an example in poster work by securing the services of the best artists of the day."[35]

Alongside the LMS's reproduction of commissioned paintings by Royal Academicians, another conspicuous strategy was the organization of poster exhibitions both in commercial West End gallery settings and in museums. The LNER, which had earlier organized annual poster exhibitions in its boardroom at King's Cross Station, held an exhibition of posters at the New Burlington Galleries in the West End in spring 1928.[36] The Underground followed suit in October 1928.[37] The LNER made this an annual event, which reached government officials, who were often asked to open exhibitions; members of the public, who attended and bought posters; and arts reviewers, who enhanced both LNER publicity and reputation. Of course, every visitor who saw the exhibitions of the company's current posters was also exposed to its advertising message. By 1932 the LNER was not only exhibiting posters in the West End but also in regional art galleries and municipal venues, such as the York City Art Gallery, the Laing Art Gallery in Newcastle upon Tyne and the Bowes Museum near Durham.[38] The Lord Mayor of York, opening an exhibition of LNER poster art at York City Art Gallery, lauded the posters of York by Fred Taylor: "The city authorities will always be mindful of the great heritage of these pictures and they will be preserved for future generations."[39] The eleventh annual London exhibition in 1933 (Fig. 18)

featured Newbould's whimsical series *East Coast Frolics,* an ensemble of six brightly colored posters in which anthropomorphic animals promote the delights of the seashore. A dolphin skims the waves, playing with a beachball, and a lively jazz band includes a top-hatted fish on sax and a crab on banjo (Fig. 19).[40]

Southern Railway was far more modest in its ambitions. One record has been found of SR holding an exhibition in the Charing Cross booking hall of the Underground.[41] The Great Western Railway, which produced smaller numbers of posters, does not seem to have pursued this avenue at all.

In addition to poster exhibitions, the LNER sought to foster the artistic reputation of its artists in other ways. It created "galleries" at major railway stations and installed monographic displays of posters by its important artists in order "to emphasise the characteristics of our posters and artists, and so cultivate public interest in pictorial representation." The first, in 1929, was devoted to Fred Taylor.[42] Other galleries featured artists like Newbould.[43]

The Underground ran a shop to sell its posters, as did the LNER and the LMS. During the seventh exhibition of LNER posters in 1929, held at the New Burlington Galleries (and perhaps to justify the expense to his superiors), the advertising manager, Cecil Dandridge, bragged that the receipts for 1928 had increased 150 percent from the previous year.[44] The sales earned revenues, and, in addition, a poster perpetually displayed in a home or office meant a perpetual advertising message, but the sales also positioned the posters as artworks. Advertisements for the London Transport poster shop convey this strategy. One in the 1933–34 volume of *Modern Publicity* announces that "lovers of Art know about this little shop and its treasures. They know that for nearly thirty years the 'Underground' has employed the foremost artists of the day, and that their works can be captured for a shilling or so"(Fig. 20).[45] A later advertisement, from July 1937, states: "Yes, we may well believe in the re-creative value of just looking round the galleries, but isn't there greater value in choosing a picture, perhaps by Laura Knight, McKnight Kauffer or Barnett Freedman, and carrying it off triumphant?"[46] Note the repeated use of the word "picture," rather than

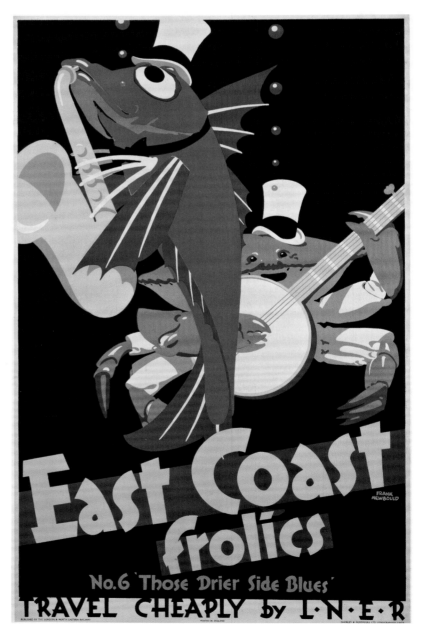

"poster," which only appears at the end of the advertisement. In November, now using a less pretentious nomenclature, London Transport was promoting "posters by modern artists, some of them eminent: posters printed with satisfying excellence."[47]

Although the LNER was anxious to present its posters as works of art through these strategies, it did not hesitate to undercut the argument when the need arose. In 1927 the LNER guaranteed five artists a minimum payment in exchange for the promise to design railway posters exclusively for that line. Artists were paid a set price for each size poster or other assignment and their total compensation could exceed the guarantee. The total guarantee was in pounds sterling, but the fee for each commission was paid in guineas. (Gentlemen in the 1920s were still paid in guineas, while tradesmen were paid in pounds.) In 1929, when it was time to negotiate a new three-year contract with "the big five," as Taylor, Newbould, Purvis, Cooper, and Frank Mason were known, W. M. Teasdale, then Assistant General Manager of the rail line, advised his successor as Advertising Manager, Dandridge, in a memo of December 1929:

When renewing the contracts I should take the opportunity to get rid of . . . blemishes to the previous scheme . . . that payment is made in guineas. Commercial Artists should welcome this distinction between their own and the Fine Art, and like ordinary business men take their payment in pounds only. . . .

I shall naturally be very interested to hear the result of your approach to the artists, and the arrangements you make for the continuity of this scheme, which results in the other Railways finding extreme difficulty in approaching your standard.[48]

Perhaps predictably, the "business men" did not take kindly to the suggestion. Cooper replied to Dandridge on December 7, 1929: "I shall be glad to confirm the arrangement therein outlined subject to the fees . . . being altered to thirty-five, sixty-five and seventy-five guineas. A very small point perhaps, but of certain professional importance!"[49] Dandridge had obviously received a similar letter from Newbould, which does not survive. On December 20, 1929, Newbould replied to him: "Many thanks for your letter of

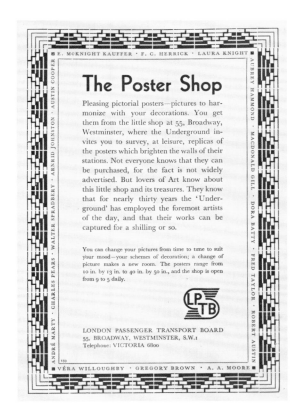

the 19th inst. in which you kindly agree to pay me the equivalent of guineas."[50] Newbould confirms that he did not ask for an increase of the single shilling on the pound price paid on each assignment, only that the prices be computed in guineas. It was the status, rather than the additional money, that motivated the artists. Not quite a year later, in September 1931, amid the misery of the Depression, all five of them signed a letter to Dandridge asking that the prices of their work be reduced by 5 percent. "We poster men feel that it would be a privilege if we were allowed to put ourselves on the same footing as you officers of the company."[51]

To accomplish his goal of creating goodwill for the Underground as well as fostering ridership and, occasionally, imparting admonitory information, Pick had to appeal to many constituencies. Appropriately, the posters exhibited a range of styles and were commissioned from a wide variety of artists. Many of the artists who worked for the Underground and the rail companies had an established identity in the art worlds of Britain. The Underground did not specifically undertake to hire Royal Academicians, as the LMS did, but some of its artists, such as Maxwell Armfield, Walter Ernest Spradbery, Dame Laura Knight,

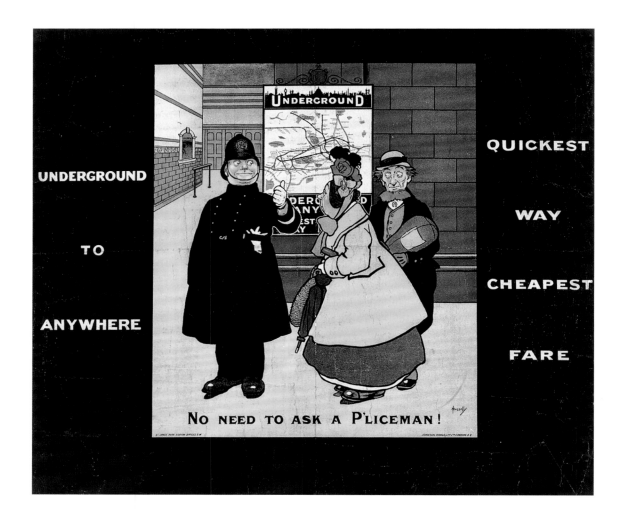

UNDERGROUND

TO

ANYWHERE

QUICKEST

WAY

CHEAPEST

FARE

NO NEED TO ASK A P'LICEMAN!

21

JOHN HASSALL

*No Need to Ask a
P'liceman!*, 1908,
commissioned by UERL,
printed by Johnson,
Riddle & Co.,
23 5/8 x 21 in.
(60 x 53.3 cm).
London Transport
Museum

Gregory Brown, Mary Adshead, Charles Pears, Doris and Anna Katrina Zinkeisen, and others had exhibited at the annual exhibition and a few were RAs.[52] Others were associated with exhibiting societies like the London Group, formed in 1913 on the model of the Salon des Indépendents in Paris, where more radical art could regularly be seen. Its original membership comprised remnants of the Camden Town Group as well as more avant-garde artists such as David Bomberg, Percy Wyndham Lewis, and Edward Wadsworth. Particularly in its earliest years, the London Group represented the vanguard of Modernism in England.[53] Edward McKnight Kauffer became a member in 1916, after he began designing for the Underground in 1915. H. S. Williamson, who first worked for the Underground in 1922, became a member in 1933. Seventeen members of this select group were employed by the Underground, including John Farleigh, C.R.W. Nevinson, Wadsworth, Phyllis Bray, Paul Nash, Graham Sutherland, Williamson, and Kauffer.[54]

Early Underground posters, in 1908 and just after, tended to follow examples Pick knew from his work on the North Eastern Railway, and emphasized traditionally drawn landscapes surrounded by letterpress. The very first commissioned Underground poster, *No Need to Ask a P'liceman!* by John Hassall, had a representational, comic spirit quite different from the Art Nouveau, Aubrey Beardsley–inflected style that Hassall had employed years before. *No Need to Ask a P'liceman!* depicts a rotund bobby standing in a sparkling tiled hall, helpfully pointing a stout matron toward the map of the Underground (Fig. 21). Hassall was well known as an illustrator, cartoonist, and poster designer of great wit. But this first poster did not set any pattern or style for the Underground.

Hassall designed his most famous poster, also created in 1908, for the Great Northern Railway. *Skegness Is So Bracing* depicts a jolly fisherman skipping down the beach with his arms outstretched. It proved to be so popular, becoming the symbol

of the town, that Hassall redesigned it several times, including a horizontal version for the LNER that dates to between 1923 and 1932 (Fig. 22). The LNER also commissioned Newbould to update it in 1933.[55]

By the next year the compositions of Underground posters began to grow more adventurous. Charles Sharland, about whom almost nothing is known, worked directly for the printers Waterlow & Sons. He designed over one hundred posters between 1908 and 1922. *No Waiting, Rapid Service of Trains,* 1909, uses a simple circle of track with underground cars running around its circumference to deliver its message (Fig. 23). Its effective use of the white paper and its placement of the diameter of the circle against the margins of the poster make the image more assertive than almost any other poster done for the Underground up to that date. An adaptable artist who executed a great many conventional landscape posters, including several for the Underground that same year, he also showed an awareness of

contemporary trends: abstraction, simplification, and radical cropping. The ever-inventive Sharland continued to create posters in a modernist style in later years.

In the early years of the poster campaign, many other designers may have worked directly for printers. Given the prosaic nature of some of the anonymous posters, one suspects that those responsible worked with little input from Underground staff and, perhaps, with little training or aptitude as artists. Transport for London holds only eight maquettes for the 108 documented posters by the hand of Sharland, possible evidence of the minimal amount of direct supervision by Underground staff.

In 1912 Anthony (Tony) Sarg, known in later years for his children's book illustrations and marionettes, designed a poster with an exaggerated urban scene, using a high viewpoint made familiar by the Impressionist landscapes of Camille Pissarro and Claude Monet. One suspects that he had seen some contemporary German posters as

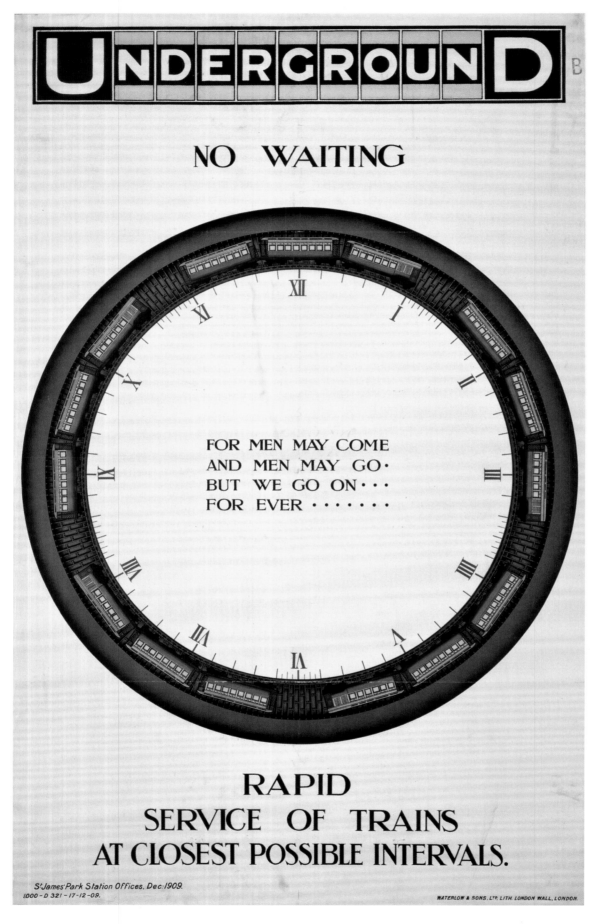

UNDERGROUND B

NO WAITING

FOR MEN MAY COME
AND MEN MAY GO·
BUT WE GO ON···
FOR EVER·······

RAPID
SERVICE OF TRAINS
AT CLOSEST POSSIBLE INTERVALS.

S! James' Park Station Offices. Dec. 1909.
1000-D 321-17-12-09.

WATERLOW & SONS.LTP. LITH. LONDON WALL, LONDON.

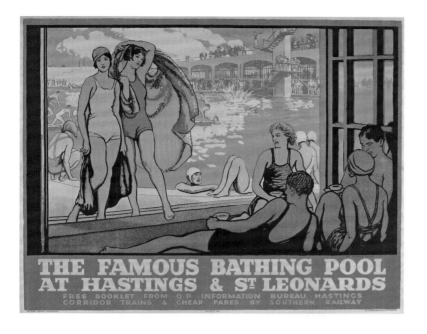

well, perhaps by the celebrated Ludwig Hohlwein. Sarg's series of twelve bold single-figure posters for the bus and tram in 1914 makes a strong statement in outline and color. By 1914 even a few letterpress posters begin to break free of their nineteenth-century ancestors with clean, bold designs and sans-serif typefaces.

Gerald Spencer Pryse was stylistically quite different, one of a small group of artists who drew directly on the stone to make lithographs, a technique called autolithography. *Underground for Sport,* from 1913 (see Fig. 59), with its strong black outline and spontaneous handling of the figure, certainly used this method. Much of the composition is drawn with the black crayon, with the white paper and accents of red and yellow creating movement through the cheering crowd.[56] The strength of Pryse's line was noted by his contemporaries: "Spencer Pryse is another designer of great power, and always through his work there is an intense feeling for subject. Although his output is large, the same high standard is invariably maintained."[57] Pryse worked for a number of commercial clients, including several rail lines, the LNER among them. *The Famous Bathing Pool at Hastings & St. Leonards,* executed for the Southern Railway in 1934, uses an even stronger black foundation drawing for his monumental swimmers, whose poses echo classical prototypes (Fig. 24). In his posters for the Empire Marketing Board, Pryse is known to have made preparatory studies with the camera.[58]

The first Underground poster chosen by Kauffer as an illustration in *The Art of the Poster* (1924) was *Go to Kew,* executed by his friend the established artist Maxwell Ashby Armfield (Fig. 25). With its asymmetrical cluster of bright colored flowers and an upside-down cockatoo whose tail is cut off by the frame, it is an arresting image. The encouraging words "Go to Kew" begin in a small font superimposed on a bush on the right and get progressively larger, transforming the triangular shrub into a megaphone until the words run across the entire bottom of the poster in large type. The design is bolder, more simplified, and more colorful than Armfield's paintings or book illustrations of that time, or than Kauffer's first efforts for the Underground. Armfield had studied posters since his days at school. He writes in an autobiographical sketch:

My removal at 16 to Leighton Park School was a definite turning point . . . I devoted a great deal of time surreptitiously to the designing of posters. "The Poster" was an excellent paper, and through its pages I made the acquaintance of the fine artists who were then making the noble but futile attempt to "link art with industry." Such designers as Dudley Hardy, Steinlen, Mucha, the "Beggarstaff Bros" . . . these I shamelessly and interminably imitated.[59]

One wonders whether Armfield's familiarity with poster history had any influence on Kauffer. It is possible that the American Kauffer encouraged Armfield in a different way: in 1915 Armfield left England for the United States, where he remained for seven years.

1915 was also the year Kauffer began designing for the Underground, his first professional poster commissions. The simplified landscape style of his early posters was anticipated in 1913 in posters done for the Underground by Walter Spradbery and Sharland. This mode was taken up by others, such as Paul Rieth, in 1914. Because posters were on display only temporarily, we cannot assume that Kauffer saw the 1914 posters when he moved to London late that year. But his own were more abstracted, his colors less naturalistic. In *Reigate*, for example, red trunks of trees create staccato accents that hug the picture plane in spite of their placement in the mid-ground of the landscape.

Kauffer's posters stood out against those of his compatriots of that year, excepting perhaps Armfield's. Kauffer had been infected by the work of avant-garde artists such as Marcel Duchamp and André Derain, which he had seen in the version of the Armory Show displayed at the Art Institute of Chicago in 1913, when he was studying there. In fact, we may see echoes in *Reigate* of Derain's *Forest of Martigues*, 1908–9, exhibited in Chicago. Other influences include works seen in his subsequent travels in Germany and France by Vincent van Gogh and Japanese printmakers. Kauffer's compositional rigor can be contrasted with the landscape poster *Epping Forest* (see Fig. 89), executed the following year by Gregory Brown, which grafts a nonnaturalistic green sky, yellow trees, and ground of bright pink and orange onto a conventional landscape structure. Still, Brown's landscapes brought a colorful vibrancy

to the posters of 1916. His poster for the 84 bus route to St. Albans, from the series of eight scenes of rural destinations he designed for the Underground Group that year, moved the bright, bleaching Fauvist sun of the south of France to the London exurbs. Mauve, pink, gold, royal blue, and orange dominate his vision of a St. Albans farm. The Norman cathedral and abbey tower shimmer in the background, decidedly more influenced by Post-Impressionism than the poster Fred Taylor created for the same destination that very year. Taylor, an artist who made a specialty of architectural subjects, has the cathedral and tower dominate his work (see Fig. 71).

26

CHARLES PAINE

Hampton Court, 1921, commissioned by UERL, printed by the Baynard Press, 29 13/16 x 19 15/16 in. (75.7 x 50.6 cm). Yale Center for British Art, Friends of British Art Fund

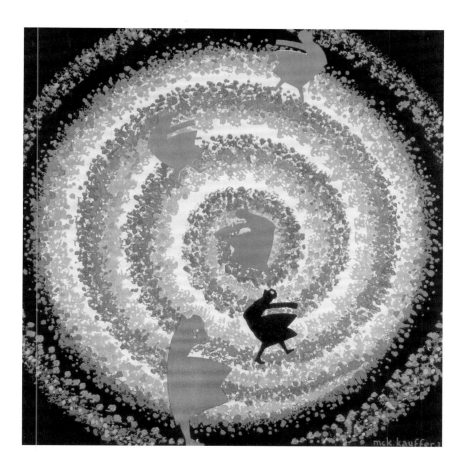

27

**EDWARD MCKNIGHT
KAUFFER**
Detail of
*Winter Sales Are Best
Reached by the
Underground,* 1922,
commissioned by UERL,
printed by Vincent
Brooks, Day & Son,
39 1/16 x 24 1/16 in.
(99.2 x 61.1 cm). Yale
Center for British Art,
Gift of Henry S. Hacker,
Yale College, Class of
1965

By the early 1920s, with the war at an end and poster production increasing as the economy slowly recovered, a number of other talented designers had joined the ranks of the Underground. One was Charles Paine. In *Hampton Court* of 1921 (Fig. 26) the symmetrical splashes of green water are highlighted against a dramatic black ground. Making very effective use of the white paper, Paine places a Mandarin duck with distinctive black and orange markings swimming in from the right. His use of bright, solid, contrasting colors in several of the thirty-one posters he designed for the Underground may reflect his experience as a maker of stained glass. His fellow poster artist Horace Taylor credits his artisanal training for shaping Paine's high standards of design. Taylor praises Paine's "decorative simplicity and sense of style such as had scarcely been seen since the days of the Beggarstaffs."[60] Pick could have known Paine's work through friends— W. R. Lethaby, with whom Paine had studied at the Royal College of Art, and F. Morley Fletcher, head of the Edinburgh College of Art when Paine led the Applied Art Department there. As early as 1922 Paine was working for the Baynard Press,

as an advertisement for the Press designed by him in the first volume of *Commercial Art* attests.[61]

Hampton Court was given a prominent position by Pick, along with other works by Paine, in the volume he edited for the Design and Industries Association.[62] Also illustrated is a wall of posters by Kauffer and Brown. The black-and-white illustrations of these four-color posters reveal the strength of Kauffer's compositions. The vortex of *Winter Sales Are Best Reached by the Underground,* 1922, reads powerfully here and even more so in the original, with accents of blue, black, and red shoppers buffeted by the swirling storm (Fig. 27; see also Fig. 11) and in its four-color reproduction in the 1923 *Commercial Art.* The commentator in that magazine was inspired by its graphic economy:

The poster strikes the note of daring the artist has almost compelled us to expect of him. . . . Is it necessary to explain the meaning and point to the moral of this symbolistic design? The cyclonic spiral of blustering winds, rain, slush, the imperative necessity of going out.

Red, blue, black, grey, fawn, traffic, sky, cold, hot, earth and water, buses heavy with people, empty streets, only a figure here and there struggling against the elements.

Down below the surface the Underground: its cosy tunnels wind their way to the shops. Go there for comfort and relative happiness. All this conveyed at a glance by a clever poster! No words are required to explain; this is perfect. Slightly sombre and perhaps not so effective at a distance, this poster has been well calculated not to exceed the range of sight of the average Underground traveller. Altogether, this poster is a masterpiece and a stroke of genius.[63]

In 1926 R. P. Gossop, poster artist and artist's agent (Kauffer was his client) discovered in it a different symbolism: the thrill of bargain hunting. He singled out this poster in a discussion of the ways poster artists had absorbed and transformed the lessons of the Cubists and Vorticists, most particularly in the posters commissioned by the Underground.[64] Although Kauffer obviously knew and valued contemporary styles such as Vorticism, his works are never derivative. But he does exploit the abstract, the elliptical, the geometric elements that characterize so much Modernist

art. His special status was broadly acknowledged by his contemporaries. *Posters and Publicity* noted in 1926 that "E. McKnight Kauffer, who, by practice and influence, has done so much to raise the standard of pictorial public appeal, continues in the forefront of this field of design."[65] The following year they praised him not only for his poster design but for creating public taste.[66] In 1925 R. R. Tatlock proclaimed in *The Burlington Magazine:*

Probably the most successful member of the group to persuade the man of the world that abstract art is not only inoffensive to him but is capable of affording him positive entertainment is Mr. E. McKnight Kauffer. This feat he accomplished largely by giving up the gilt frame and taking to the hoardings. His posters, now so familiar, at any rate to Londoners, differ in no important way, as far as I can see, from the cubist pictures he and his colleagues used to show in the exhibition rooms.[67]

He concludes by noting that other English Modernists have also wisely and successfully produced posters.

A colleague of Kauffer in this group, Frederick Herrick, also created posters of great distinction. Employed in the 1920s by the Baynard Press, which printed over nine hundred Underground posters between 1920 and 1973, Herrick supervised artists such as Shep (Charles Shepherd) and Paine, and would have been involved in the translation of designs and the addition of type to maquettes.[68] *The Source of London's Merry Christmas,* 1922 (Fig. 28), was singled out for praise by *The Spectator* and *Commercial Art.*[69] Its composition encourages ridership during the quiet holiday season by highlighting activities reached by the Underground. But it also reinforces the powerful brand identity forged by Pick by using station signage as ornaments on a Christmas tree. The motif is repeated in the border of the poster as well. The tree decorations announce actual stops: Trafalgar Square, Charing Cross, Covent Garden. Each is topped by a lit candle and a grisaille scene associated with the celebration of Christmas— children's toys, dancing, eating plum pudding, a pantomime. Thus, the poster encourages travel to these stations for varieties of Christmas cheer even as it reinforces the Underground brand. The bright green tree and royal blue ground dramatize

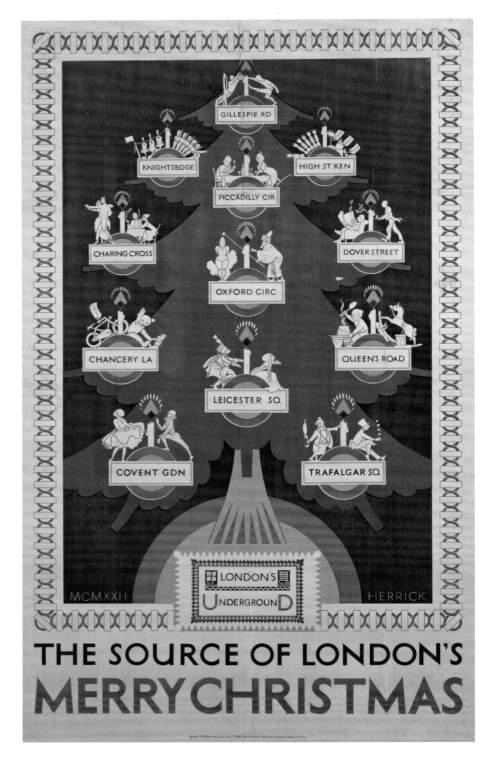

the composition, with accents of yellow and a slightly unexpected orange instead of red.

Commercial Art illustrated Herrick's *Arrest the Flying Moment* of 1924 (Fig. 29), praising his talents and noting "the sweep of the man's figure which gives the impression of speed."[70] The poster wittily evokes the Creation of Adam from Michelangelo's Sistine ceiling with a nattily dressed busi-

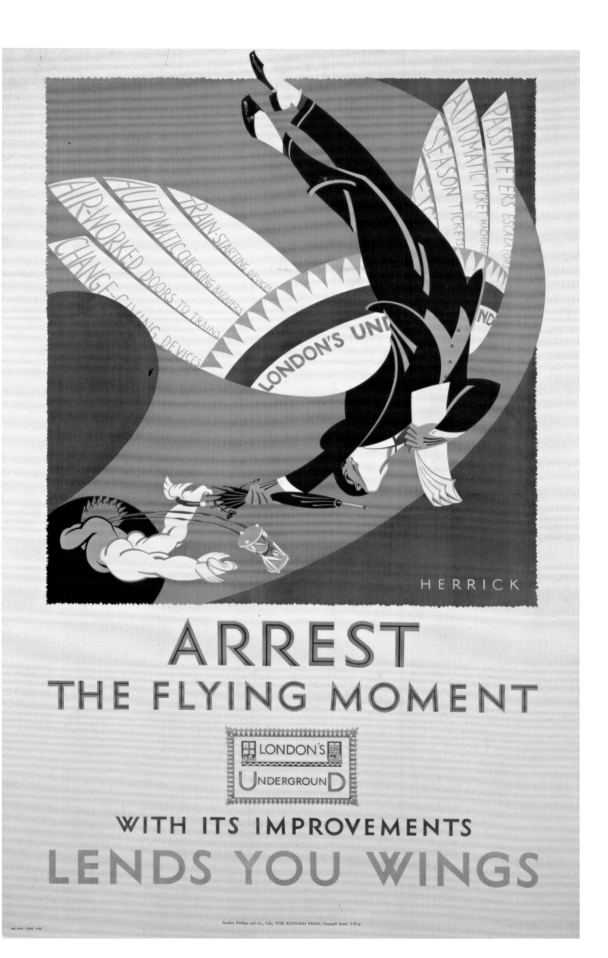

ness man flying through the air, his foot breaking through the upper frame.

Frank Newbould was another who demonstrated art-historical knowledge. In *North Berwick* (Fig. 30), executed for the LNER in 1930–31, he refers to Raphael by way of Edouard Manet's *Déjeuner sur l'Herbe*, although Newbould keeps his women clothed—whether because of the cold or English prudery is unclear.

Other posters of great imagination and power were created by artists about whom almost nothing is known. Kathleen Stenning designed a remarkable series of four panel posters in 1925. *Do Not Get Lost: Travel by Underground* (Fig. 32) places a lit entrance to the Underground prominently against a darkened cityscape, with people cast into silhouette by its welcoming light. Running along the bottom of the image, figures reduced to simple geometry are seen on the brightly lit platform, the Underground symbol repeated on the wall behind them.

Clive Alfred Gardiner, trained at the Slade and the Royal Academy schools, assimilated first a variation of Cubism and then Kauffer's style into his works of the 1920s. A series of four posters of destinations around London that Gardiner designed for the Underground in 1927 showed the clear influence of French Modernism, "the new heraldry of Cubism," in the words of John Harrison in *Commercial Art* (Fig. 31). Harrison's 1928 article notes that Gardiner's embrace of this style, which might seem confusing because of its faceting of form, actually enhanced the communicative power of his works: "The cells, the headsman's block, the suit of armour, combined, as he has combined them, give a better idea of the reasons for going to the Tower than any naturalistic picture ever could hope to give."[71]

Significant work of a different character was made for the railways at this time. Frank Brangwyn's illustrations in *The Graphic,* beginning in 1892; his prints; his large public commissions, such as the murals for the gallery L'Art Nouveau, the Houses of Parliament and the Panama Pacific Exhibition in San Francisco; numerous stained-glass commissions; and frequent exhibition of his paintings made him one of the most famous artists in the world. One of his etching specialties was bridges, so it is not surprising that W. M. Teasdale, then Advertising Manager of the LNER, asked him

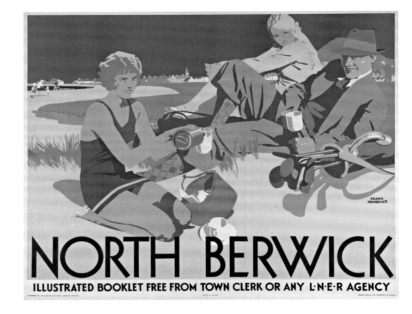

30

FRANK NEWBOULD

North Berwick, 1930–31,
commissioned by
LNER, printed by
Dobson, Molle and Co.,
39 7/8 x 49 7/8 in.
(101.3 x 126.7 cm). Yale
Center for British Art,
Gift of Henry S. Hacker,
Yale College, Class of
1965

31

**CLIVE ALFRED
GARDINER**

The Tower of London,
1927, one of a series,
commissioned by UERL,
printed by Charles
Whittingham and Griggs,
39 3/4 x 25 in.
(101 x 63.5 cm). Yale
Center for British Art,
Gift of Henry S. Hacker,
Yale College, Class of
1965

32

KATHLEEN STENNING

*Do Not Get Lost: Travel
by Underground*, 1925,
commissioned by UERL,
printed by Vincent
Brooks, Day & Son,
19 3/4 x 11 3/4 in.
(50.2 x 29.8 cm).
London Transport
Museum

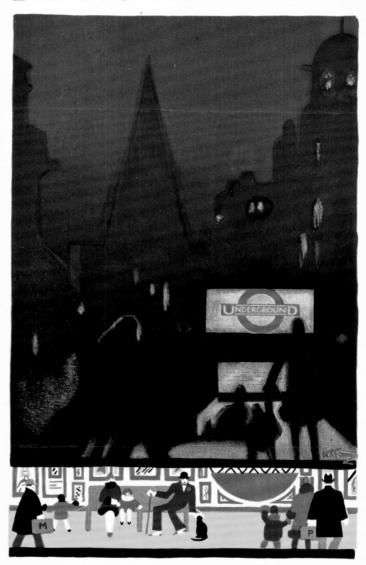

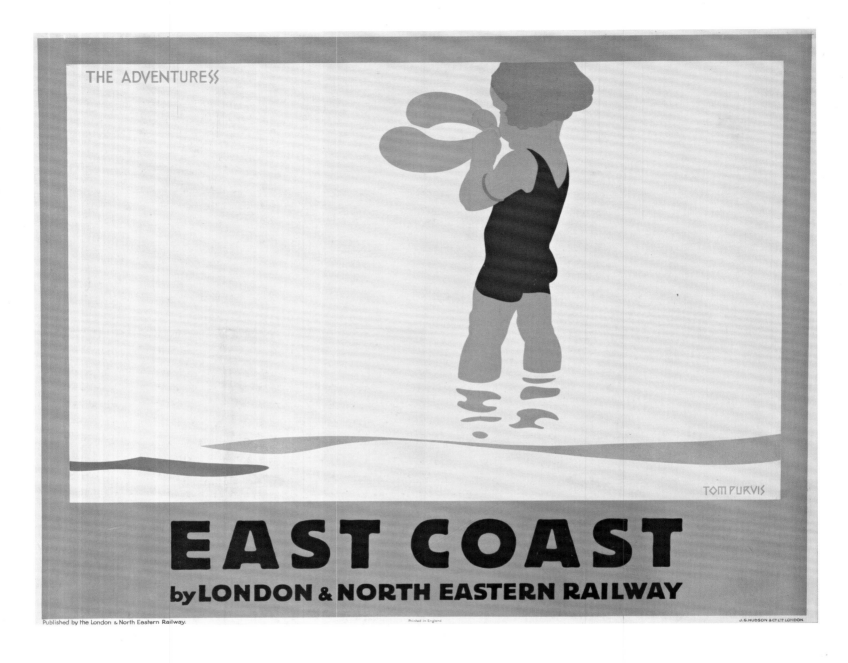

THE ADVENTURESS

TOM PURVIS

EAST COAST
by LONDON & NORTH EASTERN RAILWAY

Published by the London & North Eastern Railway. Printed in England J.G. HUDSON & C^o L^{TD} LONDON.

to undertake a series on this topic in 1923.[72] Thus, Brangwyn became the first Royal Academician to receive a commission from a rail line. He continued to work for LNER at least through the mid-1930s. Even on a huge poster, almost five feet long, Brangwyn worked in autolithography. With minimal tints of additional color, usually only one, posters such as *North East Coast Industries* show us the hand of the artist in the soft mark-making of the greasy black lithographic crayon. Their evocation of the physical power necessary for their creation, and the fame of the artist, were clearly part of their appeal. The posters proudly display the line "Lithographed by Frank Brangwyn R.A."

Who determined the subjects of Brangwyn's posters is not known, but we can only call them *picturesque,* using that word in its eighteenth-century sense. Belching black smoke against a slightly lurid gold sky, the factories in *North East Coast Industries* tower over a black mass of workers huddled at the bottom of the image (see Figs. 63, 64). The poster, not your typical depiction of holiday resorts, historic sites, or luxury hotels, was presumably meant to appeal to the industrialists who shipped freight on the rail lines. A date around 1928 can be determined from its publication in *Commercial Art.*[73]

To a contemporary eye, arguably the greatest

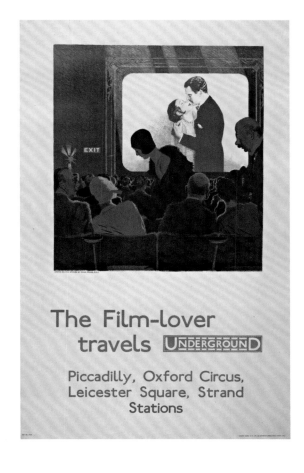

of his ideas, the more significant they become when realized. Proof of his masterly skill is given in the bewitching figure of the little girl preparing her wings for an attempt to swim."[76] Praising the coloring, composition, border and lettering, the critic of *The Times* called it "a masterpiece."[77]

Charles Pears often worked in a conventional style, frequently in seascapes, in a number of works for the Underground beginning in 1913, and for the railways after that. But a series of posters in 1930 breaks with his usual approach. *The Film-Lover Travels Underground* (Fig. 34) manages to be both representational and abstract, taking us into the magic of the cinema as the flickering light creates the images on the screen. Might that be Ronald Coleman in *Two Lovers*? The *Railway Gazette* took special notice.[78]

The works commissioned from Anna Zinkeisen for London Transport are all scenes of contemporary life, executed with lively, dynamic force. Three of her strongest compositions are *Motor Show: Olympia*, *Motor Cycle and Cycle Show: Olympia* (see Fig. 122), and *R.A.F. Display* (Fig. 35), all from 1934.[79] The spontaneity and freedom of the black line in these works suggests that they were made by autolithography; their small size would have facilitated execution. In *R.A.F. Display* both the fuselages of the planes and their rapid movement through the air are described by the same strong black line, which dashes from the noses of the planes to their tails as they cut across the sky. In a larger format, Zinkeisen's railway posters were rather staid affairs, most often of historical subjects, lacking the vivacity of her work for the Underground. Her sister Doris also worked in this historic mode for the railway.[80]

Before the Second World War a number of artists made their way to England from the continent. Hans Schleger, who used the nom de plume Zeró, had previously worked in New York. He left Berlin in 1932 because he felt "uneasy."[81] His first commission for the Underground was a panel poster, *Leicester Square, the Centre of Amusement* (Fig. 36), which uses a Cubist palette of browns to inject a natty, top-hatted figure and his female companion into the familiar bull's eye of the Underground, while the signs of entertainments hover around them.

In his treatise on the poster Austin Cooper made note of the "witty perception" of two young

talent who executed posters for the railways was Purvis. His brilliance in exploiting the possibilities of lithography undoubtedly was enhanced by his years as a lithography apprentice at the Avenue Press after art studies at the Camberwell School of Art.[74] Working in different styles for different clients, he completed his most radical abstract works for the LNER. Not surprisingly, he was consistently praised in the press. The reviewer in *The Observer* lauded him as the boldest and most original of the group of artists employed by that line, and marked the hallmarks of his style: he "understands the value of elimination and of reducing every subject to its simplest forms and bare essentials. His effective flat patterns explain themselves in a flash."[75] Probably his most widely acclaimed poster was *East Coast: The Adventuress* of 1928 (Fig. 33). A haiku—spare and evocative— the poster depicts a young girl standing in the surf, represented only by the plain white paper, a gray rippling reflection of her legs, and two waving lines, one of green, one of pink. *The Evening Post* rhapsodized: "Mr. Purvis is so richly endowed that, the more he economises in the expression

artists who produced posters collaboratively, Thomas C. (Tom) Eckersley and Eric Lombers.[82] *Commercial Art* deemed them "Young Designers of Promise" in 1935, the year they began working for the Underground.[83] The following year they created a panel poster, *Aldershot Tattoo* (Fig. 37), one of a series of eye-catching works of those years.[84] Eschewing the typical depiction of ranks of guardsmen or even men in uniform, they instead concentrate on the mode of conveyance, a red double-decker bus. But cleverly, they allude to the military exercise by incorporating the bus as the insignia on a fluttering red standard. The lettering hugs the perimeter.

The privations of World War II depleted much of the Underground poster campaign's verve and spark. Or perhaps it lost momentum after the departure of its guiding spirit, Frank Pick, in 1940. One artist who retained his prewar panache in the postwar years was the émigré German Hans Unger. His earliest commissions for London Transport, in 1950, were fairly standard informational works, primarily text with an occasional border or headpiece. By the following year, a few designed panel posters appeared. By the mid-1950s he had begun designing posters with wit and graphic power. One of the cleverest is *The Tower of London* of 1956 (Fig. 38). Departing from the common representation of the Tower, his poster depicts Lady Jane Grey at the Tower, her head being separated from her body not by the executioner's axe, but by a pair of scissors cutting the paper. Dotted lines and the instructions "cut here" make this work not simply an exhortation to visit a tourist site but a self-referential riff on the nature of posters themselves.

By the late sixties, as a result of corporate and commissioning changes, much of the art had disappeared from Underground and railway posters. If Austin Cooper were alive today and traveling by rail in Britain he would see few posters; those that exist, by and large, fall into his category of "alleged posters"—a reproduction with words slapped on the bottom, rather than an integrated design of image and type. But the achievement of the artists who created the posters in an earlier age remains. As was once said of Edward McKnight Kauffer, If they are not major artists, who is?

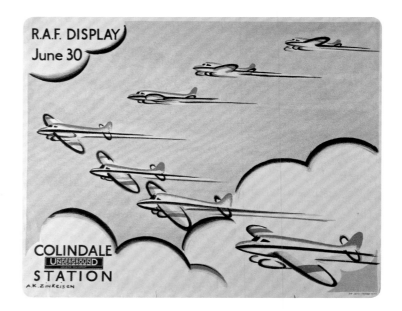

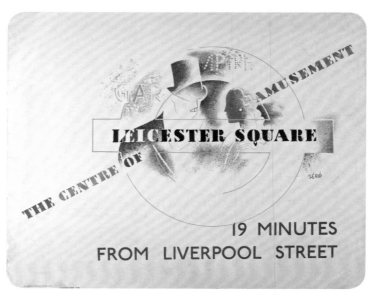

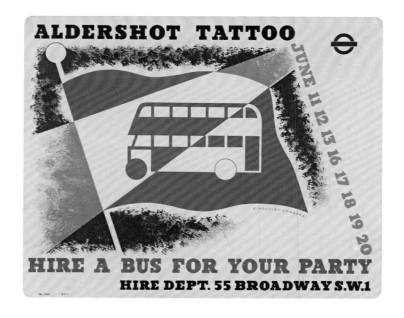

35

ANNA KATRINA ZINKEISEN

R.A.F. Display, 1934, commissioned by LT, printed by the Danger- field Printing Co., 10 1/16 x 12 7/16 in. (25.6 x 31.6 cm). Yale Center for British Art, Gift of Henry S. Hacker, Yale College, Class of 1965

36

HANS SCHLEGER (ZERÓ)

Leicester Square, the Centre of Amusement, 1935, commissioned by LT, printed by Waterlow & Sons, 9 7/8 x 12 3/8 in. (25.1 x 31.4 cm). Yale Center for British Art, Gift of Henry S. Hacker, Yale College, Class of 1965

37

THOMAS (TOM) C. ECKERSLEY
and
ERIC LOMBERS

Aldershot Tattoo, 1936, commissioned by LT, printed by the Danger- field Printing Co., 10 1/16 x 12 3/8 in. (25.6 x 31.4 cm). Yale Center for British Art, Promised gift of Henry S. Hacker, Yale College, Class of 1965

38

HANS UNGER

The Tower of London, 1956, commissioned by LT, printed by the Baynard Press, 39 7/8 x 24 15/16 in. (101.3 x 63.3 cm). Yale Center for British Art, Gift of Henry S. Hacker, Yale College, Class of 1965

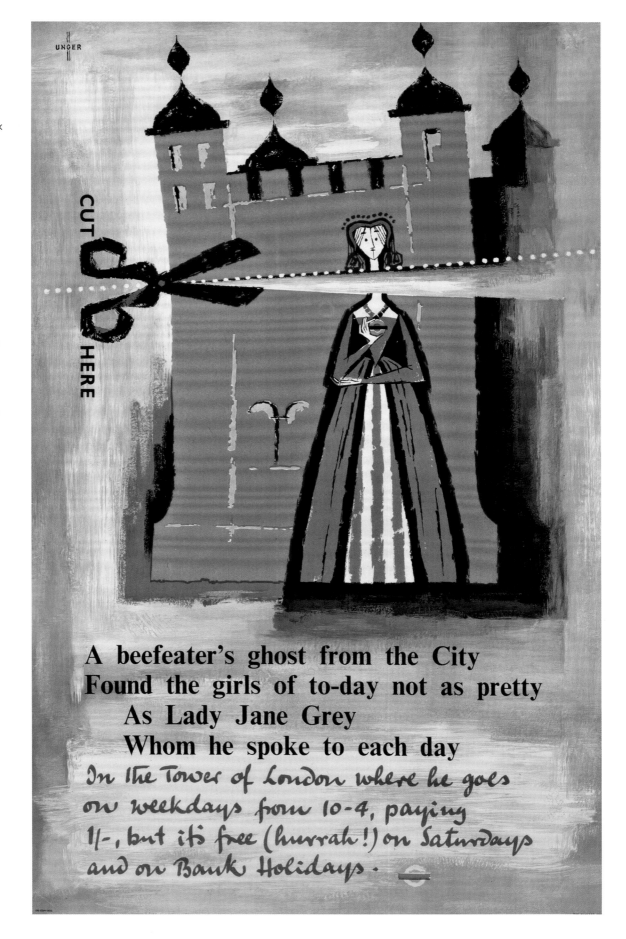

1. For a recent survey of the history of the poster see Margaret Timmers, ed., *The Power of the Poster* (London: Victoria and Albert Museum, 1998). Catherine Flood, "Pictorial Posters in Britain at the Turn of the Twentieth Century," in David Bownes and Oliver Green, eds., *London Transport Posters: A Century of Art and Design* (Aldershot, Eng.: Lund Humphries in association with the London Transport Museum, 2008), gives a survey of the state of posters in England and the Continent before the advent of posters for the Underground.

2. Charlotte Benton, Tim Benton, and Ghislane Wood, eds., *Art Deco, 1910–1939* (London: Victoria and Albert Museum, 2003). No Underground posters are illustrated in the volume. The chapters "Art Deco Graphic Design and Typology" and "Travel, Transport and Art Deco" illustrate no British posters. Christopher Wilk, ed., *Modernism: Designing a New World, 1914–1939*, exh. cat. (London: Victoria and Albert Museum, 2006) illustrates very few British posters and no Underground posters.

3. *Thirties: British Art and Design before the War*, exh. cat. Hayward Gallery, October 25, 1979–January 13, 1980 (London: Arts Council of Great Britain, 1979).

4. "'Art of the Poster,' by our Art Critic," *Evening Post*, n.d. [1928], review of LNER exhibition, Purvis papers, box 8, National Railway Museum Archives, York.

5. Robert Braun, "Artists Who Help the Advertisers, no. 20, Frank Newbould," *Commercial Art* 4 (March 1925): 82.

6. Joseph Thorp, ed., *Design in Modern Printing: The Year Book of the Design and Industries Association, 1927–28*, intro. by Sir Laurence Weaver (London: Ernest Benn, [1928]): 148. Pick was a member of the DIA and had edited the *Year Book* of the previous year. Weaver, an architectural critic, was a staunch supporter of the Arts and Crafts Movement. He was knighted for having organized the British Empire Exhibition of 1924–25.

7. Tom Purvis, "Commercial Art," *Journal of the Royal Society of Arts* (May 10, 1929): 663. Purvis received his first commission from the Underground in 1932.

8. *The Observer*, Sunday March 17, 1929, n.p., Purvis papers, box 9, National Railway Museum Archives, York.

9. At the Royal Academy Banquet, it was reported in 1923, the Prince of Wales declared that the hoardings "might now be called, without exaggeration, the art galleries of the public"; see "The Prince of Wales on the Art of the Hoardings," *Commercial Art* 1 (June 1923): 160; other such references include: "Mr. Gregory Brown has helped as much as any man to raise the tone of the 'poor man's picture gallery,'" *The Observer*, 1928, cited on the website of Vintage Posters and Signs, http://vintage.artehouse.com/perl/options.pl?imageID=2760&productTypeID=3&sessionID=216e8c6l53605e00541f286c3743d0la, accessed January 3, 2010; on the eighth exhibition of LNER posters at Grieves Art Gallery, Old Bond Street: "Their posters not only brighten the Poor Man's Picture Gallery, that is, the hoardings, but frequently enable us to decide where we shall spend our Easter and summer holidays," *Morning Post*, quoted in Cecil Dandridge, "Advertising Notes," *London & North Eastern Railway Magazine* 20, no. 5 (May 1930): 240. Others also elevated the status of the poster. See, for example, *Railway Gazette* 52 (May 16, 1931): 770: "Moreover, not only have the walls of railway premises and hoardings and other places utilized by the railways become, in a very real sense, 'A Royal Academy of the masses.'"

10. Adolphe Armand Braun, "Artists Who Help the Advertisers, No. 8: Gregory Brown, R.B.A., R.O.I.," *Commercial Art* 2 (January 1924): 352.

11. Gregory Brown, "The Picture's Part in Advertisements," *Commercial Art* 4 (1928): 130. For an excellent discussion of related issues in America see Michele H. Bogart, *Artists, Advertising, and the Borders of Art* (Chicago: University of Chicago Press, 1995).

12. Walter Shaw Sparrow, *Advertising and British Art* (London: John Lane, Bodley Head, 1924): 50. Sparrow was writing just as the posters were being issued and illustrates the original works of art but not the posters with lettering. Although Sparrow holds the posters of the Underground and LNER in high esteem, he favors posters without integrated lettering and is not an admirer of the work of Edward McKnight Kauffer. For example, he finds the red trees in Kauffer's *Reigate* of 1915 troubling and the "symbolism" in the Natural History Museum poster unintelligible.

13. Norman Wilkinson, *A Brush with Life* (London: Seeley, 1969), 104.

14. S. T. James "The Art of the Railway Poster," *Commercial Art* 3 (October 1924): 127.

15. Percy V. Bradshaw, *Art in Advertising* (London: Press Art School, n.d. [1925]): 280.

16. *The Observer*, Sunday March 17, 1929, clipping, Purvis papers, box 8, National Railway Museum Archives, York.

17. John Harrison, "That's Advertising—That Is!! Shell-Mex," *Commercial Art* 11 (1931): 40. For a discussion of the LMS poster campaign see John Hewitt, "Posters of Distinction: Art, Advertising and the London, Midland, and Scottish Railways," *Design Issues* 16, no. 1 (Spring 2000): 16–35. Hewitt asserts that the LMS discontinued the campaign in 1924 because its advertising "had simply moved on," 33. Perhaps another cause is that it was not deemed effective, either critically or commercially.

18. R. A. Stephens, "Origin and Evolution," in Edward McKnight Kauffer, ed., *The Art of the Poster: Its Origin, Evolution, and Purpose* (London: Cecil Palmer, 1924), 5.

19. John Hewitt argues that posters in an earlier period were more easily accepted as works of art. See John Hewitt, "Designing the Poster in England, 1890–1914,"

Early Popular Visual Culture 5, no. 1, April 2007: 57–70.

20. *The Observer,* Sunday, March 17, 1929, Purvis papers, box 8, National Railway Museum Archives, York.

21. W. G. Raffé, "The Elements of the Poster, I: The Poster and Its Message," *Commercial Art* 4 (1928): 150. Subsequent articles, all in 1928, were: "II: Representation and Suggestion": 216–22; "III: Composition: The Fundamental Factors in Design," 250–54; "IV: Composition: Line and Mass," 34–37; "V: The Use of Silhouette" 152–54; and "VI: The Use and Abuse of Colour," 221–22. These were later published as *Poster Design* (London: Chapman and Hall, 1929).

22. Leonard Richmond, ed., *The Technique of the Poster* (London: Sir Isaac Pitman and Sons, 1933). This is the same year that Richmond received his only commission from the Underground.

23. Austin Cooper, *Making a Poster,* in the *How to Do It* series (London: The Studio, 1938). Another prominent poster designer, Tom Eckersley, wrote a manual, but it does not have the same specific detail as Cooper's book; Tom Eckersley, *Poster Design* (London: The Studio, 1954).

24. Cooper, *Making a Poster,* 18, 19, 31.

25. The artwork for this poster design was selected by staff of the London Transport for both the *Art for All* exhibition in 1949 and the Centenary Exhibition in 1963. Harold Hutchison and James Laver, *Art for All: London Transport Posters, 1908–1949* (London: Art and Technics, 1949), pl. 39; Harold F. Hutchison, *London Transport Posters* (London: London Transport Board, 1963), pl. 31. Cooper created several poster series to publicize museums.

26. Lecture to the Reimann School of Industrial Art, typescript, Frank Pick Collection, London Transport Museum Library, PB 42.

27. "Our Philosophy," *Commercial Art* I, no. 1 (October 1922): 1.

28. Bradshaw, *Art in Advertising.*

29. A. John Dannhorn, "Art with an Object," *Commercial Art* I, no.1 (October 1922): 4, 18; W. R. Titterton, "Art and the Market," *Commercial Art* I, no. 2 (November 1922): 29: "All art which is offered for a price is commercial art. And so all the great artists of the world, from Phidias to Messrs. Epstein, Nevinson, and Bomberg have been commercial artists. . . . During the Middle Ages the Church and the Court were the best buyers, and so the artist served as publicity agent for the heavenly kingdom or the reigning house."

30. Percy V. Bradshaw, introduction of Tom Purvis, transcript of a lecture by Purvis, March 6, 1929, in *Journal of the Royal Society of Art* (May 10, 1929), 649.

31. W. G. Raffé, "I: The Poster and Its Message," *Commercial Art* 4 (1928): 150.

32. Nikolaus Pevsner, *An Enquiry into Industrial Art in England* (Cambridge: Cambridge University Press, 1937), 198.

33. Anthony Blunt, *Spectator,* April 5, 1935. The review is quoted in its entirety in Mark Haworth-Booth, *E.*

McKnight Kauffer: *A Designer and His Public* (London: Victoria and Albert Museum, 2005), 68, 70.

34. Timmers, ed., *Power of the Poster,* 14.

35. Timmers, ed., *Power of the Poster,* 13, 14. See also Martin Hardie, in association with A. K. Sabin, *War Posters Issued by Belligerent and Neutral Nations,* exh. cat. (London: Victoria and Albert Museum, 1920).

36. *London & North Eastern Railway Magazine* 18, no. 4 (April 1928): 196: "For the first time in the history of railway advertising a famous West End Gallery has been utilized for a display of posters."

37. "News in Brief," *The Times,* October 27, 1928, 9; "A Successful Poster Exhibition," *Commercial Art* 5 (1928): 242.

38. "LNER Poster Art Exhibitions: Four Exhibitions held in June: Charing Cross Underground Station, York Art Gallery, Laing Art Gallery, Bowes Museum, repeated at many of these places in other years," Cecil Dandridge, "Advertising Notes," *London & North Eastern Railway Magazine* 22, no. 7 (July 1932): 362; and Dandridge, "Advertising Notes," *London & North Eastern Railway Magazine* 25, no. 4 (April 1935): 206.

39. Cecil Dandridge, "Advertising Notes," *London & North Eastern Railway Magazine* 25, no. 6 (June 1935): 324.

40. Note, however, that in the installation the LNER did not hang the series in the order preferred by its own artist. Newbould had intended that poster number six, the aquatic jazz band, be installed as the last work on the wall, rather than the second, so that the curved movement toward the left of the piscine sax player would provide an end note for the series and move the viewer's eyes back toward poster number five, the dolphin pushing his ball to the right.

41. *Railway Gazette* 57 (August 12, 1932): 205.

42. Cecil Dandridge, "Advertising Notes," *London & North Eastern Railway Magazine* 19, no. 1 (January 1929): 10.

43. Cecil Dandridge, "Advertising Notes," *London & North Eastern Railway Magazine* 19, no. 2 (February 1929): 66. See also 20, no. 1 (January 1930): 18; and 20, no. 3 (March 1930): 126.

44. Cecil Dandridge, "Advertising Notes," *London & North Eastern Railway Magazine* 19, no. 3 (March 1929): 118.

45. "The Poster Shop," in F. A. Mercer and W. Gaunt, eds., *Modern Publicity, 1933 and 1934* (New York: William Rudge; London: The Studio), n.p.

46. *Signature,* no. 6 (July 1937): n.p. *Signature* was published by The Curwen Press.

47. *Signature,* no. 7 (November 1937): n.p. The same advertisement appeared in F. A. Mercer and W. Gaunt, eds., *Modern Publicity 1937 and 1938: Commercial Art Annual* (New York: William Rudge; London: The Studio), v.

48. LNER files, box 2, National Railway Museum Archives, York. Although guinea coins were no longer in circulation in the twentieth century, certain prices were

still fixed in guineas. A guinea represented the value of one pound plus one shilling, or 21 shillings rather than 20. (In modern currency 21 shillings equal one pound and five pence.) Thus, the disagreement was largely a symbolic one of status for the poster artists. For the railway, it would have had some financial impact over time, although Teasdale may have just wished to make bookkeeping easier, with the added advantage of paying the poster artists in the same way as other employees.

49. LNER files, box 2.
50. LNER files, box 2.
51. LNER files, box 2. The 1930, 1931, 1932 contract specified minimum payments of £1,250 to Taylor, £650 to Newbould, and £450 each to Purvis, Cooper, and Mason. Prices for individual poster designs were set according to their size: Newbould was to be paid £47.15 for double royal designs, £84 for quad, and £105 for special subjects, Cooper was to receive £35, £65, and £75 (LNER files, box 2). In mid-1935, London Transport was normally paying a minimum of 35 guineas for a double royal poster and 60 guineas for a quad royal, and a maximum of £52.10 for double royal and £94.10 for quads (Minutes of the Vice-Chairman's Publicity and Public Relations Meeting, July, 4, 1935, 226, Transport for London Archives).
52. Other RA exhibitors who worked for the Underground include Philip Connard, Kathleen Stenning, James Fitton, Henry Rushbury, Dorothy Dix, Dorothy Hutton, Ernest M. Dinkel, and Frederick Cayley Robinson.
53. For a discussion of the London Group and a list of all of its members and exhibitors, see Denys J. Wilcox, The London Group, 1913–1939: The Artists and Their Works (Burlington, Vt.: Ashgate, 1995).
54. Other nonmembers who exhibited with the group, and who designed posters for the Underground, include Leslie Porter, Heather (Herry) Perry, and Rosemary Ellis. Wilcox does not list Clifford Ellis as a member or nonmember exhibitor, although he was married to Rosemary Ellis, and they designed all their posters together.
55. Stanley Rowland, "Masters of the Poster: John Hassall," Commercial Art 13 (1932): 194–95. Hassall was the only living artist included in the "Masters of the Poster" series. See J. T. Shackleton, The Golden Age of the Railway Poster (Secaucus, N.J.: Chartwell Books, 1976), 44–46; see also "Mr. John Hassall, Humour in Posters," obituary, The Times, issue 51015, Tuesday, March 9, 1948, 2, col. G; Cecil Dandridge, "Advertising Notes: A Famous Railway Poster," London & North Eastern Railway Magazine 26, no. 8 (August 1936): 448.
56. This poster was chosen, as was the one by John Hassall above, for "A Centenary Exhibition of London Transport Posters," Royal Institute Galleries July 2–30, 1963. Michael Twyman gives a fuller description of the autolithographic process in Chapter 3.
57. Sydney R. Jones, "Posters and Their Designers," Studio, Special Autumn Number (1924): 3.
58. Major A. A. Longden, "G. Spencer Pryse, M.C.," Commercial Art 4 (March 1928): 106–12, 133.
59. Maxwell Armfield, "My Approach to Art," repr. in Maxwell Armfield, 1881–1972, exh. cat. (Southampton: Southampton Art Gallery, June 24–July 23, 1978), n.p. The Poster began publication in 1898, when Armfield was 17.
60. Horace Taylor, "The Work of Charles Paine," Commercial Art 2 (June 1927): 234, 236.
61. "Poster designed at the Baynard Press" (signed in poster, "CPaine"), Commercial Art, suppl. to 1, no. 1 (October 1922), n.p.
62. Design in Modern Industry: The Year Book of the Design and Industries Association, 1923–24 (London: Ernest Benn, [1924]), 151. Pick's caption notes that the arrangement was done in London. The wall is labeled simply, "Charles Paine," but at least one poster, that in the upper left, is by Frederick Herrick.
63. "A Masterly Poster by McKnight Kauffer," Commercial Art 1 (February–March 1923): 104.
64. R. P. Gossop, "Cubists and Tubists," Commercial Art 5 (April–May 1926): 92–93.
65. Sydney R. Jones, Posters and Publicity (London: The Studio, 1926), 6.
66. John Harrison, "Posters and Publicity," Studio (1927): 3.
67. R. R. Tatlock, "The Art Poster and the Art Book," Burlington Magazine 46 (June 1925): 305.
68. Herrick undoubtedly contributed materially to the design of innumerable posters. The Baynard Press printed 911 posters for the Underground. See also "Printers Who Help Advertisers: The Work of Baynard Press," Commercial Art 3 (June 1924): 36–39; "The head of the Studio is the well-known poster artist Herrick," 38. Horace Taylor, "The Importance of Beauty: The work of the Baynard Press," Commercial Art 2 (April 1927): 160–63; "The Baynard Press are fortunate in having the services of one of the most distinguished artists working in advertising, Mr. Herrick," 162. "The Art of 'Shep,'" Commercial Art 14 (1933): 188–89; "After the war . . . joined the firm of Sanders Phillips & Co. Ltd. (The Baynard Press), under Herrick. In 1926 he became head of their studio, and still holds this position," 188.
69. "The Baynard Press has submitted a score or so of posters for review, most of which have been produced to the order of the Underground. . . . Herrick too is responsible for some colour fantasies such as the Christmas-tree poster, . . . and Charles Paine, working in a rather less adventurous manner, invites us to Bath and to Hampton Court with placards that are not only extremely pleasant in themselves but also suggest that both places are peculiarly attractive—as, in truth, they are. . . . It has been said that the Underground more than pays for its own posters by the sale of spare copies to collectors and the general public—and it is not surprising that this is

so," *The Spectator,* March 17, 1923, quoted in Bradshaw, *Art in Advertising,* 57; see also John Harrison, "Herrick and the New Poster," *Commercial Art* I, no. I (July 1926): 4.

70. *Commercial Art* 4 (March 1925): 86.

71. John Harrison, "Clive Gardiner," *Commercial Art* 5 (July 1928): 23, 25.

72. W[illiam] Gaunt, "LNER Advertising from an Interview with Mr. W. M. Teasdale," *Commercial Art* 4 (1928): 14, 17.

73. A full-page color illustration of *North East Coast Industries* appears in R. G. Praill, "Brangwyn Lithographs," *Commercial Art* 4 (1928): 71.

74. Adolphe Armand Braun, "Artists Who Help the Advertisers, no. 15, Tom Purvis," *Commercial Art* 3 (October 1924): 129–31.

75. *The Observer,* Sunday, March 17, 1929, Purvis papers, box 8, National Railway Museum Archives, York.

76. "Art of the Poster by Our Art Critic," *Evening Post,* [1928], Purvis papers, box 8, National Railway Museum Archives, York.

77. "LNER Posters," *The Times,* March 24, 1928, 12.

78. "Some New 'Underground' Posters," *Railway Gazette* 52 (October 3, 1930): 446.

79. The RAF poster is not represented in the London Transport Museum Collection and is undated, but there is little doubt that it is from 1934. RAF displays took place on Saturdays, and in 1934, June 30, the date on the poster, fell on a Saturday. In addition, the style is comparable to the other posters by her of that year.

80. "Advertising Notes," *London & North Eastern Railway Magazine* 26, no. II (November 1936): 636–37: "An interesting poster by Miss Anna Zinkeisen has just been issued, depicting a jousting scene at Lincoln with the cathedral in the background. It is printed in 16 colours." "Advertising Notes," *London & North Eastern Railway Magazine* 27, no. 6 (June 1937): 324–25; "A new poster by Doris Zinkeisen of "Queen Elizabeth at Cambridge" depicts the scene . . . on August 5, 1564."

81. Robin Kinross, "Emigré Graphic Designers in Britain: Around the Second World War and Afterwards," *Journal of Design History* 3, no. I (1990): 35–57, 45.

82. Cooper, *Making a Poster,* 71.

83. "Young Designers of Promise: Tom Eckersley and Eric Lombers," *Commercial Art* 18 (1935): 21–25.

84. Aldershot is in Hampshire, about thirty miles southwest of London, just inside London Transport's traffic area, as established in 1933. Between the wars the Aldershot Searchlight Tattoos became enormously popular events. They were military pageants and displays with elaborate sets, historical battle reenactments, and parades held over five summer evenings in June. Crowds of up to 500,000 people attended, and special buses and trains ran from London to carry them.

PRODUCTION: FROM CHROMOLITHOGRAPHY
TO PHOTOLITHOGRAPHY

MICHAEL TWYMAN

There is a longstanding connection between the pictorial poster and lithography. It began at least sixty years before the first London Undergound poster was produced in the early years of the twentieth century and even decades before the innovative posters of Jules Chéret.[1] The connection can be traced back to the 1830s and 1840s, when French artists explored the opportunities offered by lithography to combine pictures and words in posters, advertising journals, and books,[2] and was developed a little later in England, when pictorial posters were produced by lithography for Vauxhall Gardens around 1850.[3]

London Underground posters were initially printed from hand-drawn stones in much the same way as these earlier examples, though later ones made use of photographic methods, metal plates instead of stones, and the relatively new process of offset lithographic printing (though not necessarily all together). London Underground posters produced by each of these methods, and some others too, might still be described as lithographs, even though they would not usually be considered original prints.

The lithographic process, invented right at the end of the eighteenth century by Alois Senefelder in Munich, was a method of making large numbers of multiples efficiently, without losing the hand-drawn look. It incorporated color easily and was cost-effective. It soon spread around Europe and within a few decades had been introduced to many other parts of the world.[4] Different sectors of society recognized very different possibilities in the process. Music publishers, who were the first to take it up commercially, found it cheaper than the methods they had been using for centuries;[5] artists saw its potential for making prints without the intervention of an intermediary;[6] others used it for circulars and administrative printing, or for small-scale advertising.[7] Posters came somewhat later, as large lithographic stones became more readily available,[8] and as a consequence of society's increasing appetite for printed publicity.

Lithography takes its name from the use of compact calcareous limestone as a printing surface. The finest lithographic stone, deposited in the mud flats of shallow lagoons when dinosaurs roamed the earth, came from quarries around Solnhofen in Bavaria, where it existed—and still exists—in vast quantities.[9] The stone's suitability for lithographic printing rests on its extremely fine grain and its ability to absorb water and greasy substances with equal ease. This lies at the heart of lithographic printing because these two substances do not readily mix with one another.

In the simplest and earliest form of lithography

ERNEST WILLIAM FENTON
Flowers, 1952
(detail; see Fig. 54)

43

marks are made on a slab of limestone with a greasy crayon or ink.[10] These marks are absorbed by the stone and, after special chemical treatment, become bound inextricably with it. Taking a print from the drawn stone involves damping its surface and then applying greasy printing ink to it with a roller. The greasy marks on the stone tend to reject the water whereas the bare areas attract it; for the same reason they attract greasy printing ink whereas the moistened stone rejects it.

Traditionally, stones were either ground down to produce a finely grained surface or were given a polish much like that of prepared marble. Drawings made with greasy crayon required grained stones, though ink marks could be made on both grained and polished stones. The marks would have appeared black when drawn on stone, but the black simply allowed artists to see what they had done: what counted was the penetration of the grease into the surface of the stone. Positive marks drawn with crayon or ink could be modified in several ways, either by scraping with a knife to produce negative lines or by rubbing down tonal areas with coarse cloth to reduce their strength. Light marks on a darker ground could also be drawn with a solution of gum arabic before any ink or crayon work was undertaken, since gum acts as a resist and prevents greasy drawn marks from being absorbed by the stone.

Chromolithography—printing in colors by lithography—was an almost inevitable development of printing from a single stone in black and was to become the leading form of the process from the middle of the nineteenth century. What are usually regarded as the key contributions to lithographic color printing were made by Godefroy Engelmann in Mulhouse and Charles Hullmandel in London in the second half of the 1830s.[11] Though superficially their approaches to chromolithography may appear rather similar, they were actually very different. Engelmann used more or less the same set of colors (red, blue, yellow, usually with a black) to produce a whole gamut of hue and tone by fusing one color with another optically. In principle no one stone provided the drawing: all three or four stones combined with one another to do so. Hullmandel's approach in 1839 was to print one stone in black or dark brown, which carried all the essential drawing, and to add colors from other stones,

much as a hand-colorist would add colors to a monochrome print. Both approaches had their merits, and they were used for different purposes.

The approach to chromolithography that won out across a broad range of products involved analyzing images much as Engelmann had done, but using many more stones and colors than he had envisaged. Within a few decades, even inexpensive products came to be printed from ten or a dozen stones, and the most complex, such as reproductions of works of art, from as many as thirty or so. This led to the development of numerous other ways of making marks on stone to achieve the vast range of effects that could be produced across a range of media, the results often defying analysis in the final printed product.

Crayon hatching continued to be used in such chromolithography, as did pen-and-ink work, particularly stippling with the end of a pen. Both these techniques gave chromolithographic artists

39
Keyline drawing for a poster for McDougall's self-raising flour, produced in the studios of Emilio L. Tafani, London, in the 1940s, 19⅞ × 16 in. (50.4 × 40.6 cm). Department of Typography & Graphic Communication, University of Reading, England

the opportunity to break down an image into a series of specks or dots, which, when brought together and printed in different colors, produced the effect of an almost infinite range of hues and tones. When these marks were relatively coarse, as they usually were in posters, it was left to the beholder to blend the colors, as in pointillist painting. Other techniques that were developed to increase the gamut of marks available to the lithographic draftsman included splatter work or *crachis,* the use of a fixative spray or airbrush, dry-brush work, and what were known as mechanical tints. The last of these techniques, originally called Ben Day tints after their American inventor, Benjamin Day, offered a means of producing tonal effects quickly and had a tremendous influence on many branches of commercial chromolithography in Europe as in the United States.[12]

It was from this background of well-honed skills in reproductive chromolithography that the artists and printers who produced London Underground posters emerged. Poster production was to become the last bastion of commercial chromolithography and was responsible for the survival of some of its techniques into the second half of the twentieth century. Chromolithographic draftsmen who had been trained in the traditional methods of the trade simply transferred their skills to different and often technically less demanding kinds of work. And when compared with the requirements of high-quality

reproductions of works of art and book illustrations, posters presented few technical problems.

The normal starting point for a chromolithographed poster was an original design, usually same size, but smaller in the case of very large posters. Several hundred such designs survive for London Underground posters in the London Transport Museum and the Victoria and Albert Museum. Most of these designs were interpreted by professional lithographic artists using a combination of hand and eye and—one should add—mind. This operation began with an assessment of the number of separate colors needed to reproduce the design (which would usually have been a joint aesthetic and economic decision). A tracing was then made of the original to define not just its shapes, but all its changes of tone and hue (Fig. 39). There were several ways of doing this in the period we are concerned with, but most of them led to a version of this keyline drawing being put on stone and printed off in as many copies as there were to be separate colors in the poster. Each of these proofs was dusted with red chalk (or blue dye), placed face down onto a clean stone, and pulled through the press, thereby leaving an identical nonprinting version of the keyline drawing on each of the stones in the set. The stones were then ready to receive the various parts of the drawing allocated to them.

Chromolithographic artists depicted at work in the studios of printers normally sat at desks with the stone sloped at a convenient angle, sometimes with a wooden bridge over the stone to prevent the drawing hand and arm from touching it.[13] The stones for large posters, including ones produced for the British railway companies, were often placed on stout tables with wheels (Figs. 40, 66) or on upright beer barrels. Both these arrangements allowed artists to work on a stone from all directions. Exceptionally, the Baynard Press had a special easel with lifting tackle made for Gerald Spencer Pryse, which allowed him to work on stones vertically in his own studio in Chiswick for a series of twenty-four posters for the Empire Marketing Board.[14] These stones, measuring 40 × 60 in. (101.6 × 152.4 cm), weighed around three to four hundred pounds. It is likely that Frank Brangwyn, who also worked directly on very large stones, made similar arrangements for handling them.

A simple poster requiring just four or five colors may have had all its stones drawn by the same lithographic artist, though it is likely that several artists would have been involved when many more stones were required. Those who worked on the stones of a chromolithograph often drew a tablet of solid ink in a predetermined place in one of the margins of each stone, and sometimes wrote above or below it the name of the color in which it was to be printed. The tablets were normally arranged so that they formed a color bar, which provided the printer with a means of checking the colors and the sequence in which they were to be printed. When the handwriting with the color tablets varies significantly from one tablet to another we can safely say that more than one chromolithographic artist was involved. Unfortunately very few proofs of transport posters have survived, and no London Underground poster with its color tablets has been traced, but proofs of other chromolithographs of the period suggest that they continued in use into the middle of the twentieth century (Fig. 41).

At the head of each chromolithographic studio was someone the French called a *chromiste*. His role was to analyze the original and, often in conjunction with the estimating department, determine how many colors were necessary to reproduce it effectively.[15] He would also have decided on the particular colors needed and how to allocate them to a set of stones in order to achieve the desired effect. Either he or a studio manager had responsibility for supervising the artist who worked on stone, and in the case of multiple artists had the more demanding task of coordinating their work. A simple four- or five-color poster may not have involved much color adjustment, but some writers on the subject recommended that, in more complex work, proofs should be taken of a few colors before proceeding to draw the other color stones.[16] This may have been the practice with London Underground posters that ran to many colors, such as Ada Elizabeth Edith (Betty) Swanwick's *Enjoy Your London, no. 4, The River* (1949, Fig. 61), which was printed by the Curwen Press in around thirteen colors.

After preparing the stones chemically to make them ready for printing (with one or more applications of gum arabic with a drop or two of nitric acid added), proofs were taken of one color

after another in what was usually a predetermined sequence. The sequence was important since, for example, blue after yellow would produce a very different green from yellow after blue. The usual practice was to preserve a proof of each separate color working, and also a set of proofs showing the effect of each color on those already printed. Such proofs are called progressives and were produced in the first instance on hand-presses as a guide to the machine minders who were to run off the edition. Further sets were sometimes produced on powered machines. Normally, progressive proofs were preserved while the work remained on the stones as a guide for the printing of further editions.

As far as is known, the only surviving set of progressives for a chromolithographed London Underground poster relates to *St Albans by Motor Bus,* a relatively simple six-color poster designed by Edward McKnight Kauffer, which was printed in flat colors by the Dangerfield Printing Co. in 1,000 copies in 1920 (Figs. 43–53). The proofs are of special interest because they are accompanied by the artist's same-size gouache original (Fig. 42). All the separate workings for the poster exist on separate sheets, and five further sheets show the effect each had on the previous printings. Kauffer's original was boldly rendered in flat colors without any intentional tonal variations. This was the easiest kind of image to reproduce by chromolithography, and his colors were simply interpreted on stone as solid black areas that had to fit together like the pieces of a jigsaw. This would have been so straightforward that a simple tracing would have sufficed, rather than the complex keyline drawing shown in Fig. 39, as the allocation of the colors had effectively been determined by the artist. The proofs show no overprinting of colors, except where black was printed over a color and where one color overlapped another by about 1 mm as a precaution against leaving a white gap between workings (a practice Griffits was to recommend some years later).[17] All the colors of the poster match those of the original design perfectly, except for a gray, which was translated as a warmer tone. This change of hue is so great as to suggest that it must either have been made by the artist or have stemmed from the intervention of staff of the London Underground.[18]

Proof of a poster for McDougall's self-raising flour showing tablets for each of its eleven colors, produced in the studio of Emilio L. Tafani, London, 1940s, 23 ½ x 18 ⅛ in. (59.7 x 46 cm). Department of Typography & Graphic Communication, University of Reading, England

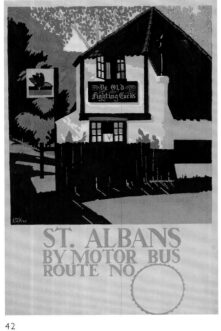

42

43

44

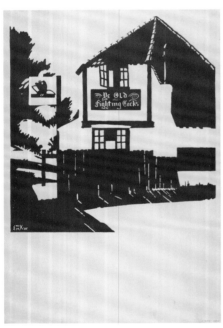

48

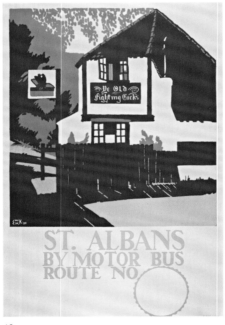

49

50

42

**EDWARD MCKNIGHT
KAUFFER**

St Albans by Motor Bus,
1920, original gouache
design for *St Albans
by Motor Bus,*
29 ¾ x 19 ⅝ in.
(75.6 x 50.5 cm).
Victoria and Albert
Museum, London

43–53

Set of progressive proofs
for Edward McKnight
Kauffer's 6-color poster
St Albans by Motor Bus,
commissioned by UERL,
printed by the Dangerfield
Printing Co., London, in
1,000 copies, 1920, 11
sheets, each 30 x 20 in.
(76.2 x 50.8 cm).
Victoria and Albert
Museum, London

45

46

47

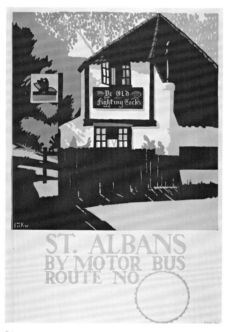

51

52

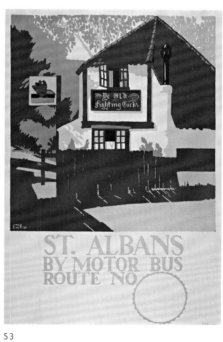

53

Though every chromolithograph was likely to present a different problem, some conventions were widely followed. The main one was that opaque colors, particularly yellow, would be among the first colors to be printed. One or more dark colors were often printed late in the sequence, and it was common practice to end with one or more neutral workings, such as gray, so that the hues of earlier printings could be modified subtly. There were, of course, exceptions, and among those who bucked the trend was Thomas Griffits, who worked regularly on London Underground and railway posters over a lifetime in the trade. He had come up from the shop floor at Vincent Brooks, Day & Son, where he worked initially as a lithographic artist, rising to become manager of the lithographic artists' department and, from 1919, the firm's Advisory Director and Works Manager. In 1935, toward the end of his career, he moved to the Baynard Press.[19]

Griffits became known for rejecting the dogma, "Print the yellow first."[20] In one case, William Fenton's London Transport poster *Flowers* (1952, Fig. 54; see also p. 42), it was claimed that Griffits managed to produce more than three times the number of colors actually printed by superimposing them over an initial black working in some parts of the poster.[21] Even more revealing is a story he told about a Southern Railway poster (untraced), for which he had responsibility soon after joining the Baynard Press. He approached the treatment of colors in his usual intuitive and creative way, informed by a lifetime's experience of chromolithography:

The colours were such that if I had decided upon a deep sage green for the trout I should have had to make the pink with a fine stipple of the strong scarlet. It seemed to me this would look very unpleasant and spotty, so after carefully stopping out the other colours, I decided to make the trout colour by printing a royal blue solid, and softening the edge with chalking, overprinting the royal blue with turquoise blue, softening the edge as well and then [adding] deep fawn with a touch of white, softening the edge in the same way. The colours finally selected were: royal blue, dark brown, scarlet, turquoise blue, black, yellow, fawn, and pink. I passed the royal blue and then the fun began. . . .[22]

54

ERNEST WILLIAM FENTON

Flowers, 1952, left panel of pair, commissioned by LT, printed by the Baynard Press, 39 7/8 × 25 in. (101.3 × 63.5 cm). Yale Center for British Art, Gift of Henry S. Hacker, Yale College, Class of 1965

Griffits was in charge, so it was simply his reputation that was at stake, but his staff made their views known in no uncertain terms. In this instance, his artist considered that there was no way in which the royal blue could be modified by subsequent printings to achieve the correct color, and his foreman printer argued that it was hopeless to print 5,000 copies of the blue since "it was only spoiling paper!" The addition of the second color alarmed the foreman even more and, despite the well-intentioned but misguided attempts of pressmen to modify the col-

ors, Griffits stood his ground. Later he found "a small gathering of printers, foreman and artist looking with astonishment at an almost perfect match of the trout on the sketch."[23] Griffits was almost alone among practicing chromolithographers in writing about his experiences, but it can be assumed that there were many others who exercised their own judgment over the complex task of selecting colors without enjoying either his seniority or the opportunities he had to publish his reminiscences.

The paper sizes used for most London Underground posters were double royal (40 × 25 in.; 101.6 × 63.6 cm), double crown (30 × 20 in.; 76.2 × 50.8 cm) or, occasionally, quad royal (40 × 50 in.; 101.6 × 127 cm), and print runs ranged from 1,000 to 3,000, with 1,000 or 1,500 being the norm.[24] As we have seen, the Southern Railway poster that Griffits discussed appears to have been printed in 5,000 copies. Small items of publicity for display inside London Underground carriages (commonly measuring 10 ⅝ × 12 ½ in.; 27 × 31.8 cm) were printed in tens of thousands, probably four to view (that is, with the same four images together on the stone or plate to speed up production). Machine speeds claimed by manufacturers at the time have to be treated critically, and in the case of the relatively short runs needed by the publicity department of the London Underground are of no great consequence. Griffits, writing about transport posters in 1940, acknowledged that some modern lithographic machines were capable of running at speeds of 2,500 to 5,000 impressions an hour, but he pointed out that railway posters, the majority of which were required in small quantities, were usually printed on hand-fed machines at just 1,000 impressions an hour.[25]

The chromolithographic practices described above relate primarily to the early days of both London Underground and railway posters. Some of these practices survived after World War II, but the lithographic industry experienced such a technological upheaval during the first half of the twentieth century that it was only in poster design and special categories of book illustration that the older methods lived on. These technological changes, though distinct from one another, combined to transform the lithographic industry in the heyday of the transport poster.

The first independent change was the transition from lithographic stone to plate, which took over a hundred years to complete. It was underway by the middle of the nineteenth century, but stone remained the dominant printing substrate in the lithographic industry at the time the first London Underground posters were issued. It was used regularly for such posters during the interwar years and remained in use on occasions even after World War II. Stone had disadvantages: it was expensive, heavy, and bulky to store; but it had several advantages over zinc and aluminum plates. Artists liked its color and the sensitivity of its surface; they also welcomed being able to produce negative marks with a knife or scraper, which they could not do on metal plates. Furthermore, it was a marvelous printing surface and—a factor not to be discounted—was still readily available in many printing houses in the interwar years of the twentieth century. Stones disappeared from them eventually, and after World War II it became increasingly difficult to find printers with stocks of stones of sufficient size to print large-format posters.[26]

The demise of printing from stone came with the increasing use of rotary printing machines to meet the need for faster printing. In rotary printing the paper is fed between an impression cylinder and a cylindrical printing surface, a method that gave great mechanical efficiency (since each cylinder moved continuously in the same direction). Lithographic plates could be wrapped around the cylinders of rotary presses, whereas lithographic stones could not.[27] The rotary lithographic press certainly advanced the case for using lithographic plates, but if the industry had not converted to metal plates such machines would have led nowhere.

The third interrelated innovation was offset lithography, which had been used for printing on metal in Europe since the 1880s, but was discovered quite independently for printing on paper by Ira Rubel in the United States around 1903.[28] In both applications the image on the printed surface was transferred to a rubber-coated cylinder and from there to paper or some other surface. The process had two great advantages over direct lithographic printing: it could be applied to a greater range of materials, and—because of the use of an intermediate cylinder—the original image came out the same way round when it was printed,

rather than reversed. Offset lithography was ideally suited to rotary printing and was another factor in the demise of lithographic stone.

But the innovation that had the greatest impact on the origination of printed matter, including ultimately London Underground and other transport posters, was the application of photographic methods to printing, and particularly the use of the halftone screen.[29] As far as commercial lithography was concerned the foundations for such methods were put in place in the last decades of the nineteenth century, and by the time the first London Underground poster was issued, full-color photolithographic work was being produced, though not very widely and certainly not for large formats. The process of photolithography started with the artist's original, which was photographed through filters so that its colors were broken down into their constituent hues, initially just yellow, cyan, and magenta. The variation in their strength resulted from the use of cross-lined screens, which converted continuous tonal gradations into dots of various sizes. Each tiny part of the original image was therefore represented by a cluster of yellow, cyan, and magenta dots, which varied in size according to their strength in the original. Later, a black working was added to the three colors, but this was not at all common until the 1920s. In theory such photographic methods did away with the need for lithographic artists to make marks on stone or plate. But in practice the difficulty and cost of applying them to large-scale work meant that original designs for London Underground and other transport posters continued to have their colors separated by hand and eye and, likewise, interpreted on stone or plate by lithographic artists for another half century. This older method of working continued into the 1950s as many posters testify, including Edward Bawden's *City* (1952)[30] and Hans Unger's *The Tower of London* (1956, Fig. 55), printed by the Curwen Press and the Baynard Press respectively.

Though we know in general terms how lithographic printing changed in the first fifty years of the London Underground poster, it is difficult to determine the methods used to produce any particular poster or series of posters without documentary evidence. Since little such evidence exists,[31] identification of the kinds of procedures

and methods discussed above is often impossible. For the most part we have to rely on evidence from the products themselves; sometimes we have the added benefit of comparing an original with the finished poster.

It is usually impossible to say whether a poster was printed from a set of stones or plates, though pressure marks around the edges of a poster, often showing traces of ink, may sometimes provide clear evidence of the use of stones. The task of determining the surface used by lithographers

55

HANS UNGER

The Tower of London, 1956, commissioned by LT, printed by the Baynard Press, 39 7/8 x 24 15/16 in. (101.3 x 63.3 cm). Yale Center for British Art, Gift of Henry S. Hacker, Yale College, Class of 1965

for the drawing is virtually impossible since it has long been the practice in commercial lithographic printing to transfer an image from stone to plate (or to another stone) or from plate to another plate, either to preserve the original image or to produce two or more examples of the same image side by side to speed up production. The position of the registration marks on at least one McKnight Kauffer poster for the London Underground, *Aster Time: Kew Gardens,* (1920, see Fig. 90), printed by the Dangerfield Printing Co., points to this practice having been followed. It was also possible to transfer other kinds of prints to lithographic plates, as was done with Edward Bawden's linocut blocks for two posters featuring country houses and for *Kew Gardens* and, as we are told on its imprint, with Walter Spradbery's *Fragrance: Honeysuckle* (Fig. 56), all of which were printed by the Curwen Press in 1936.[32] The blocks for this Spradbery poster, which was intended for display within carriages, were small (10 ⁵⁄₈ x 12 ½ in.; 27 x 31.8 cm) and were almost certainly transferred four to view onto a single lithographic plate.

It is also virtually impossible to distinguish direct lithographic printing from offset lithography. More ink is usually transferred to the paper in direct printing than in offset printing, and this may be detectable when analyzing the effects produced

by overprinting opaque colors, but in general such qualitative judgments cannot be relied on.[33]

We are on somewhat firmer ground when distinguishing photographically produced images from hand-drawn ones. In the latter, tonal effects could be produced by any one of the techniques described above, or by a combination of them. Photographically produced tonal work always shows a grid of dots of varying sizes, and, in color work, clusters of these dots in yellow, cyan, and magenta (with or without black). By the time London Transport posters were being produced photographically, which was not generally until after World War II, all four workings would have been used. There still remains the more difficult task of distinguishing hand-drawn and photographically produced work when the colors are printed in line or as solids. In practice there are so many imponderables when considering London Underground posters that it is often advisable to be cautious when attributing production methods to particular examples.

What can be stated with some confidence is that the relationship between artist/designer and printer must have varied enormously according to circumstances and the attitudes of both parties. At one extreme Barnett Freedman would have done his own drawing on stone at either the Baynard Press or the Curwen Press, as he did for the two-sheet poster *Theatre: Go by Underground* (1936).[34] It was his custom to take control of all aspects of the origination of his posters, including their color separation, and to work on stones rather than metal plates whenever this was possible (even though the images may have been transferred to plates for production purposes). At the other extreme Fred Taylor is recorded as having left the drawing on stone for a series of four London Underground posters (probably the *Hampton Court* series of 1929) entirely in the hands of T. E. Griffits of Vincent Brooks, Day & Son. It seems that Taylor was in a hurry to get away to Italy at the time and said to Frank Pick: "Tommy Griffits can put all my errors and botches right. Why not leave him to get on with it?"[35] And Pick, somewhat uncharacteristically, agreed. In between these extremes we have to assume that it was general practice for some artists to check proofs at the printers and suggest alterations. It is also likely that artists who were in close

contact with the printers sometimes made adjustments to a design, either for reasons of economy or because they were acting on instructions from the publicity staff of London Underground.

A comparison of a couple of McKnight Kauffer's original designs with the posters that were chromolithographed after them makes the point. In the case of *In Watford* (1915), which was printed in seven colors by Waterlow & Sons, significant changes were made to the design between the original gouache and the printed poster (Figs. 57, 58). Most obviously, the water was made very much lighter and less fussy in the poster, presumably so that the words "In Watford" read more clearly. Similarly, the shadows cast on the bridge, which may have been thought to obscure its form, were lightened considerably. And one significant detail, a

frame that surrounded Kauffer's monogram in the original, is no longer there in the poster. All these changes suggest some intervention from publicity staff at London Underground to make the poster read more directly and remove visual distractions. It seems clear that the changes were not lapses on the part of the lithographers, or willful departures from the original, since the subtle surface textures Kauffer produced on the water, which stem in part from the incidental effects of washes of gouache, have been followed quite skillfully by Waterlow's chromolithographic artists. Without documentation it is impossible to know the extent of Kauffer's involvement with these changes, though it is hard to believe that he would have been happy with all of them. The poster may have become somewhat easier for lay people to interpret as result of these

57

EDWARD MCKNIGHT KAUFFER

In Watford, 1915, original gouache design for the poster. Victoria and Albert Museum, London

58

EDWARD MCKNIGHT KAUFFER

In Watford, 1915, 7-color poster, commissioned by UERL, printed by Waterlow & Sons in 1,500 copies. Victoria and Albert Museum, London

changes, but it could be argued that it lost some of its force and mystery.

In the case of Kauffer's *Reigate* (1915), which was printed by Johnson, Riddle & Co., six solid colors were used to reproduce the original gouache as exactly as could be expected.[36] But the wording was changed from "Above Reigate" to "Route 160 Reigate," an alteration that must surely have been made at the instigation of staff of London Underground. As a result, the organization and style of the lettering also changed: Kauffer's highly distinctive sans serif letterforms were abandoned in favor of a much bolder commercial style of lettering, which shows every sign of having been drawn by staff at the printers.[37] Again, we have to ask whether Kauffer was party to these changes and accepted them, or whether they were made without consulting him.

For a later period, reports of meetings of the London Transport publicity committee establish beyond doubt that changes were made on a regular basis to designs and proofs. Frank Pick chaired these meetings, which, in 1937 at least, were held every few weeks.[38] The committee reviewed the range of publications that had been produced since its last meeting, established programs for the production and issue of posters, accepted or rejected designs, and regularly suggested very specific modifications to posters in a way that left little room for its views to be ignored.

An important question, which sometimes cannot be answered, is whether the artist/designer of a poster also made the drawing on stone or plate. This is rarely in doubt in the early days of London Underground posters. In this period there is a considerable and easily detectable difference between the complicated analytical work of the professional chromolithographer and that of, for example, the artist Gerald Spencer Pryse, who must have made the vigorous crayon drawing on stone himself for the black working of *Underground for Sport* in 1913 (Fig. 59). Following his documented practice, he would have been given a proof of this drawing to color by hand as a guide for the printer's lithographers, in this case the Westminster Press, to interpret on a set of stones.[39]

The heyday of the London Underground poster coincided with a period when attitudes to lithography were in a state of flux. Chromolithography in particular had gained a bad reputa-

tion over the years, comparable to that of commercial wood engraving, but probably worse. Both trades—quite unjustifiably—were regarded by those brought up under the influence of the Arts and Crafts movement as debased, soulless, and commercial. Frank Pick may well have shared such views. In a letter he wrote to Martin Hardie of the Victoria and Albert Museum in August 1925 in response to a request for his views on poster design, he observed that the "flat-colour treatment" of posters was only a phase, and that it was necessary "in order to get away from the old fashioned chromolithograph."[40] This was one response to the repositioning of lithography; another was the coining and regular use of the term "auto-lithography" in an attempt to distance the process from the commercial world and to reclaim it for the artist.[41] The term was used to describe lithographic work done on stone, plate, or transfer paper by artists themselves, in order to make a distinction between this and lithographs made either photographically or copied by hand from an artist's original, both of which were regarded by many at the time as inferior methods. The word "auto-lithography" had wide currency for a couple of decades from the 1930s, when lithography had something of a revival as a printmaking and illustration process, which was reflected in the attention paid to it by British art schools.

Thomas Griffits and Barnett Freedman, in company with the Baynard Press and the Curwen Press, were at the forefront of this campaign to promote "autolithography," which accorded perfectly with Pick's ideas for bringing art to the London public through posters. Griffits, who was trained at the tail end of the nineteenth century as a chromolithographer and was later responsible for printing many London Underground posters, had a difficult job squaring the notion of autolithography with poster production of the day, which was still mostly in the hands of commercial chromolithographers working after artists' originals. The delicate line he took was that their role in such cases was one of interpretation rather than slavish copying,[42] but this position was hard to sustain in the face of the efforts made by chromolithographers at the Baynard Press and the Curwen Press to demonstrate their skills by reproducing the incidental effects of washes,

N° 3.

"HE knows nothing, who does not mix with the crowd."
Spanish Proverb.

UNDERGROUND

FOR SPORT

FOOTBALL AT WALHAM GREEN OR GILLESPIE ROAD

THE WESTMINSTER PRESS

scumbling, and dry brushwork—for example in Betty Swanwick's *The River* (Figs. 60, 61) and Hans Unger's *The Tower of London* (Fig. 55).[43]

In the early days of London Underground posters, chromolithographic artists of several printing establishments tried to replicate the marks of the original as closely as possible, as they did, for example, for Fred Taylor. This would have been the way they were trained to work. Gradually, recognizing that posters are rather different from book illustrations and reproductions of works of art, this changed. McKnight Kauffer, for example, produced originals in gouache in the ten years or so after World War I that reveal variation in the laying in of areas of color, which may have been deliberate on some occasions, but probably not on others. Since some of these areas were interpreted on stone as flat solid colors, whereas others were rendered in a variety of tones (perhaps using more than one stone), someone at the printing house must have had to make decisions over what was intentional in the original and what was not.

The large expanse of water in Kauffer's original design for *Epping Forest* shows marked changes of tone, which appear as predominantly vertical striations.[44] But in the six-color finished poster, the lithographers at the Dangerfield Printing Co. provided a substantially muted version using two light blue workings.[45] This seems to have been a compromise design solution rather than a technical deficiency. Dangerfield's chromolithographic artists were perfectly capable of reproducing the incidental effects of Kauffer's brush, but a decision seems to have been taken on aesthetic grounds to simplify the blue area of water while paying lip service to Kauffer's textures. In other Kauffer posters, for example two printed by Johnson, Riddle & Co., comparable techniques have been painstakingly replicated to produce meaningful effects, as in the brown ploughed fields of *The North Downs* (1915)[46] and the maroon slopes of *The Heaths No. 178 Surrey* (1916).[47]

It is possible that a few artists of the interwar period who made posters, in addition to Barnett Freedman (Fig. 62), did some drawing on stone themselves. Artists could hardly have been ignorant of the arguments in favor of autolithography, and since many of them would have had experience of drawing on stone and making color

separations at art school, it can be imagined that a few of them must have been tempted to do their own poster work on stone. In many cases it was in the interests of Pick for them to do so, since he was spared the cost of paying for the work that was normally done by lithographic artists at the printers.[48] There may well have been objections from the trade unions to artists working on stone themselves, though Freedman managed to sidestep them at the Curwen Press.[49] In addition to Freedman, a few other designers of transport posters did their own drawing on stone or plate, including Pryse (Fig. 59) and Frank Brangwyn (Figs. 63, 64), who produced images based on a strong foundation drawing, either in tinted lithography or with a very limited range of colors. In other cases, where several colors were used in a rather simple way, it is difficult to be sure whether the artist was responsible for the lithographic drawing or not.

More than one hundred firms were involved in the printing of London Underground posters: many produced fewer than ten and some just one, but four of them together produced well over 2,000.[50] The most prolific was the firm of Waterlow & Sons, with over 1,000 to its credit between 1901 and 1973. In descending order of output, Waterlow was followed by the Dangerfield Printing Co.; Johnson, Riddle & Co.; and Vincent Brooks, Day & Son. Though not quite so prolific as some of the above, the Baynard Press and the Curwen Press must rank alongside them in importance by virtue of the quality of their work and the artists they attracted. All these printers had offices or factories in London and worked for the London Underground for twenty or more years (Baynard, Curwen, Waterlow, and Johnson, Riddle, for over half a century). This is a remarkable record of successful partnerships, particularly as London Underground's involvement with the Dangerfield Printing Co. and Vincent Brooks, Day & Son only stopped with the outbreak of World War II. It could be argued that London Underground posters helped to sustain these firms by keeping their presses rolling, which they clearly did to some degree, but the choice of such long-lasting firms may also reflect the sound judgment of the London Underground's publicity department.

Waterlow & Sons were probably the longest surviving lithographic printers in Britain, and when they began working for the London Underground in 1901 they were still situated, among other locations, in Birchin Lane and London Wall in the City of London. James Waterlow registered as a letterpress printer in Birchin Lane in 1822[51] and was using the lithographic process from at least 1832.[52] Over the years the firm diversified from being specialists in law stationery and security printing to taking on an enormous range of work, and in 1908 (when it also had a factory in Birmingham) it listed chromolithography as one of the specialties of its London house.[53] It became a limited company in 1875 and in 1940, having relocated to a spacious factory some thirty miles from London in Dunstable, described itself on letterheads as "Bank note, postage stamp & general engravers, protective cheque specialists, commercial printers and lithographers, account book & envelope manufacturers, photogravure & art printers." The printing of color-lithographed posters represented just a small part of Waterlow's business, and its output of more than a thousand posters for London Underground over a period of seventy years would not have stretched its resources to any great degree (Fig. 65).

The Dangerfield Printing Co. of 23 Bedford Street, London, appears to have grown out of the firm of Frederick Dangerfield, who was working as a lithographer in Church Place, Covent Garden in 1851, but later moved to Bedford

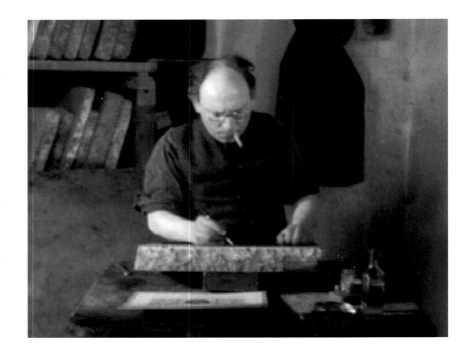

62

Barnett Freedman working at Vincent Brooks, Day & Son, London, 1935. He is seen drawing the artwork for the stamp commemorating George V's Silver Jubilee on stone, which was done six times its linear size. Still from the film *The King's Stamp,* 1935, directed by William Coldstream

63

**FRANK WILLIAM
BRANGWYN**

*North East Coast
Industries* (proof of
black working), 1927,
commissioned by LNER,
printed by the Avenue
Press, 39 ½ x 51 in.
(100.3 x 129.5 cm). Yale
Center for British Art,
Gift of Henry S. Hacker,
Yale College, Class of
1965

64

**FRANK WILLIAM
BRANGWYN**

*North East Coast
Industries*, 1927,
commissioned by LNER,
printed by the Avenue
Press, 39 ½ x 50 ¼ in.
(100.3 x 127.6 cm). Yale
Center for British Art,
Gift of Henry S. Hacker,
Yale College, Class of
1965

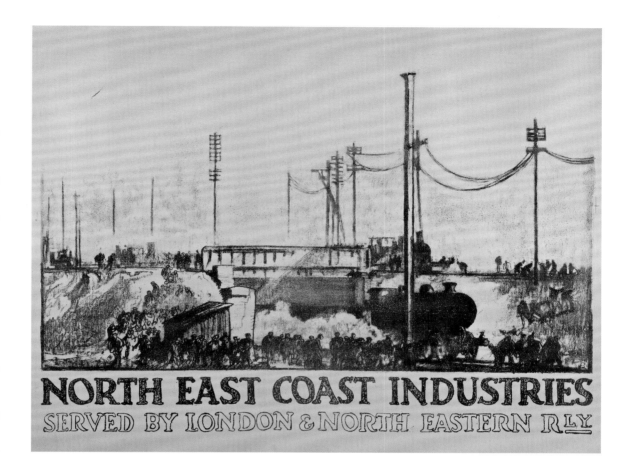

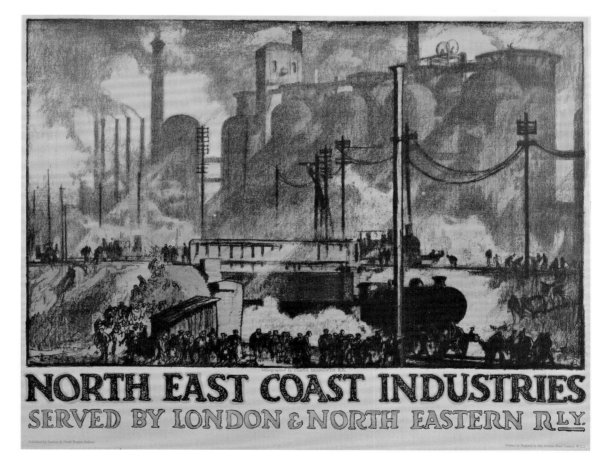

Street.[54] At some stage the firm worked from the same address as the lithographers Ashbee and Dangerfield. Early in the twentieth century the Dangerfield Company was featured in an article by L. Gray-Gower, "How a Chromolithograph Is Made," which was published in the *Strand Magazine* in 1904.[55] It shows a set of reproductions of an eighteen-color chromolithograph after Raphael's *The Ansidei Madonna* as a means of explaining the process to lay people. This particular chromolithograph was being printed at Dangerfield's St. Albans plant at the time of the writer's visit, and the article shows the color separations of the print (all in monochrome) and an illustration of the artists' room at the press (Fig. 66). Men are shown inspecting and working on large stones, one of which is seen propped up at a steep angle; but most obviously the walls of the room are plastered with enormous posters, which suggests that the firm was specializing in this branch of work long before it printed its first poster for the London Underground in 1914. Between then and 1940 Dangerfield was responsible for printing around 370 such posters.

Johnson, Riddle & Co. of Southwark Bridge Road, south of the River Thames, printed almost three hundred London Underground posters over the longest time span of all its printers (1905–75), but is probably not as well known as the others mentioned here. The firm, listed as lithographers and chromolithographers, had occupied the same premises since at least 1880 with the business name Riddle & Couchman, later Johnson, Riddle, Couchman & Co.,[56] and then, from about the time it began working for London Underground, Johnson, Riddle & Co.[57]

The London Underground printers with the greatest long-term reputation for color work were Vincent Brooks, Day & Son, who were awarded a gold medal for poster work at the Printing, Stationery and Allied Trades Exhibition of 1925, with a somewhat embarrassed Frank Pick acting as sole judge.[58] Both Vincent Brooks and Day & Son worked independently as lithographers in London in the mid-nineteenth century and had considerable experience in chromolithography.[59] Day & Son undertook the printing and publication of numerous color-plate books from the 1850s,[60] and in the 1860s was a pioneer photo-lithographer.[61] But when the firm ran into finan-

cial difficulties, ending with its liquidation in 1867, it was bought by Vincent Brooks. He took over the premises in Gate Street, Lincoln's Inn, before moving to Parker Street just before the end of the century. This was where Thomas Griffits, who did more than anyone else in Britain to introduce artists to lithography in the interwar years, worked for thirty-five years. It was mainly in these years, when he was in charge of the press, that Vincent Brooks, Day & Son printed around 230 London Underground posters.

The two British firms best known for bridging the gap between artists and chromolithography in the twentieth century were the Curwen Press and the Baynard Press. Though they produced fewer posters for London Underground than the other printers mentioned here, their significance lies in the way in which they encouraged artists to work with the lithographic trade in one capacity or another.

Founded in 1863 with a speciality in music printing, the Curwen Press was transformed under the guidance of Harold Curwen to become a design-conscious printing house.[62] This process began in 1917 but gained momentum in 1920 with the appointment of Oliver Simon as typographer to the press. The firm's *forte* was quality book design, but it was also exceptional for the attention it gave to the design and production of routine ephemera, which bore witness to Curwen's belief that printing was printing, regardless of the

65
"Waterlow's 'Smeed Road Factory. — lithographic artists' room,'" from *Waterlow & Sons Ltd* (London: [1914]). The British Library

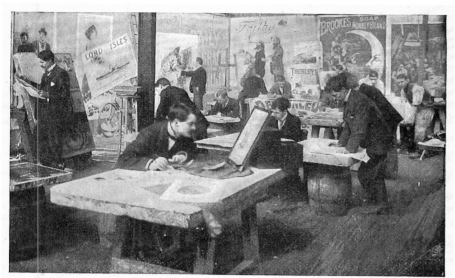

THE ARTISTS' ROOM AT THE DANGERFIELD COMPANY'S WORKS, SHOWING THE
From a Photo. by] LITHOGRAPHIC STONES. *[the Dangerfield Co.*

66

"The artists' room at the Dangerfield Company's works," from L. Gray-Gower, "How a chromo-lithograph is printed," *Strand Magazine* 27 (February–July 1904): 33. Courtesy of the Yale University Library

status of what was being produced. Curwen's need for illustrators, its promotion of stenciling, and its passion for decorative papers brought many artists into its orbit, including Edward Bawden, Claude Lovat Fraser, Barnett Freedman, Enid Crystal Dorothy Marx, Paul Nash, and Albert Rutherston. Posters were not originally the press's strength, though in later years it built up a reputation for such work, encouraging artists to work on stone at the press.[63]

The Baynard Press was the public face of Sanders Phillips & Co., which was originally founded in 1876 and became a limited liability company in 1894.[64] Though working as general printers in the nineteenth century, the firm had a longstanding involvement with lithography. In later years its interests extended beyond the mere commercial to printing as a craft, and after World War I it followed the Curwen Press and a few other design-conscious printers by employing typographic designers. The firm's concern to attract artists to work with it was considerably enhanced in 1935 when Thomas Griffits joined it, having resigned his directorship of Vincent Brooks, Day & Son. By this time Griffits had spent almost forty years in the lithographic trade and had already been involved with the production of London Underground posters for a couple of decades. In 1950, by a curious twist of fate, the Baynard Press (Sanders Phillips & Co.) absorbed Vincent Brooks, Day & Son.

Those who printed more than a handful of posters for the London Underground include some other well-known names in British printing: S. C. Allen & Co., Eyre & Spottiswoode, McCorquodale & Co., Ernest Nister, Photochrom, Sun Engraving Co., John Swain and Son, John Waddington, and the Westminster Press. Other printers, either specialists in poster printing (such as David Allen & Sons and James Upton) or printers with high reputations (for example, Balding & Mansell, Jarrold & Sons, the Kynoch Press, Hazel Watson & Viney), had a passing involvement with the London Underground and produced no more than the very occasional example. We can only speculate about the reasons for this. It is possible that they priced themselves out of the market; but whatever the reason, the London Underground's general practice seems to have been to turn again and again to the same relatively small group of printers, most of which were in London or close to it.

Some of the firms that undertook the production of posters for the London Underground in the 1920s and 1930s, including the Baynard Press, the Dangerfield Printing Co., Vincent Brooks, Day & Son, J. Weiner, and Waterlow & Sons also did so for the railway companies. Many of their posters were larger than the typical London Underground poster and were in landscape (horizontal) format, but they involved the same well-established techniques of chromolithography. Probably the most prolific of the printers of railway posters was McCorquodale & Co. of London, who printed posters for many of the railway companies (in addition to some thirty for the London Underground). Other printers who produced railway posters on a fairly regular basis, including Jarrold & Sons and David Allen & Sons, were among those who printed just a few for the London Underground.

The impact of such railway posters on the chromolithographic trade extended as far as Australia, as we can glean from a vivid and convincing description of the apprenticeship of a young lithographic artist in George Johnston's semi-autobiographical Australian classic, *My Brother Jack.*[65] Though the printing house was not named in the book, the author served his apprenticeship with the major Melbourne firm of Troedel & Cooper in the years leading up to the depression

of the early 1930s. In the book, the author's alter ego, David Meredith, describes the walls of the studio in which he and nine others drew on stone or plate on huge, sloping tables:

A kind of strange exotic beauty had been imparted to these walls by a semi-accidental montage of overseas posters which for years had been pasted up on the pulpboard, presumably as outstanding examples of commercial art, and had since become exquisitely textured by the prickings of a million pins. I never realized then that there were museum pieces among them . . . because most of the posters were from the British railway companies, Great Western and London North Eastern, usually by Fred Taylor or Frank Newbold [sic], and from the very beginning it seemed wonderful to me to be working in that grubby, crowded, utilitarian place with the vision always before one's eyes of Tintern Abbey and the [sea] front at Scarborough and the stained glass of York Minster and the chalk cliffs of Dover and the Welsh mountains and the fishing trawlers bucking out of Grimsby.[66]

Some poster artists in Britain were associated with particular printers, or at least worked with them regularly. Most obviously, the Italian immigrant artist Emilio L. Tafani (Fig. 67) produced eleven posters for the printer Ernest Nister & Co. in 1915.[67] Curiously, though he signed his posters, they are all lettered within a standard cartouche, "Designed & printed by Ernest Nister 26–28 St Bride St. E.C." Tafani was a trained chromolithographer and the wording cited here suggests that he may have worked as an employee of Nister; it is not impossible therefore that he did his own drawing on stone for these posters, much as he did for other products later on. Other artist/printer relationships include Fred Taylor's regular work in the 1920s for Johnson, Riddle & Co. (though over his long career he worked for many other printers too), and T. R. Way, whose father

67

EMILIO L. TAFANI

The Mystery of the Craft, probably 1944, oil on canvas, 30⅞ x 44⅞ in. (78.5 x 114 cm). Department of Typography & Graphic Communication, University of Reading, England

printed many of Whistler's lithographs.[68] An artist-lithographer strongly influenced by Whistler, T. R. Way, also owned a printing works (T. R. Way & Co.), where he printed his own posters as well as many by Paul Rieth in the years leading up to World War I.

Other chapters of this book point to the impact made by transport posters on urban life during the interwar years of the twentieth century, and it takes an act of imagination and a good understanding of the attitudes and tastes of the day to begin to appreciate the reactions of people to them. But we can be reasonably certain that only a tiny proportion of those who saw such posters at the time would have stopped to consider how they were produced. Little if anything would have been gained from doing so. Retrospectively, however, we can see these posters in a different light. As this account reveals, the numerous transport posters that survive, some with their original designs, provide unparalleled insights into poster production from the era of hand-produced chromolithography through to that of four-color photolithography.

1. Virginie Vignon, "Jules Chéret: créateur d'une industrie publicitaire (1866–1932)," 3 vols., Doctoral thesis, Université de Paris X–Nanterre, 2007.

2. Réjane Bargiel and Ségolène Le Men, eds., L'Affiche de Librairie au XIXe Siècle (Paris: Éditions de la Réunion des Musées Nationaux, 1987).

3. Michael Twyman, Printing, 1770–1970: An Illustrated History of Its Development and Uses in England (London: Eyre & Spottiswoode, 1970; 2nd ed., British Library, 1998), fig. 278.

4. For the dissemination of lithography, see Journal of the Printing Historical Society, no. 27 (1998), a bicentenary issue devoted mainly to the spread of lithography; and Michael Twyman, Breaking the Mould: The First Hundred Years of Lithography (London: British Library, 2001), particularly 16–21.

5. Michael Twyman, Early Lithographed Music (London: Farrand Press, 1996), 42–53.

6. F. H. Man, "Lithography in England (1801–1810)," in C. Zigrosser, ed., Prints (London, 1963), 97–130, and Man, 150 Years of Artists' Lithographs, 1803–1953 (London, 1953); Michael Twyman, Lithography, 1800–1850: The Techniques of Drawing on Stone in England and France and Their Application in Works of Topography (London: Oxford University Press, 1970).

7. Twyman, Breaking the Mould, 28, 84–88, 136–40, 160, 161.

8. In the middle of the nineteenth century the largest stones regularly available would have measured no more than about 30 × 36 in. (76.2 × 45.7 cm). By the 1890s stones measuring 42 × 62 in. (107 × 157.5 cm) were in general use in Britain for the largest powered machines. For further discussion of the sizes of lithographic stones available during the nineteenth and early twentieth centuries see Michael Twyman, "Lithographic Stone and the Printing Trade in the Nineteenth Century," Journal of the Printing Historical Society 8 (1972): 1–41.

9. Maria L. Müller-Burger, Die Solnhofer Plattenkalk-Industrie in Vergangenheit und Gegenwart, Wirtschäfts- und Verwaltungsstudien mit besonderer Berücksichtigung Bayerns (Leipzig and Erlangen: Deichertsche Verlagsbuchhandlung Dr. Werner Scholl, 1926), no. 70; Twyman, "Lithographic Stone": 2–6, 16, 37–39, pls. I–VII.

10. For an explanation of the chemical basis of lithography and the various methods of making lithographs see particularly Garo Z. Antreasian and Clinton Adams, The Tamarind Book of Lithography: Art and Techniques (Los Angeles: Tamarind Lithographic Workshop; and New York: Harry N. Abrams, 1971).

11. In 1837, with his son Jean, Godefroy Engelmann patented a method of producing full-color images from stone using just three or four colors, which he called chromolithographie (French patent 8848, July 31, 1837). In the same year he published a set of seven sample plates to demonstrate the capabilities of his process, with the title Album chromo-lithographique. Hullman-del's seminal contribution was made a couple of years later with the plates he printed for Thomas Shotter Boys's Picturesque Architecture in Paris, Ghent, Antwerp, Rouen, etc. (London, 1839), though he had already printed four double-page plates in flat areas of color for G. A. Hoskins's Travels in Ethiopia (London, 1835). For the early development of chromolithography see Bamber Gascoigne, Milestones in Colour Printing, 1457–1859 (Cambridge, Eng.: Cambridge University Press, 1997), and Michael Twyman, Images en couleur: Godefroy Engelmann, Charles Hullmandel et les débuts de la chromolithographie (Lyon: Musée de l'Imprimerie; Paris: Panama Musées, 2007).

12. Benjamin Day filed a patent application to protect his invention in the United States on January 4, 1878 ("Improvement in printing-films," no. 214, 493), which was granted April 22, 1879. A provisional specification was lodged in England for the idea on July 26, 1881, and a more complete one on January 26, 1882 ("Films for printing, &c," no. 3280). The starting point was the manufacture of sheets of gelatin with relief patterns on them, mostly different configurations of dots and lines in varying resolutions, but also rather more bizarre patterns. A sheet of this kind was inked up in greasy ink with a roller, and placed face down above the stone in a special apparatus. This allowed it to be positioned with great precision over a partially drawn image. The lithographic artist then rubbed the back of the sheet in order to transfer the grease to those parts where tints were needed.

13. The practice goes back to the early days of lithography, see C. Hullmandel, The Art of Drawing on Stone (London: C. Hullmandel and R. Ackermann, 1824), 10–11, pl. I, fig. 10.

14. "Drawn on Stone: Something of the Life and Work of Thomas E. Griffits, Lithographer, Part 2: The Mature Craftsman," The Pleasures of Printing 2 (ca. 1955): 11–12.

15. A different approach was adopted by one railway company (probably the London and North Eastern Railway) in the interwar years of the twentieth century. Cecil Bye, a chromolithographic artist who worked for the firm of Jarrold & Sons in Norwich at the time, recalled that it was the custom of this company to specify in advance the number of colors, usually around twelve, that were to be used on its posters. The company also insisted on seeing proofs of each color separately, presumably to ensure that it had not been cheated. (Bye suspected that someone on its publicity staff had once been a chromolithographer.) Inevitably, things did not always work out as planned. A railway poster designed by Doris Zinkeisen featuring a vineyard in France, and described as showing grapes in great detail, was held by the customer to be unsatisfactory. Zinkeisen had produced her original in body color, which had a matte surface, but the proofs appeared shiny as a consequence of successive overprintings. The solution was for Jarrold & Sons to add, at their own

expense, a light gray ink over much of the image to reduce or eliminate the shine. Taped interview with Cecil Bye, October 1, 1996, St Bride Library, London, and Department of Typography & Graphic Communication, University of Reading.

16. David Cumming, *Handbook of Lithography* (London: Adam & Charles Black, 1904), 179.

17. Thomas E. Griffits, *The Technique of Colour Printing by Lithography* (London: Faber and Faber, 1940), 60–61.

18. More than twenty years later, the minutes of the London Transport publicity committee, an influential body chaired by Frank Pick, reveal that it intervened regularly to modify designs. Minutes of the Vice-Chairman's Publicity and Public Relations Meetings, January–December 1937, Transport for London Archives, (NEW) LT000606/011.

19. "Drawn on Stone: Something of the Life and Work of Thomas E. Griffits, Lithographer, Part I: Early Days," *The Pleasures of Printing* 1 (March 1955): 2–9; "Part 2: The Mature Craftsman": 8–14.

20. Thomas E. Griffits, *Colour Printing* (London: Faber and Faber, 1948), 1–3; Caroline Hawkes, *The Pleasures of Colour Printing: A Biography of Thomas Griffits, 1883–1957* ([Stroud], 1977), 24–25; and "T. E. Griffits Celebrates," *Modern Lithographer and Offset Printer* 52, no. 4 (April 1956): 32.

21. Hawkes, *Pleasures of Colour Printing*, 25; and "T. E. Griffits Celebrates," 32.

22. Griffits, *Colour Printing*, 17; cited with minor differences by Hawkes, *Pleasures of Colour Printing*, 18.

23. Griffits, *Colour Printing*, 18; Hawkes, *Pleasures of Colour Printing*, 19.

24. Print runs are gleaned from details at the foot of the posters themselves.

25. Griffits, *Technique of Colour Printing*, 20.

26. The largest stones available when the first series of "Lyons lithographs" was being discussed in 1946 measured 30 x 40 in. (76.2 x 101.6 cm); copy of letter, Jack Beddington to Julian Salmon of J. Lyons and Co., January 24, 1946, Manchester Metropolitan University Library, FRE/I/I/251. J. Lyons and Co. commissioned three series of original prints by artists to hang on the walls of its chain of restaurants.

27. Though in the middle of the nineteenth century several machines were proposed that used stone cylinders as the printing surface. See Michael Twyman, "The Lithographic Hand Press 1796–1850," *Journal of the Printing Historical Society*, 3 (1967): 44, 46–48.

28. Twyman, *Printing 1770–1970*, 57–58.

29. Charles W. Hackleman, *Commercial Engraving and Printing* (Indianapolis: Commercial Engraving Publishing, 1921); Twyman, *Printing 1770–1970*, 29–33.

30. London Transport Museum, 1983/4/6565.

31. Transport for London, the agency that administers the London transit system, holds most of the surviving archives of the organizations it succeeded; others are held on its behalf by the London Metropolitan Archives. The London Transport Museum also holds some archives. Additional sources include the Barnett Freedman archives at Manchester Metropolitan University Library.

32. One of the two country-house posters and *Kew Gardens* were described as "Cut in linoleum and transferred onto lithographic printing plates," in *Drawn by Hand: A Retrospective of Auto-lithography Printed at the Curwen Press, Plaistow, 1920–1950*, exh. cat. (London: Curwen Gallery, 1966), items 9, 15. Bawden's two posters are London Transport Museum, 1983/4/4585 and 1983/4/4588; *Kew Gardens* is 1983/4/4577.

33. A note, "Bronze Printing and the Offset Press," in *Modern Lithographer & Offset Printer* 20, no. 3 (March 1924), 74, claimed that "the ink deposit upon the paper in offset printing is only one half that of direct printing."

34. London Transport Museum, 1983/4/4700.

35. Hawkes, *Pleasures of Colour Printing*, 17.

36. Victoria and Albert Museum, original 839–1926, poster E 499–1916 (LTM 1983/4/730).

37. Though the alphabet the calligrapher Edward Johnston designed for the exclusive use of the London Underground in 1916 was rigorously applied to its signs from that year, and to printed notices later, it was not widely used on its pictorial posters. Many were the work of artists who had little understanding of lettering: some ignored lettering entirely in their initial designs, perhaps because they had not been given copy, others simply gave an idea of what was intended. Consequently there is little consistency in the lettering of these posters. Edward Johnston's brief was to design an alphabet that should have "the bold simplicity of the authentic lettering of the finest periods and yet belong unmistakably to the XX century." See Priscilla Johnston, *Edward Johnston* (London: Faber and Faber, 1959), 199. It seems that Pick was not concerned with using letterforms as a means of establishing the London Underground's brand image on pictorial posters, since variety lay at the very heart of this campaign. It would also have been difficult from a practical point of view as Johnston's typeface, in a font made of wood letters, could only have been printed over light tones. Other options would have been for chromolithographic artists to trace the Johnston letters onto a set of stones and draw on each as required, or to reverse the lettering out of a solid area of dark ink, which was often done. The latter approach would have involved either a staff artist drawing the lettering, or reversing it out photographically. In addition to the changes to Kauffer's lettering referred to here, London Transport meeting minutes stipulate that the lettering of a set of posters by Mary Adshead (see Fig. 114) should be "a strong black type of the nature suggested by Mary Adshead, but with a less exaggerated difference between the thick and thin lines." Minutes of the Vice-Chairman's Publicity and Public Relations Meeting, Frank Pick

in the Chair, January 6, 1938, Transport for London Archives.

38. Minutes of the Vice-Chairman's Publicity and Public Relations Meetings, January–December 1937, Transport for London Archives, (NEW)LT000606/011.

39. "Drawn on Stone . . . Part 2": 12.

40. Letter, Frank Pick to Martin Hardie, August 31, 1925, Transport for London Archives, (NEW)LT000535/012.

41. The distinction had its origins in the painter-engraver movement in France and the initiatives of James McNeill Whistler and the lithographic printer Thomas Way (the father of T. R. Way) in Britain. It was promoted by *The Studio* through its publication of "auto-lithographs" from 1893, and then by the Senefelder Club (founded 1910), which encouraged artists to produce original lithographs.

42. Griffits made this point largely by reference to his own work, for example in the accounts, based on interviews with him, in "Drawn on Stone . . . Part I": 9; "Part 2": 12, 14.

43. The skills chromolithographers displayed when reproducing an artist's original were fully acknowledged by Harold Hutchison (Publicity Officer at London Transport) in a letter to the artist Ivon Hitchens in 1951. He wrote that until he was within a few inches he was unable to tell the difference between the artist's original design for the poster *Flowers* (London Transport Museum, 1983/4/6385) and the poster itself, which was drawn by Thomas Griffits at the Baynard Press (cited by Alan Powers in "Artist and Printer: Poster Production, 1900–70," in David Bownes and Oliver Green, eds., *London Transport Posters: A Century of Art and Design* (Aldershot, Eng.: Lund Humphries, in association with the London Transport Museum, 2008), 75; the original and the poster are shown side by side, 74, 75.

44. Victoria and Albert Museum, 838–1926.

45. Victoria and Albert Museum, E 2024–1921.

46. London Transport Museum, 1983/4/754.

47. London Transport Museum, 1983/4/757.

48. Though in 1951 Hutchison argued that this was not the case. See Powers, "Artist and printer," 76.

49. Pat Gilmour, *Artists at Curwen* (London: Tate Gallery, 1977), 69; Michael Twyman, "Barnett Freedman: Master Lithographer," in Ian Rogerson, *Barnett Freedman: The Graphic Art* (Huddersfield, Eng.: Fleece Press, 2006), 206.

50. Figures gathered from an analysis of the London Transport Museum's website: www.ltmuseum.co.uk, which posts collection information, accessed January 10, 2010.

51. William B. Todd, *A Directory of Printers and Others in Allied Trades, London and Vicinity, 1800–1840* (London: Printing Historical Society, 1972), 205.

52. Geoffrey Wakeman and Gavin D. R. Bridson, *A Guide to Nineteenth Century Colour Printers* (Loughborough, Eng.: Plough Press, 1975), 106–7.

53. *Kelly's Directory of Stationers, Printers, Booksellers, Publishers, Paper Makers, &c* (London: Kelly's Directories, 1908).

54. Michael Twyman, *Directory of London Lithographic Printers, 1800–1850* (London: Printing Historical Society, 1976), 29.

55. L. Gray-Gower, "How a Chromo-lithograph is Printed," *Strand Magazine* 27, no. 5 (1904): 33–39.

56. *Post Office London Directory* (London: Kelly's Directories, 1880, 1890); *Kelly's Directory of Stationers* (1900).

57. *Kelly's Directory of Stationers* (1908).

58. Letter, Frank Pick to A. E. Owen Jones, May 22, 1925: "There would seem to be only one firm which had a comprehensive series of posters on show which showed variety of treatment and reached an adequate standard." Pick was apologetic about granting the award to Vincent Brooks, Day & Son, partly because they were one of his principal suppliers of posters, but mainly because "other considerable firms doing poster work were not represented". The printers he referred to in this category were the Avenue Press, Eyre & Spottiswoode, Johnson, Riddle & Co., and Sanders Phillips & Co., all of which had already produced posters for the London Underground.

59. Wakeman and Bridson, *Guide*, 17–19, 30–32

60. Ruari McLean, *Victorian Book Design and Colour Printing* (London: Faber and Faber, 1972).

61. Michael Twyman, *Early Lithographed Books* (London: Farrand Press and Private Libraries Association, 1990), 252–53.

62. Gilmour, *Artists at Curwen*; Holbrook Jackson, "A Cross-section of English Printing: The Curwen Press, 1918–1934," *Curwen Press News-letter*, no. 9 (March 1935): 1–14.

63. In 1966 the Curwen Gallery organized a small exhibition of work drawn on stone and printed at the Curwen Press in the period 1920–50, consisting of book illustrations, prints, and posters, including a few for London Transport (*Drawn by Hand*, Curwen Gallery).

64. "Drawn on Stone . . . Part I": 1.

65. George Johnston, *My Brother Jack* (Sydney: A & R Classics, Harper Collins, 1990; and several later editions), first published in Australia by William Collins & Sons, 1964.

66. Johnston, *My Brother Jack*, 60.

67. London Transport Museum, 1983/4/ 489, 492, 495, 498, 500, 503, 506, 507, 510, 513, 516. Later, Tafani designed posters that were printed by the Avenue Press, Waterlow & Sons, and Chorley & Pickersgill.

68. Patrick Frazer, "Thomas Way and T. R. Way: Commercial and Artistic Lithographers," PhD thesis, University of Reading, 2000.

ST ALBANS

84

4

RAILWAY POSTER DISPLAY:

HOW THE UNDERGROUND SET THE PACE

OLIVER GREEN

In the early twentieth century the pictorial poster became, for a while, the most powerful medium of mass visual communication. It was used to sell products and services, to explain or to persuade. At its best, a skillfully crafted combination of words and images on public display was highly effective advertising or publicity in a growing consumer society. The successful poster represented art applied to a very particular purpose, in which a combination of good design and the right display environment could be immensely persuasive. Prominently placed posters were difficult to ignore on the street or in a railway station.

Even before the arrival of pictorial posters in the 1890s, British railway companies had a close relationship with the developing world of advertising. Busy stations, especially in urban areas, were key sites with some of the largest wall areas available for hire as commercial advertising space for any product under the sun. At the same time, but quite separately, the railways themselves were beginning to use posters for information and publicity about their own services. In the late Victorian period neither of these activities was carried out very effectively or efficiently.

Between the 1900s and the 1930s major changes took place in the presentation and display of the railways' own posters. The period came to be seen as a golden age for railway posters,

ushered in by the arrival of color pictorials at the turn of the century and led by developments at a new and in many ways unique transport organization, the Underground Electric Railways of London (UERL). The Underground's influence was in turn largely due to the energy and drive of one individual, Frank Pick, who was the first commercial manager in Britain to use posters in a dynamic and creative way.

Without Pick the UERL would still have become a major urban transport operator, but its public image and design style might have remained mediocre. Frank Pick rose through the company from having initial responsibility for publicity in 1908 to becoming Managing Director in the 1920s and, finally, the first Chief Executive of London Transport, the city's integrated public transit authority, created in 1933. For over thirty years Pick used posters as the cornerstone of what he referred to as his organization's "appearance values."[1] Posters became an integral feature in a powerful and systematic approach to visual communication throughout first the Underground and then London Transport, both of which became almost synonymous with the image of a modern, progressive city.

Railway stations had been prime display areas for commercial advertising since at least the 1870s. Poster sites were managed on the railway

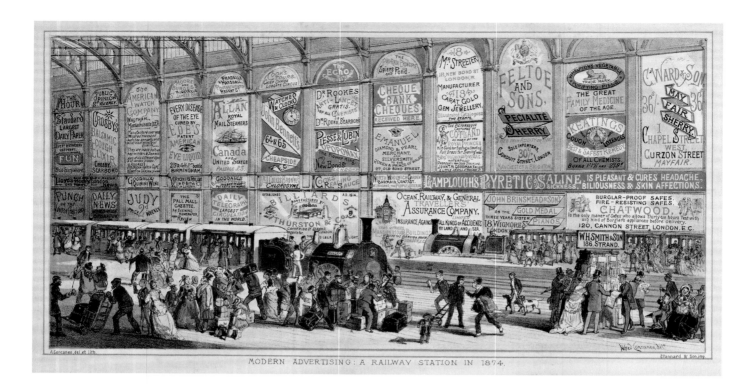

MODERN ADVERTISING: A RAILWAY STATION IN 1874.

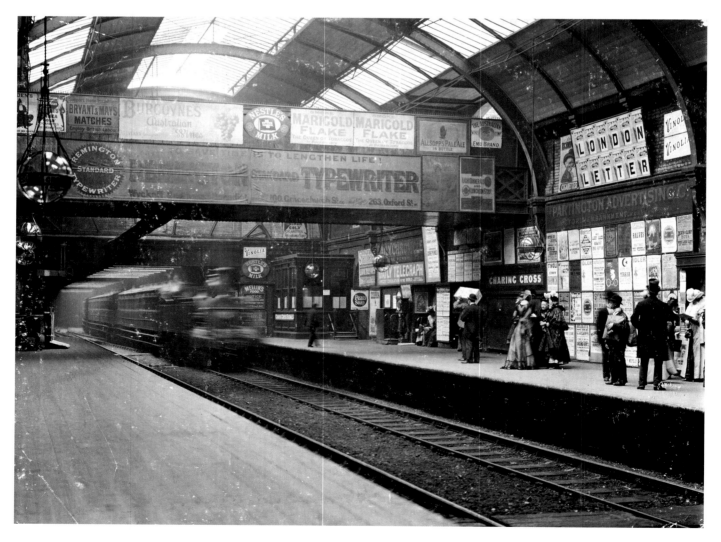

companies' behalf by advertising agents who generally showed little creative skill in their presentation. A well-known print of 1874 (Fig. 68) shows both passengers and trains at an unnamed station dominated by a giant wall of advertising. This may appear to be a caricature, but a similar photograph from the 1890s confirms that stations did indeed look like this in the late Victorian period: an environment of apparent visual chaos (Fig. 69). The picture shows Charing Cross (now Embankment) Station on the District Railway, one of the original steam-worked London underground lines, in 1894. Commercial advertising, all of it simply lettered with no pictorial content, covers every wall and vertical surface in the station. This was supposedly managed on the railway's behalf by the Partington Advertising Company, whose name appears prominently above the poster display on the right. In practice Partington's, which also managed a lot of street billboards in London, seem to have let the commercial advertising on stations run riot. Although this is an underground station, any of the main-line termini in London would have looked very similar, and the presentation does not

reflect at all well on the railway company, as no attempt has been made to control it.

Looking at this photograph, it is easy to sympathize with the writer Rudyard Kipling's complaint about the "besplattering of railway platforms with every piece of information in the world except the name of the station."[2] Kipling was a vocal member of SCAPA, the Society for Checking the Abuses of Public Advertising, an influential pressure group formed in 1893 to campaign against the unregulated spread of outdoor advertising. The railways, inevitably, were one of SCAPA's main targets, although in the end the government legislation that SCAPA successfully got introduced was aimed primarily at controlling advertising in the countryside and the urban streetscape.[3] The railways eventually became adept at self-regulation by cleaning up their own act, particularly once Pick had set an example at the Underground.

As well as selling advertising space to others, individual railways displayed posters promoting their own services. In the 1890s these were still mainly plain letterpress productions with timetables and similar information, but at about this time the first color illustrated posters appeared. The subjects chosen for the new medium were usually seaside resorts and other leisure destinations served by each company's trains. Initially, the quality of the posters was indifferent, with uninspired images and a confusing jumble of text in a mixture of typefaces.

A poster issued by the North Eastern Railway (NER) in 1898 (Fig. 70) is one of the earliest surviving British railway pictorials, and typical of its time. This was not designed by a commercial artist but produced on the railway company's behalf by one of its regular printers, A. Reid & Co. of Newcastle, who clearly had little experience of integrating images and lettering. The layout is cluttered, fussy, and has far too much text to make an effective and arresting poster. Even set against the standard letterpress posters of the time, its impact on the hoardings must have been muted.

Several of the railway companies created their own advertising departments in the early 1900s and started using posters as part of a more proactive and coordinated approach to publicity. Poster sizes became standardized, with railway "bills," as

they were known, normally being printed in quad royal (40 x 50 in.; 101.6 x 127 cm) or double royal format (40 x 25 in.; 101.6 x 63.5 cm). Standard-size wooden hoardings were created both on stations and beyond the companies' property on the streets, which began to meet some of SCAPA's complaints about presentation. Unfortunately a more organized approach to display did little in itself to improve the quality of design work coming from the printers. This is where Frank Pick's new approach to poster commissioning at the Underground made a particular impact that stood out from both commercial advertising and existing railway publicity. While the posters produced by other companies remained conservative and unremarkable, Pick actively sought out new artistic talent and became involved in poster design and production.

When Pick began his railway career as a management trainee with the North Eastern Railway in 1902, the NER was considered one of the more progressive lines in its publicity, though this did not amount to anything radical. It was a good starting point from which to learn, and he progressed rapidly after his subsequent move to the completely different environment of the London Underground in 1906. When he was given responsibility for developing and publicizing UERL services in 1908, Pick immediately began to use posters to develop a much wider promotional strategy than any other railway, including the NER, had even considered. This was to grow with the rapid expansion of the UERL into a transport "combine," running bus, tram, and other underground railway services. Pick's posters, commissioned from an exceptionally wide range of artists, encouraged Londoners to explore everything the city and its countryside had to offer.

Initially, the approach to publicity was driven by tough business circumstances. Pick had joined a company that was less than five years old and shaped by a new American approach to running urban transit. It had none of the conservative baggage of the traditional Victorian railway companies, but it was in serious financial trouble. Having bought and electrified the old District underground railway and completed three brand-new deep-level Tube railways at huge expense, the UERL found itself on the brink of bankruptcy. It had built impressive new engineering assets but

was not attracting enough passengers to give its investors the financial return they expected.

Pick was part of the new management brought in to run the company after the sudden death of its American founder, Charles Tyson Yerkes. Albert Stanley (later Lord Ashfield), brought from the United States to become General Manager in 1907, led the UERL's recovery and gave Pick the vital task of generating revenue through publicity and traffic development. Despite the financial crisis, Stanley developed the "combine" through merger and expansion rather than cutting the budget, as a more cautious manager might have done. By 1914 his UERL had swallowed most of its rivals except the Metropolitan Railway and the council-run tramways. In the 1920s Ashfield's astute business leadership and Pick's progressive management were the twin forces that eventually led to the creation of London Transport in 1933 as a single authority for the capital.

The UERL's acquisition in 1912 of London's main bus operator, the London General Omnibus Company (LGOC), was a particularly significant early step. Pick's posters were a very effective way of promoting the new coordinated bus and train services that gave Londoners weekend access to the city's countryside. Fred Taylor's poster of St. Albans Cathedral branded with the number 84, signifying the bus route (Fig. 71), is a typical example. It was printed in the smaller double crown format so that it could be displayed on the front panels of LGOC buses, but would also have appeared in Underground stations. The first series of posters by Edward McKnight Kauffer, issued in 1915–16, were also bus posters in the same format, but with only an identifying place name and not even a route number. It was the gentlest of inducements to travel.

Pick saw posters not as window dressing but as a prime means of attracting and sustaining ridership for his new services, with a growing emphasis on leisure travel rather than daily commuting. His strategy was to use the art of suggestion rather than the direct approach of product advertisers in order to establish what he called "good will and good understanding between the passengers and the companies."[4] Pick's vision for this, despite his lack of experience, was creative but essentially practical. Applied art and design, properly managed, could make a significant contribution to

7 I

FRED TAYLOR

St. Albans, Bus 84,
1916, commissioned by
UERL, printed by
Johnson, Riddle & Co.,
29 ¹³/₁₆ x 19 ¹³/₁₆ in.
(75.7 x 50.3 cm). Yale
Center for British Art,
Gift of Henry S. Hacker,
Yale College, Class of
1965

cial art. Reviewing a collection of the latest railway posters in 1927, *The Times* was insistent that "there can be no doubt at all that the credit for the earliest consistent issue of good posters of any kind belongs to the Underground."[6]

The context in which poster advertising was seen in stations had also changed, again led by the example of the Underground. As Ivor Fraser, Pick's Publicity Manager at the UERL, told the International Advertising Convention in 1924, "A great deal depends upon the surroundings in which posters are placed. For this reason the Underground pays particular attention to the manner in which all their advertisements are displayed."[7] Presentation was as important as the design of the individual poster.

Back in 1908 none of the new breed of advertising managers working for the established railway companies seems to have understood this. Pick, with no training or background in advertising, realized it straight away and sensed that posters could be at the heart of the Underground's plans to build public confidence in its operations. He approached the poster displays almost as a theatrical presentation in which change, variety, and pace were all part of a carefully planned mix, with a range of appropriate display methods for particular sites in the system. This was quite different to the main-line railways, which all had as many posters on commercial billboards well away from their property as they had in stations and other sites. Pick's priority was his own backyard.

When he took on the UERL's publicity in 1908, Pick's initial poster commissions were a way of giving the system visual coherence as well as enticing passengers. He had inherited a motley collection of stations and sites with little apparent connection because they looked so disparate. The venerable District stations, newly electrified by the UERL, were up to forty years old, mostly located in shallow, open cuttings rather than below ground, and had a similar character to overground railway stations. The company's three deep Tube lines were quite different: brand new and with a standard station design both above and below ground. But the Tubes were much smaller spaces, and the platforms were in deep tunnels requiring elevator access, creating a quite separate and, for many, distinctly claustrophobic feel to the underground environment.

solving quite a major business problem. Posters were the front line in this approach, backed up by other media, such as press advertising.

"A poster is to be seen twice," wrote Pick in 1927, looking back on nearly twenty years of commissioning for the Underground. "Across a road or railway station it must have meaning and form sufficient to excite a wish to see it closer. When seen closer it must have further meaning and subtler form to awake interest, so that seeing it closer appears to have been worthwhile."[5] The NER's Lake District poster, produced thirty years earlier, would certainly have failed Pick's test, but by the 1920s railway posters in general were being hailed as some of the best examples of commer-

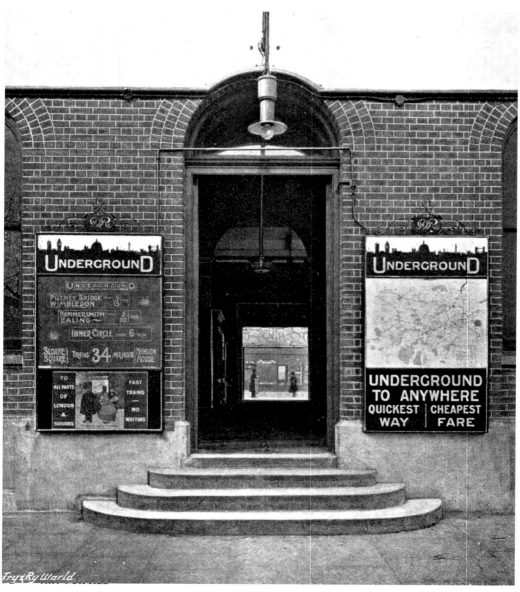

74

The main entrance to the Piccadilly line Tube at Finsbury Park Station after retiling and new lighting for improved poster display, 1927; Underground posters on the right, main-line railway posters on the left. London Transport Museum

Rationalizing the display of posters and information at stations was a priority. It seems that little thought had been given before Pick's appointment to how any poster display on the UERL's new Tubes should work. Early photographs, such as a view of an entrance to the Bakerloo line at Waterloo Station (Fig. 72), show almost random billposting directly on to the tiled station exteriors. Before adopting a new standard, Pick was forced to experiment, but quickly.

Possibly on the advice of the company's passenger agent, Walter Gott, Pick engaged John Hassall to design the UERL's first pictorial poster in 1908.[8] In some respects this was an obvious starting point. Hassall was already the best-known and most successful independent commercial artist in the country. His *No Need to Ask a P'liceman!* for the UERL appeared at the same time as the first version of his equally celebrated seaside poster, *Skegness Is So Bracing*, for the Great Northern Railway. But instead of following main-line railway practice and using the double royal portrait (vertical) format, Pick had Hassall's artwork reproduced in a reduced size and landscape (horizontal) format for display below the new Underground map frames he had chosen for station entrances (Fig. 73).

Although Hassall's design was an inspired choice, this display format was quickly abandoned.

For the very next poster, Pick went back to the double royal size, which became the standard, and poster frames this format were subsequently fitted to every station entrance. The Underground map had to go alongside, where space allowed, initially often as an enamel sign, but later as a quad royal printed poster. "Underground" in new lettering appeared above the map frame and in larger format as a vertical sign that could be seen from a distance. The three key visual features of clear signage, system map, and prominent poster display were thereby combined at every station entrance. It was an early attempt to create a house style that would become recognizable to everyone on the street.

Inside every station, Pick created wall space for both double and quad royal poster displays. In the street-level booking halls and down on the platform areas the UERL's own publicity posters were rigorously separated from commercial advertising. Originally there were no plans for platform advertising by other advertisers, but this lucrative income stream was soon harnessed by Pick in a carefully planned scheme. All of the below-ground poster areas, including corridors, were turned into grids, originally demarcated by paper and later marked out in tile frames as new or modernized stations were developed in the 1920s. This allowed Underground publicity posters, information, and commercial advertising room to breathe and get their discrete messages across.

The pedestrian subway at Finsbury Park Station, modernized in 1927, is a good example (Fig. 74). The layout incorporates tile-bordered frames for Underground posters and exhibitions on the right. On the left are separately framed sites for main-line railway posters, the nearest being for the Southern Railway. The photograph was taken to demonstrate the impressive effect of new concealed indirect floodlighting on a station interior, which added "brilliance without glare" to the poster display.[9]

On platforms the first version of the Underground symbol, a blue bar across a red disc, was introduced in 1908 as a station nameboard. This soon became the company logo and was often incorporated in poster designs. By 1913 Pick had also commissioned a display typeface for the Underground from the calligrapher Edward

75
Night view of the
newly opened South
Wimbledon Station,
designed by Charles
Holden, 1926. London
Transport Museum

76
Tube car interior with
panel posters (*Torchlight
Tattoo* by Joy Williams,
left, and *Wimbledon
Championships* by
Leonard Applebee,
right), displayed on the
glass draft screens, 1939.
London Transport
Museum

Johnston. After 1918 Johnston's simple and highly legible sans-serif lettering was used on most Underground information signage and many of the Underground's posters. In the 1920s Johnston redesigned the logo as a bar and circle device that could incorporate his lettering. On platforms it doubled as a station nameplate and a divider between the poster grids.

These characteristic design features underlined the Underground's distinctive visual environment without making it overwhelmingly corporate. A passenger's journey through a station from entrance to train was marked out in carefully separated posters, information, and non-Underground advertising. Underground posters were given special prominence on station facades, where they would be seen first, and these positions were used for the main batch of posters commissioned each month, their importance emphasized by bronze frames and special lighting. This became more sophisticated in the 1920s, when Pick, promoted to Assistant Managing Director, began working closely with a consultant architect, Charles Holden, on new station designs (Fig. 75).[10]

"Throughout the new stations the posters and their lighting remained almost the sole means of colour decoration," Holden recalled, "the architectural treatment of the stations being carried

out in subdued or neutral colours in order to give the poster its maximum decorative value, a fact which incidentally added to the commercial value of the poster display."[11]

For use on vehicles, smaller-format panel posters were introduced; these were pasted directly on to the glass draft screens just inside the doors of Underground cars (Fig. 76) and on the side panels of buses beside the entrance platform. These panel posters often promoted specific seasonal events and occasions in London, so had to be changed every three or four weeks. At least twice as many panel posters as standard double and quad royals were produced. By the 1920s clear systems of display had been developed for each area of a station, as well as other locations such as vehicles, elevators and escalators, bus garages, and passenger shelters. The billposting arrangements for publicity posters were separate from the commercial advertising, which was set up as a new internal UERL department to replace the long-running agency contracts.

When Christian Barman arrived at London Transport (LT) as Pick's Publicity Officer in 1935, he was particularly struck by the incredible speed and efficiency with which LT carried out poster display changes. Yet despite this almost military precision there was no absolute standardization

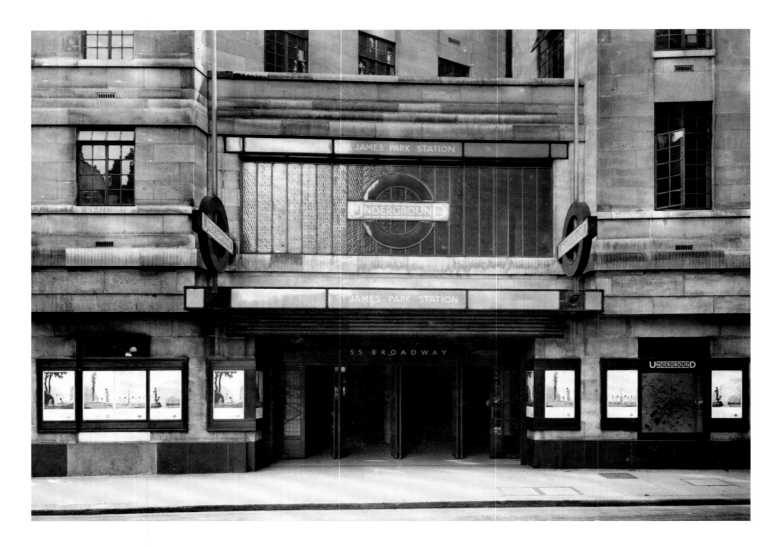

of sizes or procedures, as measuring the posters and trawling through the record photographs reveals.

In fact, there was variation everywhere within the carefully worked-out system. London Underground cars designed for the deep-level Tubes are much smaller than the "surface" stock trains used on the Metropolitan, District, and Circle lines, and therefore panel and screen sizes vary considerably. Posters were probably changed about once a month, but even if this was a general rule it was not universally adhered to. Artists were often commissioned to produce up to four or five posters on a related theme, which could be displayed together as a run in special locations, such as outside the Head Office at St. James's Park (Fig. 77). These were also designed to be suitable for solo display.

Variety and rapid changeover were the essential features of Underground poster display. Experimentation was encouraged, hence Pick's

comment that "there is room in posters for all styles. They are the most eclectic form of art. It is possible to move from literal representation to the wildest impressionism so long as the subject remains understandable to the man in the street."[12] His quality standards were very high, and Pick claimed to reject at least half the artworks he bought before making a final choice, but he was always willing to use work that was not to his own taste if it did its job as a poster.[13] Even when he had become Chief Executive of London Transport, Pick remained closely involved with the poster selection. Beryl Valentine, his former office manager and personal assistant, recalled many years later that these were the only meetings in his fixed bimonthly schedule that always overran.[14]

Pick's eclectic but carefully planned approach to commissioning and displaying publicity posters set standards well above the typical commercial advertising of the 1920s, but the Underground's style was not widely emulated. Government bod-

77
The entrance to St. James's Park Station below the Underground Head Offices at 55 Broadway, London, designed by Charles Holden, showing a series of four posters by André Marty, 1931. London Transport Museum

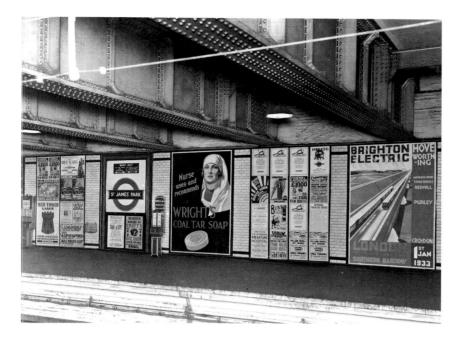

78

Poster grid on the Underground station platform at St. James's Park, 1933, showing the display sizes available for commercial advertising, ranging from double crown up to 12-sheet for the SR *Brighton Electric* poster by Pat Keely on the far right. London Transport Museum

ies such as the Empire Marketing Board and the General Post Office made similar use of posters, as did Shell Oil and the shipping lines, but all were on a much smaller scale.

The interesting contrast was with the main-line railways, which had all used posters extensively before the Underground, and now showed varying enthusiasm in following Pick's approach. This was partly influenced by their changing circumstances, which were very different from the Underground's. In 1923 the government consolidated Britain's huge number of privately run railways (120 of them) into just four big companies. These were the Great Western Railway (GWR); Southern Railway (SR); London, Midland, and Scottish Railway (LMS); and London and North Eastern Railway (LNER). All of them continued to produce publicity posters, but only the LNER, and to a lesser extent the Southern, made strong use of posters as a means to establish a distinctive visual identity for their newly merged companies. The GWR and LMS used other publicity media such as guidebooks and even jigsaw puzzles but did not give commissioned pictorial posters the same prominence. [15]

John Elliot, who was appointed the Southern Railway's first public relations officer in 1925, considered the SR's posters "second rate as to both text and artwork," publicizing little other than a few of the south coast resorts. Knowing nothing about posters, Elliot took immediate advice

from Frank Pick on how to develop a campaign to promote the SR's scheme to electrify its London suburban rail line network, which was the biggest in the world but barely publicized. He commissioned a set of posters with illustrations by the watercolorist Ethelbert White and the slogans "Live in Surrey, Free from Worry" and "Live in Kent and be Content," which appeared all over the Southern's London termini and at every suburban station. To his delight Pick rang him personally to offer his congratulations, and Elliot soon developed the confidence to commission a wide range of SR posters, as well as complementary material, such as a newsletter for first-class commuters. [16]

By the 1930s the Southern's publicity, its new electric trains, and its Modernist architecture and design were reflecting a company that had transformed its image in less than a decade. Some of its strongest designs were those displayed away from its own stations, using large twelve-sheet displays that stood out boldly from smaller commercial advertising. Pat Keely's powerful design promoting the completion of the electrification of the SR line to Brighton in 1933 (Fig. 78) is a good example, shown here on an Underground platform at St. James's Park Station. There is no clash either with the commercial advertising grid alongside or the Underground's own publicity posters, which are grouped together out of the photograph further along the platform.

The continued presence of fairly conservative seaside poster advertising by all four main-line companies was partly a reflection of the available funding. New government legislation in 1921 allowed local resorts to fund their own publicity out of local taxes, and a contribution to costs of posters made by the railways was one obvious way to do this. The LMS, for example, had 101 separate agreements in place in 1928 for joint funding of individual resort posters, usually on a 50/50 basis between the railway and the local authority. [17] This could mean a poster presence in stations and other sites by nearly every resort in each railway's region, but of course there was wide variation in scale. Blackpool, the largest resort on the LMS, always dominated its poster advertising (Fig. 79). The resorts usually wanted to approve the poster designs as part of the agreement, which meant that the great majority ended up as generic views of a promenade or bay

or, increasingly, what Pick scathingly referred to as a "bathing beauty" scene.[18]

The LNER took a much stronger line with the holiday resorts in its territory that it publicized. Even when joint funding agreements were in place, the company insisted that the choice of artist, image, and design lay with the railway as poster commissioner. William Teasdale, its first Advertising Manager, took a forceful, strategic approach to all the company's publicity initiatives, which was continued by his successor, Cecil Dandridge. The LNER favored general publicity for the East Coast, its countryside, and the company's services rather than the promotion of individual resorts. The strong and colorful artistic style of the LNER's favored poster designers tended to support this approach, as Tom Purvis and Frank Newbould in particular could turn out very powerful and memorable designs that evoked holidays and leisure rather than specific locations (Fig. 80).

In complete contrast to the Underground, where the context of the posters was considered so important, the LNER's posters were actively promoted in various ways beyond the hoardings. They were as likely to be seen displayed in special art gallery exhibitions, in promotions in the windows of travel agents and shops, in schools, at major country shows or trade exhibitions, or even overseas in travel promotions in Europe and the United States.[19] This was partly a compensation for the poor display environment of the company's aging stations. Unlike the Underground the LNER had very few new or modern stations in which to display its publicity, so each individual poster had to work harder to be effective. There was always a sense that displays at some grimy Victorian stations were used as a cheap way to brighten up an environment that really needed complete reconstruction.

The LNER produced fewer posters than the Underground, but they were much more widely distributed across a very large network. They were also on display longer. Dandridge often referred to poster changes being carried out for a season, with summer-holiday posters disappearing by October to be replaced by those with "autumn and winter appeal."[20] This presumably meant they could be posted for up to six months, rather than the Underground's one month. Annual resort posters all had to go up

early in the year, in time for holiday bookings, and remain in situ, while posters that were not time-dependent, such as those promoting restaurant car services or goods facilities, were posted in the autumn. There was even a degree of cooperation between the rival companies, with poster exchanges and joint productions. All four companies used the commercial advertising space on the Underground for poster display at special rates, and in 1931 the Underground even provided free exhibition space at Charing Cross Station for a "See Britain by Rail" display of posters from each of them.[21] But at overground stations it was never possible to achieve the seductive effect of the carefully laid-out, highly controlled Underground environment (Fig. 81).

Interest in using posters as publicity seemed to drain away completely from the main-line railways when they were nationalized after World War II. British Railways commissioned very few posters after 1948, although some inspired work went into documentary film production under the new British Transport Films unit. This was presumably seen as a more appropriate use of a limited publicity budget in a difficult period of austerity. Poster campaigns have been few and far between ever since, and the design quality of commissioned work has generally been mediocre.

At London Transport the culture of high-

80

TOM PURVIS

East Coast by LNER,
1929, commissioned
by LNER, printed by
the Haycock Press,
40 ⅛ x 50 ¹⁄₁₆ in.
(101.9 x 127.2 cm). Yale
Center for British Art,
Gift of Henry S. Hacker,
Yale College, Class of
1965

81

Poster displays at
Harrow-on-the-Hill
Station, 1934, showing
LNER resort posters
(center, right of kiosk),
including Frank
Newbould's updating
of John Hassall's
Skegness Is So Bracing.
London Transport
Museum

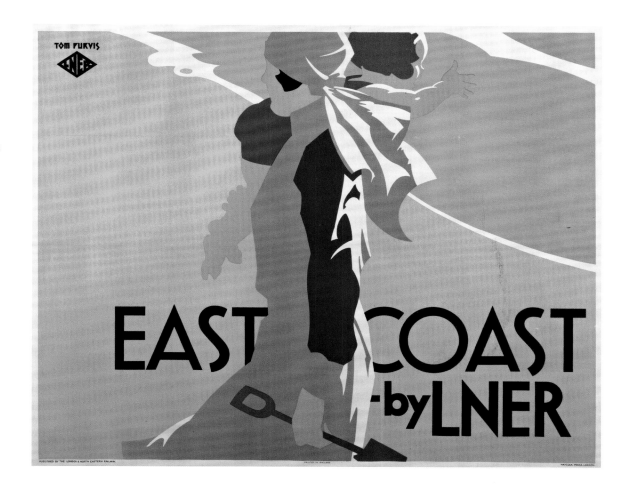

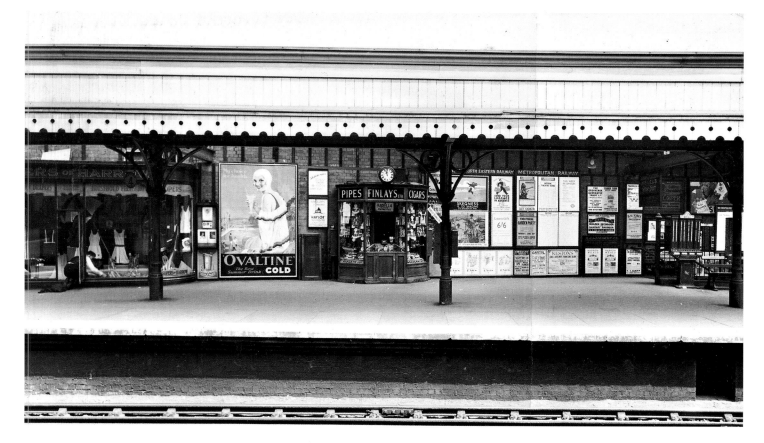

quality design and strong "appearance values" that Pick had championed remained long after his own departure in 1940 and death in 1941. Harold Hutchison, the new Publicity Officer appointed after the war, recognized that a well-presented visual environment, led by pictorial posters, had become a public expectation of London Transport.[22] With passenger numbers at record levels, the posters were no longer required to promote travel, but their role in providing information was more important than ever.

With this in mind, Hutchison made extensive use of pair posters, wherein the main publicity posters were designed in two halves, each a portrait double royal. One half was frequently entirely pictorial, while the other half, given a border design by the same artist to act as a matching frame, was usually given over to text. This gave both the artist/designer and the copywriter more space and freedom to develop an idea (Fig. 82).

Despite Hutchison's enthusiasm for maintaining the poster tradition, the reality was that commissioning on London Transport never returned to prewar levels. The pictorial poster went into decline everywhere from the 1950s on, in both numbers and quality. It was no longer considered a prime medium of publicity and at the same time did not seem to attract young designers with the cutting-edge quality of Kauffer and his contemporaries. London Transport was no longer actively encouraging new talent and tended to play safe in its reduced commissions.

A photograph of Baron's Court Station in 1956 (Fig. 83) offers a late example of a range of commissioned pictorial posters displayed together, with some impressively varied work by both well-established and younger artists. They include Barnett Freedman (Fig. 84), Peter Roberson (Fig. 85), Frederic Henrion, and Hans Unger. Ten years later, this view would not have revealed anything like the same range, and by the 1970s LT was only commissioning three or four pictorial posters a year. Publicity posters were nearly all contracted out to agencies that tended to use photographic images rather than artworks and rarely commissioned work from an individual designer.

Yet the pictorial poster has never entirely disappeared, and the unique display environment of the London Underground has encouraged periodic revivals in poster commissioning, starting

with the Art on the Underground program in the late 1980s. David Booth's *Tate Gallery by Tube*, printed in 1986 (Fig. 86), remains one of the most successful ever produced, still outselling every other Underground poster, even though it has not appeared in stations for over twenty years. These modern posters are no longer intended to promote traffic, but they continue to have value in creating the goodwill of passengers that Pick felt was so important.

Transport for London, London Transport's successor body in the twenty-first century, still commissions posters that provide information or inducement in thoughtful and creative ways. Artworks can effectively improve and enhance the often uncomfortable experience of using a heavily overcrowded transit system by providing an enjoyable and intriguing visual diversion that is not trying to sell the passenger anything. At the

82
Concrete units of lamp standard, nameboard, and poster display designed by Charles Holden for the Underground's surface stations in the 1930s, at East Finchley, 1948. A pair poster by Antony Gilbert, *Enjoy Your London: No. 1, The Museums,* is being pasted up. London Transport Museum

83

The booking hall, Baron's Court Underground Station, 1956: Harry Beck's iconic Underground map is on the left; also seen are posters by Hans Unger, Barnett Freedman, Frederic Henrion, and Peter Roberson. London Transport Museum

84

BARNETT FREEDMAN

Amid the Groves, under the Shadowy Hills, 1956, commissioned by LT, printed by the Baynard Press, 40 x 25 in. (101.6 x 63.5 cm). Yale Center for British Art, Gift of Henry S. Hacker, Yale College, Class of 1965

85

PETER ROBERSON

London's Museums and Galleries, 1956, commissioned by LT, printed by the Baynard Press, 40 1/16 x 25 in. (101.8 x 63.5 cm). Yale Center for British Art, Gift of Henry S. Hacker, Yale College, Class of 1965

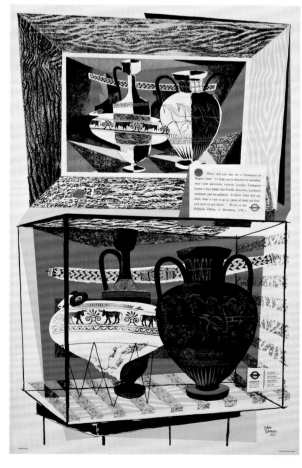

86
DAVID BOOTH,
MALCOLM FOWLER,
AND NANCY FOWLER /
THE FINE WHITE LINE
Tate Gallery by Tube,
1986, commissioned
by LT, 30 x 20 in.
(76.2 x 50.8 cm).
London Transport
Museum

THE TATE GALLERY
by Tube

One of a series of new paintings commissioned by London Underground

same time, the London Underground remains the most attractive and lucrative public environment in the country for advertisers. Pick's display system, with the careful visual and physical separation of Underground information and publicity sites from commercial advertising, is still maintained, and it remains distinctively different to any other metro or urban transport system in the world. Remarkably, a powerful poster continuity has now been maintained in this concentrated public environment for more than a century, surely a unique achievement.

1. Frank Pick, "Appearance Values," *Proceedings of London Transport 3rd Annual Staff Conference,* (1938): 35–47, London Transport Museum Library.

2. Unreferenced quotation in E .S. Turner, *The Shocking History of Advertising* (Harmondsworth, Eng,: Penguin Books, 1952), 115.

3. For a concise summary of SCAPA's activities and impact see Mark Haworth-Booth, *E McKnight Kauffer: A Designer and His Public* (London: Gordon Fraser 1979), 17–19.

4. Frank Pick, "Underground Posters," handwritten notes for an article, 1927, Pick archive, B6, Box 4, London Transport Museum Library.

5. Pick, "Underground Posters."

6. "Art in Posters, New Designs for the Railways," *The Times,* February 22, 1927.

7. *Railway Gazette,* 41 (July 18, 1924): 96.

8. Gott had commissioned the UERL's original publicity material for the new Tubes in 1906–7, such as postcards, and had also worked for the Great Northern Railway. See Catherine Flood, "Pictorial Posters in Britain at the Turn of the Twentieth Century," in David Bownes and Oliver Green, eds., *London Transport Posters: A Century of Art and Design* (Aldershot, Eng.: Lund Humphries in association with the London Transport Museum, 2008): 19–27.

9. The photograph of Finsbury Park is reproduced as a demonstration of the Underground's latest station lighting arrangements in J. P. Thomas, *Handling London's Underground Traffic* (London: London Underground, 1928), 181. Thomas was the Underground's Operating Manager. His book describes every aspect of the organization in considerable detail, and was originally intended as a staff manual. Frank Pick decided it should be published to demonstrate the UERL's innovation and progressive management practice. In his foreword he describes the book as "a groundwork for further advancement," which echoes his belief in continuous improvement as a business philosophy.

10. The collaboration of Pick and Holden produced the classic architectural house style of the London Underground that was refined between 1925 and the early 1930s in the new stations of the Northern and Piccadilly line extensions, the reconstruction of Piccadilly Circus, and the new Underground headquarters at St. James's Park. It is well described in two complementary recent publications: Eitan Karol, *Charles Holden, Architect* (Donington, Eng.: Shaun Tyas, 2007), 259–383; and David Lawrence, *Bright Underground Spaces: The Railway Stations of Charles Holden* (Harrow Weald, Eng.: Capital Transport, 2008).

11. Charles Holden, *Architects' Journal* 96 (March 26, 1942): 233.

12. Pick, "Underground Posters."

13. This was not his stated policy, but it can be inferred from some of the choices made, particularly in the 1930s. Pick found Surrealism completely baffling as an art movement, for example, and was highly critical of favored poster artists like Kauffer when they experimented with it, but he continued to use Kauffer at London Transport. He could also be persuaded by Christian Barman, after his appointment as LT Publicity Officer, to use Modernist designers like László Moholy-Nagy, although Pick did not really like his work. It is sometimes difficult to decide whether Pick was encouraging variety or simply making idiosyncratic and inconsistent decisions!

14. Conversation of Lady Valentine, Oliver Green, and Nicholas Long at the London Transport Museum, September 15, 1988, about her recollections of working for Frank Pick.

15. Beverley Cole and Richard Durack, *Railway Posters, 1923–1947* (London: Laurence King 1992).

16. Sir John Elliot, *On and Off the Rails* (London: George Allen & Unwin, 1982): 20–26.

17. Stephen V. Ward, *Selling Places: The Marketing and Promotion of Towns and Cities, 1850–2000* (London: Routledge, 1998): 42–50.

18. Frank Pick, "The Meaning of Posters," 1922, Pick archive, B11, London Transport Museum Library.

19. These promotions are regularly described in the *London & North Eastern Railway Magazine,* published monthly from 1923 on, primarily for staff. In 1928 Cecil Dandridge, the LNER's Advertising Manager, began contributing a regular "Advertising Notes" page, which gives a good indication of the range of promotional sites used by the company.

20. See, for example, *London & North Eastern Railway Magazine* 22, no. 11 (November 1932): 590.

21. *London & North Eastern Railway Magazine* 21, no. 8 (August 1931): 392.

22. Harold F. Hutchison, "The Policy Behind Our Posters," *London Transport Magazine,* 1, no. 8 (1947).

CIVIC IDENTITY, PROMOTION, AND MASS TRANSIT:
A TALE OF THREE CITIES

NEIL HARRIS

The arresting marriage between mass transit and publicity so skillfully midwived by Frank Pick was certainly an exceptional episode in the history of twentieth-century commercial art (Fig. 87). Few other modern patrons can claim to have inspired (or so successfully sustained) a campaign of such promotional brilliance, one that has now outlived his personal supervision by more than seventy years.

While Frank Pick's gifts and energies were indeed extraordinary and his philosophy of design comprehensive, his strategy lacked neither precedents nor contemporary parallels. In an era when great cities were overturning old notions of scale and ambition, urban leaders and their technical advisers confronted the task of controlling, coordinating, and unifying their diverse stakeholders.[1] "We can never again get back to the unconscious design which sprang from natural and orderly growth," Pick observed in the 1920s.[2] In many instances these new leaders included businessmen who aligned the fortunes of their companies and their quest for profits with the expansion of marketing territories. Self-interest and civic ambition moved along parallel tracks. In Pick's case, popularizing mass transit meant identifying its progress with that of the city that hosted it. There were other great branding efforts in the twentieth century, and other corporate patrons of major

influence. Names like AEG (the German electrical combine served by the architect and designer Peter Behrens), IBM, Container Corporation of America, Shell Oil, Michelin spring to mind. But none so clearly serviced a single geographical entity, encouraged a civic identity, or relied upon so many artistic contributors.[3]

The international flavor of this effort is evidenced by the early history of the London Underground.[4] American personnel, American experience, and American capital were significant shapers of British policy. It is doubtful that a unified London Underground could have emerged without the involvement of the Chicago traction magnate Charles Tyson Yerkes. Yerkes, notorious in several American cities for his aggressive, corrupt, and ingenious adventures in traction consolidation, set up the Underground Electric Railways of London (UERL) in 1902 as a holding company to electrify the existing underground railways. He had an extraordinary capacity to raise investment capital. He also acquired an existing tram system and built three new deep-tunnel Tube lines. Yerkes died in New York in 1905, while his London railways were still under construction.[5]

The man who eventually oversaw London Transit as a whole, Albert Stanley, later Lord Ashfield, was brought back to the Britain of his birth in 1907, after an American upbringing and experi-

ence running transit systems in New Jersey and Detroit. Stanley retained leadership of the UERL and its successors, culminating in the 1933 creation of London Transport. Stanley personified the reputation Americans enjoyed for innovative methods of merchandising and publicity. British business leaders understood the advertising energies unleashed by American marketing and branding; Stanley's great success, and his partnership with Frank Pick, validated the emphasis on promotion and expansion.[6] Giving Pick responsibility for UERL publicity in 1908 was risky but inspired, leading in time to a substantial growth of ridership and financial progress.

But by the 1930s Pick and his artist allies had moved far beyond the original goals to create something that transcended mere issues of profit. Using the cause of improved design and effective communication as a mandate, Pick's transformations of publicity, service, functionality, and appearance led to a virtual identification of London Transport with London itself. London Transport became not simply a system of mass transit but a signifier of the city's very identity, embedding this single enterprise deep in the consciousness of residents and visitors. Tourist icon and mundane convenience both, the organization managed to connect Londoners spiritually as well as physically. Many contemporaries, particularly in the period between the two world wars, recognized something distinctive, perhaps unique, about the London Underground and commented upon its impact, while making sporadic efforts to imitate it.

Pick's broad program aimed to nurture a civic consciousness whose immediate ancestry lay in the Victorian and Edwardian eras, though its roots were older. The two largest cities in the English-speaking world after London, New York and Chicago, also witnessed efforts to harness graphic art to the cause of transportation. Their serious aims merit consideration, and their tactics will occupy much of this essay. But in the end their performance never rivaled that of London, making the achievement of London Transport even more impressive—an emulated but still unequaled campaign to mate mass transit with urban identity.

By 1906, the year Pick began in London, a movement to promote what might be called place loyalty was under way in Britain and the United States.[7] Sudden growth, new technologies, diverse populations, reshaped work patterns, and a burgeoning economy of leisure and consumption had combined to raise questions about the management and future development of urban centers. The tensions and opportunities were felt most keenly in large cities. While not confined to them exclusively, they hosted the most dramatic efforts to market, internally and externally, their special virtues and attractions.

The modern era of urban marketing in the Anglo-American world was probably launched by the Great Exhibition of 1851, housed in the Crystal Palace, erected in London's Hyde Park. The range of issues encompassed by this event was immense: commerce, pageantry, tourism, crowd control, public behavior, racism, advertising, commodity display, nationalism, colonialism, public transport, hospitality profits, design reform, museum creation. All combined to make it enormously influential. It would be recalled, studied, and above all imitated in the decades that followed, as dozens of cities across the world sought to capture the prestige and the profits that flowed from such expositions.[8]

These fairs, like the modern Olympic Games, were moments in which to test as well as to expand urban capacities. Cities had to accommodate the physical needs of large numbers of visitors; move them to and from the exposition grounds; house, feed, and entertain them; define what would later be called "residuals" in the nearby parks, neighborhoods, and institutions; and above all refine the instruments of publicity—mainly textual and graphic in the years before World War I—that would entice so many millions to make the trip. The expositions were linked tightly to expanded literacy, cheap printing, the multiplication of magazines and newspapers, improved railroad and urban transit, and techniques of visual reproduction that could convey their scale and novelty in powerful, if ephemeral, representations. Maps, guidebooks, posters, photographs, chromolithographed views, calendars, broadsides, postcards, focused attention not only on the fairs themselves but on their host cities and on the routes connecting them to the larger world. Such printed materials were created not only by the exposition authorities, but also by

*Robert Treat directing
landing of founders
of Newark, 250th
Anniversary Celebration,
Newark, New Jersey,
May–October 1916
from The Newark Posters
Catalogue, (Newark,
N.J.: The Essex Press,
1915). Courtesy of the
Yale University Library*

organizations and industries hoping to profit from the event—railroad companies and manufacturers among them. The graphics drew on colorful traditions that owed something to theatrical and industrial publicity, as well as established civic personifications, generally classically attired women in static poses welcoming the world and brandishing emblems of local achievement.

Given their heavily private financing American world's fairs, more particularly, were moments for cities to identify a leadership class, advertise opportunities, mobilize citizen loyalty, and, occasionally, actually begin a broader planning process. Hosting a major exposition could emerge as a solution to problems created by rapid growth, as well as an instrument to encourage still more development, investment, and tourism.

But expositions, however influential, lasted only for months. Afterward, their immense publicity campaigns were of interest mainly to nostalgists and collectors. And they were only one of many devices nineteenth- and twentieth-century cities relied upon to inspire allegiance and investment, create distinctive identities for themselves, and encourage feelings of civic commitment. By the early twentieth century cities like London and New York were opening museums built around their own histories. Carnivals and pageants were mounted to highlight local traditions. And in the wake of the fairs many municipalities, including New York, Chicago, Philadelphia, and Boston, established commissions on public art and beautification, convinced that physical enhancements would stimulate more than art appreciation, improving public behavior and nurturing virtue and mutual respect among citizens.[9] "To make our city loved, we must make our city lovely," declared one Chicago planner in the early twentieth century.[10]

During the late nineteenth and early twentieth centuries, cities were concerned to establish identifying symbols as well as to improve urban landscapes. This can be seen as part of a larger movement, involving organizations of almost every kind, to promote and project values as well as to sell products. It happened in business with an explosion of brand names and trademarks; it happened in academe with ceremonies, regalia, songs of loyalty, and official colors.[11] Cities and civic groups invented public rituals, flags, seals,

slogans, and signs. It was the breadth of the pursuit that distinguished the urban enterprise, rather than any particular form or medium.[12] A city flag, declared some supporters, was not simply a decorative banner but a "page of history," a "distinctive advance in the cultivation of city pride."[13]

Promotion of place by either public authorities or private interests inevitably sought out graphic forms. One suggestive campaign occurred in Newark, New Jersey, celebrating its 250th anniversary in 1916. As part of its planning, the authorities sponsored a poster competition, whose prizes attracted some 230 entries.[14] Nine thousand visited the two-week exhibition, and a pamphlet described (and depicted) many of the designs. In the end the judges chose as winner Adolph Treidler's dramatic portrait of Robert Treat, dressed in Puritan costume, founding the city in 1666 (Fig. 88). The competition raised questions about the best way to combine historical themes, celebratory intentions, and contemporary civic references—all part of any municipal booster's vocabulary. It also presented an occasion for critics to develop positions on broader design principles in poster art, a discussion much

amplified by the flood of war posters just starting to attract American attention.[15]

Commentators rated the variety of the entries higher than their quality. Treidler's design, an unimpressed *New York Times* pointed out, presumed "knowledge of Newark's history on the part of the public to which it is addressed." For this reason it added text identifying Treat and his central role.[16] And Newark's own name was weakly placed. "These defects are poster defects pure and simple."

Such clumsiness may have owed something to the scarcity of American posters dealing with local history and identity. This absence may appear surprising, given the growth of urban tourism in early twentieth-century America, a well-developed European tradition of travel posters, the highly competitive state of municipal economics, and the increasing variety of graphic advertising during these years.[17] But for whatever reasons—the dominance of the billboard, the importance of newspaper promotions, the popularity of magazine and brochure publicity—posters were not yet a favorite instrument of place advertising.[18]

This was about to change. Several American railroads had begun, tentatively, in the early twentieth century to promote destination points and regions through which they regularly traveled, especially the Southern Pacific and the Atcheson, Topeka, and Santa Fe.[19] The Santa Fe's advertising manager, William H. Simpson, who admired contemporary French and German design, supervised advertising campaigns that made use of both large billboards (composed of twenty-four-sheet prints) and smaller pieces. Santa Fe artists, such as Louis Treviso and Oscar Bryn, extolled the wonders of California and Western scenery, along with an emphasis on traditional Navajo culture. But according to one account, Simpson treated the art as one might treat oil paintings, placing the originals in ticket-office windows rather than reproducing them as one-sheet posters. They were seen, in full color at least, by a relatively small number of people; the vast majority of consumers formed their visual impressions of the West from other forms of publicity.[20]

By the early 1920s, however, American experience with regional promotion, place advertising, and poster art more generally was becoming both more sophisticated and more widespread. The

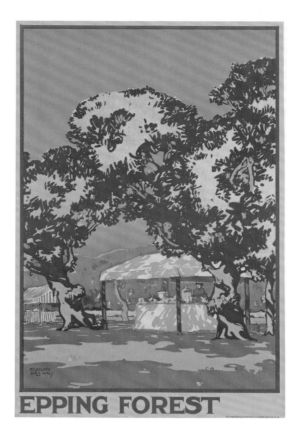

EPPING FOREST

89

F. GREGORY BROWN
Epping Forest, 1916, commissioned by UERL, printed by the Dangerfield Printing Co., 29⅞ x 19⅝ in. (75.9 x 49.8 cm). Yale Center for British Art, Promised gift of Henry S. Hacker, Yale College, Class of 1965

London Underground campaigns, as well as British railway posters, were capturing attention.[21] Starting about 1920 *The Poster*, the major journal for America's outdoor advertising industry, began to comment regularly on European poster exhibitions in the United States. When the Chicago Public Library exhibited a set of French railway posters, the magazine reproduced four of them and wondered aloud, "Why can't Americans have something like this?"[22] Let's "get more of this romance and beauty and magic into our posters," commented Eleanor Jewett, the *Chicago Tribune* art critic.[23] The University of Chicago became the venue for a series of European poster shows in the early 1920s.

There remained skeptics. That same year, while admiring a display of Swiss railway posters, an American reviewer argued that they would not be effective with the ordinary American. "Nature is not enough to lure the American tourist," Frank Arnold wrote. "He wants a home-and-mother element." Like their French counterparts Swiss posters belonged to a "more advanced civilization, and are too sophisticated, take too much for granted. Americans . . . like to see themselves in imagination walking at Palm Beach or loung-

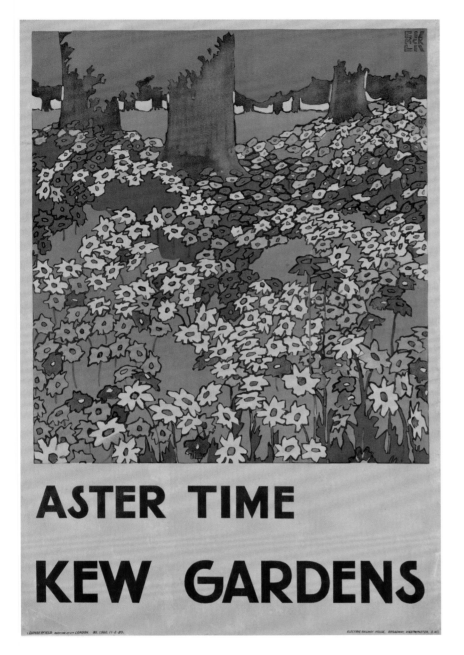

ASTER TIME

KEW GARDENS

90

EDWARD MCKNIGHT KAUFFER

Aster Time: Kew Gardens, 1920, commissioned by UERL, printed by the Dangerfield Printing Co., 29 15/16 x 19 13/16 in. (76 x 50.3 cm). Yale Center for British Art, Gift of Henry S. Hacker, Yale College, Class of 1965

ing in bathing suits."[24] Canadian Pacific posters seemed more successful, focused on passengers in a dining car gazing at the Rockies. The Rockies by themselves were not persuasive.

But even skeptics respected the British posters. They were less aggressive than their German counterparts, declared *The Poster;* they didn't make their mark by assault and battery.[25] Reviewing a Chicago exhibition of Underground posters in 1922, Edwin Bangs reported he was "chiefly impressed by their merit as works of art. They were such paintings as might be hung in an art gallery and there win the approval of exacting critics." Singling out Edward McKnight Kauffer

and Gregory Brown (Fig. 89) for attention, Bangs also reported "that it is as difficult to get a poster displayed on the boards of the Underground as it is to get a canvas hung in the Royal Academy." While standards were different, they were "no less rigorous in the case of the Combine."[26]

Another *Poster* critic declared London to be "mad over advertising." The Tube, wrote Robert Allerton Parker, was filled with posters, and buses were covered with them. It was one of the "peculiarities" of British advertising to place posters in Underground stations to entice riders to visit suburban and country spots. It was as though New York's Interborough Rapid Transit (the subway) "should display posters enticing us to Van Cortlandt Park or the Bronx Zoo by subway, or entice us to join the merry throng on the Forty-Second Street shuttle," he marveled.[27] Parker's astonishment that mass transit could be made the site of destination marketing was a commentary on the New York subways as well as on the strange ways of foreign advertisers. But he took pride in the fact that an American, Kauffer, had become the master of British poster art (Fig. 90).

Parker was not alone in simultaneously admiring and raising questions about the Underground campaign. Still another *Poster* contributor, commenting on an Underground poster show at Selfridge's department store, praised the artists Gregory Brown and Emilio. L. Tafani, and E. A. Cox's series, *London Characters.* But he wondered why a company would court more patronage with expensive, full-color posters, "seeing that notoriously the Combine's trains and buses are already, literally crowded to excess."[28] The answers he proposed to this puzzle were, in fact, fairly persuasive. First, to earn goodwill. Indeed, this was Pick's most frequently stated justification for the campaign. Second, to generate additional revenue by stimulating other advertisers to use the Underground platforms for their own displays. And finally, to gain public support for legislative proposals of interest to the company—notably, of course, the raising of fares.

Apparently aware of the rising use of place-oriented posters, and possibly in response to some ongoing exhibitions, a group of Chicagoans announced their intention to create a poster campaign to advertise their own city. Sponsored by the notorious mayor William Hale Thompson

(political ally of the equally notorious Al Capone), the project enlisted the local Advertising Club to make known "the name and the greatness of Chicago throughout the country."[29] While little apparently came of this proposal, Chicago did host several other poster campaigns during the 1920s. Some were purely prescriptive in character and had nothing to do with city branding or reputation, the goals of Mayor Thompson. Thus one local printing establishment, the Mather Company, created a series of "Constructive Organization Posters," emphasizing the values of teamwork, amiability, and hard work (Fig. 91).[30] They were marketed to employers who hoped the posters might motivate their labor force in the office and on the factory floor. In six years, between 1923 and 1929, the Mather Company produced more than 350 different posters, organizing them under therapeutic categories that would attract clients seeking to improve productivity. The messages were short and the images striking. How well they accomplished their purpose is unclear, but they did reveal lingering faith in the power of posters to affect behavior. In this respect they mirrored a range of London Underground posters that were aimed at riders, employees, and sometimes the public in general. Many of these consisted entirely of lettering, but a number featured colorful images (Fig. 92).

No evidence suggests that George Mather was influenced by London's Underground, but another Chicago project most certainly was. And this was the effort of Chicago's major transport system. The elevated city rail lines (the "El," or "L," as they were called), two interurban (and interstate) electric railroads, and a suburban railroad were all controlled by the British-born traction magnate and Midwestern electricity czar Samuel Insull.[31] In the mid-1920s the "L" lines were consolidated under the name Chicago Rapid Transit Company. Insull, perhaps the major utilities magnate of the 1920s, and his chief lieutenant, Britton I. Budd, needed to increase ridership on their various lines, particularly the recently acquired and renamed Chicago South Shore and South Bend Railroad, which ran south and east from the city to small cities and rural areas ripe for development. Insull's holding company, the Midland Electric Corporation, decided on a massive reinvestment program. To accompany this they devised a

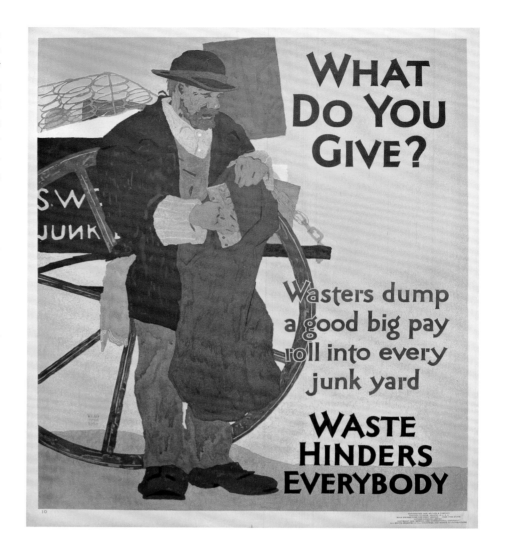

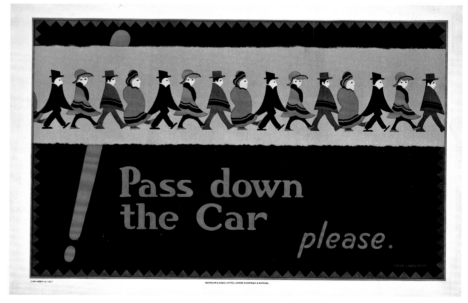

91

WILLARD FREDERIC ELMES

What Do You Give?, 1929, printed by Mather & Co., Constructive Organization Poster, 36 x 43 in. (91.4 x 109.2 cm). Poster Plus, Chicago

92

FREDA LINGSTROM

Pass Down the Car, Please!, 1923, commissioned by UERL, printed by Waterlow & Sons, 12 ½ x 17 in. (31.8 x 43.2 cm). London Transport Museum

93

ERVINE METZL

Field Museum by the Elevated Lines, printed by Illinois Litho. Co., Chicago, 20 x 30 in. (50.8 x 76.2 cm). Poster Plus, Chicago

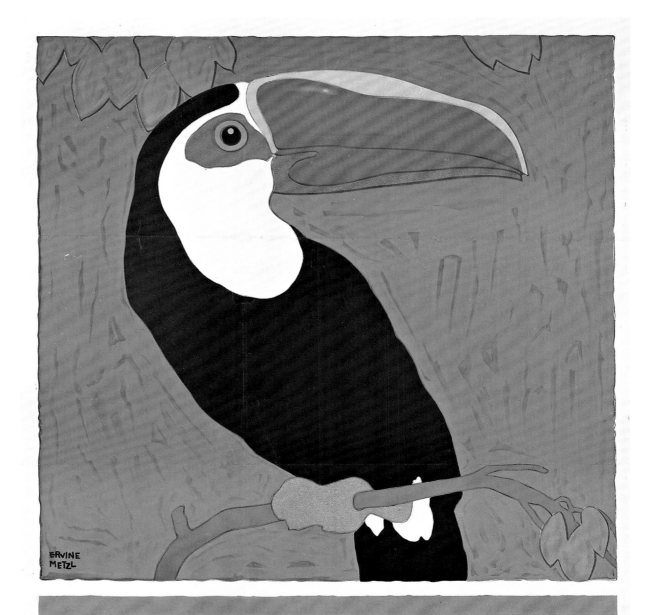

series of extensive promotional campaigns, begin-
ning in 1922 with the Chicago Elevated lines and
the Chicago and North Shore Railroad. The South
Shore line soon followed. Budd is credited with
specific responsibility for the operation.[32]

It was not surprising that Chicagoans were
aware of Pick's work. Pick, and his chief, Albert
Stanley, were frequent visitors to the United
States, to New York and Chicago particularly. In
1926 Pick noted the special challenges of a city
like Chicago, with three million people "of which
less than a quarter are native born of native par-
ents, so that it is, in effect, peopled by strangers
without common habits or common traditions,
and presents a social problem of amazing intricacy
and instability."[33] Chicagoans might have pointed
out that the core of the city's business life was
located in the Loop, a central commercial district
defined by the circular loop of the Elevated rail
line that served it and the source of some of the
city's "common habits" and "common traditions."
Transport, in essence, helped shape daily life and
define a distinctive identity.

By the early 1920s, with more than a dozen
years of Pick's posters in place, London Under-
ground's publicity efforts had created an inter-
national audience, aided by a set of American
exhibitions and a wealth of favorable critical com-
mentary. Insull and Budd drew their own con-
clusions about the value of graphic design, and
incorporated this kind of program in their larger
revitalization plans.

Just as impressed were leaders of Chicago cul-
tural institutions, led by the Civic Opera (much
subsidized by Insull) and the Field Museum, who
were determined to promote their own interests
through a poster presence on the Elevated lines
(Fig. 93). It is not absolutely clear just who paid
for what. The opera posters, for example, were
commissioned by the Civic Opera, but the Field,
according to one reporter, received the promo-
tions free of charge. The result was a concen-
trated graphic effort unlike what any American
city had yet experienced.

The precise numbers remain unclear, for not
all the posters have survived, but in just six or
seven years, starting in 1922, close to two hun-
dred posters appeared. They featured attractions
in Chicago itself or in areas just to the city's north
and south. The posters on the interurban rail-

"BOUL MICH"
by the ELEVATED LINES

European than Midwestern in design and coloring; they suggest the railway posters advertising the chateau country of Touraine and those of London's Underground."[34] Edwin Bangs in *The Poster* declared the American designs to be "directly inspired by the British," some of them "so much alike as to be obvious imitations." As a group, Bangs went on, "the Chicago series represented a happy medium between impressionism and realism, with a tendency toward realistic representation, even as the Underground posters showed an inclination toward the impressionistic side." The more "impressionistic" designs, he observed, produced a far more favorable response than the "realistic" posters.[35] But the subject matter was appropriate for both cities. The head of the "L" advertising department said he wanted each of Chicago's "recreational advantages" put before the public so vividly that the passerby "won't be satisfied until he has visited it."[36]

Some of this advertising proved immediately effective. The opera reduced its deficit by thousands of dollars in the 1922–23 season, primarily, it was argued, through colorful posters, while the Field Museum linked dramatic growth in exhibition attendance directly to specific one-sheet posters and advertising cards featuring, severally, a toucan, a scarlet ibis, a Chinese pagoda, and a seahorse, among others. Attendance increased by 110,000 in the four months following the posters' appearance.[37]

The artists, for the most part, were local and, so far as can be determined, entirely male. While one or two, like Leslie Ragan, who later worked extensively for the New York Central Railroad, went on to distinguished illustrating careers, others remain obscure to this day. Obscurity and distinction were not mutually exclusive. Oscar Rabe Hanson, with a downtown studio to his credit, won several national prizes and had his posters featured in British publicity journals (Fig. 95). But Hanson died quite young in an accident and most of the other work was fairly conservative, reflecting the influence of German and Austrian poster makers of an earlier generation, just as had the Mather Posters, only more so. (Willard Frederic Elmes was the only Mather artist also to design for this campaign.) The odd juxtapositions, the abstractions, the distortions, the witty exaggerations, the concise, symbolic details that

94

ROCCO NAVIGATO

"Boul Mich" by the Elevated Line, 1924, printed by National Printing & Engraving Co., 21 × 40 in. (53.3 × 101.6 cm). Poster Plus, Chicago

95

OSCAR RABE HANSON

25 Miles of Beach Via South Shore Line, 1925, printed by National Printing & Engraving Co., 24 × 36 in. (61 × 91.4 cm). Poster Plus, Chicago

ways, like those of the London Underground, highlighted attractive recreational scenes, ranging from the sand dunes of nearby Indiana to the fishing resources of neighboring Wisconsin, and in some cases paid direct homage to the appeal of suburban home ownership.

The "L" posters in Chicago, on the other hand, concentrated on major cultural and civic institutions. Financed and commissioned (for the most part) by the transit system, they focused on the cityscape, the tall buildings along Michigan Avenue (Chicago's grand commercial boulevard) by day or night (Fig. 94), the parks, and occasionally on an event. Dana Hubbard, in *Printers' Ink Monthly*, noted in late 1922 that the posters seemed "more

characterized the work of contemporaneous Europeans—from Lucian Bernhard in Berlin to Achille-Lucien Mauzan in Italy to Alexander Rodchenko in the USSR to Kauffer and Charles Paine and Clive Gardiner and Freda Beard in London— were conspicuously absent.

Unlike so many American railroad posters, those for the "L" got wide publicity, shown at stations and on platforms throughout the Chicago transit and suburban systems. They attracted occasional attention in the press, invariably approving. But considering the scope and the novelty of the operation, commentary was fairly sparse. There was no attempt, as in London, to unify the images in any way by attaching some logo or motto. The lettering was widely various, and emphasis lay on uplift rather than consumption. In contrast to the London campaign, shopping, department stores, theaters, and movie going were never featured. Within performance culture only the opera enjoyed some notice. Humor was notably rare and there was little evidence of wit. Certainly more than a few posters were dramatic in their lighting and use of color and suggested the presence of talent. Hanson's and Ervine Metzl's pieces were especially striking. But most artists acknowledged few of the dramatic changes taking place in the graphic arts in the late 1920s and demonstrated little direct artistic awareness of the London examples. They were shown, moreover, in the shadow of Chicago's dominant outdoor advertising, here, as in the rest of the United States, featuring large billboards selling automobiles, gasoline, and other national brands.

Nonetheless, in focusing upon the city's built and natural landscape and linking awareness of its appeal to a mass-transit system, Insull, Budd, and their artists suggested a direction for the future of posters. They even played a part in Chicago's early efforts to market itself as a major tourist center and, especially, a summer vacation spot. This last theme was to be developed still further in the promotion surrounding the 1933–34 Chicago "Century of Progress" World's Fair (Fig. 96). Five years before the exposition opened, in 1928, the Art Institute of Chicago and fair authorities jointly hosted a poster competition with $4,000 in prizes. Although the results were broadly condemned as mediocre, five hundred entries from throughout the world poured in.[38]

The local press did not fully embrace the possibilities of the mass-transit publicity campaign, while the Great Depression, as well as changes in management and ownership, made it difficult to keep the poster program alive. No archive apparently exists, no repository was created for their protection, and quite a few have not survived. In this it resembles the fate of the federal government's WPA poster efforts just a few years later, forgotten and then rediscovered through some happy accidents. Chicago's experience, then,

96

WEIMER PURSELL

Chicago World's Fair: A Century of Progress, 1933, printed by Neely Printing Co., 28 x 42 in. (71.1 x 106.7 cm). Poster Plus, Chicago

despite bringing together civic consciousness, transit promotion, and artistic design, emphasized just how far the city—and other American cities—lagged behind London in a whole variety of ways.

Like Chicago, New York made a variety of efforts to promote its identity during the years before and after World War I. Tourism was growing, and the newly consolidated city, today's five boroughs, faced huge problems of coordination. New York's transit system, far better established and much more extensive than Chicago's, more heavily used than London's, also experienced considerable growth in the 1920s. Like Chicago, New York maintained an extensive system of elevated railroads, but unlike Chicago it enjoyed a major and increasingly crucial subway system. The coming of the subways was viewed by some early enthusiasts as a semi-magical solution to the problem of Manhattan's congestion, and in its first few years aroused utopian hopes. Subways, writes Michael Brooks, once resembled something like a "civic miracle," promising a better future for New Yorkers as they discovered a new metropolis being built around them. Church bells, steam whistles, exultant cartoons, and sheet music greeted the subway's opening in the fall of 1904.[39]

With a far shorter history than London's underground railways (whose first line opened in 1863), the New York underground rail system, Interborough Rapid Transit, began as an integrated whole, very different than the competitive and somewhat Balkanized pattern that operated for so many decades in London. There were efforts to provide continuity if not uniformity of design in the IRT's stations and subway entries (London was trying to do the same at this point), and to distinguish its signage graphically from the chaos of placards and signboards that marked the streets above it.[40] The designing architect, C. Grant LaFarge (of Heins & LaFarge, an important architectural firm), and the chief engineer, William Barclay Parsons, envisioned a highly efficient and sometimes elegant underground world with spacious platforms, Romanesque tile vaults, terra cotta, faience, mosaics, even occasional stained glass serving a wide social spectrum of customers.[41] If the two differed, as engineers and architects often did, about how to mediate issues of ornamentation and functionality, they nonetheless conceived together a system meant to reinforce pride in the city's capacity to solve its extraordinary congestion problem.

But almost from the start the subway system faced problems, some technical, others political. Riders multiplied so rapidly that congestion became overwhelming almost immediately. Determined to pay dividends to IRT shareholders, management turned to advertising as a source of revenue, and quickly installed vending machines for candy and gum.[42] This attracted virulent criticism and swift litigation. Newspaper editorials attacked the system's private ownership, and retention of the 5-cent fare became a rallying cry in the popular press of William Randolph Hearst. The elegant kiosks erected as street entries were decried as traffic obstacles and taken down. And furious debates about extensions, public ownership, and financing methods quickly turned mass transit into a perennial source of controversy and denigration, a political football involving both City Hall and the Governor's Mansion. While they struggled with inadequate revenues and fearsome congestion, the subways did indeed become symbolic of New York City and its special identity, but hardly as a source of inspiration. Instead the suffering of straphangers became a staple of jokes and canards, evidence of daily stress and managerial incapacity.

By 1916 the Interborough Rapid Transit, facing competition from the newly established Brooklyn Rapid Transit and strike threats from its workers, decided to become more aggressive about both its public image and employee relations.[43] For an annual retainer they hired Ivy Lee, a celebrated publicist who had previously worked to polish the tarnished reputation of John D. Rockefeller.[44] Lee advised the IRT to prepare publications in magazine form for employees and the public alike. He set about cultivating popular opinion, issuing press releases, distributing a newsletter entitled *Rapid Transit,* inviting letters and suggestions, and creating a series of several hundred posters. These cheaply printed announcements, taking the form of a newspaper page and using the name of *The Subway Sun* or, on surface lines, *The Elevated Express*, were pasted on the inside of car windows, and formed a rather ambitious campaign (Fig. 97).

As miniature billboards the rather wordy

communiqués sought to reassure the public about transit safety, accustom them to innovations (like turnstiles), encourage visits to local institutions like parks and museums, instruct in public courtesy and polite behavior, and, above all, campaign in favor of a subway rate hike.[45] The series employed the talents of some gifted newspaper cartoonists and illustrators (again, apparently all male), among them Ernest Hamlin Baker, C. R. Macauley, George V. Shanks, and Denys Wortman. Heavily didactic, it was quickly caricatured in the local press, ridiculed for its self-absorption and self-interest. Far more humorous (if artistically less ambitious) than their Chicago counterparts, the announcements resembled editorial pages rather than posters, although a few examples in full color attempted to imitate London's efforts. Their lengthy texts must have absorbed many bored straphangers, and they were changed every few weeks. They were apparently popular (despite the lampoons), but as attempts to justify a fare raise they were less than successful, as Lee admitted. Lee also attracted criticism for his large consulting fees, at a time when the transit budget was dangerously constrained.

Drawbacks aside, this program emerged as the only artistic effort, before World War II at least, to identify New York City's growth and prosperity with the fate of its mass transit. While systematically coordinated and ringing the changes on many of the London Underground's own programmatic intentions, its aesthetic ambitions were low. In the following decade, as public-art programs exploded during the Depression, there were larger proposals to place art within the subway system itself, but these became political casualties in an early battle of the culture wars.

Many New Yorkers seemed aware of Pick's innovations.[46] Local museums featured British posters, and to excellent reviews.[47] Foreign correspondents praised the signage system, and were delighted by the splendors of a transformed Piccadilly Circus Station, which opened in 1928. The murals by Stephen Bone "arrest the eye and compel attention," wrote Kathleen Woodward in *The New York Times*. The "intention of the artist is to show that subway travel carried out in miniature the whole business of a world; as Piccadilly is the centre of London's travel, so London is represented as the centre of the world's travel."[48] And

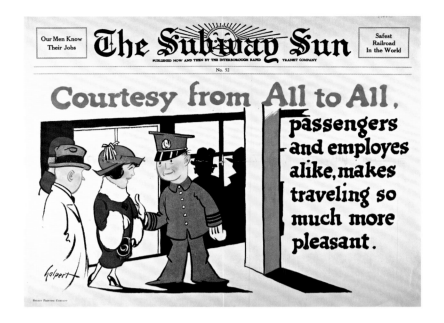

the advertising art was just as splendid. The "issue of a new poster is something of an event, and copies of posters are bought by admiring passengers, to be hung in their homes."[49]

But despite the power of this transatlantic example, promoting mass transit did not assume the centrality in New York that it enjoyed in London, nor were the subways and elevated train lines among a typical tourist's fond memories.[50] There was, however, one impressive analogue to Pick's achievement. If New York's transportation system never really promoted civic identity or served to legitimate, as in London, the joys of consumption and the appeals of escapist travel, these did find a powerful local expression: the vivid covers of *The New Yorker* magazine, which began appearing in 1925. On a weekly basis they constituted, for a more selective audience, a graphic equivalent to the Pick program. Dreams of rural flight haunted the imaginations of artists in both cities (Fig. 98). But there were also notable differences. Week after week the frenetic energy of New York and its jagged-edged skyline reinforced local identification with the potency of an unfettered modernity. The forests of skyscrapers, the maze of electric signs, the busy streets and crowded beaches linked the larger city to anarchic rhythms and unlikely shapes.[51]

Londoners, by contrast, while acknowledging temptations that were novel and even freakish, valued disciplined efficiency and public order.[52] London's master symbols during the interwar

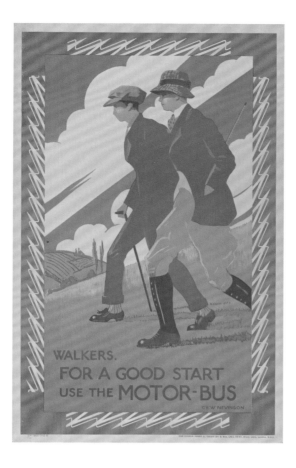

years may well have been St. Paul's cathedral, the abbey church of Westminster, the Big Ben clock tower of Parliament, and its mass-transit system, but these were hardly the emblems of freewheeling capitalism or commercial enterprise.

Yet Frank Pick's promotional schemes were hardly staid or moralizing in character. They freely trumpeted the hedonistic pleasures of consumption and spectatorship, the summer and winter department store sales, football matches (Fig. 99), visits to the zoo, nights at the theater, and creature comforts of various kinds, along with walks in the country and quiet communion with nature. "Folk will flock together for amusement but not for worship," Pick admitted, and he was willing to serve this taste, even when he did not share it personally.[53] His last assistant, Christian Barman, argued that Pick knew he had to concentrate his publicity on "every kind of enjoyment," the "things that could make London an experience beyond the reach of all mankind, except only the lucky few who had the privilege of living there or discovering it as visitors."[54] The enormous variety of posters Pick commissioned testified to a latitudinarian attitude toward his audience. "Every-

one is different and responds to different suggestions"—this was how Barman portrayed his chief's convictions. "And so the advertiser who is enabled to publish a whole series of posters has a far better prospect of success than the advertiser who must rely on one or two." In this respect Pick was lucky as a patron. He did not have a single product to sell but "the most interesting city in the world."[55] Posters, Pick wrote, were "the most eclectic form of art" and, so long as the main idea was not lost, could endure almost any kind of tone—humorous, descriptive, historical, sardonic.

London's transport posters played with many themes—escaping the city for the country, escaping the weather for the Underground, enjoying special events, discovering public institutions, admiring historic figures, and cherishing municipal landmarks. They admonished, inspired, and instructed Londoners in how to use new equipment or behave properly; they celebrated the greatness of the city and the grandeur of royalty; they promoted a cause or simply made visual and verbal puns. There was almost nothing they could not address. And the "imaginative geography" of

100
**ERNEST MICHAEL
DINKEL**
Visit the Empire, 1933,
commissioned by UERL,
printed by Waterlow
& Sons, 39 ⅞ x 24 ⅞ in.
(101.3 x 63.2 cm). Yale
Center for British Art,
Promised gift of Henry
S. Hacker, Yale College,
Class of 1965

the posters popularized, among other things, the global empire still run from London during those years. If the "imperial city was at the centre of the world," write Felix Driver and David Gilbert, posters placed "the empire at the heart of the urban experience" (Fig. 100).[56]

Graphic artistry, moreover, helped vitalize the most mundane statistics, and elevated maintenance and reinvestment to the level of adventure. The spats-wearing, pipe-smoking passenger drawn by Irene Fawkes in 1924, seated like Gulliver upon a miniature railroad, epitomized the client-centered messages running through the colorful posters (Fig. 101). The London Passenger Transport Board, Pick told its first annual conference, has a life and being of its own, and it "is through publicity that the Board comes to be this corporate being, vital and important to London. The Board has got to have a heart," and it was up to the Publicity Department to provide it with one.[57] In this sense the signs, the logos, the posters, the typography all served not simply communication, but identity itself.[58]

Pick himself believed that movement was fundamental to the health of a great city. "The great

affair is to move," proclaimed another Fawkes poster, quoting Robert Louis Stevenson. Analyzing (over long periods of time) daily trips within the world's major cities Pick argued that they formed "the pulse rates of urban life." Without "intense and continuous movement a city cannot maintain itself as a whole or realize or appreciate its unity. It remains a mere agglomeration which, under such circumstances, is neither justified nor excusable."[59] London Transport was, in effect, the great physician.

Americans remained fascinated if perhaps a bit bemused by this huge investment in publicity. While "the London underground itself is only perhaps a degree more attractive than are the New York subways," a *New York Times* correspondent exclaimed on seeing a gallery display in New York, "the posters setting forth the delight of places to be reached by means of subterranean travel in the English city strongly impel a patron to drop in his twopence or threepence and make any one of a dozen or so journeys."[60] Rich in imagination and coloring, they eclipsed an adjacent American poster display. "Nowhere have I seen the idea of civic art more actively expressed," wrote Amelia Defries about the posters, recalling an Underground excursion she had just made to Hampstead Garden Suburb with Patrick Geddes, the celebrated Scottish regional planner. The London Underground was wise to give its artists a free hand.[61] "The English poster's story of . . . even a day in the parks, is what we would call irresistible," *The New Yorker* commented approvingly, praising the British poster's dependence "upon the pictorial value rather than the text for its pull. This puts the load on the artist rather than the copy writer. And somehow we think this is shrewder, words meaning so many other things."[62]

That commercial promotion could be accepted as civic art was certainly ironic in a culture still wary of capitalist exuberance and notoriously skeptical about ballyhoo. It was also a constituency not particularly friendly to Modernism in architecture or design. Yet in the years after World War I Pick's corps of designers—architects like Charles Holden as well as graphic artists—were encouraged to take chances, to introduce configurations, suggestions, juxtapositions, and references that confounded and irritated as well as delighted their audiences, just because they broke with tradition.

Not all transport artists did so, of course. Many, in fact, did not challenge conventions directly. But it is the tolerant, inclusive eclecticism of Pick's program, in the graphic arts at least, that impresses at this distance—and its continuing levels of artistic originality. Underscoring Pick's absorption with the role of great cities and the fundamental part played by their transportation networks, the London posters—along with the system's famous roundel logo, Harry Beck's great transit map (Fig. 102), and Edward Johnston's enduringly distinctive typography—did far more, in the end, to consolidate and strengthen a sense of the metropolis than any flags, seals, murals, or special events could.[63] In selling the advantages of mass transport and associating them with metropolitan opportunities, these posters strengthened civic identity and product marketing at the same time. They, and the Beck map, helped make the city more coherent, opening it up as structure and experience to residents and visitors alike. They also created a standard of design excellence which maintenance and equipment had to meet.

The decades following Pick were not good ones for mass transit in London, nor in Chicago or New York. Pick linked publicity to substantial reinvestment as well as continuing redesign in all parts of the system. Promotional energy and managerial excellence can be symbiotic, but both depend on the conviction that the product or service is worth reinvestment. When that belief wanes, sustaining quality becomes very difficult. For Americans whom it served, mass transit was

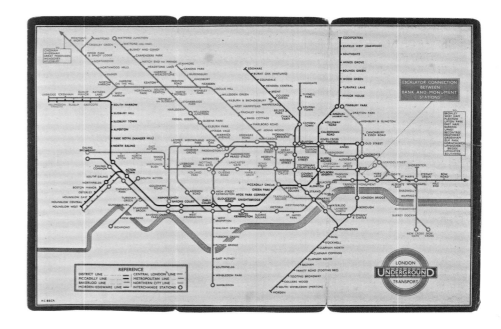

a necessary convenience. It was rarely treated with the adoration and delight greeting the automobile. Other parts of the world also lost their hearts to the private pleasures of the motor car, but they never fully abandoned their romance with the trams, trains, trolleys, and buses that had for so long served their needs. There are many explanations for this, which economists, political scientists, geographers, and demographers can easily supply. But it must be acknowledged that the care, sensitivity, and risk taking assumed by Frank Pick and his designers played a uniquely nurturing role in one place at least. Which made Pick not merely a considerable art patron, but a great social engineer as well.

102

HARRY BECK

Railway Map, London Transport Underground, no. 2 (London: Johnson, Riddle & Co., 1935). Yale Center for British Art, Anonymous Gift

1. D. L. LeMahieu, *A Culture for Democracy: Mass Communication and the Cultivated Mind in Britain between the Wars* (Oxford: Clarendon Press, 1988), chapter 4, "Regaining Authority: Approaches to Cultural Reform."
2. Frank Pick, "Design in Cities," in *Design in Everyday Life and Things: The Year Book of the Design and Industries Association, 1926–27* (London: Ernest Benn, [1927]), 22.
3. Consideration of other campaigns falls outside the scope of this essay. Some of which, such as that of Josiah Wedgwood, began before the nineteenth century. For a summary of a number of such efforts, particularly Walter Paepcke's at the Container Corporation, and for references to further catalogues, articles, and monographs, see Neil Harris, "Designs on Demand: Art and the Modern Corporation," in *Art, Design, and the Modern Corporation* (Washington,

D.C.: Smithsonian Institution Press, 1985), 8–30.
4. Later the London Passenger Transport Board. The institution changed its name several times between 1906, when Frank Pick began his London work, and 1940, when he left London Transport. "Underground" is the generic name.
5. On Yerkes's role in the building of the London rail system, and the importation of other Americans, see T. C. Barker and Michael Robbins, *A History of London Transport: Passenger Travel and the Development of the Metropolis*, vol. 2, *The Twentieth Century to 1970* (London: Allen & Unwin, 1974), 60–85. Involvement by another American tycoon, the banker J. P. Morgan, Barker and Robbins conclude, would have been somewhat more benevolent.
6. British journals like *Commercial Art*, annuals like *Modern Publicity* (under various names), both publications

of *The Studio*, acknowledged, often admiringly, the scope and aggressiveness of American advertising. See LeMahieu, *A Culture for Democracy*, chapter 4. German responses were somewhat different; see Corey Ross, "Visions of Prosperity: The Americanization of Advertising in Interwar Germany," in Pamela E. Swett et al., *Selling Modernity: Advertising in Twentieth-Century Germany* (Durham: Duke University Press, 2007), 52–77; and Kevin Repp, "Marketing, Modernity, and 'The German People's Soul,' " in ibid. 27–51.

7. See Stephen V. Ward, *Selling Places: The Marketing and Promotion of Towns and Cities, 1850–2000* (London: Routledge, 1998), chs. 5–6, for the promotional activities of the Metropolitan Railway and the London Underground on behalf of suburban real-estate development, particularly Metro-land, northwest of the city, in the early twentieth century. See also Gerry Kearns and Chris Philo, eds., *Selling Places: The City as Cultural Capital, Past and Present* (Oxford: Pergamon, 1993).

8. In the enormous literature on the Great Exhibition see, recently, Jeffrey A. Auerbach, *The Great Exhibition of 1851: A Nation on Display* (New Haven: Yale University Press, 1999); John R. Davis, *The Great Exhibition* (Stroud, Eng.: Sutton, 1999); and Thomas Richards, *The Commodity Culture of Victorian England: Advertising and Spectacle, 1851–1914* (Stanford: Stanford University Press, 1990).

9. See Michele H. Bogart, *The Politics of Urban Beauty: New York and Its Art Commission* (Chicago: University of Chicago Press, 2006); and Jon A. Peterson, *The Birth of City Planning in the United States, 1840–1917* (Baltimore: Johns Hopkins University Press, 2003).

10. Edward Bennett, "City Planning: Chicago," in *The Significance of the Fine Arts* (Boston: Marshall Jones, under the direction of the Committee on Education of the American Institute of Architects, 1923), 361. Bennett was coauthor, with Daniel Burnham, of the 1909 Plan of Chicago; he attributed the saying to a Greek proverb.

11. The term *brand name* was invented in the early twentieth century. See *Fame* 12 (February 1903), 51; and "Identity in Advertising," *Fame* 11 (April 1902), 152–54. On the history of the trademark, see Arnold B. Barach, *Famous American Trademarks* (Washington, D.C.: Public Affairs Press, 1971); and I. E. Lambert, *The Public Accepts: Stories Behind Famous Trade-Marks, Names and Slogans* (Albuquerque: University of New Mexico Press, 1941). On academic ritual see James W. Alexander, "Undergraduate Life at Princeton—Old and New," *Scribner's Magazine* 21 (June 1897), 663–91.

12. See Catherine Cocks, "The Chamber of Commerce's Carnival: City Festivals and Urban Tourism in the United States, 1890–1915," in Shelley Baranowski and Ellen Furlough, eds., *Being Elsewhere: Tourism, Consumer Culture, and Identity in Modern Europe and North America* (Ann Arbor: University of Michigan Press,

2001), 89–107; David Glassberg, *American Historical Pageantry: The Uses of Tradition in the Early Twentieth Century* (Chapel Hill: University of North Carolina Press, 1990); Neil Harris, "Urban Tourism and the Commercial City," in William R. Taylor, ed., *Inventing Times Square: Commerce and Culture at the Crossroads of the World* (New York: Russell Sage, 1991), 66–82; Sarah J. Moore, *John White Alexander and the Construction of National Identity: Cosmopolitan American Art, 1880–1915* (Newark: University of Delaware Press, 2003); and Bailey van Hook, *The Virgin and the Dynamo: Public Murals in American Architecture, 1893–1917* (Athens, Oh.: Ohio University Press, 2003).

13. John B. Pine, ed., *Seal and Flag of the City of New York* (New York: Putnam's, 1915), 90. See also John M. Purcell, "U. S. Municipal Flags: An Overview," *Flag Bulletin* 10 (Spring–Summer, 1971), 81–97.

14. The contest is described, and a series of posters illustrated, in *The Newark Posters Catalogue* (Newark: Committee of 100, 1915).

15. "This was the first war [in which] artists, as such, were used by their governments, and art became a powerful weapon." Albert Eugene Gallatin, *Art and the Great War* (New York: Dutton, 1919), 21. A huge literature exists on the posters of World War I; on the war's impact on poster collecting, see Neil Harris, "American Poster Collecting: A Fitful History," *American Art* 12 (Spring, 1998), 11–39.

16. "Art Notes," *New York Times*, November 14, 1915, 18.

17. Even the American world's fairs, before 1915, were not major poster commissioners. One exception was the Pan-American Exposition in Buffalo in 1901, which inspired a celebrated poster. See Porter Aichele, "The 'Spirit of Niagara': Success or Failure," *Art Journal* 44 (Spring 1984), 46–49. But this was relatively unusual. Before World War I European tourist posters tended to emphasize vacationing and natural scenery. Urban tourism was less represented. In 1913 and 1914 Paul Ruben published two large, well-illustrated volumes, *Die Reklame: Ihre Kunst und Wissenschaft*, 2 vols. (Berlin: Verlag für Sozialpolitik, 1913; Berlin: Hermann Paetel Verlag, 1914), These offered a colorful review of the great German advertising studios and of the designers Julius Klinger, F. H. Ehmcke, Lucian Bernhard, Hans Rudi Erdt, and Julius Gipkens, among others. As they show, poster commissions in Germany were dominated by retail and industrial advertising, especially promotions for beer, cigarettes, automobiles, and other commodities, and entertainment. More than ten years later, in Walter F. Schubert, *Die Deutsche Werbe Graphik* (Berlin: Francken & Lang, 1927), things had not changed. This impression is confirmed in more recent surveys, see Hellmut Rademacher et al., *Kunst! Kommerz! Visionen: Deutsche Plakate 1888–1933*, exh. cat. (Berlin: Braus, 1992). Generalization is difficult for the various national traditions, but German practices do not seem atypical.

18. The only real exceptions here were the American railroads. Bogart, *Artists, Advertising, and the Borders of Art,* 79–124, summarizes the art poster-vs.-billboard debate in the United States, and recounts the triumph of the billboard. Some in England were convinced of the artistry and effectiveness of the American billboard. Sir Charles Higham, "British and American Pictorial Advertising," *Commercial Art* 2 (March 1927), 89, declared that "No poster that I have seen on the British hoardings is comparable, either in beauty of design or in the length of time during which it retains its original colour with that of the Palmolive poster."

19. On early twentieth-century railroad advertising, and the artists here mentioned, see Michael E. Zega and John E. Gruber, *Travel by Train: The American Railroad Poster, 1870–1950* (Bloomington: Indiana University Press, 2002), chs. 3–4.

20. Gruber, *Travel by Train,* 43.

21. The Wisconsin Historical Society in Madison began receiving London Underground posters in 1917, and by the early 1920s is said to have held the largest number of Underground posters in the United States. Its 1917 activities were launched in connection with the collecting of war posters. See "English Poster Exhibit," *The Poster* 14 (November 1923): 27. At some point the Art Institute of Chicago also began receiving Underground posters regularly, presumably sent by Frank Pick, who visited the city.

22. "Artistic French Railway Posters," *The Poster* 11 (August 15, 1920): 28.

23. Eleanor Jewett, "Railroad Posters Lure Travelers to France," *The Poster* 11 (October 15, 1920): 61.

24. Frank R. Arnold, "Swiss Railway Posters," *The Poster* 11 (September 15, 1920): 43.

25. "Marked Improvement in Recent British Poster Art," *The Poster* 11 (October 15, 1920): 25–26.

26. Edwin R. Bangs, "Travel Posters at the University of Chicago," *The Poster* 13 (December 1, 1922): 19–20. The London Traffic Combine, or Combine for short, referred commonly to the Underground Group of Companies, or the enlarged UERL.

27. Robert Allerton Parker, "Edward McKnight Kauffer," *The Poster* 11 (December 1920): 35.

28. "New Series of Underground Posters," *The Poster* 11 (July 15, 1920): 49.

29. "Posters to Advertise Chicago," *The Poster* 11 (March 1920): 31.

30. See Robert Klara, "The Art of Enterprise," *American Heritage* 52 (June 2001): 70–77.

31. On Insull see Forrest McDonald, *Insull* (Chicago: University of Chicago Press, 1962); Harold L. Platt, *The Electric City: Energy and the Growth of the Chicago Area, 1880–1930* (Chicago: University of Chicago Press, 1991); and John F. Wasik, *The Merchant of Power: Samuel Insull, Thomas Edison, and the Creation of the Modern Metropolis* (New York: Palgrave MacMillan, 2006).

32. The posters are described in Ronald D. Cohen and Stephen G. McShane, eds., *Moonlight in Duneland: The Illustrated Story of the Chicago South Shore and South Bend Railroad* (Bloomington: Indiana University Press, 1998). See also Carla Davidson, "Chicago Transit," *American Heritage* 37 (December 1985): 33–39; "The Romance of Transit," *Chicago History* 24 (Summer 1995): 22–37; and John Gruber and J. L. Sedelmaier, "Sic Transit," *Print* 52 (July–August 1998): 64ff. All of these are heavily illustrated. The following paragraphs draw on these accounts.

33. Frank Pick, from "Growth and Form in the Modern City," a talk given at the Institute of Transport, January 3, 1926, Frank Pick Collection, London Transport Museum Library, PA 16.

34. Dana M. Hubbard, "How Chicago Elevated Is Advertising Chicago to Chicagoans," *Printers' Ink Monthly* 5 (November 1922): 53.

35. Bangs, "Travel Posters," 20.

36. Bangs, "Travel Posters," 20. The advertising department's chief was J. J. Moran.

37. H. S. McCauley, "How a Museum Increased Attendance by Advertising," *Printers' Ink Monthly* 8 (April 1924): 116–19.

38. See *Chicago Tribune,* June 10, 1928, 22. Eleanor Jewett, the *Tribune* art critic, declared of the two hundred posters selected to be shown at the Art Institute, that "a less impressive collection of pictorial art . . . would be hard to find." *Chicago Tribune,* October 4, 1928, 29.

39. Michael W. Brooks, *Subway City: Riding the Trains, Reading New York* (New Brunswick: Rutgers University Press, 1997), 3.

40. *The New York Subway: Interborough Rapid Transit* (New York: Interborough Rapid Transit Company, 1904), ch. 1, summarizes assumptions about station design.

41. *The New York Subway,* ch. 3. I have relied upon Brooks's very interesting book, and refer to his characterizations of New York opinion about mass transit. On the station decorations, designs, artists, and manufacturers, see the detailed study by Philip Ashforth Coppola, *Silver Connections: A Fresh Perspective on the New York Area Subway Systems,* 2 vols. (Maplewood, N.J.: Four Oceans Press, 1984).

42. On the advertising controversy see Coppola, *Silver Connections,* vol. 2, ch. 8.

43. The Brooklyn system eventually became the Brooklyn- Manhattan Transit (BMT). The IRT and the BMT were joined, in the early 1930s, by the city-owned Independent Subway (the IND). In 1940 the city took over the bankrupt IRT and BMT.

44. On Lee see Ray Eldon Hiebert, *Courtier to the Crowd: The Story of Ivy Lee and the Development of Public Relations* (Ames: Iowa State University Press [1966]), ch. 8.

45. Ivy Lee's papers are at the Princeton University Library, and contain many of the only surviving examples of this graphic program. They formed the basis for a highly informative exhibition at the New

York Transit Museum's Gallery Annex at Grand Central Station in 2004, and a gallery talk by Charles Sachs, "The World's Safest Railroad: How Ivy Lee Promoted New York's Subway System, 1916–1932," which can be found in webcast form at the Transit Museum's website, www.transitmuseumeducation. org, under "Online Gallery Talks," accessed November 25, 2009.

46. "English Taste in Art Seen in Posters and Dwellings," *New York Times*, July 26, 1925, X8.

47. Henry L. Sparks, "An Exhibit of Modern British Posters," *The Poster* 16 (July 1925): 17–18. This exhibition at the British Museum was based upon several American private collections.

48. Kathleen Woodward, "Art Descends into the London Subway," *New York Times Sunday Magazine*, October 13, 1929, 12. The New York press covered the opening of the Piccadilly Circus station extensively; see *New York Times*, December 11, 1928, 33.

49. Woodward, "Art Descends into the London Subway," 17.

50. In the 1940s and thereafter car cards and posters were used increasingly to animate the ride. Edward McKnight Kauffer and Paul Rand both produced posters extolling the value of subway advertising, the Miss Subways contests were begun, and a set of other innovations suggested heightened interest.

51. In some ways Harold Ross, the founder of *The New Yorker*, and his art editor Rea Irvin, were Pick's counterparts, commissioning posterlike covers from artists in a regular, well-sustained, and well-received campaign that frequently touched upon many of the city's notable landmarks, and caught the population at work and at play. For a brief, perceptive summary of *New Yorker* covers see the foreword by John Updike to *The Complete Book of Covers from The New Yorker, 1925–1989* (New York: Knopf, 1989), v–vii. Starting in 1926 Chicagoans were treated to their own cavalcade of images in *The Chicagoan*, an imitator of *The New Yorker* whose color covers glorified that local scene. See Neil Harris, *The Chicagoan: A Lost Magazine of the Jazz Age* (Chicago: University of Chicago Press, 2008). While often brilliantly designed, *The Chicagoan* ended in 1935, after only nine years.

52. The tension between a desire for discipline and control on the one hand and exaltation in freedom and diversity on the other is a theme in Cathy Ross, *Twenties London: A City in the Jazz Age* (London: Museum of London, 2003). Ross's study of London's "reluctant modernism" accompanied an exhibition at the Museum of London.

53. Frank Pick, "Design in Cities," typescript, March 1925, Frank Pick Collection, London Transport Museum Library PA 16.

54. Christian Barman, *The Man Who Built London Transport: A Biography of Frank Pick* (Newton Abbot, Eng.: David & Charles, 1979), 32.

55. Barman, *The Man Who Built London Transport*, 33.

56. Felix Driver and David Gilbert, "Imperial Cities, Overlapping Territories, Intertwined Histories," in Felix Driver and David Gilbert, eds., *Imperial Cities: Landscape, Display and Identity* (Manchester: Manchester University Press, 1999), 3.

57. *London Transport, First Annual Conference*, November 19, 1936, 30–31, printed pamphlet, London Transport Museum Library.

58. Pick and the Underground do not quite fit the argument presented by Victoria de Grazia, *Irresistible Empire: America's Advance Through Twentieth-Century Europe* (Cambridge, Mass.: Harvard University Press, 2005), 250–62. The "crisis of the poster" de Grazia isolates, "under siege by American advertising methods on the Continent, does not seem to have occurred with the same intensity in Britain. Pick's consumers were also his public, a blend of commercial and civic interests, and his conception of the poster as an effective instrument of persuasion survived, even flourished, while poster makers on the Continent were mobilizing public interest rather than inviting individual consumption" (262). For a more extended treatment of this issue see Victoria de Grazia, "The Arts of Purchase: How American Publicity Subverted the European Poster, 1920–1940," in Barbara Kruger and Phil Mariani, eds., *Remaking History* (Seattle: Bay Press, 1989), 221–57.

59. Pick, "Growth and Form in the Modern City," 60.

60. *New York Times*, January 15, 1928, 137.

61. Amelia Defries, "English Commercial Posters," *Poster* 11 (April 1920): 23. Geddes called the posters "the art gallery of the people," a phrase repeatedly invoked.

62. *The New Yorker*, September 4, 1926, 38.

63. On other fabled design accomplishments of the Pick era see Ken Garland, *Mr. Beck's Underground Map* (Harrow Weald, Eng.: Capital Transport, 1994); Stephen Halliday, *Underground to Everywhere: London's Underground Railway in the Life of the Capital* (Stroud, Eng.: Sutton Publishing and the London Transport Museum, 2001); Justin Howes, *Johnston's Underground Type* (Middlesex: Capital Transport, 2000); David Lawrence, *A Logo for London: The London Transport Symbol* (Harrow Weald, Eng.: Capital Transport, 2000); Nikolaus Pevsner, "Patient Progress: The Life Work of Frank Pick," *Architectural Review* 92 (August 1942), 31–48; and Gavin Stamp, " 'A Little Grit and Ginger': The Impact of Charles Holden on the Architecture of the London Underground, 1923–1940," in Julian Holder and Stephen Parissien, eds., *The Architecture of British Transport in the Twentieth Century* (New Haven: Yale University Press, 2004). See also Zachary M. Schrag, *The Great Society Subway: A History of the Washington Metro* (Baltimore: Johns Hopkins University Press, 2006), 250–61, on maps, the Beck inheritance, and the role of cartography and icons in shaping local identity and knowledge.

GRAPHIC OPPORTUNITIES:

WOMEN ARTISTS AND THE UNDERGROUND

TERI J. EDELSTEIN

HEATHER (HERRY)
PERRY

*Country Joys from
Victoria Station,* 1930
(detail; see Fig. 120)

In 1925 the Design and Industries Association (DIA) published their annual yearbook, *Design in Modern Life and Industry,* with a section of eighteen pages devoted to recent posters, almost all of them created for the London Underground.[1] It seems likely that the man who commissioned the Underground posters, Frank Pick, played a major role in choosing works for it. An active member of the DIA, he had edited the previous *Yearbook.* Of fifteen artists selected, six were women. So strong a representation may seem surprising for the first quarter of the twentieth century, but the Underground employed many women artists in those years. Explaining why is a challenge. Personal taste, political philosophy, historic circumstance, and marketing goals certainly played some role. At times, gender may have seemed irrelevant to individual commissions, with women working on subjects and in styles that defied conventional expectations. But for certain poster campaigns, at least, the perceived ability of women to communicate with a specific audience most probably influenced their hiring. Identifying these artists, reviewing the scale of their efforts, and examining their stylistic preferences may clarify contemporary practices and offer some insight into the special character of the London Underground program.

The Underground engaged women artists from its earliest years. Ella Coates executed a landscape poster of Kew Gardens in 1910, just two years after the poster campaign began (Fig. 103). Because the designers of thirty-one out of thirty-seven posters printed in the first two years remain unknown, it is possible that she was not the first, or even the only, woman artist at the time. Several other women followed her in the first five years, among them Mabel Lucie Attwell, Agnes Richardson, Anna Louisa Pressland, and Hilda Cowham.[2] Between 1908 and 1913 forty-six artists can be identified, of whom eight are known to be women. (The artists of almost one hundred posters are not known.) Many of the early posters follow the stylistic conventions of nineteenth-century landscape painting or children's book illustration. Women did not challenge these traditions. Attwell, who became almost a brand with her popular children's books and Annuals, produced through the 1940s, may have begun her depictions of sweet chubby children in books in 1911, the year before she created her first poster for the Underground (Fig. 104). Cowham, who contributed to *Punch, The Graphic,* and *The Sketch,* worked in much the same mode, as did Richardson. Pressland, who trained at the Slade School, served other commercial clients as well with her flowers, landscapes, and still lifes.

That more women received commissions may reflect the political gains realized by women in

KEW GARDENS BY TRAM TO KEW BRIDGE

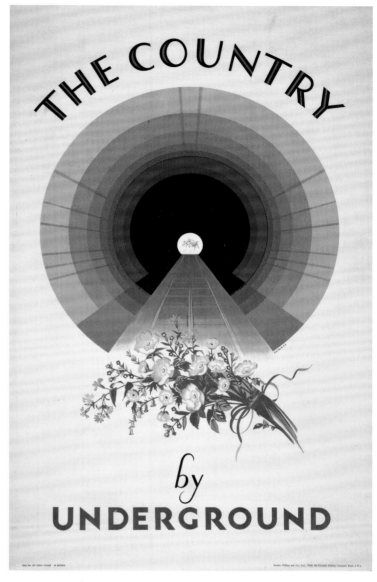

these years. The campaign for political rights for women in Britain began in the mid-nineteenth century but significant advancements in suffrage were not realized until the early twentieth century. Between 1918 and 1928 women achieved greater political parity in Britain. The Representation of the People Act of 1918 extended suffrage to women over the age of 30 who met certain minimum property-holding requirements. Women received full electoral equality in the Representation of the People Act of 1928.

By the 1920s and 1930s Underground poster commissions to women had multiplied dramatically, and their stylistic vocabularies had expanded concomitantly. Heather Perry designed more than fifty distinctive posters between 1928 and

1937, Dora Batty produced almost fifty, and Irene Fawkes executed more than twenty-five (Fig. 105). These included some of the strongest posters of this era. Of course mere numbers do not equate with quality or significance, and many women as well as men designed only one or two posters, although they could be quite imaginative and powerful.

At least 164 women have worked for the London Underground designing posters in its history, but the actual numbers are surely higher. We must assume, for example, that some of the almost fifteen hundred posters designed by artists whose gender is not known (unsigned or signed with initials) were by women. A 1928 article in *Commercial Art* identified the artist previously known

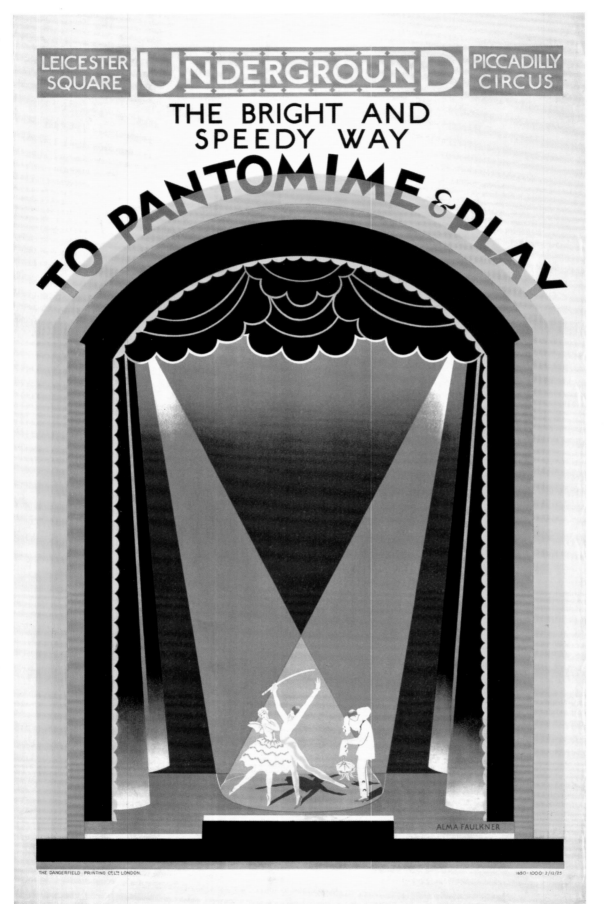

106
ALMA FAULKNER
*The Bright and Speedy
Way to Pantomime*, 1925,
commissioned by UERL,
printed by the
Dangerfield Printing
Company, Ltd,
40 x 25 in.
(101.6 x 63.5 cm).
London Transport
Museum

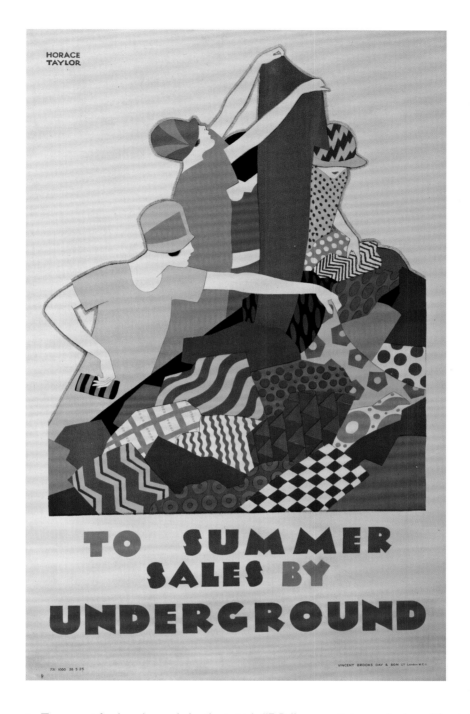

to Transport for London only by the initials "F. B.," as Freda Beard. Minutes of London Transport publicity meetings reveal the identity of L. Blanch as Mrs. Lesley Blanch. The discovery process is ongoing.[3] At least thirteen female artists worked for the Underground Group by 1919 and were joined, at minimum, by twenty-six others between 1920 and 1925. Some of them, such as Batty, Perry, Dorothy Paton, Fawkes, Freda Lingstrom, and Alma Faulkner (Fig. 106), produced posters for years to come.

Themes and subjects are not infallible clues to gender of authorship. Certainly many women artists worked on "feminine" subjects—flowers (Fig. 110), children, shopping—but such posters were also commonly done by men. Examples include *To Summer Sales by Underground,* 1926, by Horace Taylor, with its eager bargain hunters in their brightly colored frocks (Fig. 107); *Winter Sales Are Best Reached by the Underground*, 1922, by Edward McKnight Kauffer, whose brave shoppers struggle against a storm (see Fig. 11); Walter E. Spradbery's *Fragrance: Honeysuckle* (1936; see Fig. 56), one of many flower images he created in his long association with the Underground; numerous

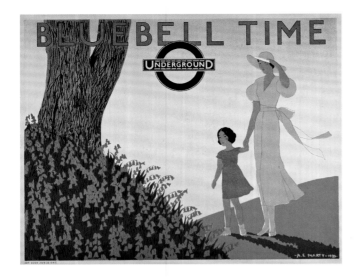

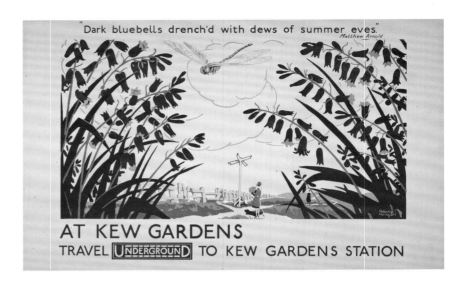

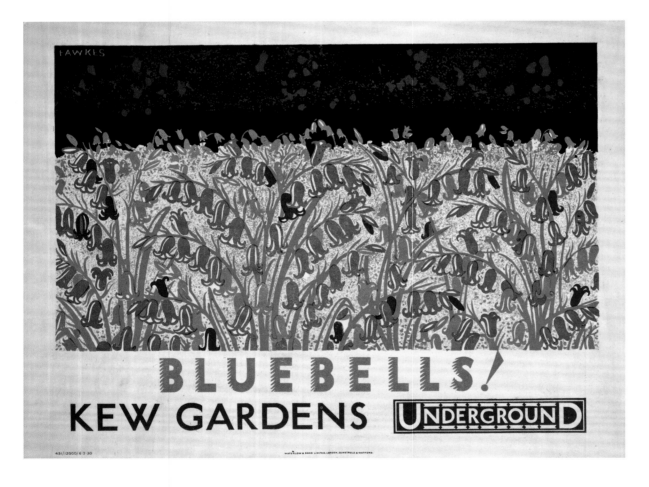

108

ANDRÉ MARTY

Bluebell Time, 1933, commissioned by UERL, printed by the Dangerfield Printing Co., 12 ½ x 10 in. (31.8 x 25.5 cm). London Transport Museum

109

DAVID WILSON

At Kew Gardens, 1926, commissioned by UERL, printed by the Dangerfield Printing Co., 11 ⅝ x 18 ¼ in. (29.5 x 46.5 cm). London Transport Museum

110

IRENE FAWKES

Bluebells! Kew Gardens, 1930, commissioned by UERL, printed by Waterlow & Sons, 9 ½ x 12 ¾ in. (24.2 x 32.4 cm). London Transport Museum

floral posters by Frank Newbould; *Bluebell Time* by André Marty (Fig. 108); and David Wilson's *At Kew Gardens*, 1926 (Fig. 109). Conversely, many posters by women cross a putative gender boundary in the opposite direction: *Rugby at Twickenham*, executed by Laura Knight in 1921; *The Rugby League Cup Final: Wembley*, 1929, by Paton; and *Epsom Summer Meeting* (Fig. 111) and *Football* (see Fig. 99), both 1933, by

Andrew Power (Sybil Andrews), among numerous others.[4]

One way to gauge the special character of Underground commissions is to compare them with work for the railways. Exhaustive documentation is not available, but the extensive collection of the National Railway Museum, York, and contemporary publications such as *Railway Maga-*

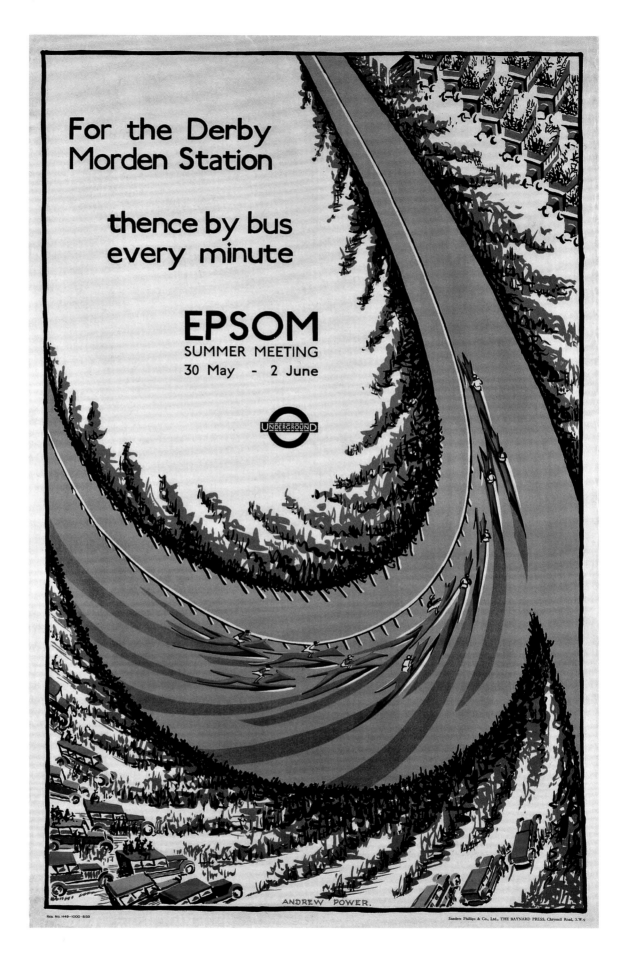

zine and *London & North Eastern Railway Magazine,* reveal the comparative rarity of commissions for women by the four railway lines extant between 1923 and 1947. Their increased numbers in the 1930s may have been inspired by the example of Pick's practices.

Batty, Perry, and Anna Zinkeisen, who worked extensively for Pick, all completed railway posters. Perry executed posters for the Great Western Railway (GWR) and the London, Midland, and Scottish Railway (LMS) in 1930 and 1931. Batty drew several posters for the GWR, among them *Historic Bath* of 1935. Anna Zinkeisen's *The White Cliffs of Dover,* depicting a nineteenth-century scene in a faux gold frame, one of at least two posters for Southern Railway, was executed in 1938. Helen Madeleine McKie also worked for Southern Railway, designing at least two monumental posters for them, as well as booklets, other publicity materials, and clothing and textile designs. She also did a series of posters for the LNER to advertise hotel festivities.[5]

McKie's two posters for Southern Railway commemorated the 100th anniversary of Waterloo Station in 1948: *Waterloo Station: A Centenary of Uninterrupted Service During Peace and War, 1848–1948.* Her compositions pay homage to William Powell Frith's well-known canvas, *The Railway Station* of 1862, which depicts another terminal of the Victorian Age, Paddington. McKie presents a bird's-eye view of the vast space of the station, whose bustling, crowded animation recalls the varied incidents of Frith's painting. The two companion posters refer to the recent war, with similar sets of travelers: in *War* Guardsmen wear khaki and a group in military garb marches through the station; in *Peace,* soldiers appear in their red dress uniforms where the Guardsmen stood, and a group of girls, attired for school in skirts and white shirts, appear in the place of military figures (Fig. 112).

Not surprisingly, the rail line with the best-developed poster program, the London and North Eastern Railway (LNER), commissioned the largest number of posters by women artists, but even these were relatively few. LNER employed Freda Lingstrom to design the covers for many booklets, from at least 1924 through 1929. An article in *Commercial Art* in 1929 stated that Lingstrom had designed twenty-two covers in one year.[6] None-

WATERLOO STATION
1848 A CENTENARY OF UNINTERRUPTED SERVICE DURING PEACE AND WAR 1948
SOUTHERN RAILWAY

theless, documentary evidence reveals her subordinate status within the LNER hierarchy. Five artists, all male—Fred Taylor, Frank Newbould, Tom Purvis, Austin Cooper, and Frank Mason—were kept on retainer by LNER and designed posters for no other railway. In 1927 the publicity manager, W. M. Teasdale, considered adding Lingstrom to this roster, proposing a yearly guarantee of £100 for her. Alas, her name is crossed out; she was offered no contract. But even if she had been, the contrast with her financial value was clear: the minimum payments that year to the artists on retainer were: £1,000 for Taylor; £500 for Newbould; £450 for Purvis; and £250 each for Cooper and Mason.[7] But while never invited to join this exclusive gentleman's club, Lingstrom did occasionally create posters for the line.[8] Laura Knight designed *Yorkshire Coast* for them in 1928 or 1929, and Doris and Anna Zinkeisen also worked for the LNER. Anna designed several posters in 1933, including *Dovercourt* and *Rotten Row.*[9] The latter work, reproduced from a painting by the artist, was printed in a special edition for display on the Underground in quad royal size. She also designed a series of menus in 1934 and a poster in 1936.[10] Other women designed for the railways, but their percentage remained low, and, presumably at the

112

HELEN MADELEINE MCKIE

Waterloo Station: A Centenary of Uninterrupted Service During Peace and War, 1848–1948, Peace, 1947, one of a pair with *War,* commissioned by SR, printed by the Baynard Press, 40 x 49¾ in. (101.6 x 126.4 cm). Yale Center for British Art, Gift of Henry S. Hacker, Yale College, Class of 1965

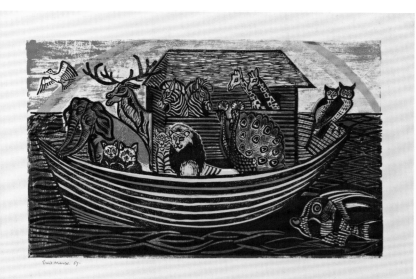

Old Noah stocked his sturdy Ark
With animals both old and gnu
And sailed away to Regent's Park
To found a comprehensive Zoo.

To Whipsnade, then, the course was clear
For Shem the navigator,
To start one in the open air
Ideal for the spectator.

The booklet 'How to Get There' cites
Admission fees and when to go
To Zoos and all the other sights
The London visitor should know.

 The best way to the Zoo at Regent's Park is to go by Underground to Camden Town or Baker Street and take a 74 bus to the gate. The best way to Whipsnade is to take a 726 Green Line coach from Baker Street (Allsop Place, just behind the station) direct to the gate. The single fare to Whipsnade is 4/3.

'How to Get There' is a London Transport booklet which lists some 400 of London's places of interest, both famous and less well-known, together with times of opening, prices of admission and how to get there by London Transport. 'How to Get There' is included free with the guide-book 'Visitor's London' which costs 4/6. It can also be bought separately, price 6d. All London Transport publications, including free maps and leaflets, can be obtained from the Publicity Officer, London Transport, 55 Broadway, Westminster, S.W.I.

113

ENID CRYSTAL DOROTHY MARX

The Zoo: Noah's Ark, 1957, commissioned by LT, printed by McCorquodale & Co., 39 15/16 x 24 15/16 in. (101.4 x 63.3 cm). Yale Center for British Art, Gift of Henry S. Hacker, Yale College, Class of 1965

actually, women were accorded parity with men.[11] This was true of other institutions that Pick respected, including—again theoretically—the Bauhaus in Germany.[12] Thus, it is possible that the large numbers of women artists commissioned by Pick reflected his political philosophy. Pick's friend Harold Curwen, who joined his family's printing firm in 1908, two years after Pick joined the Underground Group, was active with Pick in the Design and Industries Association. He embraced the tenets of the Arts and Crafts movement and employed substantial numbers of women at the Curwen Press.[13] It is conceivable that Curwen was the conduit for several artists who later worked for Pick, among them Margaret Calkin James, Irene Fawkes, and Enid Marx. However, it should be noted that a number of the women at Curwen, like Fawkes, were employed only as colorists for stenciled books rather than as creative artists, and several, such as James in 1922 and 1927 and Marx in 1927, designed patterned papers rather than illustrations.[14]

On the other hand, James created posters for the Underground beginning in 1929. Pick expressed his admiration for her work in a handwritten letter of December 24, 1938, thanking her for a Christmas card, noting the "great care you have given to it and then I speak only of the least of the ingredients which go to make it what it is. It has given me much pleasure and so I justly say: Thank you."[15] Marx worked for London Transport producing textiles and posters. One of her later posters, *The Zoo: Noah's Ark*, 1957 (Fig. 113), crowds its animals into the Ark under a colorful rainbow. Reminiscent of a chapbook's naive woodcuts, it demonstrates not only the economy of Marx's art, but her own academic interests in the origins of this style. The "simplicity and directness of the broadside woodcuts," she wrote in 1948, "made them extremely effective propaganda."[16] She studied at the Central School of Arts and Crafts and later the Royal College of Art under Paul Nash and became the first woman engraver named a Royal Designer for Industry.

Increasing numbers of women were being trained as artists in early twentieth-century Britain. Design education was also a burgeoning field, and this may well have eased their way to Underground work.[17] Throughout his life, Pick demonstrated a great commitment to formal art

request of their employers, most of their work was far more conventional than their work for the Underground.

But of greater importance than the exact numbers of women artists who designed for the Underground is explaining why so many received commissions. The archives of Transport for London contain no definitive answer, but a number of possibilities present themselves.

Pick greatly admired the Arts and Crafts movement in which, theoretically, if not always

education. Many of his lectures and other activities reveal his active involvement.[18] Several of his close friends, including W. R. Lethaby and B. J. Fletcher, directed significant art schools in England. A number of artists hired by the Underground were recent graduates of art schools—indeed, Betty Swanwick received her first commission in 1936, while still a student. Pick commissioned at least five posters from students at the Reimann School and Studios of Industrial and Commercial Art in London, a venue at which he lectured and whose principal was Austin Cooper, one of his lead designers. Women students were particularly prevalent there, as they had been at the original school in Germany. James drew her first poster for the Underground, *Q.E.D.*, while she was enrolled at the Westminster School, where she studied with Kauffer.[19]

Contemporary exhibitions demonstrate the increasing presence of women artists and their formal training. Royal Academy exhibitions, for example, included a number of women artists. Several of the London Underground artists exhibited at the Royal Academy, among them Annie Gertrude Fletcher, Mary Adshead (Fig. 114), and Anna and Doris Zinkeisen. Statistically, an even larger number of women exhibited with the avant-garde London Group, again including artists who worked for the Underground.

Given his involvement with education it is clear that Pick wished to encourage young artists, but there may also have been an economic motivation to hire both young and women artists. Women and recent graduates commanded lower prices than established male artists. There is also some evidence that many women were studying design at this time and may even have outnumbered men in the field.[20]

Naturally, historical circumstances had a powerful impact on the presence of women artists. In the years 1914–18 and again during World War II the numbers of employed women increased in Great Britain. A London Transport poster designed by Eureka Design in 1992, *In 1916 Florence Cordell Stormed a Male Stronghold . . . The Number 27 Bus,* reminds us of their changing circumstances. Following both wars there was a sentiment that they should relinquish the jobs they had temporarily held in order to make way for returning servicemen in need of employment. The

immediate postwar economy did not encourage broad employment of women.[21]

Commissioning patterns at the Underground broadly echoed these general trends during the war. War meant fewer resources for commercial campaigns. At least seventeen of the 122 posters commissioned in 1913 were executed by women. Of the seventy-seven posters printed in 1914, only four can definitely be assigned to women artists.[22] In 1918–19, when poster production had almost ceased, no posters by women were published. And when production rebounded to over

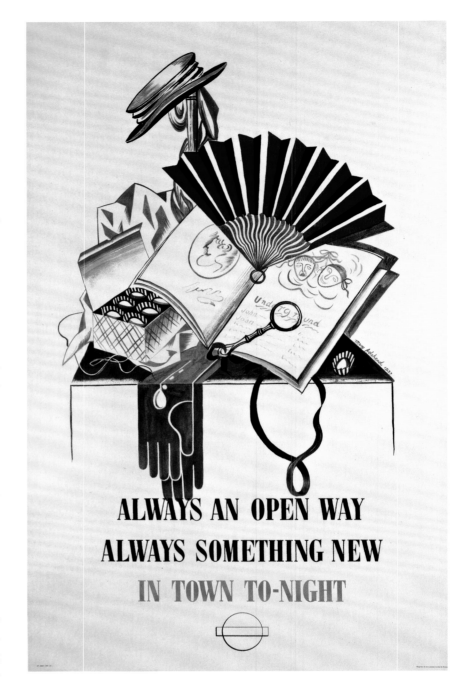

114

MARY ADSHEAD

Always an Open Way, 1937, commissioned by LT, printed by Waterlow & Sons, 39 7/8 x 24 15/16 in. (101.3 x 63.3 cm). Yale Center for British Art, Gift of Henry S. Hacker, Yale College, Class of 1965

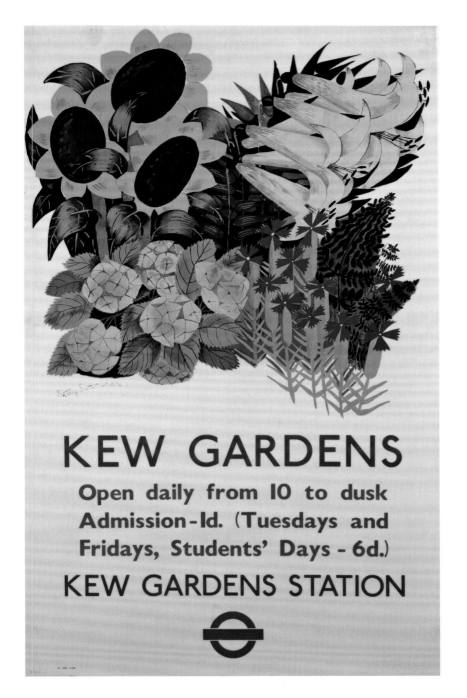

only slightly higher than it had been in 1921, a year of post war economic depression."²³ Moving firmly against these trends, in 1931 a minimum of twenty-one of 115 Underground posters were by women.

Posters could be viewed as an economic stimulus in themselves, and this may help explain just why so many women were employed to design them. Interestingly, the Depression saw no diminution of the numbers of posters printed for the Underground. One of the chief reasons for the creation of the poster campaigns, often voiced by Pick, was to create goodwill on behalf of the system. Inevitably problems would occur in any large transportation network, and the understanding and positive attitude of the public was important in the face of difficulties. An equally important use was to increase travel during off-peak hours. Women were a primary target for these messages, either on their own or as planners for their families: shopping; going to the zoo, movies, museums, or theaters; taking an excursion to the country or to that bit of the country in the city, Kew Gardens. Several recent historical monographs postulate that working-class and middle-class women frequently made the daily financial decisions and managed decisions about consumption.²⁴ Betty Swanwick's *Kew Gardens,* 1937 (Fig. 115), with its profusion of summer sunflowers, hydrangeas, lilies, and pinks, may reflect this marketing goal. Twenty-two of seventy-eight posters depicting Kew Gardens can be identified as the work of women artists.

During the years after World War I a number of advertising specialists assumed that women were better than men at communicating with other women, either directly or subliminally. William Crawford, founder of one of Britain's most successful advertising agencies and a great admirer of Pick and his poster campaign, employed many women in his agency for that express reason. The increase of women's pages in newspapers in this period, corresponding to the rise of advertisements for the growing department stores, mirrors this. An advertisement in 1924 trumpets "the Feminine Appeal in Commercial Art" and exclaims, "How many times an Advertisement misses perfection through lack of the right feminine touch to the illustration." Ethel M. Wood, writing in *Commercial Art* in 1927, noted,

one hundred in 1920, only three works can be absolutely attributed to a woman artist. Yet, as the economy improved the Underground published more and more posters and repeated its earlier pattern of commissioning significant numbers of women artists to design them. In 1921, of sixty-six posters commissioned, at least six were designed by women; in 1922, a minimum of eighteen of ninety-one works; and for 1923, twenty of ninety-three. Jane Lewis argues that "in 1931 the percentage of the number of women working was smaller than it had been in 1911, and

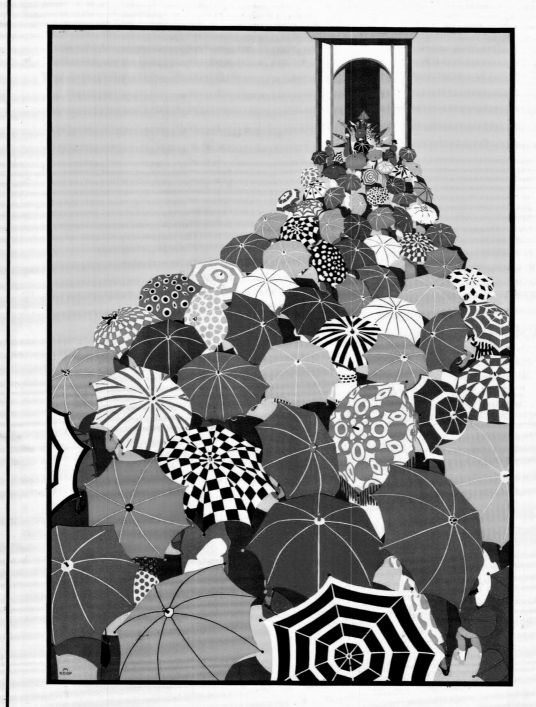

SUMMER SALES
QUICKLY REACHED BY

UNDERGROUND

THE DANGERFIELD PRINTING CₒLTᵈ LONDON 250·1000· 5/3/25

116

MARY KOOP

Summer Sales, 1925,
commissioned by UERL,
printed by the Danger-
field Printing Co.,
40 x 24 ¹⁵⁄₁₆ in.
(101.6 x 63.5 cm).
London Transport
Museum

117

DORA M. BATTY

*For Picnics and Rambles
from Town to Open
Country*, 1925,
commissioned by UERL,
printed by Vincent
Brooks, Day & Son,
40 ⅛ x 25 ⅛ in.
(101.9 x 63.8 cm). Yale
Center for British Art,
Promised gift of Henry
S. Hacker, Yale College,
Class of 1965

BY UNDERGROUND

FOR PICNICS & RAMBLES

30 MINUTES
FROM TOWN TO
OPEN COUNTRY

Some of the most charming advertisement designs produced in England to-day are the work of women artists. . . . The advertisement for I. and R. Morley has the decorative convention of modern art combined with some of the quality of Shakespeare's "King Lear." The color plate reproduced shows an excellent gift of color. And good as advertising? Certainly. Freda Beard's work disengages itself at once from the ruck of advertising. It is not overbearing, but in true feminine fashion wins by its charm.[26]

"The great majority of selling appeals must be addressed to women, so that it is worth while endeavoring to find out what does or does not appeal to them." Julia Bingham concludes that the use of behavioral psychology in making advertising decisions became much more widespread in this period.[25]

Although its language and tone are, to some degree, condescending and not borne out by the artist's robust illustrations, a 1928 article on Freda Beard details a contribution by women artists rarely noted elsewhere:

This combination of economic stimulus and appeal to a particular market segment can be seen in a number of posters related to shopping. The rise of the department store created a space, along with libraries, museums, exhibitions, and restaurants, in which it was acceptable for an unaccompanied woman to be seen.[27] The trope of the woman shopping with her children appeared for the first time in an Underground poster in 1913, in *Winter Sales,* a maquette for which no printed copy exists. (No biographical information survives for the artist, Everill Bonnett, whose name does not identify gender.) A number of posters created after the war repeat this theme. *Shop between Ten and Four, Avoid Crowded Hours,* 1920, by Gladys Mary Rees, depicts a stylishly dressed woman with her two small children, holding many packages. Clothed in traffic-light yellow, red, and green, respectively, the figures stand out against their black background. A contemporary commentator noted approvingly that she "takes us away from simpering prettiness."[28] The same year an unknown artist placed a woman and her children against a clock face for *Winter Sales, Shop between 10 and 4.* In Mary Koop's *Summer Sales* of 1925 (Fig. 116), a stream of gaily colored umbrellas, few solid black ones (the universal color for men) in sight, is funneled to its shopping goal. Was the black-and-white umbrella with a design reminiscent of a spider's web, right up against the picture plane, an allusion to the snares of consumerism? Dora Batty depicts another smartly dressed woman holding packages in *By Underground for Shopping from Country to the Heart of Town,* also in 1925. She clutches her umbrella as insurance against the inevitable rain when she leaves the shelter of the Underground. This poster, and another in this

series, were singled out for praise by *The Studio*: "Quite a fresh note has been contributed to the famous London Underground Railway posters by Miss D. M. Batty, whose subjects for 'Shopping' and 'Theatres and Dances,' both very personal in manner and drawn with sureness and decorative feeling, raise the hope that more may follow on similar lines."[29] The third poster in the series, *For Picnics and Rambles from Town to Open Country* (Fig. 117), shows a woman at the middle of a family, a perfect example of the centrality of women in making leisure-time decisions. A woman stands at the center of the composition in each of the three posters. In another depiction of shopping, Annie Gertrude Fletcher's 1926 poster deployed an image within a circle alluding to a clock face (Fig. 118). In the top half of the circle, women sit in quiet comfort in an Underground car on their way to shopping between 10:00 AM and 4:00 PM (off-peak for commuter travel). In the bottom half, their tardy compatriots are forced to straphang in the Cubist confusion of men and women crowded in the Underground car during rush hour. To underscore the comparison, both groups of women, those riding in the "quiet hours" between 10:00 and 4:00 and those crushed in peak-hour trains, wear red and gray. Fletcher used the same conceit in a 1927 poster, but this time a woman who is easily strolling with her two offspring between 10:00 and 4:00 at the top of the poster becomes separated from them in the mêlée of the post–4:00 PM scrum.

Many other posters by women for the Zoo, historical sites, or seasonal events like the Molesey Regatta (Fig. 119) demonstrate the importance of family outings to the publicity of the Underground. Among numerous examples are a pair of *Country Joys* posters designed by the prolific artist Herry Perry in 1930. The posters feature bird's-eye views of a brightly colored, naive landscape refulgent with green grass, massive trees, and plentiful hedgerows, and dotted with amiable sheep, cows, chickens, and people, the latter enjoying pubbing, picnicking, fishing, and walking (Fig. 120).

Although the two *Country Joys* posters are double royal size, at least thirty-five of the fifty-five posters designed by Perry were the smaller-size panel posters. Similarly, almost every one of the nineteen works executed by Anna Zinkeisen for the Underground Group was of the small panel

118

**ANNIE GERTRUDE
FLETCHER**

Shop between 10 and 4,
1926, commissioned
by UERL, printed by
Chorley & Pickersgill,
40 x 24 ¹⁵/₁₆ in.
(101.6 x 63.3 cm)
London Transport
Museum

119

FREDA BEARD

Molesey Regatta by Tram,
1924, commissioned by
UERL, printed by the
Dangerfield Printing
Co., 11 ⅓ x 18 ½ in.
(28.6 x 47 cm).
London Transport
Museum

120

**HEATHER (HERRY)
PERRY**

*Country Joys from
Victoria Station,* 1930,
commissioned by
UERL, printed by the
Dangerfield Printing
Co., 39 ⅞ x 25 in.
(101.3 x 63.5 cm). Yale
Center for British Art,
Gift of Henry S. Hacker,
Yale College, Class of
1965

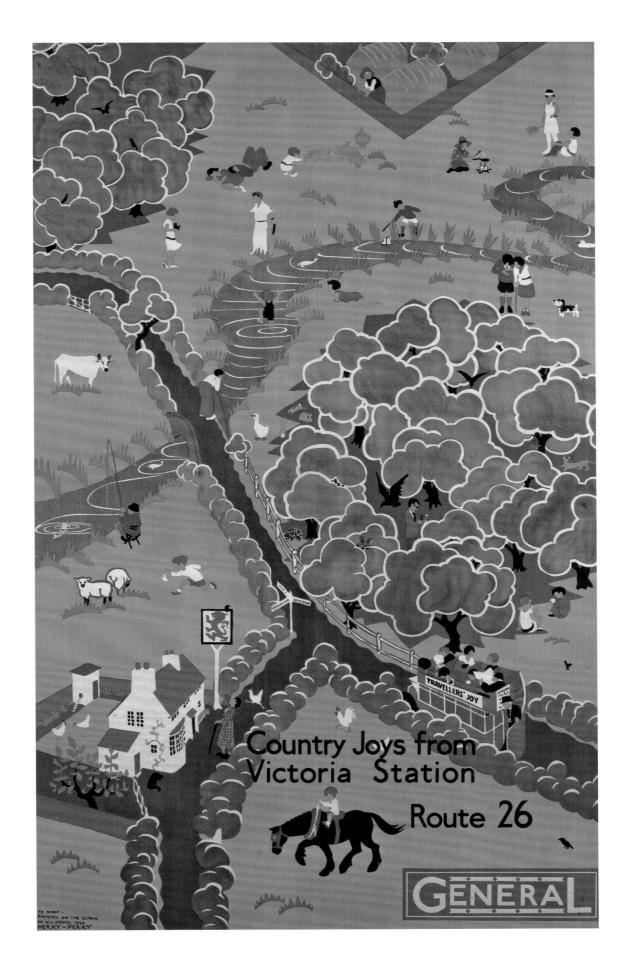

size, although they were by no means confined to "feminine" iconography, and included promotions of the Motor Cycle and Cycle Show (Fig. 122), an RAF air display (see Fig. 35), the football and rugby Cup Finals, the Aldershot Tattoo, Trooping the Colour, and the Royal Tournament—all of which might be construed as events appealing to masculine tastes. Their small size undoubtedly allowed Zinkeisen to draw the lithography directly on the stone. These pieces have a spontaneity and vibrancy not seen in her larger posters or her paintings. Thus the size of panel posters, while earning a lower rate of remuneration, imposed no limits on the artist's imagination.[30] Several men were also commissioned to do panel posters almost exclusively. Charles Burton, one of the most talented designers ever to work for the Underground, designed twenty-three posters, of which only three were not panel posters. André Marty, an illustrator of great renown in his native France, designed eighteen posters, of which all but four were small-format works (see Fig. 108).[31] Aldo Cosomati worked in this format frequently, as did Kauffer.

Perhaps because they were shown for a shorter time, the panel posters often exhibit greater creative freedom. The 1923 example by Lingstrom, *Pass Down the Car, Please!* places its toylike row of men and women marching across the top of the poster in lockstep. They form a colorful row against a pink ground. The admonitory words standing out against black have the staccato accent of a gigantic red exclamation point (Fig. 121). A panel poster by Kathleen Stenning from 1925, *Take Cover; Travel Underground,* contrasts a bilious green sky traversed from top to bottom by a gigantic bolt of lightning standing out against a large, simplified black cloud. The passengers below, reading newspapers, chatting, or

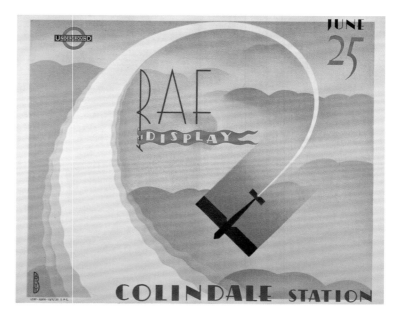

121

FREDA LINGSTROM

Pass Down the Car, Please!, 1923, commissioned by UERL, printed by Waterlow & Sons, 12 ½ x 17 in. (31.8 x 43.2 cm). London Transport Museum

122

ANNA KATRINA ZINKEISEN

Motor Cycle and Cycle Show: Olympia, 1934, commissioned by LT, printed by the Dangerfield Printing Co., 10 ½ x 12 ½ in. (26.7 x 31.8 cm). Yale Center for British Art, Gift of Henry S. Hacker, Yale College, Class of 1965

123

DOROTHY PATON

Motor Show, 1929, commissioned by UERL, printer unknown, 9 ½ x 13 in. (24.2 x 33 cm). London Transport Museum

124

DORA M. BATTY

RAF Display, 1932, commissioned by UERL, printed by the Dangerfield Printing Co., 10 x 13 in. (25.5 x 33 cm). London Transport Museum

125

KATHLEEN STENNING

Take Cover; Travel Underground, 1925, commissioned by UERL, printed by Vincent Brooks, Day & Son, 19 ¾ x 11 ¾ in. (50.2 x 29.8 cm). London Transport Museum

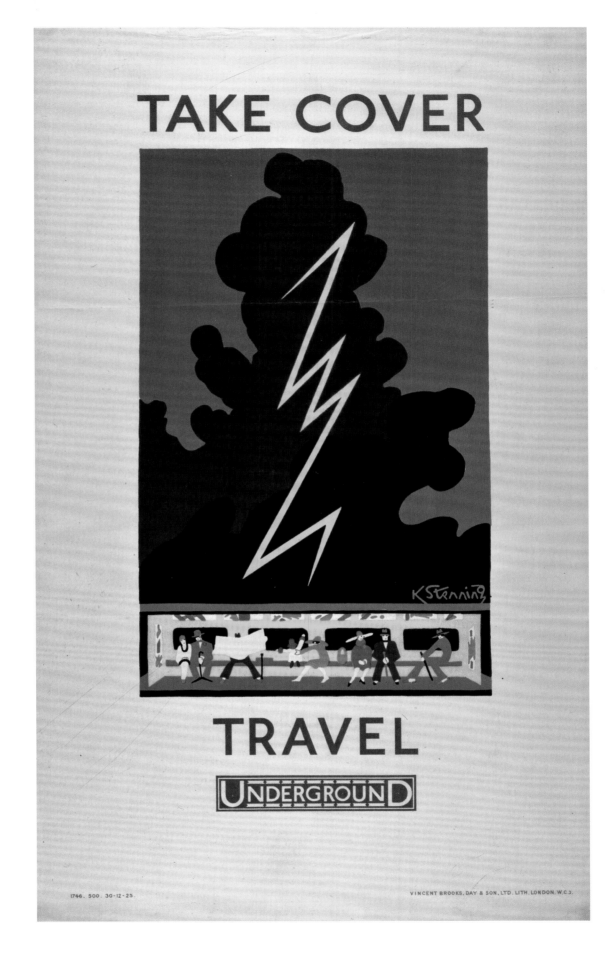

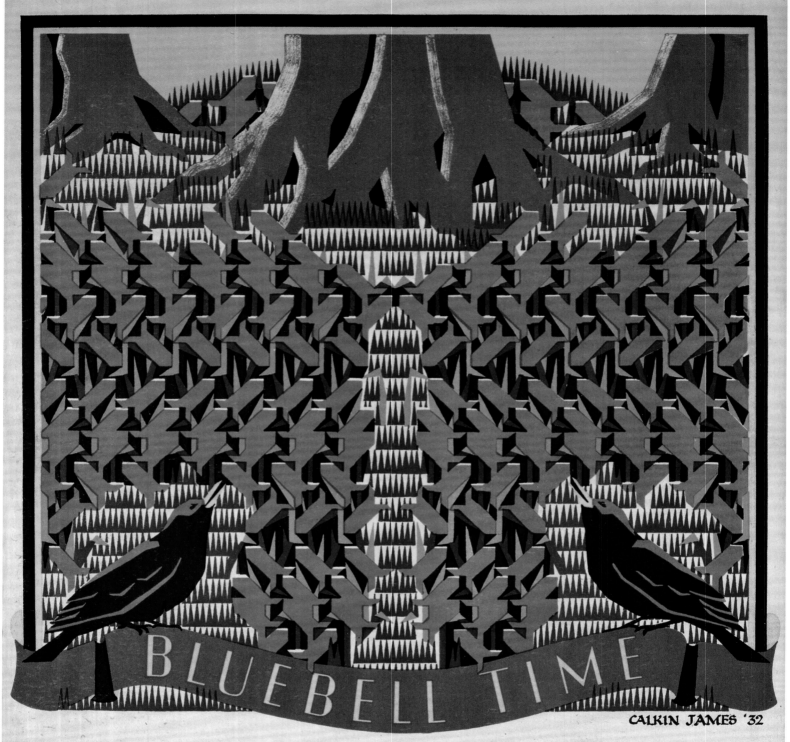

BLUEBELL TIME

CALKIN JAMES '32

IN KEW GARDENS
AND THE GENERAL COUNTRY

LOCAL MUSEUMS are treasure houses where unlikely objects — curious, ingenious, comic, even beautiful — lie stranded for our gaze. They indicate local pride and sense of identity. More vividly evocative of the everyday past than are grander institutions, they deserve and reward our notice.

A new London Transport free leaflet lists a selection with a brief indication of what each museum contains, times of opening and how to get there. It also identifies many of the oddities you see above. The *Museums and Art Galleries* booklet (also free) deals with the major collections. Ask at any London Transport Enquiry Office or write to the Public Relations Officer, 55 Broadway S.W.1.

126
MARGARET CALKIN JAMES
Bluebells, 1931, commissioned by UERL, printed by the Curwen Press, 11 x 12 ¾ in. (28 x 32.4 cm). London Transport Museum

127
JOY SIMPSON
Local Museums, 1968, commissioned by LT, printed by Leonard Ripley & Co., 39 ⅛ x 25 in. (99.4 x 63.5 cm). Yale Center for British Art, Gift of Henry S. Hacker, Yale College, Class of 1965

just sitting cozily in their Tube car, are spared the crack of thunder and blast of light against the darkened sky (Fig. 125). *Motor Show,* a 1929 panel poster by Dorothy Paton, depicts two colossal Underground roundels receding in perspective toward a Motor Show sign, using a giant tire to mimic the Tube symbol (Fig. 123). And although the majority of posters by Dora Batty are double royal size, her panel posters like *RAF Display* (Fig. 124), were among her most inventive.

Margaret Calkin James stands out as one of the most commanding artists to work for the Underground. Even her small panel posters have a monumental presence. Like Lingstrom, she trained at the Central School of Arts and Crafts, where Batty taught textiles after 1932—and afterwards at the Westminster School of Art. At her business, the Rainbow Workshop, she designed in a variety of media, later working as a freelance designer.[32] In *Bluebells* of 1931 (Fig. 126), two colossal bluebirds, flanking serried rows of the seasonal flower, are placed with the same military precision as her ranks of Guardsmen in *Trooping the Colour* of the following year (see Fig. 10). Both use color and geometry to powerful effect. No other poster of this flower conveys so well the overwhelming visual spectacle of masses of bluebells. Posters by women artists continued to be commissioned by the Underground in later years (Fig. 127).

Definitive answers as to why the poster campaign launched by Pick included so many women artists remain elusive. A progressive stance toward female participation, an absence of gender prejudice, respect for education, and marketing goals all played their part. Whatever the reasons may have been, the opportunities provided to women like Margaret Calkin James, Herry Perry, Anna Zinkeisen, and Dora Batty found realization in a string of memorable works for the Underground. In the end, neither numbers nor explanations are as relevant as the achievement of the posters themselves.

All information on statistics of women artists employed by the Underground compiled by author through an analysis of information available on the LTM website, accessed May 2009.

1. *Design in Modern Life and Industry: Year Book of the Design and Industries Association, 1924–25* (London: Ernest Benn, 1925), 122–40. One of the artists, M. A. Carter, uses only initials, so no gender identification is possible. Founded in 1915 on the model of the Deutscher Werkbund, the Design and Industries Association fostered good design among manufacturers, retailers, and the British public. To accomplish this they organized exhibitions, lectures, and publications. Frank Pick was one of the founders and was very active in the Association, along with Harry Peach, a furniture maker and design reformer; W. R. Lethaby, architect and professor of design at the Royal College of Art; Ambrose Heal, furniture maker and retailer; and Harold Curwen, printer. On the DIA see Stephen Hayward, " 'Good Design Is Largely a Matter of Common Sense': Questioning the Meaning and Ownership of a Twentieth-Century Orthodoxy," *Journal of Design History* 11, no. 3 (1998): 217–33.

2. The launch of the Underground poster program coincided with the campaign for women's suffrage in Britain. The suffrage movement also excelled at marketing and creating brand identity. One of the strategies of the Women's Social and Political Union (WSPU) was the adoption of a distinctive color scheme: purple, white, and green, which became not only an identifying symbol but a rallying cry. The tricolor was "a new language of which the words are so simple that their meaning can be understood by the most uninstructed and most idle of passers-by in the street," wrote Emmeline Pethick-Lawrence in *The Women's Exhibition 1909, Prince's Skating Rink, Knightsbridge, London, May 13th to 26th* (London: Woman's Press, 1909), an exhibition program that contained a history of the WSPU; see also Lisa Tickner, *The Spectacle of Women: Imagery of the Suffrage Campaign, 1907–1914* (Chicago: University of Chicago Press, 1988), 93 and 294; and *Suffragettes in the Purple, White and Green London, 1906–1914* (London: Museum of London, 1992). Several posters by both male and female artists printed between 1911 and 1914, at the height of the movement, feature this palette. I thank Margaret Timmers for suggesting this avenue of inquiry.

3. John Harrison, "Freda Beard," *Commercial Art* 4 (1928): 278–83. A series of panel posters depicting a bee with various punning headlines such as *Hum Along: The Shops, the Markets, the Pictures* from 1938, currently listed as by an unknown artist, can be attributed to Miss E. Marks, possibly a misspelling in the minutes of a meeting of Enid Marx, who was commissioned to design fabric for the Underground in 1937. Minutes of the Publicity Meeting, minute 926, April 4–December 24, 1938, Transport for London Archives.

4. The pseudonym Andrew Power conflates the names of the artists Sybil Andrews and Cyril E. Power, who shared a studio. Sybil Andrews informed Oliver Green, Head Curator of the London Transport Museum, that Power had received the original commission but that she executed all the works. She incorporated Power's name in recognition of the commission. Of course, it is possible that Power had some input into the work.

5. On Perry see *Commercial Art* 10 (1931): 127; and *Commercial Art* 12 (1932): 5. On Zinkeisen and McKie see Beverly Cole and Richard Durack, *Railway Posters: 1923–1947* (London: Laurence King, 1992), 86, 90; and (on McKie) Cecil Dandridge, "Advertising Notes," *London & North Eastern Railway Magazine* 23, no. 1 (January 1933): 11.

6. K. O. Fearon, "The Work of Freda Lingstrom," *Commercial Art* 7 (1929): 263–65; see also Allan Middleton, *It's Quicker by Rail! The History of LNER Advertising* (Stroud, Eng.: Tempus, 2002), 42.

7. Documents in the National Railway Museum Archives, York.

8. *Railway Gazette* 53 (June 19, 1931): 905, positive review of a poster by Freda Lingstrom.

9. Cecil Dandridge, "Advertising Notes," *London & North Eastern Railway Magazine* 22, no. 11 (November 1932): 590–91; see Alfred Page "The LNER Exhibition: An Object Lesson," *Commercial Art* 10 (1931): 206–19; and Cecil Dandridge "Advertising Notes," *London & North Eastern Railway Magazine* 26, no. 10 (October 1936): 574.

10. *Commercial Art* 17 (1934): 112.

11. See Michael T. Saler, *The Avant-Garde in Interwar England* (London: Oxford University Press, 1999); and Christian Barman, *The Man Who Built London Transport: A Biography of Frank Pick* (Newton Abbot, Eng.: David & Charles, 1979).

12. Anja Baumhoff, *The Gendered World of the Bauhaus* (Frankfurt-am-Main and Oxford: Peter Lang, 2001), discusses the disconnection between the theory and practice of gender equality in the movement.

13. I thank Peyton Skipwith for this suggestion. Correspondence between Curwen and Pick in the Transport for London Archives does not mention women artists.

14. Fiona Hackney, "Women at Curwen," in Jill Seddon and Suzette Worden, eds., *Women Designing: Redefining Design in Britain between the Wars* (Brighton: University of Brighton, 1994): 51–57. She notes: "Of over 100 designers recorded as working at Curwen between 1927 and 1941 more than 50 were women," 51. However, the major illustrators were men: Edward Bawden, Kauffer, and Barnett Freedman. James's decorative paper *Harlequin* was probably the first printed by Curwen in 1922, when the line of decorative papers was launched. By 1938 it had sold some 24,613

sheets. See David McKitterick, *A New Specimen Book of Curwen Pattern Papers* (Manor Farm, Eng.: Whittington Press, 1987), 12, 62. See also Betty Miles, *At the Sign of the Rainbow: Margaret Calkin James, 1895–1985* (Alcester, Eng.: Felix Scribo, 1996). Miles asserts (49) that James received rather different treatment than her male colleagues. Although *Harlequin* was one of the bestselling papers ever published by Curwen, Curwen never added James's name to her sheet, a courtesy he extended to Bawden, Harold Jones, and other artists. James designed a second paper in 1927 for which she was paid £3–15s.–7d, the same sum as Thomas Lowinsky and Bawden. Marx was paid 3 guineas that same year for a patterned paper design. See McKitterick, *New Specimen Book*, 42, 60, 66.

15. Miles, *At the Sign of the Rainbow*, 37.

16. Enid Marx and Margaret Lambert, "English Popular and Traditional Art," in *British Craftsmanship*, W. J. Turner, ed. (London: Collings, 1948): 259.

17. See numerous essays in Seddon and Worden, eds., *Women Designing;* and Paul Rennie, "The New Publicity: Design Reform, Commercial Art, and Design Education, 1910–39," in Bownes and Green, eds., *London Transport Posters*, 85–108

18. Nikolaus Pevsner, *An Enquiry into Industrial Art in England* (Cambridge, Eng.: Cambridge University Press, 1937). Pevsner discusses this extensively. The London Transport Museum Archive contains a number of lectures by Pick to educational institutions.

19. "New Talent" *Commercial Art* 5 (1928): 178–80. On the Reimann School see Yasuko Suga, "Modernism, Commercialism, and Display Design in Britain: The Reimann School and Studios of Industrial and Commercial Art," *Journal of Design History* 19 (Summer 2006): 137–54, 140.

20. Hilary Cunliffe-Charlesworth, "Women and Design Education: The Royal College of Art, in Seddon and Worden, eds., *Women Designing*, 10–15. Cunliffe-Charlesworth offers statistics from the Diploma lists of the RCA and a questionnaire distributed to graduates. However, she notes (15, nn. 5 and 6) that the Diploma lists are very incomplete. They only start in 1923 and 1924–27, 1935–36, 1938–39, and 1943–45 are missing. The questionnaire was from 143 graduates and responses were self-selected.

21. Martin Pugh, *Women and the Women's Movement in Britain*, 2nd ed. (London, MacMillan, 1992, 2000), 77 and ch. 4, "The Anti-Feminist Reaction"; Jane Lewis, "In Search of a Real Equality: Women Between the Wars," *Class Culture and Social Change: A New View*

of the 1930s, Frank Gloversmith, ed. (Brighton: Harvester Press, 1980), 208–39; D. L. LeMahieu, *A Culture for Democracy: Mass Communication and the Cultivated Mind in Britain between the Wars* (Oxford: Clarendon Press, 1988), 44.

22. This declined to sixty-three posters in 1915, of which three were definitely by women, and fifty-two in 1916, of which two can be assigned to women, before falling precipitously to ten, eight, and eleven in the years 1917–19.

23. Lewis, "In Search of a Real Equality," 209.

24. LeMahieu, *A Culture for Democracy,* 34 and n. 70, which lists a number of other sources.

25. Julia Bingham, "Advertising as a Career," in Seddon and Worden, eds., *Women Designing*: 22. For a discussion of women employed in Crawford's firm, see G. H. Saxon Mills, *There Is a Tide: The Life and Work of Sir William Crawford* (London: Wm. Heinemann, 1954), 50. For a discussion of Pick and the poster campaign see Mills, *There is a Tide*, 66. On women's pages in newspapers see LeMahieu, *A Culture for Democracy,* 34, 35. The advertisement for Brockhurst Studios, "The Feminine Appeal in Commercial Art" appeared in *Commercial Art* 3 (June 1924): n.p., repeated in July 1924. The quotation from Ethel M. Wood is found in her "Some Problems of Advertising to Women," *Commercial Art* 3 (1927): 216.

26. Harrison, "Freda Beard," 78.

27. See Mica Nava, "Modernity's Disavowal: Women, the City and the Department Store," in Mica Nava and Alan O'Shea, eds., *Modern Times: Reflections on a Century of English Modernity* (London: Routledge, 1996), 38–76, 43, and passim.

28. Walter Shaw Sparrow, *Advertising and British Art* (London: John Lane, Bodley Head, 1924), 160. Sparrow may not have known the artist's gender; he refers to her as G. M. Rees.

29. Sydney R. Jones, *Posters and Publicity* (London: The Studio, 1926), 6, ill. 15.

30. Minutes of the Vice-Chairman's Publicity and Public Relations Meeting, July 4, 1935, minute 226, Transport for London Archives, states the maximum payment for a car panel as £18.18 and the minimum payment for a double royal poster as £21.

31. Emmanuelle Dirix, "Fashioning the Tube: Women and Transport," in David Bownes and Oliver Green, eds., *London Transport Posters: A Century of Art and Design* (Aldershot, Eng.: Lund Humphries in association with the London Transport Museum, 2008), 139.

32. Miles, *At the Sign of the Rainbow,* passim.

7

EDWARD MCKNIGHT KAUFFER:

THE UNDERGROUND POSTER KING

PEYTON SKIPWITH

Painter, draftsman, printmaker, graphic artist, theater and textile designer, and photographer, Edward McKnight Kauffer mastered a formidable armory of skills, which he deployed to great effect throughout his career. Seldom was he more effective than in the posters he designed for the London Underground during the 1920s and later for Shell. Handsome, talented, gregarious, ambitious, but as yet unknown, the twenty-four-year-old Kauffer arrived in London during the early months of the First World War along with his wife, Grace, and quickly set about establishing a reputation. The life of an impoverished artist struggling in a garret held no attractions for him; he had had enough of poverty and hardship during his childhood in Montana and, having reached Europe, was in a hurry to put this behind him by any means at his disposal. During his early years in London he worked furiously and effectively to build useful connections; he joined the avant-garde London Group of artists in 1916 and over the next three years exhibited nearly thirty paintings with it.[1] The following year he boasted to Maxwell Armfield that he had been elected to the Artists' Committee of the Allied Artists Association: "So gradually I have put a finger into all the good pies."[2] The Allied Artists Association, an unjuried exhibition founded in 1908, was the brainchild of the critic Frank Rutter, to whose journal *Art and*

Letters—successor to *Wheels,* the Sitwells' counterblast to the conservative anthology *Georgian Poetry*—Kauffer contributed. He also designed sets and costumes for the Travelling Theatre of the Arts League of Service. In addition to all this, and most importantly, he made his mark with his earliest posters for the London Underground.

Early in 1917 Kauffer wrote a long and self-revealing letter to his friend Maxwell Armfield, who was by then living in America. Armfield, who had designed the 1915 poster *Go to Kew* (see Fig. 25), was a leading exponent of tempera painting, and from Kauffer's letter we get some interesting insights into his own approach both to his art and materials. In one passage he says: "Naturally not having ever worked in real tempera I can't understand your worship of it. To me all mediums are merely ones [*sic*] tools and one medium has not a quality above the other. It depends entirely upon what one says with the medium. Of course you will agree!!"[3] The sentence, with its two exclamation marks, clearly indicates that he did not expect agreement, and that his elevation of subject matter, image, and message above technique was deliberately, if affectionately, provocative.

In 1920, Percy Wyndham Lewis organized the X Group exhibition in the Mansard Gallery at Heal's department store in Tottenham Court Road; Kauffer was one of the ten exhibitors. He

was already familiar with the gallery, as it was the venue for the London Group's exhibitions, and Kauffer had produced a shockingly stark poster for the Group's show the previous year (Fig. 128). With its daring mix of upper- and lowercase lettering, background of floating pink irregular rectangles, and central motif of two confrontational, nutcrackerlike figures, it is both titillating and menacing. It also prefigures posters for the Negro cabarets that were to become such a defining feature of the European social scene, especially in Paris, during the following decade. The ten exhibitors—"X" may have been intended to stand for ten—had all been members of the London Group, but had resigned *en bloc* to join Lewis in his ill-defined scheme. The X Group was reminiscent of Roger Fry's Omega Workshops and the breakaway Rebel Art Centre of prewar years, but in the event it proved to be merely a last late flourish of Vorticism. Lewis recorded in his autobiography, *Blasting and Bombardiering,* that "One of X Group's most prominent members was MacKnight [*sic*] Kauffer, who became the Underground poster king; he disappeared as it were below ground, and the tunnels of the 'Tube' became henceforth his subterranean picture galleries."[4]

Kauffer had joined the London Group soon after moving to the capital and first exhibited with them in 1916; four years later, by the time of the X Group exhibition, he was twenty-eight years old and already at the top of his profession. His rise from a broken home in Montana to such heights had been meteoric. As a child he had spent many solitary hours copying illustrations from cheap magazines, delighting particularly in Frederic Remington's spirited scenes of the American Wild West. After a spell as a scene painter with a touring theater company, he got a job in a San Francisco bookshop, which enabled him to study art at evening classes at the Mark Hopkins Institute, where many of the painters and muralists of what came to be known as the California School also studied. Among the best-known of these was Maynard Dixon (1875–1946), whose *Navajo Indian from Life* (Fig. 129) had been made into a Sunset Poster in 1903 and sold over a quarter of a million copies. Dixon, a protégé of Remington's, had attended the Mark Hopkins Institute—or rather, the California School of Design, as it was then

called—where he had trained under its forceful director, Arthur Mathews.[5] The Institute was run on contemporary lines, free of the academic trappings of plaster casts, etc., and the students were encouraged to paint direct from nature and to exult in the wide open spaces of the still largely unspoiled California landscape that had inspired Mathews. His paintings and murals were "characterized by flat contours and Art Nouveau colors,"[6] and this became the hallmark of the California School artists. Although he had retired several years before Kauffer entered the Institute, his

128
EDWARD MCKNIGHT KAUFFER
untitled poster for the London Group, 1919, 30 × 20 in. (76.2 × 50.8 cm). Victoria and Albert Museum, London

MAYNARD DIXON

Navajo Indian from Life,
1902, 28 × 17¾ in.
(71.1 × 45.1 cm).
California History Room,
California State Library,
Sacramento

legacy was still the dominant influence on teachers and pupils alike.

Thanks to a financial loan from Joseph E. McKnight, a professor at the University of Utah whom he met at this time, Kauffer was able to leave California and move to Paris to continue his studies. En route he stopped in Chicago and enrolled for six months in the "antique" program at the School of the Art Institute, studying painting, anatomy, and art history; he also exhibited with the Art Students League there. For a young man of eclectic tastes, who was destined to be one of the century's most brilliantly original creative "magpies," the six months he spent in Chicago couldn't have been better timed. In March 1913 a selection of works from the Armory Show was exhibited at the Art Institute. The Armory Show, so called because its original New York venue had been the Armory of the 69th Cavalry Regiment, is still regarded as the twentieth century's seminal exhibition of modern European

and American art. In its original conception the exhibition was overwhelming, containing over a thousand works embracing every trend—Classicism, Romanticism, Realism, Impressionism, Fauvism, Cubism, Expressionism, and abstract art—and even when reduced it remained a seriously impressive exhibition. For Kauffer it was a revelation; it was as though he had been let loose in an art candy store with a multiplicity of styles ripe for the picking. At the time it was the works of Cézanne and van Gogh that made the most immediate impact on his own painting, but the exhibition also introduced him to Picasso and Braque, as well as the Futurists; influences that were to play an important role in his graphic work throughout his life.

Three months later, with the stimulus of the Armory Show still fresh, he left America, sailing from Baltimore to Venice, whence he proceeded to Munich to spend the summer. It was here that he first encountered the graphic work of Ludwig Hohlwein (1874–1949). Hohlwein was the most brilliant and prolific German poster artist of the twentieth century, whose work was strongly influenced by that of the Beggarstaff Brothers—William Nicholson and James Pryde. The outstanding characteristics of the Beggarstaffs' work were the simplification of image and the use of flat, plain color, often achieved through collage (see Fig. 4).[7] The impact of Hohlwein on Kauffer was strong, and nowhere is this more evident than in the series of bale labels, *Toucan, La Casita, Afamado,* and *Jockey* (Fig. 130) among them, which he designed between 1916 and 1928 for the Manchester textile firm of Steinthal & Co., exporters of cotton piece goods to South America.

Hohlwein's use of flat areas of primary color, stronger than but not dissimilar to those favored by Arthur Mathews, demonstrated to him how van Gogh's Post-Impressionist palette could be exploited for maximum impact, not only on bale labels but, even more publicly, on advertising hoardings. Equally, Cézanne's sculptural analysis of the planar construction of landscape, still life, and the human figure, prefiguring Cubism with its geometric simplifications, showed him how to simplify his own forms in order to achieve intense visual effects.

Once in Paris, Kauffer enrolled at the Académie Moderne and began a translation of

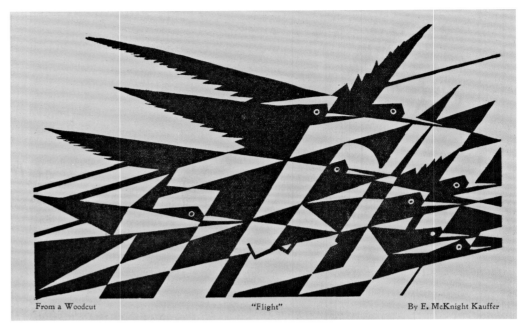

From a Woodcut "Flight" By E. McKnight Kauffer

Ambrose Vollard's biography of Cézanne. In July 1914 he married Grace Ehrlich, a young American pianist studying at the Conservatoire. The timing was not propitious, as Britain and France declared war on Germany the following month, forcing the two expatriates to leave Paris for Britain. Kauffer was still intent on becoming a painter, but the necessity of earning a living made him aware of the opportunities in the fast-growing field of commercial art, later known as graphic design. Maria Petrie, a friend of Grace's with whom the couple first stayed in Durham on their arrival in Britain, recalled him trying, unsuccessfully, to find a market for textile and poster designs. Having failed in Durham, the Kauffers moved to London late that year or early in 1915, where a serendipitous introduction to Frank Pick, the Commercial Manager of the Underground Electric Railways of London (UERL), proved to be the turning point of his career.

The generally accepted account of the initial meeting between the two men is that given by Christian Barman sixty-four years later, from which it would seem that Kauffer only showed Pick figurative or design work, and Pick regretted he did not do landscapes.[8] This seems unlikely, as the first posters Pick commissioned were both landscapes—Oxhey Woods and In Watford (both 1915; see Fig. 58), both painted in a strong Post-Impressionist palette. Although modifications were made to the design of In Watford during its

translation from the original gouache to chromolithography (see Chapter 2 and Fig. 57), the composition reveals that Kauffer had a well-developed awareness of Japanese prints: the poster image, despite its idealized English suburban setting, is clearly based on Hokusai's color woodblock print, Ariwara Narihara's Poem from 100 Poems Explained by the Nurse. Japonism had a profound effect on art and design during the 1870s and 1880s, and Japanese prints, with their clearly defined forms, had influenced a wide range of artists from Whistler to van Gogh, so it is not surprising that Kauffer should have familiarized himself with such images.[9] Mark Haworth-Booth singles out Satō Suiseki's Flock of Birds as the source for Kauffer's famous Vorticist woodcut, Flight (Fig. 131), which later became the poster for the Daily Herald, one of the most sensational advertising images of twentieth-century Britain.[10] Although it had initially been illustrated in the January 1917 issue of Colour magazine, it did not appear in poster form until 1919, having been bought by Francis Meynell, who perceived its potential as the inspirational banner for this fledgling radical newspaper. Post-Impressionism, Fauvism, Cubism, Orphism, Vorticism, and Japanese prints were all grist to Kauffer's aesthetic mill; he foraged widely, borrowing, refining, and reinventing. He was a plagiarist with the wit to see how all these art forms, largely unknown to the general public, could be turned into a personal language, used and popularized.

130
EDWARD MCKNIGHT KAUFFER
Package Label for Cotton (Jockey), ca. 1920, 8 7/8 x 7 in. (22.5 x 17.8 cm). Cooper-Hewitt, National Design Museum, Smithsonian Institution, New York, Gift of Mrs. E. McKnight Kauffer

131
EDWARD MCKNIGHT KAUFFER
Flight, reproduced in The Apple (of Beauty and Discord) 1, no. 1 (London: Colour Publishing Co., 1920): 38 Yale Center for British Art, Friends of British Art Fund

EDWARD MCKNIGHT KAUFFER

Berkshire Landscape, 1916, oil on canvas, 12 x 13¾ in. (30.5 x 35 cm). Southampton City Art Gallery, Hampshire, England

Oxhey Woods and *In Watford* were followed the next year by four further posters commissioned by Pick, *Godstone; Route 160: Reigate; The Heaths, No. 178: Surrey;* and *The North Downs,* after which Kauffer received no further commissions from the Underground until 1920. This may have been as much his choice as Pick's, as for the next few years he concentrated his energies on furthering his career as a painter rather than as a graphic designer, holding solo exhibitions at Hampshire House, Hammersmith, in 1916, and at the Birmingham Repertory Theatre the following year. In terms of subject matter he spread his net widely, painting still lives, portraits, and landscapes; he included among his works at the London Group exhibition in the spring of 1917 a Berkshire landscape (Fig. 132), and the following year a portrait of the Camden Town painter Harold Gilman, who, with Charles Ginner, was art editor of Rutter's *Art and Letters*.[11]

Kauffer produced few posters during 1917 and 1918, apart from a couple each for the Derry and Toms department store and the London Group, and there is no official record of any work for the Underground from this period. However, in his 1917 letter to Maxwell Armfield, he wrote: "The big map for the Underground is finished and I am about *finished* as well. All agree that I have accomplished something quite unique in maps. I am glad for I have conscientiously done my best. Certainly from the remunerative point of view it is a complete failure. But I took it and now it's done."[12] Transport for London retains no records of this assignment, despite the fact that it was both a prestigious and time-consuming project—he told Armfield that it had taken him six months. Perhaps Kauffer's reference to its "complete failure" in financial terms indicates that it was not a direct commission and that he received no payment.

However, whatever the fate of the map, the two designs he made for *Autumn* (1917) and *Summer* (1919) at Derry and Toms during these years

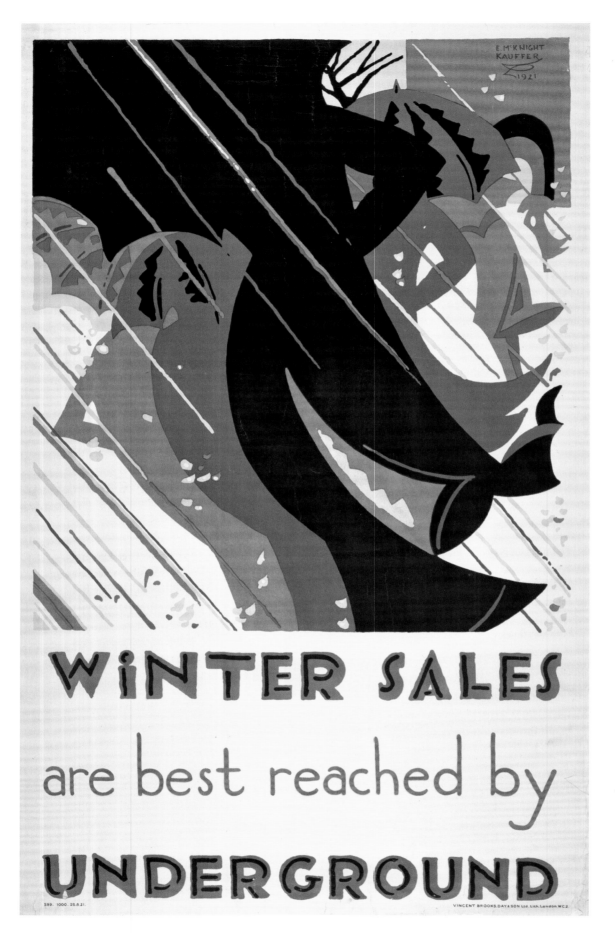

133
**EDWARD MCKNIGHT
KAUFFER**
Winter Sales, 1921,
commissioned by UERL,
printed by Vincent
Brooks, Day & Son,
40 x 25 in.
(101.6 x 63.5 cm).
London Transport
Museum

led to some of the finest work he was to do for the London Underground: the sequence of posters for winter sales. The series started in 1919 with *Winter Sale at Derry & Toms,* commissioned by the department store and designed to lure the public to shop in Kensington High Street. The poster was displayed on the Underground, and Pick clearly saw its potential. Over the next few years he commissioned a series of posters advertising the glamour of sales in general, with the clear intention of enticing the public onto the Underground as the most desirable means of reaching them.

During the next five years Kauffer shifted the focus of his imagery from the explicit to the implicit, from pictorial to abstract, which he achieved by emphasizing the complex beauty and geometry of his subject rather than its immediate visual appeal. He had been analyzing geometric form for some time as is evident in his comment to Armfield on one of the latter's recent paintings, *Construction,* of which Armfield had sent him a photograph: "Is it not curious in this picture the extraordinary sense of height that the stack boiler creates? Now this to me is something well worth studying. Is it because of its pyramidal direction of line together with its isolation and strong silhouette?"[13] In 1919 for a Derry and Toms image, he had used a simple diagonal made up of three figures—a woman in red between two men in black—leaning backward at 45 degrees against a screen of driving snow; by 1921 his London Underground poster *Winter Sales* (Fig. 133) is a cool, near-abstract composition in muted gray and mauve, with an enticing warm orange square in the top right corner: an abstract image of a comforting, alluring, but unspecified goal. Here, although he virtually eliminates all narrative reference, he exploits the geometric possibilities of his subject, using a strong black diagonal with just sufficient hint of form to enable the viewer to interpret it as a figure holding an unfurled umbrella, thus, by implication, identifying the staccato diagonal lines that streak the picture's surface as rain, sleet, or snow, and the orange square as a desirable refuge. The subliminal message is clear: the best way to avoid the weather and reach these welcoming sales is to go by Underground. As Teri Edelstein has noted in chapter 2, Kauffer's 1922 poster *Winter Sales Are Best Reached by the Underground* (see

Figs. 11, 27), with its "cyclonic spiral" of blustering wind, rain, and slush, continues this theme. By 1924 Kauffer had moved his vocabulary forward again, this time producing a near-abstract design of two barely identifiable figures, slanting rain or snow, and unfurled umbrellas: the overall image, while appealing directly to the acquisitiveness of the metropolis's shopping public, is close to the Constructivist images from avant-garde Soviet ceramics.[14]

The design of these four posters exemplifies Kauffer's approach to the poster. In an interview with G. S. Sandilands for *Commercial Art* he explained that he had "studied the processes of human thought with regard to the appeal of the poster. And the hoardings taught him many things. For instance, he frequently found while looking at an expensive poster that something in its color or line movement led his attention right into a crowd of other posters. In a word, he saw that one man was sometimes paying for the advertisements of another. Quite often, too, he noticed posters that seemed to have the right impulse; but somewhere or other the impulse flagged and petered out. Advertisers were not getting their money's worth. Posters were not doing their job."[15] As a result of this quasi-scientific analysis he developed his ideas of how to contain the viewer's interest within the picture space and gradually evolved the geometric theories that came to dominate his designs during the 1920s, whether representational or abstract. As has been noted, in his 1922 poster *Winter Sales Are Best Reached by the Underground,* he abandoned the use of diagonals for a descending spiral with five highly stylized figures whirled around in a vortex of snow. He used the image of the spiral again to great effect a couple years later in his cover design for *The Week-End Book* (Fig. 134), but here the expanding concentric rings are exalted and encircle a blast of steam rising, like an exploding champagne cork, from a locomotive. It is a joyful evocation of Harold Monro's 1917 poem, "Week-End" ("The Train! The twelve o'clock for paradise / Hurry, or it will try to creep away. / Out in the country everyone is wise: / We can be only wise on Saturday. . . .") Once again, the geometric shapes and restricted palette—mauve, orange, red, and black—invite comparison with Russian Constructivist graphics.

Frank Pick, despite commissioning a wide

range of artists, liked to link posters together thematically. For an abstract notion such as "sales" a moody composition of color and pattern might be suitable; however, he, like his target traveling public, could be essentially conservative in matters of taste. One series that he commissioned from Kauffer during the early 1920s was targeted at weekenders with leisure to travel into the countryside by bus and had imagery based on specific places—Kew Gardens, Windsor, Epping Forest (all 1920)—while another was designed to entice the public to explore the many and varied museums of London. For the latter the means of travel was not specified; bus and Underground were equally available. Kauffer's use of subject matter for this series combined geometric theory with realistic imagery—crystals for the Museum of Practical Geology (1922), a prehistoric mammoth for the Natural History Museum, Mr. Stephenson's "Rocket" for the Science Museum (both 1923, Fig. 135), and so on.

Following the development of photolithography, the 1920s became the great era of the illustrated book. As Oliver Simon, a partner at the Curwen Press, noted in a lecture toward the end of the decade, most of them were now produced by the trade, rather than the private presses that under the influence of William Morris and Emery Walker, had dominated the years immediately prior to the Great War. This shift had been made possible by the enormous advances in printing technology effected during the first decades of the twentieth century, which had changed printing from a handcraft to a machine-based skill. The creation of the new professions of graphic designer and typographer were a direct result of this change.[16]

The Week-End Book, with its Kauffer jacket, like *The Anatomy of Melancholy* (1925), *Benito Cereno* (1926, Fig. 136), and *Don Quixote* (1930), was produced by Francis Meynell at the Nonesuch Press. While *The Anatomy of Melancholy* had been printed for Meynell at his cousin's Westminster Press, the other two were printed by Curwen at Plaistow in East London. Kauffer's contacts with Harold Curwen and Oliver Simon were important. Simon's Bloomsbury office, from which he edited *The Fleuron,* became a regular international meeting place for those interested in printing and typographic design, while examples of fine printing

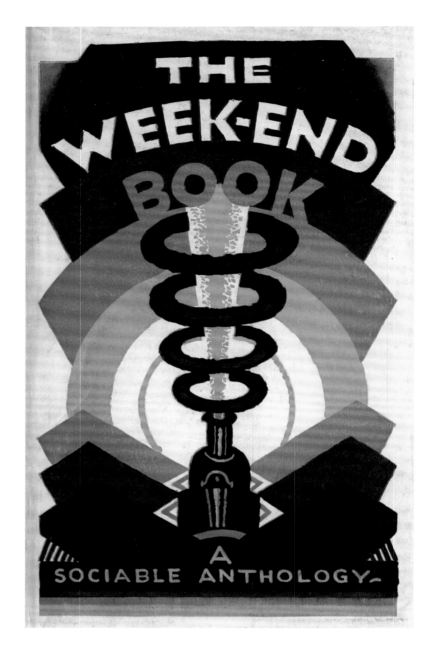

from Europe and America were bound into each issue of the journal.[17] The Curwen Press, in addition to having been in the vanguard of developing photolithography, pioneered the hand-stenciling, or *pochoir* process, in England, the method by which they reproduced Kauffer's illustrations to *Benito Cereno, Don Quixote,* and Arnold Bennett's two novels, *Elsie and the Child* and *Venus Rising from the Sea.*[18] A deeply impressed Paul Nash, writing of *Elsie and the Child,* noted that while Curwen had "produced every reasonable effect demanded of it by illustrators," with this book, "spurred on by Mr Kauffer, it seems to have jumped into the realms of improbability."[19] Kauffer, in his turn, was equally enthusiastic about Nash's illus-

134
EDWARD MCKNIGHT KAUFFER
The train! The twelve o'clock for paradise, ca. 1924, cover design for Vera Meynell, Francis Meynell, and John Goss, eds. *The Week-End Book* (London: Nonesuch Press, 1924).

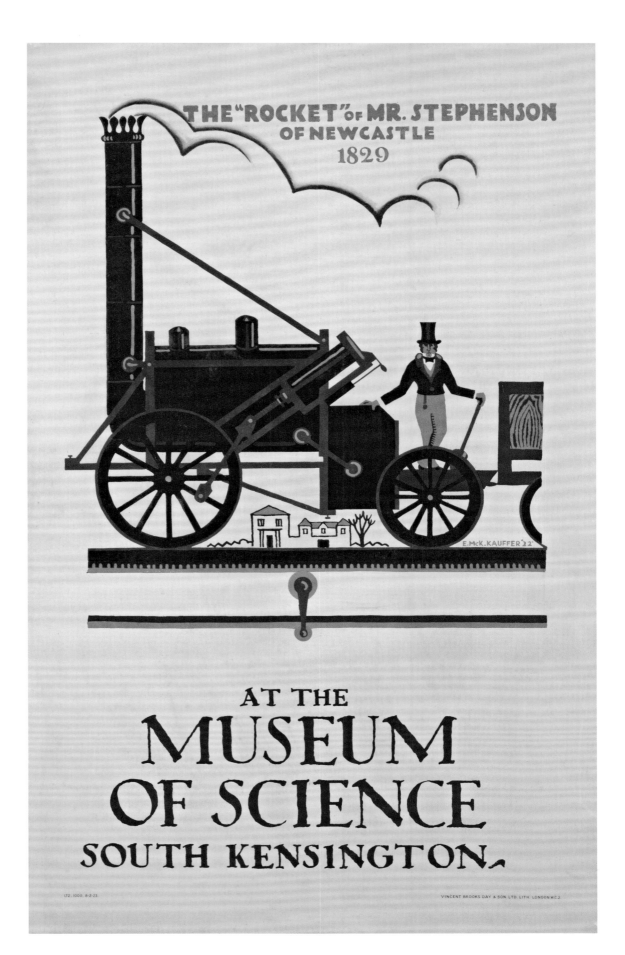

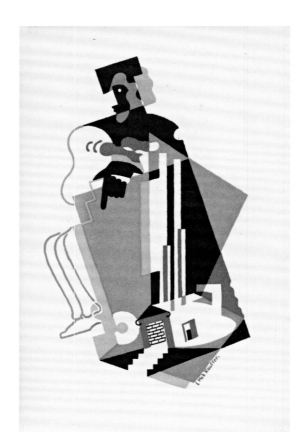

136
EDWARD MCKNIGHT
KAUFFER
hand-colored etching,
illustration to Herman
Melville, *Benito Cereno*
(London: Nonesuch
Press, 1926), 7. Yale
Center for British Art,
Paul Mellon Collection

137
EDWARD MCKNIGHT
KAUFFER
stencil and watercolor,
frontispiece to T. S. Eliot,
A Song for Simeon
(London: Faber & Gwyer
Ltd., 1928). Yale Center
for British Art, Friends
of British Art Fund

trations when *Urne Buriall*, the last of Curwen's hand-stenciled books, appeared in 1932.[20] The illustrations to *Elsie and the Child* were stenciled in gouache, while those for *Venus Rising from the Sea* were more delicately tinted in transparent watercolor; both books were published by Cassell & Co. Two other important links for Kauffer with the publishing world were established at this time by Curwen; one with the avant-garde publishers Etchells & Macdonald, for whom he illustrated *Robinson Crusoe* (1929) and the other with Faber and Gwyer—later Faber and Faber—for whom he illustrated a series of T. S. Eliot's *Ariel Poems*, thus cementing a friendship that was to endure to the end of his life. These illustrations, which were also reproduced by the *pochoir* process, ranged in style from the Cubistic image for the poem *A Song for Simeon* (1928, Fig. 137) through the Picassoesque, classical *Marina,* to the Surrealist *Triumphal March* (both 1930).

Kauffer and Eliot had originally met through the Arts League of Service, which had been founded in 1919 to bring together artists, writers, dancers, and others interested in the wider arts; it promoted poetry readings and lectures

and also set up a traveling theatrical company. Kauffer, with his early experience in repertory and at the Grand Opera House in Evansville, Indiana, involved himself over the years in the League's activities. Among other productions, he designed the costumes and sets for *Mary Queen of Scots* (1934; Fig. 138). While costume was often exuberant and colorful, sets at that time, especially those designed by the more avant-garde young artists, were strongly influenced by the extreme ideas propounded by the impresario and theater theorist Edward Gordon Craig. A number of models for such stage sets were exhibited in 1922 at the Amsterdam International Exhibition of Theatre Art and Craft, and later at the Victoria and Albert Museum, London. One of Kauffer's models, of which a negative exists in the Lund Humphries Archive, now at the Yale Center for British Art (Fig. 139), strongly reflects Craig's influence, while his best-known design, *The Geometry of Chess*— the backdrop for Ninette de Valois's Sadler's Wells Ballet *Checkmate*—of 1937 is a typical Surrealist fantasy. Not surprisingly, Kauffer was also interested in films and the film industry; he designed posters for the first British showing of Robert

138

EDWARD MCKNIGHT
KAUFFER

design for King Henry
VIII's costume in *Mary
Queen of Scots,* 1934,
gouache and graphite
on white wove paper,
18⅝ x 12³⁄₁₆ in.
(47.3 x 31 cm). Cooper-
Hewitt, National Design
Museum, Smithsonian
Institution, New York,
Gift of Mrs. E. McKnight
Kauffer

139

Photograph of a model
for proposed design for
a stage set by Edward
McKnight Kauffer,
probably for the Arts
League of Service,
between1919 and 1935.
Yale Center for British
Art, Lund Humphries
Archive

Wiene's 1920 film *The Cabinet of Dr. Caligari* and Fritz Lang's Futurist film *Metropolis* (ca. 1926). He was a founder member of the Film Society and, as one of the consultants to Associated Realist Film Producers, along with John Grierson, Alberto Cavalcanti, and Julian Huxley, was involved with documentary films, the only section of the industry in which Britain led the world.

Kauffer had many clients who became good friends: Frank Pick at London Underground; Sir Stephen Tallents at the Empire Marketing Board (and later the GPO Film Unit); his cousin, Thomas Tallents, and Colin Anderson at the Orient Shipping Line; Gerald Meynell at the Westminster Press and his cousin, Francis, at the Pelican and Nonesuch Presses; Harold Curwen and Oliver Simon at the Curwen Press; Peter Gregory at Percy Lund Humphries; and Jack Beddington at Shell. Many of these individuals and firms had links with each other, often arising from shared membership in the Design and Industries Association.

In any discussion of Shell advertising the names of Kauffer and Beddington are invariably, and justifiably, conjoined, but Kauffer had been employed to produce Shell promotional material for a num-

ber of years prior to Beddington taking charge of the firm's publicity department. This earlier material, however, was mostly restricted to black and white drawings used primarily in press advertisements, commissioned through one or other of the Meynells—although the Shell Archive also possesses four painted and lettered panels dating from 1920. His first commissioned poster, *International Aero Exhibition—Shell 1929* (Fig. 140), marks the beginning of a new phase in Kauffer's work. The age of the T-square had arrived.

A big change had occurred in Kauffer's life in 1923, when he met Marion Dorn in Paris and subsequently set up home with her in one of the studio flats in the newly built Swan Court in Chelsea. Among their immediate neighbors were Eric Craven Gregory, known as Peter, a director of the Bradford-based printing firm of Percy Lund Humphries, and the sculptor Antony Gibbons Grinling, whose stylish apartment was designed by Serge Chermayeff. Dorn was a well-established textile designer, at the same professional level as Kauffer, and like him able to supply a client's needs whether for bold floral design or abstract pattern. However, she and Kauffer shared a commitment

to the Modernist geometric aesthetic of the Bauhaus, and nowhere is this more evident than in the rugs they designed for the Royal Wilton Carpet Factory (Fig. 141). In an article for *The Studio* Kauffer related the design of these rugs directly to modern architecture, commenting that while Gothic windows had been tall and narrow and eighteenth-century ones square, windows in the modern house were wide and horizontal; thus the modern rug should, equally, "by its pattern, suggest the horizontal."[21] He seldom theorized about his own practice, but three years earlier, in "The Poster and Symbolism," he had written: "The terms 'Cubistic,' 'Futuristic,' and the like are too often applied to the present-day poster in error. . . . For my own part, the brief research I have made as a painter, has been beneficial to me. . . . It has made it possible to make new translations of old forms, and it has assisted me to emphasize the qualities and importance of the use of colour, and helped to simplify my arrangement of ideas."[22] Although the comment is here specifically about posters, it is symptomatic of his general approach to design.

In line with these principles the patterning of

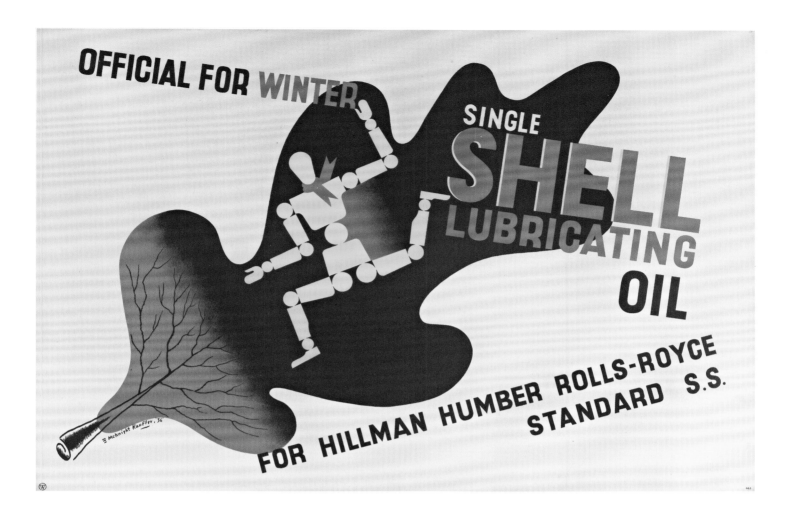

OFFICIAL FOR WINTER
SINGLE
SHELL
LUBRICATING
OIL
FOR HILLMAN HUMBER ROLLS-ROYCE STANDARD S.S.

142

EDWARD MCKNIGHT KAUFFER

Official for Winter: Single Shell Lubricating Oil, 1936, commissioned by Royal Dutch Shell Co., printed by Waterlow & Sons, 29¾ x 44⅝ in. (75.6 x 113.3 cm). Yale Center for British Art, Gift of Henry S. Hacker, Yale College, Class of 1965

Kauffer's and Dorn's rugs was largely confined to the geometrical, while their format emphasized their horizontality. By happy coincidence this period of designing for the Wilton Factory coincided with his earliest poster commissions for Shell. Unlike most of his previous poster work, the Shell posters were to be horizontal rather than vertical, as they were mainly displayed as bills on the sides of trucks rather than on the traditional hoardings. *International Aero Exhibition* is distinguished by its rectangles in mauve, yellow, and red against a white ground; in contrast to the solidity of these blocks of color, the subtle use of the airbrush suggests the speed of the stylized aircraft. Consciously or unconsciously Kauffer was conforming to the theories expounded as early as 1916 by the Bauhaus master Johannes Itten: "The clear geometric form is the one most easily comprehended and its basic elements are the circle, the square and the triangle. Every possible form lies dormant in these formal elements. . . . Form

is also colour. Without colour there is no form."[23] During these years Kauffer was in the vanguard of British Modernism, discussing the formation of Unit One, a new artists' group devoted to Modernism, with the critic Herbert Read, the architect Wells Coates, and the painters Paul Nash and Ben Nicholson, as well as sharing a photographic studio at Lund Humphries with Man Ray.

His connection with the printing firm of Percy Lund Humphries was fostered by his friendship with Peter Gregory, who was both a patron and a neighbor.[24] Kauffer designed publicity material for Lund Humphries in his most avant-garde geometric manner, exhibited in their gallery, and had a studio on their premises in Bloomsbury. The archive now at the Yale Center comprises a record of Kauffer's published work kept by the firm, as well as a few of Kauffer's own negatives.

Although Beddington was an enlightened collector of contemporary art, professionally he was well aware that more traditional pictorial imagery

remained important for his public; while delighting in such geometric and typographic designs as *International Aero Exhibition* and *Magicians Prefer Shell,* he also encouraged Kauffer's use of photomontage as well as the use of his witty articulated man. This figure became an unofficial company logo, appearing in many guises and poses on a wide range of promotional material from posters, lorry bills, and press advertisements to cans of lubricating oil and lapel badges. In his poster *Official for Winter: Single Shell Lubricating Oil* (1936, Fig. 142), for instance, the articulated man dances gaily in front of a large autumnal oak leaf, whose veins are the skeletal branches of winter trees, while the leaf itself is a pool of flowing oil.

Beddington, like Pick, stepped back from Kauffer's more radical imagery when he felt it was in the best interests of Shell. In contrast to *Winter,* the 1939 poster for *Summer Shell* depicts a carelessly tossed-aside straw boater lying neglected on the grass, while its owner abandons himself to other, unspecified, pleasures. The previous year Kauffer had produced an even more pared-down image to advertise an exhibition of modern silverwork at Goldsmiths' Hall (Fig. 143), for which he used one of his own photographs, the negative of which is in the Yale archive. It depicts a fluted vase—one of a set of six designed by Professor R. Y. Gleadowe and made by H. G. Murphy for the Goldsmiths' Company—juxtaposed against a lion's head, the hallmark for the London Assay Office.

At heart Kauffer may have nurtured the ambition to be in the avant garde of international modern art and design, an ambition he nearly achieved; what he did achieve, however, was the distinction of bringing modern art to a broad swathe of the British public. In the decade following Kauffer's death the art historian Kenneth Clark, through the medium of television, introduced a mass audience to the richness of western culture.[25] Kauffer, exploiting the possibilities of a more limited, but nonetheless equally popular medium, the poster, surreptitiously introduced Cubism, abstraction, geometric nonfiguration, and Surrealism to the British commuter. His most daring nonfigurative designs for Shell, Lund Humphries, and Fortnum & Mason exploited geometric forms and block lettering and stood at the cutting edge of design, as did his striking poster *Great Western to Devon's*

Moors for the Great Western Railway (Fig. 144). It is a hauntingly surreal image with the airlessness of a Magritte, and like so many of Magritte's images it is both seductive and slightly scary. Where will that endless road lead us? Are its dislocations an invitation or a rejection? Is that dominating cross really as innocent as a road intersection? This spookiness is heightened by the ghostliness of the typography: it would be hard to reduce further the lettering of the words "GREAT WESTERN TO" and still make them readable to the passing public.

All this was to end with the outbreak of war in September 1939. Kauffer and Dorn were designated aliens and as such were required to apply for police papers each time they wished to travel from their apartment in Chelsea to their rented country retreat in Buckinghamshire. Despite his ardent Anglophilia, and the fact that he was the most highly respected graphic artist in the country, Kauffer was only offered an insignificant post at the Ministry of Information on behalf of the war effort. Depression overtook him and Dorn, and on July 1, 1940, acting on impulse, they boarded the SS. *Washington* bound for New York and never returned to England.

Kauffer had been to New York before, having first exhibited there in the early 1920s, and as recently as 1937 the Museum of Modern Art had staged a retrospective exhibition of his posters, whose catalogue cover he had designed (Fig. 145).

143
EDWARD MCKNIGHT KAUFFER
Exhibition of Modern Silverwork, 1938, commissioned by LT, printed by the Baynard Press, 10 x 12 ½ in. (25.4 x 31.8 cm). Yale Center for British Art, Gift of Henry S. Hacker, Yale College, Class of 1965

**EDWARD MCKNIGHT
KAUFFER**

*Great Western to
Devon's Moors*, 1933,
commissioned by
GWR, 40 x 25 in.
(101.6 x 63.5 cm).
National Railway
Museum, York

Yet he now found himself a novice in a largely unfamiliar environment. He wrote to his friends St. John and Mary Hutchinson: "My work is well known, it is highly respected but it has 'the European point of view' and this is not saleable. So I must restate myself in different terms!"[26] The emotional strain was too great and he suffered a breakdown. Dorn wrote to Mary Hutchinson later in the year: "Ted was in hospital for two months, desperately ill, ever since May. . . . He was unconscious when they put him on the stretcher and took him away. . . . It all came from Teds [sic] mental disturbance at finding himself here, and a sense of guilt that he could not stifle."[27] He and Marion had left England on impulse; as Hans Schleger wrote in his obituary, "He left because—impatiently mistaken—he believed himself suddenly unwanted. The shock felled him."[28]

This powerful, if irrational, sense of guilt dogged him for the remainder of his life and although he got plenty of jobs doing product promotions, magazine covers, and book jackets for Ringling Brothers, *The Saturday Review of Literature, Harpers Bazaar, Fortune* magazine, and Random House, American Airlines was the only major client who in any way challenged him to try and recapture the heights that had consistently marked his achievements of the interwar years. He died in New York on October 22, 1954. He had, percipiently, written his own epitaph in a letter to Colin Anderson soon after arriving back in the United States: "Perhaps it is an expatriate's (one who has withdrawn from his own country) fate to remain betwixt and between."[29] Fifty years after his death Kauffer, the greatest Anglo-American graphic artist of the twentieth century, continues to be "betwixt and between," having no entry in either the British or American Dictionaries of National Biography. But to be betwixt and between is also to be a bridge and a conduit, and so Kauffer stands as the link between high Modernism and popular culture, mediating the two immense innovations of the years before World War II: the invention of mass advertising and the invention of avant-garde art.

145

EDWARD MCKNIGHT KAUFFER

Cover of Edward McKnight Kauffer, *Posters: with Notes by E. McKnight Kauffer and a Foreword by Aldous Huxley* (New York: The Museum of Modern Art, 1937). Yale Center for British Art, Friends of British Art Fund

The author would like to thank Edward McKnight Kauffer's grandson, Simon Rendall, Dr. Gail S. Davidson and Floramae McCarron-Cates (Smithsonian Institution, Cooper-Hewitt National Design Museum), Lord Hutchinson of Lullington, QC, Paul Atterbury, Brian Webb (Webb & Webb), Nicky Balfour (Shell Archive), Adrian Glew and Emily White (Tate Gallery Archive), and Tim Craven (Southampton City Art Gallery).

1. I am unable to establish the precise number. The photocopy of the November 1918 London Group catalogue in the Tate Gallery Archive is incomplete, blanking out immediately after listing the titles of three of Kauffer's exhibited works. In most of the other London Group exhibitions he showed the permitted five works.

2. Letter, Edward McKnight Kauffer to Maxwell Armfield, Tate Gallery Archive, TGA 976. Although the letter is undated, he tells Armfield that the Allied Artists exhibition "will be held in June at the Grafton Galleries." Kauffer only exhibited with the AAA on one occasion, at the Grafton Galleries in June 1917. I am grateful to Teri Edelstein for drawing my attention to this letter.

3. Kauffer to Armfield, TGA 976.

4. Percy Wyndham Lewis, *Blasting and Bombardiering* (London: Eyre & Spottiswoode, 1937), 211.

5. Arthur F. Mathews was Director of the California School of Design from 1890 to 1906. The school was renamed when it inherited the Mark Hopkins House.

6. Donald Hagerty, *Desert Dreams: The Art and Life of Maynard Dixon*, rev. ed. (Salt Lake City: Gibbs Smith, 1997), 10.

7. Kauffer identified the eighteenth-century silhouette as a precursor of much twentieth-century advertising imagery; the silhouette when combined with the Japanese print "produced a compound type of design which is familiar to our sight today. The Beggarstaff Brothers are chiefly responsible for this, though Toulouse-Lautrec indicated very strongly this direction as well"; in Edward McKnight Kauffer, ed. *The Art of the Poster, Its Origin, Evolution, and Purpose* (London: Cecil Palmer, 1924), 84. He went on to illustrate his point with, among others, several of Ludwig Hohlwein's posters, including that of the dancer Kitty Starling.

8. See Christian Barman, *The Man Who Built London Transport: A Biography of Frank Pick* (Newton Abbot, Eng.: David & Charles, 1979), 40.

9. Japonism is the term generally applied to the influence exerted on Western design following the opening up of Japan to commerce with the west in the mid-nineteenth century. The Japanese display at the 1862 London International Exhibition drew considerable attention, which, in due course, was followed by the opening of Liberty's London emporium and Siegfried Byng's Hotel de l'Art Nouveau in Paris, both of which became major importers of Japanese wares. These wares often arrived wrapped in discarded woodcuts, which attracted the interest of the stores' artistic clientele; thus, by the turn of the twentieth century, the forms and imagery of the Japanese print had become a commonplace of western pictorial art, particularly poster art. Tiffany's, New York, employed Japanese craftspeople to fashion many of their wares, especially pieces involving the complex use of different metals.

10. See Mark Haworth-Booth, *E. McKnight Kauffer: A Designer and His Public* (London: Victoria and Albert Museum, 2005), 6.

11. London Group, *6th Biannual Exhibition*, exh. cat. (London: Goupil Gallery, April 26–May 26, 1917), no. 72, *Berkshire*. Apart from the title, the catalogue gives no further details to help in identification, so this is not necessarily the landscape illustrated above.

12. Kauffer to Armfield, TGA 976.

13. Kauffer to Armfield, TGA 976.

14. In the aftermath of the Russian Revolution Lenin and Lunacharsky ordered revolutionary artists to use the stocks of white blanks they found in the Imperial Porcelain Factory in Petrograd for the purpose of propaganda. The results were a radical rethinking of decoration on Constructivist and Cubist lines, with a mixture of fragmentary images and geometric forms. For a detailed account see Nina Lobanov-Rostovsky, *Revolutionary Ceramics: Soviet Porcelain, 1917–1927* (London: Studio Vista, 1990). Kauffer's interest in Soviet graphics is manifest in his edited volume, *The Art of the Poster*, which reproduces several examples from his own collection, particularly Soudeikine's *Bat Theatre,* as well as agitprop posters from the collection of the British Museum.

15. *Commercial Art* 3, no. 13 (July 1927).

16. For the text of Oliver Simon's lecture at Stationers' Hall see *Caxton Magazine* 31, no. 2 (February 1929).

17. *The Fleuron* remains the most influential typographical journal ever published. The first four volumes (1923–25) were edited by Oliver Simon and printed at the Curwen Press, while volumes 5–7 were edited by Stanley Morison and printed at the Cambridge University Press.

18. The *pochoir* process of hand-stenciling was originally developed in France, as its name implies. Harold Curwen pioneered the process in England, cutting the stencils himself before he trained a skilled team of young women both to cut the stencils and apply the color in either watercolor or gouache. In addition to aesthetic advantages, for limited-edition books or pamphlets printed in quantities of less than a thousand, the process was considerably cheaper than more traditional methods of printing.

19. Draft review for *The Bibliophile's Almanack,* Cambridge University Library, Morison Room Papers, xxvii.323

20. In the postscript to a letter to Nash, November 9, 1932, Kauffer wrote, " 'Urne Buriall' is I think the best illustrated book done in England. Hats off—to you!" Tate Gallery Archive 8313/1/2/110.

21. "New Rug Designs by E. McKnight Kauffer and Marion V. Dorn," *Studio* 97 (1929): 37–38.

22. Edward McKnight Kauffer, "The Poster and Symbolism," *Penrose Annual* 26 (1924): 42.

23. Quoted in Frank Witford, *Bauhaus* (London: Thames & Hudson, 2003), 10.

24. When Kauffer and Dorn left England in July 1940 they abandoned virtually all their possessions; Kauffer even had to create a new portfolio of work. After the war he was reunited with a large body of his work, which now forms an archive at the Cooper-Hewitt Museum, New York. During the war Peter Gregory took over Kauffer's apartment in Chelsea, as well as having access to the studio at Lund Humphries, so he is the most likely person to have been in a position to assemble and ship the work to New York later.

25. In 1969 Clark presented the popular BBC television series *Civilisation.*

26. Edward McKnight Kauffer, letter to St. John and Mary Hutchinson, February 14, 1941, private collection, UK.

27. Marion Dorn, letter to Mary Hutchinson, November 10, 1941, private collection, UK.

28. Hans Schleger, *Advertising Review* 1, no. 3 (Winter 1954–55): 33.

29. Edward McKnight Kauffer, letter to Sir Colin Anderson, February 10, 1941, photostat in the Kauffer Estate.

Dekk

CHECKLIST OF THE BRITISH POSTER COLLECTION

OF THE YALE CENTER FOR BRITISH ART

COMPILED BY JO BRIGGS AND ANDREA WOLK RAGER

Artists' life dates are established according to best available information. Dimensions are sheet size unless otherwise noted.
Commissioning railway companies are abbreviated as follows:
BR: British Railways GWR: Great Western Railway LMS: London, Midland, and Scottish Railway
LNER: London and North Eastern Railway LT: London Transport SR: Southern Railway
UERL: Underground Electric Railways of London

MARY ADSHEAD
1904–1995
Always an Open Way, 1937
One of a series
Commissioned by LT
Printed by Waterlow & Sons
Lithograph
40 x 25 1/16 in. (101.6 x 63.7 cm)
Gift of Henry S. Hacker, Yale College, Class of 1965
B2006.24.3

MARY ADSHEAD
1904–1995
Shared Joys Are Doubled, 1937
One of a series
Commissioned by LT
Printed by Waterlow & Sons
Lithograph
39 7/8 x 24 15/16 in. (101.3 x 63.3 cm)
Gift of Henry S. Hacker, Yale College, Class of 1965
B2006.24.1

BRUCE ANGRAVE
1914–1983
City Towers: Sir Christopher Wren, 1964
Commissioned by LT
Printed by the Baynard Press
Lithograph
38 3/8 x 25 in. (97.5 x 63.5 cm)
Gift of Henry S. Hacker, Yale College, Class of 1965
B2004.18.33

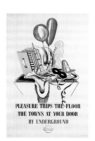

MARY ADSHEAD
1904–1995
Pleasure Trips the Floor, 1937
One of a series
Commissioned by LT
Printed by Waterlow & Sons
Lithograph
40 x 25 in. (101.6 x 63.5 cm)
Gift of Henry S. Hacker, Yale College, Class of 1965
B2006.24.2

JOHN ARTHUR MALCOLM ALDRIDGE
1905–1983
Shell Guide to Norfolk, ca. 1960
One of a series
Commissioned by Royal Dutch Shell Co.
Printed by C. Nicholls and Co.
Lithograph
29 x 20 in. (73.7 x 50.8 cm)
Promised gift of Henry S. Hacker,
Yale College, Class of 1965

MAXWELL ASHBY ARMFIELD
1881–1972
Go to Kew, 1915
Commissioned by UERL
Printed by Waterlow & Sons
Lithograph
29 1/2 x 19 3/8 in. (74.9 x 49.2 cm)
On this copy of the poster, the name "Armfield"
has been altered by hand to read "Mayfield"
Friends of British Art Fund
B2008.33

ANTHONY ATKINSON
born 1929
Shere Church, 1966
Commissioned by LT
Printed by John Swain and Son
Lithograph
39 ³/₁₆ x 25 in. (99.5 x 63.5 cm)
Gift of Henry S. Hacker, Yale College, Class of 1965
B1993.3.10

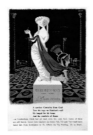

JOHN BAINBRIDGE
1920–1978
Verulamium: Careless Centurion from Gaul, 1956
Commissioned by LT
Printed by the Baynard Press
Lithograph
40 x 25 in. (101.6 x 63.5 cm)
Gift of Henry S. Hacker, Yale College, Class of 1965
B1993.3.7

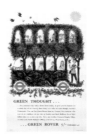

EDWARD ROBERT BARTELT
Green Thought, 1961
Commissioned by LT
Printed by Leonard Ripley & Co.
Lithograph
39 ⁷/₈ x 24 ⁷/₈ in. (101.3 x 63.2 cm)
Gift of Henry S. Hacker, Yale College, Class of 1965
B1993.3.8

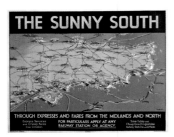

GEORGE AYLING
1887–1960
The Sunny South, 1932
Commissioned by SR
Printed by McCorquodale & Co.
Lithograph
39 ¼ x 49 ⁷/₈ in. (99.7 x 126.7 cm)
Gift of Henry S. Hacker, Yale College, Class of 1965
B2002.22.2

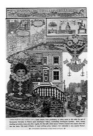

CAROL MINTUM BARKER
born 1938
London Museum, 1969
Commissioned by LT
Printed by John Swain and Son
Lithograph
38 ⁷/₈ x 24 ¹⁵/₁₆ in. (98.7 x 63.3 cm)
Gift of Henry S. Hacker, Yale College, Class of 1965
B2004.18.32

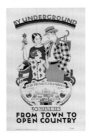

DORA M. BATTY
1900–1966
For Picnics and Rambles from Town to Open Country, 1925
One of a series
Commissioned by UERL
Printed by Vincent Brooks, Day & Son
Lithograph
40 ¹/₈ x 25 ¹/₈ in. (101.9 x 63.8 cm)
Promised gift of Henry S. Hacker,
Yale College, Class of 1965

STANLEY ROY BADMIN
1906–1989
Shell Guide to Surrey, ca. 1960
One of a series
Commissioned by Royal Dutch Shell Co.
Printed by Henry Stone and Son
Lithograph
29 ½ x 20 in. (74.9 x 50.8 cm)
Promised gift of Henry S. Hacker,
Yale College, Class of 1965

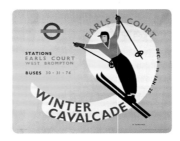

MARGARET BARNARD
1898–1992
Winter Cavalcade, 1938
Commissioned by LT
Printed by Waterlow & Sons
Lithograph
10 x 12 ½ in. (25.4 x 31.8 cm)
Gift of Henry S. Hacker, Yale College, Class of 1965
B2000.8.35

JOAN BEALES
born 1926
London's Museums, 1955
Right panel of pair
Commissioned by LT
Printed by the Baynard Press
Lithograph
40 ¹/₁₆ x 25 in. (101.8 x 63.5 cm)
Gift of Henry S. Hacker, Yale College, Class of 1965
B2004.18.26

JOAN BEALES
born 1926
*Cassiobury Park / Hatfield House / Hampton Court /
St. Albans*, 1956
Left panel of pair with *Epping / Richmond /
Whipsnade / Windsor*
Commissioned by LT
Printed by the Baynard Press
Lithograph
40 x 25 in. (101.6 x 63.5 cm)
Gift of Henry S. Hacker, Yale College, Class of 1965
B2004.18.22

JOAN BEALES
born 1926
Epping / Richmond / Whipsnade / Windsor, 1956
Right panel of pair with *Cassiobury Park /
Hatfield House / Hampton Court/ St. Albans*
Commissioned by LT
Printed by the Baynard Press
Lithograph
40 x 24 ¹⁵/₁₆ in. (101.6 x 63.3 cm)
Gift of Henry S. Hacker, Yale College, Class of 1965
B2004.18.21

DONALD BLAKE
1908–1997
Britain: Spearhead of Attack, between 1939 and 1945
Printed by Alf Cooke
Lithograph
19 ¹³/₁₆ x 29 ⁹/₁₆ in. (50.3 x 75.1 cm)
Promised gift of Henry S. Hacker,
Yale College, Class of 1965

SUSANNA BOTT
Country Walks: Hampstead Heath, 1961
Commissioned by LT
Printed by the Baynard Press
Lithograph
39 ¹⁵/₁₆ x 24 ¹⁵/₁₆ in. (101.4 x 63.3 cm)
Gift of Henry S. Hacker, Yale College, Class of 1965
B2000.8.8

WILLIAM BOWYER
born 1926
Cornwall, after 1948
Commissioned by BR
Printed by N. Lloyd & Co.
Lithograph
39 ³/₄ x 49 ³/₄ in. (101 x 126.4 cm)
Gift of Henry S. Hacker, Yale College, Class of 1965
B2004.18.13

FRANK WILLIAM BRANGWYN
1867–1956
North East Coast Industries (proof), 1927
Commissioned by LNER
Printed by the Avenue Press
Lithograph
39 ½ x 51 in. (100.3 x 129.5 cm)
Gift of Henry S. Hacker, Yale College, Class of 1965
B2002.22.3

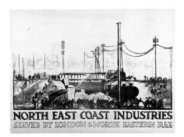

FRANK WILLIAM BRANGWYN
1867–1956
North East Coast Industries, 1927
Commissioned by LNER
Printed by the Avenue Press
Lithograph
39 ½ x 50 ¼ in. (100.3 x 127.6 cm)
Gift of Henry S. Hacker, Yale College, Class of 1965
B2002.22.4

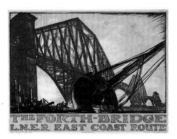

FRANK WILLIAM BRANGWYN
1867–1956
Over the Nidd near Harrogate, 1927
Commissioned by LNER
Printed by the Avenue Press
Lithograph
40 x 50 in. (101.6 x 127 cm)
Paul Mellon Fund
B1992.22.19

FRANK WILLIAM BRANGWYN
1867–1956
The Forth-Bridge, 1930
Commissioned by LNER
Printed by the Avenue Press
Lithograph
40 x 49 ⁷/₈ in. (101.6 x 126.7 cm)
Paul Mellon Fund
B1992.22.20

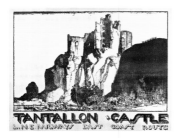

FRANK WILLIAM BRANGWYN
1867–1956
Tantallon Castle (proof for *North Berwick for Tantallon Castle, Scotland by East Coast Route*),
ca. 1932
Commissioned by LNER
Printed by the Avenue Press
Lithograph
39 ¾ x 50 ⁹/₁₆ in. (101 x 128.4 cm)
Gift of Henry S. Hacker, Yale College, Class of 1965
B2002.22.5

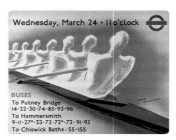

PERCY DRAKE BROOKSHAW
1907–1993
Boat Race, 1937
Commissioned by LT
Lithograph
9 ¹⁵/₁₆ x 12 ⁷/₁₆ in. (25.2 x 31.6 cm)
Gift of Henry S. Hacker, Yale College, Class of 1965
B2000.8.33

JOHN MACKINTOSH BURNINGHAM
born 1936
London Parks: Autumn Leaves, 1961
Commissioned by LT
Printed by Waterlow & Sons
Lithograph
40 x 25 in. (101.6 x 63.5 cm)
Gift of Henry S. Hacker, Yale College, Class of 1965
B1993.3.2

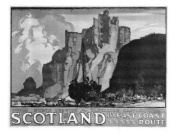

FRANK WILLIAM BRANGWYN
1867–1956
North Berwick for Tantallon Castle, Scotland by East Coast Route, ca.1932
Commissioned by LNER
Printed by the Avenue Press
Lithograph
39 ⁵/₁₆ x 49 ½ in. (99.9 x 125.7 cm)
Gift of Henry S. Hacker, Yale College, Class of 1965
B2002.22.6

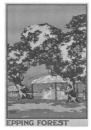

F. GREGORY BROWN
1887–1941
Epping Forest, 1916
Commissioned by UERL
Printed by the Dangerfield Printing Co.
Lithograph
29 ⁷/₈ x 19 ⁵/₈ in. (75.9 x 49.8 cm)
Promised gift of Henry S. Hacker,
Yale College, Class of 1965

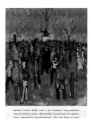

PETER LEONARD CAREY
born 1931
Speakers' Corner, 1966
Commissioned by LT
Printed by Johnson, Riddle & Co.
Lithograph
39 ³/₁₆ x 24 ⁷/₈ in. (99.5 x 63.2 cm)
Gift of Henry S. Hacker, Yale College, Class of 1965
B1993.3.11

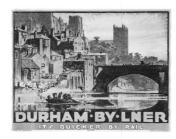

FRANK WILLIAM BRANGWYN
1867–1956
Durham by LNER: It's Quicker by Rail, ca. 1933
Commissioned by LNER
Printed by the Avenue Press
Lithograph
39 ⁷/₈ x 50 in. (101.3 x 127 cm)
Paul Mellon Fund
B1992.22.21

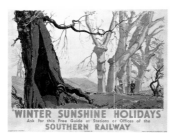

F. GREGORY BROWN
1887–1941
Winter Sunshine Holidays, 1937
Commissioned by SR
Printed by McCorquodale & Co.
Lithograph
39 ¾ x 49 ¾ in. (101 x 126.4 cm)
Gift of Henry S. Hacker, Yale College, Class of 1965
B2000.8.21

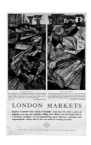

GAYNOR PATRICIA CHAPMAN
1935–2000
London Markets, 1961
Commissioned by LT
Printed by McCorquodale & Co.
Lithograph
39 ¹⁵/₁₆ x 24 ⁷/₈ in. (101.4 x 63.2 cm)
Gift of Henry S. Hacker, Yale College, Class of 1965
B2000.8.9

GAYNOR PATRICIA CHAPMAN
1935–2000
Country Walks: The Naturalist, 1963
Commissioned by LT
Printed by Waterlow & Sons
Lithograph
39 ¹⁵/₁₆ x 25 in. (101.4 x 63.5 cm)
Gift of Henry S. Hacker, Yale College, Class of 1965
B2000.8.10

KENNETH GEORGE CHAPMAN
1908–1993
*Competition: Sculpture Guessing: Make the Most
of Your Public Transport*, 1955
Right panel of pair
Commissioned by LT
Printed by Waterlow & Sons
Lithograph
39 ¹⁵/₁₆ x 24 ⅞ in. (101.4 x 63.2 cm)
Gift of Henry S. Hacker, Yale College, Class of 1965
B2004.18.27

GRAHAM ARTHUR CLARKE
born 1941
Knole, 1967
Commissioned by LT
Printed by Johnson, Riddle & Co.
Lithograph
39 ½ x 25 in. (100.3 x 63.5 cm)
Gift of Henry S. Hacker, Yale College, Class of 1965
B1993.3.1

AUSTIN COOPER
1890–1964
Innsbruck via Harwich Twice a Day,
between 1923 and 1947
Commissioned by LNER
Printed by Hermann Sontag & Co.
Lithograph
40 x 50 ⅛ in. (101.6 x 127.3 cm)
Promised gift of Henry S. Hacker,
Yale College, Class of 1965

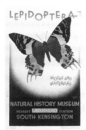

AUSTIN COOPER
1890–1964
Natural History Museum: Lepidoptera, 1928
One of a series
Commissioned by UERL
Printed by the Baynard Press
Lithograph
39 ¾ x 25 in. (101 x 63.5 cm)
Friends of British Art Fund
B2008.7

AUSTIN COOPER
1890–1964
America: British Museum, 1930
One of a series
Commissioned by UERL
Printed by the Baynard Press
Lithograph
39 ¾ x 24 ¹³/₁₆ in. (101 x 63 cm)
Promised gift of Henry S. Hacker,
Yale College, Class of 1965

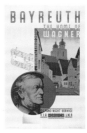

AUSTIN COOPER
1890–1964
*A Music Lover's Pilgrimage, No. 3:
Bayreuth, the Home of Wagner*, 1930
One of a series
Commissioned by LNER
Printed by Ben Johnson & Co.
Lithograph
39 ¹³/₁₆ x 25 ¹/₁₆ in. (101.1 x 63.7 cm)
Gift of Henry S. Hacker, Yale College, Class of 1965
B2002.22.7

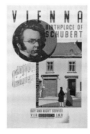

AUSTIN COOPER
1890–1964
*A Music Lover's Pilgrimage, No. 5:
Vienna, Birthplace of Schubert*, 1930
One of a series
Commissioned by LNER
Printed by Ben Johnson & Co.
Lithograph
39 ¾ x 25 ¹/₁₆ in. (101 x 63.7 cm)
Gift of Henry S. Hacker, Yale College, Class of 1965
B2002.22.8

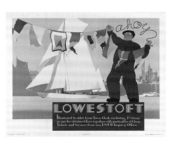

AUSTIN COOPER
1890–1964
Lowestoft, 1932
Commissioned by LNER
Printed by McCorquodale & Co.
Lithograph
40 ¹/₁₆ x 50 ¹/₁₆ in. (101.8 x 127.2 cm)
Promised gift of Henry S. Hacker,
Yale College, Class of 1965

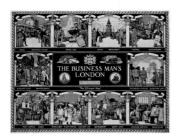

RICHARD T. COOPER
1884–1957
The Business Man's London, 1930
Commissioned by UERL
Printed by Waterlow & Sons
Lithograph
39 ¾ x 49 ⅝ in. (101 x 126 cm)
Gift of Henry S. Hacker, Yale College, Class of 1965
B2001.16.1

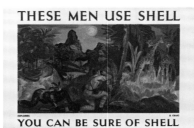

FRANK BARRINGTON (BARRY) CRAIG
1902–1951
These Men Use Shell, 1938
Commissioned by Royal Dutch Shell Co.
Printed by the Baynard Press
Lithograph
30 x 45 in. (76.2 x 114.3 cm)
Promised gift of Henry S. Hacker,
Yale College, Class of 1965

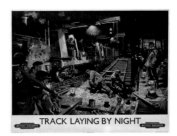

TERENCE TENISON CUNEO
1907–1996
Track Laying by Night, after 1948
Commissioned by BR
Printed by Waterlow & Sons
Lithograph
39 ¼ x 48 ⅞ in. (99.7 x 124.1 cm)
Gift of Henry S. Hacker, Yale College, Class of 1965
B2004.18.2

ALDO COSOMATI
active 1915–1938
Shop by Underground, 1926
Commissioned by UERL
Printed by John Waddington
Lithograph
40 x 24 ⅞ in. (101.6 x 63.2 cm)
Friends of British Art Fund
B2006.11.1

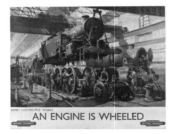

TERENCE TENISON CUNEO
1907–1996
Derby Locomotive Works: An Engine Is Wheeled,
after 1948
Commissioned by BR
Printed by Waterlow & Sons
Lithograph
39 ⁵⁄₁₆ x 48 ¼ in. (99.9 x 122.6 cm)
Gift of Henry S. Hacker, Yale College, Class of 1965
B2004.18.1

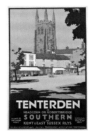

VERNEY L. DANVERS
Tenterden, before 1923
Commissioned by Southern and Kent
and Essex Railways
Printed by Ben Johnson & Co.
Lithograph
39 ⅞ x 25 ⅛ in. (101.3 x 63.8 cm)
Gift of Henry S. Hacker, Yale College, Class of 1965
B2000.8.6

ELIJAH ALBERT COX
1876–1955
British Empire Exhibition, April to October 1924, 1924
Commissioned by British Empire Exhibition
Printed by John Waddington
Lithograph
118 ¾ x 78 ¹¹⁄₁₆ in. (301.6 x 199.9 cm)
Promised gift of Henry S. Hacker,
Yale College, Class of 1965

TERENCE TENISON CUNEO
1907–1996
*Scotland for Your Holidays: The World Famous
Forth Bridge*, after 1948
Commissioned by BR
Printed by Waterlow & Sons
Lithograph
39 ⅝ x 49 ¹⁄₁₆ in. (100.6 x 124.6 cm)
Gift of Henry S. Hacker, Yale College, Class of 1965
B2000.8.1

AMAR DE
The Old Fort Jodhpur, between 1933 and 1953
Commissioned by Indian National Airways
Printed by Imperial Art Cottage, Calcutta
Lithograph
40 ³⁄₁₆ x 27 ¼ in. (102.1 x 69.2 cm)
Gift of Henry S. Hacker, Yale College, Class of 1965
B2004.18.7

DORRIT DEKK
born 1917
We Londoners, 1961
Commissioned by LT
Printed by John Swain and Son
Lithograph
40 ¹/₁₆ x 25 ¹/₁₆ in. (101.8 x 63.7 cm)
Gift of Henry S. Hacker, Yale College, Class of 1965
B1993.3.14

DOBSON
(possibly Eric Dobson, 1923–1992)
(Clement Dane Studio)
Sightseeing Bus Tours: Enjoy London Transport's Twenty Miles, 1963
Commissioned by LT
Printed by Waterlow & Sons
Lithograph
39 ¹⁵/₁₆ x 24 ¹³/₁₆ in. (101.4 x 63 cm)
Gift of Henry S. Hacker, Yale College, Class of 1965
B1991.46.8

THOMAS C. (TOM) ECKERSLEY
1914–1997
Watch or Catch, 1954
Left panel of pair
Commissioned by LT
Printed by Waterlow & Sons
Lithograph
40 x 24 ⁹/₁₆ in. (101.6 x 62.4 cm)
Gift of Henry S. Hacker, Yale College, Class of 1965
B2004.18.30

ERNEST MICHAEL DINKEL
1894–1983
Visit the Empire: Australia . . . , 1933
One of a series
Commissioned by UERL
Printed by Waterlow & Sons
Lithograph
39 ⁷/₈ x 24 ⁷/₈ inches (101.3 x 63.2 cm)
Promised gift of Henry S. Hacker,
Yale College, Class of 1965

ANTHONY JOHN ECKERSLEY
1937–2004
Old St. Paul's, 1964
Commissioned by LT
Printed by Waterlow & Sons
Lithograph
39 x 25 in. (99.1 x 63.5 cm)
Gift of Henry S. Hacker, Yale College, Class of 1965
B2004.18.31

THOMAS C. (TOM) ECKERSLEY
1914–1997
The London Museum, 1963
Commissioned by LT
Printed by Leonard Ripley & Co.
Lithograph
39 ⁷/₈ x 25 in. (101.3 x 63.5 cm)
Gift of Henry S. Hacker, Yale College, Class of 1965
B2004.18.29

ERNEST MICHAEL DINKEL
1894–1983
Visit the Empire: Canada . . . , 1933
One of a series
Commissioned by UERL
Printed by Waterlow & Sons
Lithograph
39 ⁷/₈ x 24 ⁷/₈ in. (101.3 x 63.2 cm)
Promised gift of Henry S. Hacker,
Yale College, Class of 1965

THOMAS C. (TOM) ECKERSLEY
1914–1997
AND ERIC LOMBERS
1914–1978
Aldershot Tattoo, 1936
Commissioned by LT
Printed by the Dangerfield Printing Co.
Lithograph
10 ¹/₁₆ x 12 ³/₈ in. (25.6 x 31.4 cm)
Promised gift of Henry S. Hacker,
Yale College, Class of 1965

THOMAS C. (TOM) ECKERSLEY
1914–1997
Ceremonial London, 1976
Commissioned by LT
Printed by Walter Brian
Silkscreen
40 x 25 ¹/₁₆ in. (101.6 x 63.7 cm)
Friends of British Art Fund
B2009.8

THOMAS C. (TOM) ECKERSLEY
1914–1997
Tom Eckersley: Posters and Other Graphic Work, 1980
Commissioned by Yale Center for British Art
Printed by Sirocco
Silkscreen
32 $^{15}/_{16}$ x 23 $^{1}/_{8}$ in. (83.7 x 58.7 cm)
Gift of Thomas C. Eckersley
B1993.32

JOHN FREDERICK WILLIAM CHARLES FARLEIGH
1900–1965
Westminster Abbey, 1961
Commissioned by LT
Printed by the Curwen Press
Lithograph
40 x 24 $^{7}/_{8}$ in. (101.6 x 63.2 cm)
Gift of Henry S. Hacker, Yale College, Class of 1965
B1991.46.7

JOHN FINNIE
born 1935
Waterways, 1965
Commissioned by LT
Printed by Johnson, Riddle & Co.
Lithograph
39 $^{1}/_{16}$ x 24 $^{15}/_{16}$ in. (99.2 x 63.3 cm)
Gift of Henry S. Hacker, Yale College, Class of 1965
B2004.18.24

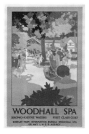

HOWARD K. ELCOCK
active 1910–1923
Woodhall Spa: Bromo-Iodine Waters, First Class Golf, between 1923 and 1947
Commissioned by LNER
Printed by the Dangerfield Printing Co.
Lithograph
39 $^{3}/_{4}$ x 25 in. (101 x 63.5 cm)
Gift of Henry S. Hacker, Yale College, Class of 1965
B2006.24.11

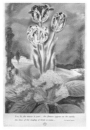

JOHN FREDERICK WILLIAM CHARLES FARLEIGH
1900–1965
Country Walks: Spring, 1965
Commissioned by LT
Printed by the Baynard Press
Lithograph
38 $^{3}/_{8}$ x 24 $^{7}/_{8}$ in. (97.5 x 63.2 cm)
Gift of Henry S. Hacker, Yale College, Class of 1965
B2004.18.39

BARNETT FREEDMAN
1901–1958
Amid the Groves, under the Shadowy Hills, 1956
Commissioned by LT
Printed by the Baynard Press
Lithograph
40 x 25 in. (101.6 x 63.5 cm)
Gift of Henry S. Hacker, Yale College, Class of 1965
B1993.3.5

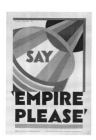

DOUGLAS ENGLAND
Say Empire Please, 1927
Commissioned by Empire Marketing Board
Printed by Roberts and Leete
Lithograph
30 x 20 in. (76.2 x 50.8 cm)
Promised gift of Henry S. Hacker,
Yale College, Class of 1965

ERNEST WILLIAM FENTON
1920–1993
Flowers, 1952
Left panel of pair
Commissioned by LT
Printed by the Baynard Press
Lithograph
39 $^{7}/_{8}$ x 25 in. (101.3 x 63.5 cm)
Gift of Henry S. Hacker, Yale College, Class of 1965
B2004.18.10

ABRAM GAMES
1914–1996
Round London Sightseeing Tour, 1971
Commissioned by LT
Printed by the Curwen Press
Lithograph
39 x 25 in. (99.1 x 63.5 cm)
Gift of Henry S. Hacker, Yale College, Class of 1965
B2000.8.11

CLIVE ALFRED GARDINER
1891–1960
The Tower of London, 1927
One of a series
Commissioned by UERL
Printed by Charles Whittingham and Griggs
Lithograph
39 ³/₄ x 25 in. (101 x 63.5 cm)
Gift of Henry S. Hacker, Yale College, Class of 1965
B2008.26.2

DAVID GENTLEMAN
born 1930
London Centenaries 1961, 1961
Commissioned by LT
Printed by the Baynard Press
Lithograph
40 x 24 ³/₄ in. (101.6 x 62.9 cm)
Gift of Henry S. Hacker, Yale College, Class of 1965
B1993.3.3

RONALD GLENDENING
born 1926
The Bright Lights of the West End, 1957
Commissioned by LT
Printed by the Curwen Press
Lithograph
39 ⁷/₈ x 25 in. (101.3 x 63.5 cm)
Gift of Henry S. Hacker, Yale College, Class of 1965
B1991.46.1

CLIVE ALFRED GARDINER
1891–1960
By Green Line Coach D to Westerham, 1937
Commissioned by LT
Printed by the Baynard Press
Lithograph
39 ¹/₂ x 24 ⁵/₁₆ in. (100.3 x 61.8 cm)
Gift of Henry S. Hacker, Yale College, Class of 1965
B2001.16.4

DAVID GENTLEMAN
born 1930
Shell Guide to Nottinghamshire, ca. 1961
One of a series
Commissioned by Royal Dutch Shell Co.
Printed by Henry Stone and Son
Lithograph
29 ¹/₂ x 20 in. (74.9 x 50.8 cm)
Promised gift of Henry S. Hacker,
Yale College, Class of 1965

DUNCAN JAMES CORROWR GRANT
1885–1978
You Can Be Sure of Shell: St. Ives Huntingdon, 1932
Commissioned by Royal Dutch Shell Co.
Printed by Vincent Brooks, Day & Son
Lithograph
Image: 29 ⁵/₈ x 44 ³/₄ in. (75.2 x 113.7 cm)
Promised gift of Henry S. Hacker,
Yale College, Class of 1965

DAVID GENTLEMAN
born 1930
Visitor's London, 1956
Uncut pair poster
Commissioned by LT
Printed by McCorquodale & Co.
Lithograph
39 ⁷/₈ x 49 ³/₄ in. (101.3 x 126.4 cm)
Gift of Henry S. Hacker, Yale College, Class of 1965
B2004.18.17

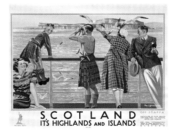

TOM GILFILLAN
active 1932–1953
Scotland: It's Highlands and Islands,
between 1923 and 1947
Commissioned by LMS
Printed by John Horn
Lithograph
Image: 39 ¹/₄ x 49 ¹/₄ in. (99.7 x 125.1 cm)
Promised gift of Henry S. Hacker,
Yale College, Class of 1965

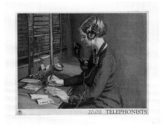

DUNCAN JAMES CORROWR GRANT
1885–1978
20,011 Telephonists, 1939
One of a series
Commissioned by General Post Office
Lithograph
19 ⁷/₈ x 24 ⁵/₈ in. (50.5 x 62.5 cm)
Promised gift of Henry S. Hacker,
Yale College, Class of 1965

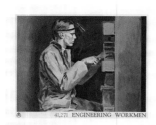

DUNCAN JAMES CORROWR GRANT
1885–1978
41,271 Engineering Workmen, 1939
One of a series
Commissioned by General Post Office
Lithograph
20 x 24 ⁹/₁₆ in. (50.8 x 62.4 cm)
Promised gift of Henry S. Hacker,
Yale College, Class of 1965

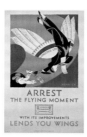

FREDERICK CHARLES HERRICK
1887–1970
Arrest the Flying Moment, 1924
Commissioned by UERL
Printed by the Baynard Press
Lithograph
40 x 25 ⅛ in. (101.6 x 63.8 cm)
Friends of British Art Fund
B2007.9.2

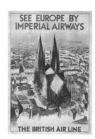

HOLLAND
(possibly James Sylvester Holland 1905–1996)
See Europe by Imperial Airways, between 1924
and 1939
Commissioned by Imperial Airways
Printed by Stuarts
Lithograph
29 ⁵/₁₆ x 19 ¼ in. (74.5 x 48.9 cm)
Promised gift of Henry S. Hacker,
Yale College, Class of 1965

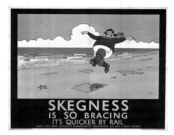

JOHN HASSALL
1868–1948
Skegness Is So Bracing, between 1923 and 1932
Commissioned by LNER
Printed by Waterlow & Sons
Lithograph
40 x 49 ¾ in. (101.6 x 126.4 cm)
Promised gift of Henry S. Hacker,
Yale College, Class of 1965

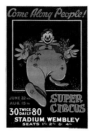

VICTOR HICKS
Come Along People: Super Circus, ca. 1925
Commissioned by Wembley Stadium
Printed by Waterlow & Sons
Lithograph
117 ½ x 78 ⅛ in. (298.5 x 198.4 cm)
Promised gift of Henry S. Hacker,
Yale College, Class of 1965

HAROLD DAVID HUSSEY
1912–1998
Birds, 1952
Left panel of pair
Commissioned by LT
Printed by the Baynard Press
Lithograph
40 ¹/₁₆ x 24 ¹⁵/₁₆ in. (101.8 x 63.3 cm)
Gift of Henry S. Hacker, Yale College, Class of 1965
B2000.8.12

FREDERICK CHARLES HERRICK
1887–1970
The Source of London's Merry Christmas, 1922
Commissioned by UERL
Printed by the Baynard Press
Lithograph
38 ½ x 23 ½ in. (97.8 x 59.7 cm)
Friends of British Art Fund
B2006.11.2

VICTOR HICKS
The New Wembley, ca. 1925
Commissioned by British Empire Exhibition
Printed by Haycock, Cadle & Graham
Lithograph
118 ⁵/₁₆ x 79 ³/₁₆ in. (300.5 x 201.1 cm)
Promised gift of Henry S. Hacker,
Yale College, Class of 1965

ANDREW JOHNSON
Woodhall Spa: It's Quicker by Rail (maquette),
between 1923 and 1947
Commissioned by LNER
Gouache
41 ¼ x 24 ¼ in. (104.8 x 61.6 cm)
Gift of Henry S. Hacker, Yale College, Class of 1965
B2008.26.7

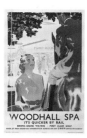

ANDREW JOHNSON
Woodhall Spa, between 1923 and 1947
Commissioned by LNER
Printed by Adams Bros. and Shardlow
Lithograph
39 ³/₄ x 25 in. (101 x 63.5 cm)
Gift of Henry S. Hacker, Yale College, Class of 1965
B2008.26.3

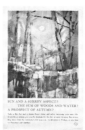

JOHN E. KASHDAN
1917–2001
Sun and a Surrey Aspect, 1962
Duplicate of B2004.18.28
Commissioned by LT
Printed by Waterlow & Sons
Lithograph
39 ⁷/₈ x 25 in. (101.3 x 63.5 cm)
Gift of Henry S. Hacker, Yale College, Class of 1965
B1993.3.9

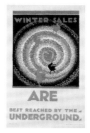

EDWARD MCKNIGHT KAUFFER
1890–1954
Winter Sales Are Best Reached by the Underground,
1922
Commissioned by UERL
Printed by Vincent Brooks, Day & Son
Lithograph
39 ¹/₁₆ x 24 ¹/₁₆ in. (99.2 x 61.1 cm)
Gift of Henry S. Hacker, Yale College, Class of 1965
B2001.16.3

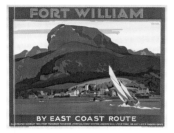

GRAINGER JOHNSON
(possibly Tom Grainger and Andrew Johnson)
Fort William by East Coast Route, between 1923
and 1947
Commissioned by LNER
Printed by the Dangerfield Printing Co.
Lithograph
39 ¹/₂ x 49 ³/₁₆ in. (100.3 x 124.9 cm)
Gift of Henry S. Hacker, Yale College, Class of 1965
B2006.24.10

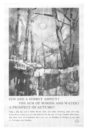

JOHN E. KASHDAN
1917–2001
Sun and a Surrey Aspect, 1962
Duplicate of B1993.3.9
Commissioned by LT
Printed by Waterlow & Sons
Lithograph
39 ⁷/₈ x 25 in. (101.3 x 63.5 cm)
Gift of Henry S. Hacker, Yale College, Class of 1965
B2004.18.28

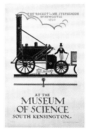

EDWARD MCKNIGHT KAUFFER
1890–1954
*At the Museum of Science: The "Rocket" of
Mr. Stephenson of Newcastle 1829*, 1923
Commissioned by UERL
Printed by Vincent Brooks, Day & Son
Lithograph
39 ³/₄ x 24 ³/₄ in. (101 x 62.9 cm)
Friends of British Art Fund
B2007.9.1

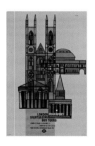

GEORGE BRZEZINSKI (KARO)
born 1924
London Transport Sightseeing Bus Tours, 1961
Commissioned by LT
Printed by the Curwen Press
Lithograph
40 x 25 in. (101.6 x 63.5 cm)
Gift of Henry S. Hacker, Yale College, Class of 1965
B1991.46.6

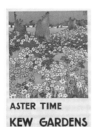

EDWARD MCKNIGHT KAUFFER
1890–1954
Aster Time: Kew Gardens, 1920
Commissioned by UERL
Printed by the Dangerfield Printing Co.
Lithograph
29 ¹⁵/₁₆ x 19 ¹³/₁₆ in. (76 x 50.3 cm)
Gift of Henry S. Hacker, Yale College, Class of 1965
B2001.16.6

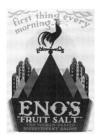

EDWARD MCKNIGHT KAUFFER
1890–1954
Eno's Fruit Salt, 1929
Commissioned by J. C. Eno Limited
Printed by the Westminster Press
Lithograph
29 ³/₄ x 20 ³/₁₆ in. (75.6 x 51.3 cm)
Friends of British Art Fund
B2009.7

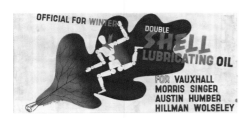

EDWARD MCKNIGHT KAUFFER
1890–1954
Double Shell Lubricating Oil (maquette for *Official for Winter: Single Shell Lubricating Oil*), 1936
Commissioned by Royal Dutch Shell Co.
Gouache
Image: 10 ³/₈ x 22 ³/₈ in. (26.3 x 56.8 cm)
Gift of Henry S. Hacker, Yale College, Class of 1965
B2008.26.9

EDWARD MCKNIGHT KAUFFER
1890–1954
Outposts of Britain: A Postman in Northern Scotland, 1937
One of a series
Commissioned by General Post Office
Lithograph
19 ⁷/₈ x 25 ¹/₁₆ in. (50.5 x 63.7 cm)
Gift of Henry S. Hacker, Yale College, Class of 1965
B2008.26.13

EDWARD MCKNIGHT KAUFFER
1890–1954
Exhibition of Modern Silverwork, 1938
Commissioned by LT
Printed by the Baynard Press
Lithograph
10 x 12 ¹/₂ in. (25.4 x 31.8 cm)
Gift of Henry S. Hacker, Yale College, Class of 1965
B2000.8.32

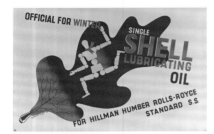

EDWARD MCKNIGHT KAUFFER
1890–1954
Official for Winter: Single Shell Lubricating Oil, 1936
Commissioned by Royal Dutch Shell Co.
Printed by Waterlow & Sons
Lithograph
29 ³/₄ x 44 ⁵/₈ in. (75.6 x 113.3 cm)
Gift of Henry S. Hacker, Yale College, Class of 1965
B2008.26.14

EDWARD MCKNIGHT KAUFFER
1890–1954
Outposts of Britain: A Postman in the Pool of London, 1937
One of a series
Commissioned by General Post Office
Lithograph
19 ⁷/₈ x 25 in. (50.5 x 63.5 cm)
Gift of Henry S. Hacker, Yale College, Class of 1965
B2008.26.12

EDWARD MCKNIGHT KAUFFER
1890–1954
How Bravely Autumn Paints upon the Sky, 1938
Commissioned by LT
Printed by the Baynard Press
Lithograph
39 ⁵/₈ x 25 in. (100.6 x 63.5 cm)
Promised gift of Henry S. Hacker,
Yale College, Class of 1965

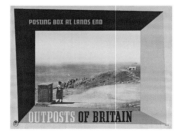

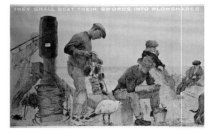

EDWARD MCKNIGHT KAUFFER
1890–1954
Outposts of Britain: A Postman in Northern Ireland, 1937
One of a series
Commissioned by General Post Office
Lithograph
19 ⁷/₈ x 25 ¹/₁₆ in. (50.5 x 63.7 cm)
Gift of Henry S. Hacker, Yale College, Class of 1965
B2008.26.11

EDWARD MCKNIGHT KAUFFER
1890–1954
Outposts of Britain: Posting Box at Lands End, 1937
One of a series
Commissioned by General Post Office
Lithograph
19 ⁷/₈ x 25 ¹/₈ in. (50.5 x 63.8 cm)
Gift of Henry S. Hacker, Yale College, Class of 1965
B2008.26.10

JAMES KERR-LAWSON
1864–1939
The Empire Stands for Peace: "They Shall Beat Their Swords into Plowshares . . . ," 1929
First of five panels
Commissioned by Empire Marketing Board
Printed by Eyre & Spottiswoode
Lithograph
39 ³/₁₆ x 59 ⁷/₁₆ in. (99.5 x 151 cm)
Gift of Henry S. Hacker, Yale College, Class of 1965
B2005.20.4

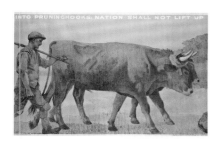

JAMES KERR-LAWSON
1864–1939
The Empire Stands for Peace: ". . . Into Pruninghooks:
Nation Shall Not Lift Up . . . ," 1929
Third of five panels
Commissioned by Empire Marketing Board
Printed by Eyre & Spottiswoode
Lithograph
39 ³/₄ x 59 ⁷/₈ in. (101 x 152.1 cm)
Gift of Henry S. Hacker, Yale College, Class of 1965
B2005.20.5

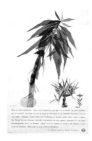

MARY M. KESSEL
1914–1977
Kew Gardens, 1964
Commissioned by LT
Printed by Gilbert Whitehead and Co.
Lithograph
39 x 24 ¹⁵/₁₆ in. (99.1 x 63.3 cm)
Gift of Henry S. Hacker, Yale College, Class of 1965
B2000.8.13

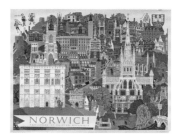

KERRY LEE
born 1904
Norwich, 1953
Commissioned by BR
Printed by Waterlow & Sons
Lithograph
40 x 50 in. (101.6 x 127 cm)
Gift of Henry S. Hacker, Yale College, Class of 1965
B2004.18.19

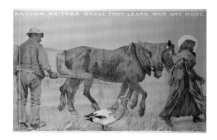

JAMES KERR-LAWSON
1864–1939
The Empire Stands for Peace: ". . . Nation, Neither
Shall They Learn War Anymore," 1929
Fifth of five panels
Commissioned by Empire Marketing Board
Printed by Eyre & Spottiswoode
Lithograph
39 ³/₁₆ x 59 ³/₈ in. (99.5 x 150.8 cm)
Gift of Henry S. Hacker, Yale College, Class of 1965
B2005.20.6

LAURA KNIGHT
1877–1970
Country Walks: Winter, 1957
Commissioned by LT
Printed by Waterlow & Sons
Lithograph
39 ¹⁵/₁₆ x 24 ⁷/₈ in. (101.4 x 63.2 cm)
Gift of Henry S. Hacker, Yale College, Class of 1965
B2000.8.14

WILLIAM EDWARD LEESON
born 1934
Ancient and Modern, 1965
Commissioned by LT
Printed by Leonard Ripley & Co.
Lithograph
39 ³/₁₆ x 24 ¹⁵/₁₆ in. (99.5 x 63.3 cm)
Gift of Henry S. Hacker, Yale College, Class of 1965
B1991.46.3

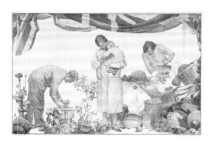

JAMES KERR-LAWSON
1864–1939
Service of Empire: "The People Bring Much More
than Enough . . . ," 1932
Third of five panels
Commissioned by Empire Marketing Board
Printed by St. Michael's Press
Lithograph
Image: 39 ¹/₈ x 59 ¹/₂ in. (99.4 x 151.1 cm)
Promised gift of Henry S. Hacker,
Yale College, Class of 1965

KERRY LEE
born 1904
Cambridge, 1953
Commissioned by BR
Printed by John Waddington
Lithograph
39 ¹³/₁₆ x 49 ⁹/₁₆ in. (101.1 x 125.9 cm)
Gift of Henry S. Hacker, Yale College, Class of 1965
B2004.18.15

WILLIAM EDWARD LEESON
born 1934
London Zoo, 1965
Commissioned by LT
Printed by Waterlow & Sons
Lithograph
38 ⁷/₈ x 24 ³/₄ in. (98.7 x 62.9 cm)
Gift of Henry S. Hacker, Yale College, Class of 1965
B2004.18.38

CLARA ELLALINE HOPE (CLARE) LEIGHTON
ca. 1900–1989
Harvest, between 1926 and 1933
Commissioned by Empire Marketing Board
Printed by Waterlow & Sons
Lithograph
39 1/8 x 58 7/8 in. (99.4 x 149.5 cm)
Promised gift of Henry S. Hacker,
Yale College, Class of 1965

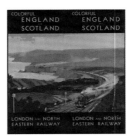

FRANK HENRY MASON
1876–1965
Colorful England and Scotland,
between 1923 and 1947
Commissioned by LNER
Lithograph
8 5/8 x 7 15/16 in. (21.9 x 20.2 cm)
Gift of Henry S. Hacker, Yale College, Class of 1965
B2006.24.12

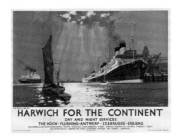

FRANK HENRY MASON
1876–1965
Harwich for the Continent, 1940
Commissioned by LNER
Printed by Jordison and Co.
Lithograph
40 1/8 x 49 7/8 in. (101.9 x 126.7 cm)
Promised gift of Henry S. Hacker,
Yale College, Class of 1965

STELLA MARSDEN
Engraved Brasses, 1955
Uncut pair poster
Commissioned by LT
Printed by McCorquodale & Co.
Lithograph
39 3/4 x 49 7/8 in. (101 x 126.7 cm)
Gift of Henry S. Hacker, Yale College, Class of 1965
B2004.18.16

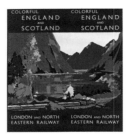

FRANK HENRY MASON
1876–1965
Colorful England and Scotland,
between 1923 and 1947
Commissioned by LNER
Lithograph
8 11/16 x 7 7/8 in. (22.1 x 20 cm)
Gift of Henry S. Hacker, Yale College, Class of 1965
B2006.24.13

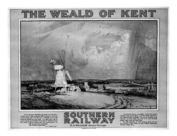

DONALD MAXWELL
1877–1936
The Weald of Kent, 1924
Commissioned by SR
Printed by McCorquodale & Co.
Lithograph
39 1/4 x 49 7/8 in. (99.7 x 126.7 cm)
Gift of Henry S. Hacker, Yale College, Class of 1965
B2000.8.20

ENID CRYSTAL DOROTHY MARX
1902–1998
The Zoo: Noah's Ark, 1957
Commissioned by LT
Printed by McCorquodale & Co.
Lithograph
39 15/16 x 24 15/16 in. (101.4 x 63.3 cm)
Gift of Henry S. Hacker, Yale College, Class of 1965
B2004.18.25

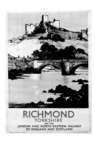

FRANK HENRY MASON
1876–1965
Richmond Yorkshire, between 1923 and 1947
Commissioned by LNER
Printed by Vincent Brooks, Day & Son
Lithograph
36 3/4 x 24 3/4 in. (93.3 x 62.9 cm)
Gift of Henry S. Hacker, Yale College, Class of 1965
B2004.18.9

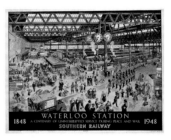

HELEN MADELEINE MCKIE
1889–1957
*Waterloo Station: A Centenary of Uninterrupted
Service During Peace and War, 1848–1948,
Peace*, 1947
One of a pair with *War*
Commissioned by SR
Printed by the Baynard Press
Lithograph
40 x 49 3/4 in. (101.6 x 126.4 cm)
Gift of Henry S. Hacker, Yale College, Class of 1965
B2000.8.22

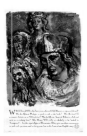

CHARLOTTE (SHIRLEY) MENSFORTH
born 1936
Westminster Abbey: Royal Effigies, 1961
Commissioned by LT
Printed by the Baynard Press
Lithograph
40 x 25 in. (101.6 x 63.5 cm)
Gift of Henry S. Hacker, Yale College, Class of 1965
B1991.46.9

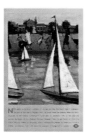

PAUL MILLICHIP
born 1929
Round Pond, Kensington Gardens, 1958
Commissioned by LT
Printed by the Baynard Press
Lithograph
40 x 25 in. (101.6 x 63.5 cm)
Gift of Henry S. Hacker, Yale College, Class of 1965
B1991.46.12

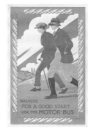

CHRISTOPHER RICHARD WYNNE NEVINSON
1889–1946
Walkers, For a Good Start Use the Motor-Bus, 1921
One of a series
Commissioned by UERL
Printed by the Avenue Press
Lithograph
39 ¾ x 24 ¹⁵/₁₆ in. (101 x 63.3 cm)
Gift of Henry S. Hacker, Yale College, Class of 1965
B2008.26.1

FRED MILLETT
1920–1980
London after Dark, 1968
Commissioned by LT
Printed by Waterlow & Sons
Lithograph
38 ³/₁₆ x 24 ¹⁵/₁₆ in. (97 x 63.3 cm)
Gift of Henry S. Hacker, Yale College, Class of 1965
B2000.8.15

JOHN NORTHCOTE NASH
1893–1977
Shell Guide to Cambridgeshire, 1963
One of a series
Commissioned by Royal Dutch Shell Co.
Printed by C. Nicholls and Co.
Lithograph
29 x 20 in. (73.7 x 50.8 cm)
Promised gift of Henry S. Hacker,
Yale College, Class of 1965

FRANK NEWBOULD
1887–1951
Felix Hotel, Felixstowe, between 1923 and 1947
Commissioned by LNER
Printed by the Dangerfield Printing Co.
Lithograph
39 ⁷/₈ x 49 ⁷/₈ in. (101.3 x 126.7 cm)
Gift of Henry S. Hacker, Yale College, Class of 1965
B2008.26.5

PAUL MILLICHIP
born 1929
Country Walks: Spring, 1957
Commissioned by LT
Printed by the Baynard Press
Lithograph
39 ¹⁵/₁₆ x 24 ¹⁵/₁₆ in. (101.4 x 63.3 cm)
Gift of Henry S. Hacker, Yale College, Class of 1965
B2000.8.16

PAUL NASH
1889–1946
Home Gardens for Home Markets, 1930
One of a series
Commissioned by Empire Marketing Board
Printed by Waterlow & Sons
Lithograph
20 x 30 in. (50.8 x 76.2 cm)
Promised gift of Henry S. Hacker,
Yale College, Class of 1965

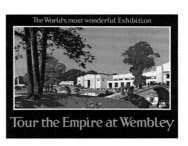

FRANK NEWBOULD
1887–1951
*The World's Most Wonderful Exhibition:
Tour the Empire at Wembley*, 1924
Commissioned by British Empire Exhibition
Printed by Chorley & Pickersgill
Lithograph
Image: 38 ½ x 49 in. (97.8 x 124.5 cm)
Promised gift of Henry S. Hacker,
Yale College, Class of 1965

FRANK NEWBOULD
1887–1951
Jaffa: Buy Jaffa Oranges, 1929
One of a series
Commissioned by Empire Marketing Board
Printed by Waterlow & Sons
Lithograph
19 ¹⁵/₁₆ x 30 ¹/₁₆ in. (50.6 x 76.4 cm)
Promised gift of Henry S. Hacker,
Yale College, Class of 1965

FRANK NEWBOULD
1887–1951
Empire Buying Makes Busy Factories:
Cutting Bananas in Jamaica, 1930
One of a series
Commissioned by Empire Marketing Board
Printed by Waterlow & Sons
Lithograph
19 ⁹/₁₆ x 29 ⁵/₈ in. (49.7 x 75.2 cm)
Promised gift of Henry S. Hacker,
Yale College, Class of 1965

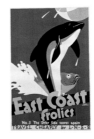

FRANK NEWBOULD
1887–1951
East Coast Frolics, No. 5: "The Drier Side"
Scores Again, 1933
One of a series
Commissioned by LNER
Printed by Chorley & Pickersgill
Lithograph
39 ¹/₂ x 24 ⁷/₈ in. (100.3 x 63.2 cm)
Gift of Henry S. Hacker, Yale College, Class of 1965
B2006.24.4

FRANK NEWBOULD
1887–1951
Jerusalem, ca. 1929
Commissioned by Empire Marketing Board
Printed by Johnson, Riddle & Co.
Lithograph
20 x 29 ⁵/₈ in. (50.8 x 75.2 cm)
Promised gift of Henry S. Hacker,
Yale College, Class of 1965

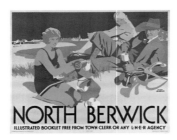

FRANK NEWBOULD
1887–1951
North Berwick, 1930–31
Commissioned by LNER
Printed by Dobson, Molle and Co.
Lithograph
39 ⁷/₈ x 49 ⁷/₈ in. (101.3 x 126.7 cm)
Gift of Henry S. Hacker, Yale College, Class of 1965
B2008.26.4

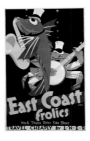

FRANK NEWBOULD
1887–1951
East Coast Frolics, No. 6: "Those Drier Side Blues,"
1933
One of a series
Commissioned by LNER
Printed by Chorley & Pickersgill
Lithograph
39 ³/₁₆ x 24 ³/₄ in. (99.5 x 62.9 cm)
Gift of Henry S. Hacker, Yale College, Class of 1965
B2006.24.5

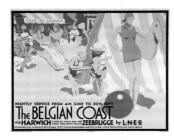

FRANK NEWBOULD
1887–1951
The Belgian Coast, via Harwich, ca. 1930
Commissioned by LNER
Printed by the Haycock Press
Lithograph
39 ¹⁵/₁₆ x 49 ⁷/₈ in. (101.4 x 126.7 cm)
Gift of Henry S. Hacker, Yale College, Class of 1965
B2008.26.6

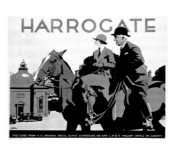

FRANK NEWBOULD
1887–1951
Harrogate, 1932
Commissioned by LNER
Printed by McCorquodale & Co.
Lithograph
40 x 50 in. (101.6 x 127 cm)
Gift of Henry S. Hacker, Yale College, Class of 1965
B2000.8.18

FRANK NEWBOULD
1887–1951
Penny a Mile, 1935
Commissioned by GWR, LNER, LMS, SR
Printed by Waterlow & Sons
Lithograph
39 ³/₄ x 24 ⁷/₈ in. (101 x 63.2 cm)
Promised gift of Henry S. Hacker,
Yale College, Class of 1965

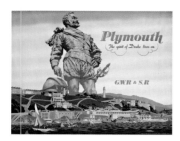

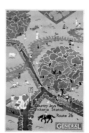

FRANK NEWBOULD
1887–1951
Plymouth: The Spirit of Drake Lives On, 1946
Commissioned by GWR and SR
Printed by the Haycock Press
Lithograph
39 ⅛ x 49 ¹/₁₆ in. (99.4 x 124.6 cm)
Gift of Henry S. Hacker, Yale College, Class of 1965
B2004.18.5

CHARLES PAINE
1895–1967
Hampton Court, 1921
Commissioned by UERL
Printed by the Baynard Press
Lithograph
29 ¹³/₁₆ x 19 ¹⁵/₁₆ in. (75.7 x 50.6 cm)
Friends of British Art Fund
B2009.11

HEATHER (HERRY) PERRY
1893–1962
Country Joys from Victoria Station, 1930
Commissioned by UERL
Printed by the Dangerfield Printing Co.
Lithograph
39 ⅞ x 25 in. (101.3 x 63.5 cm)
Gift of Henry S. Hacker, Yale College, Class of 1965
B2000.8.4

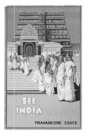

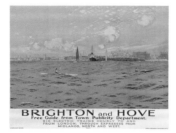

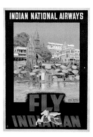

DOROTHY NEWSOME
See India: Travancore State, ca. 1935
Commissioned by Government of India
Printed by G. Claridge & Co.
Lithograph
39 ⁷/₁₆ x 24 ⁷/₁₆ in. (100.2 x 62.1 cm)
Gift of Henry S. Hacker, Yale College, Class of 1965
B2004.18.20

CHARLES PEARS
1873–1958
Brighton and Hove, between 1923 and 1947
Commissioned by SR
Printed by Waterlow & Sons
Lithograph
39 ¾ x 49 ⅞ in. (101 x 126.7 cm)
Gift of Henry S. Hacker, Yale College, Class of 1965
B2005.20.1

SANYAI PHANI
Hindu Bathing Ghats, Ganges, between 1933
and 1953
Commissioned by Indian National Airways
Printed by Imperial Art Cottage, Calcutta
Lithograph
40 ⅛ x 27 ⁵/₁₆ in. (101.9 x 69.4 cm)
Gift of Henry S. Hacker, Yale College, Class of 1965
B2004.18.6

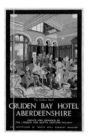

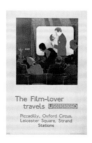

GORDON NICOLL
1888–1959
Cruden Bay Hotel Aberdeenshire: The Golfer's Hotel,
between 1923 and 1947
Commissioned by LNER
Printed by the Dangerfield Printing Co.
Lithograph
39 ⅞ x 24 ⅞ in. (101.3 x 63.2 cm)
Gift of Henry S. Hacker, Yale College, Class of 1965
B2006.24.7

CHARLES PEARS
1873–1958
The Film-Lover Travels Underground, 1930
One of a series
Commissioned by UERL
Printed by Johnson, Riddle & Co.
Lithograph
39 ⅛ x 25 in. (99.4 x 63.5 cm)
Gift of Henry S. Hacker, Yale College, Class of 1965
B2002.22.9

LESLIE R. PORTER
London's Tramways: Kew in Autumn, 1925
Commissioned by London County Council
Tramways
Printed by Vincent Brooks, Day & Son
Lithograph
29 ⅛ x 14 in. (74 x 35.6 cm)
Promised gift of Henry S. Hacker,
Yale College, Class of 1965

(ANDREW POWER)
(Sybil Andrews, 1898–1992)
Football, 1933
Commissioned by LT
Printed by the Baynard Press
Lithograph
39 ⁵/₈ x 24 ⁷/₁₆ in. (100.6 x 62.1 cm)
Promised gift of Henry S. Hacker,
Yale College, Class of 1965

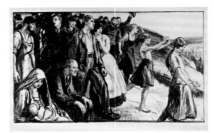

GERALD SPENCER PRYSE
1882–1956
To-Morrow—When Labour Rules (proof), 1922
One of a series
Commissioned by the Labour Party
Printed by Vincent Brooks, Day & Son
Lithograph
38 ¹⁵/₁₆ x 60 in. (98.9 x 152.4 cm)
Promised gift of Henry S. Hacker,
Yale College, Class of 1965

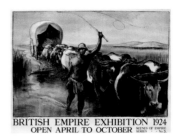

GERALD SPENCER PRYSE
1882–1956
*British Empire Exhibition 1924: Scenes of Empire
Series, No. 3. South Africa: The Trekking Wagon*, 1924
One of a series
Commissioned by British Empire Exhibition
Printed by Vincent Brooks, Day & Son
Lithograph
39 ³/₄ x 49 ³/₄ in. (101 x 126.4 cm)
Gift of Henry S. Hacker, Yale College, Class of 1965
B2005.20.8

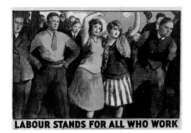

GERALD SPENCER PRYSE
1882–1956
Labour Stands for All Who Work, 1913
Commissioned by the Labour Party
Printed by Vincent Brooks, Day & Son
Lithograph
29 ¹³/₁₆ x 39 ⁷/₈ in. (75.7 x 101.3 cm)
Promised gift of Henry S. Hacker,
Yale College, Class of 1965

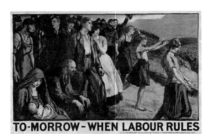

GERALD SPENCER PRYSE
1882–1956
To-Morrow—When Labour Rules, 1922
One of a series
Commissioned by the Labour Party
Printed by Vincent Brooks, Day & Son
Lithograph
39 ⁷/₈ x 59 ⁵/₈ in. (101.3 x 151.4 cm)
Promised gift of Henry S. Hacker,
Yale College, Class of 1965

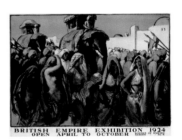

GERALD SPENCER PRYSE
1882–1956
*British Empire Exhibition 1924: Scenes of Empire
Series, No. 4. India: The Procession of Elephants*, 1924
One of a series
Commissioned by British Empire Exhibition
Printed by Vincent Brooks, Day & Son
Lithograph
39 ⁵/₈ x 49 ⁷/₈ in. (100.6 x 126.7 cm)
Gift of Henry S. Hacker, Yale College, Class of 1965
B2005.20.9

GERALD SPENCER PRYSE
1882–1956
Underground for Sport, 1913
Commissioned by UERL
Printed by the Westminster Press
Lithograph
40 x 25 ⁵/₁₆ in. (101.6 x 64.3 cm)
Gift of Henry S. Hacker, Yale College, Class of 1965
B2000.8.24

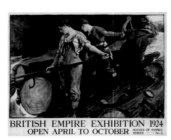

GERALD SPENCER PRYSE
1882–1956
*British Empire Exhibition 1924: Scenes of Empire
Series, No. 2. Canada: Log Rolling*, 1924
One of a series
Commissioned by British Empire Exhibition
Printed by Vincent Brooks, Day & Son
Lithograph
39 ³/₄ x 49 ⁵/₈ in. (101 x 126 cm)
Gift of Henry S. Hacker, Yale College, Class of 1965
B2005.20.7

GERALD SPENCER PRYSE
1882–1956
*British Empire Exhibition 1924: Scenes of Empire
Series, No. 5. Australia: Team Ploughing*, 1924
One of a series
Commissioned by British Empire Exhibition
Printed by Vincent Brooks, Day & Son
Lithograph
39 ¹³/₁₆ x 49 ⁷/₈ in. (101.1 x 126.7 cm)
Gift of Henry S. Hacker, Yale College, Class of 1965
B2005.20.10

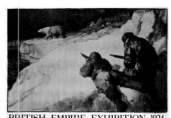

GERALD SPENCER PRYSE
1882–1956
British Empire Exhibition 1924: Scenes of Empire Series, No. 7. Arctic Territories: The Polar Bear, 1924
One of a series
Commissioned by British Empire Exhibition
Printed by Vincent Brooks, Day & Son
Lithograph
39 ½ x 49 ¹³⁄₁₆ in. (100.3 x 126.5 cm)
Gift of Henry S. Hacker, Yale College, Class of 1965
B2005.20.15

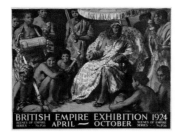

GERALD SPENCER PRYSE
1882–1956
British Empire Exhibition 1924: Scenes of Empire Series, No. P30, 1924
One of a series
Commissioned by British Empire Exhibition
Printed by Vincent Brooks, Day & Son
Lithograph
39 ⅞ x 50 ⁵⁄₁₆ in. (101.3 x 127.8 cm)
Gift of Henry S. Hacker, Yale College, Class of 1965
B2002.22.10

GERALD SPENCER PRYSE
1882–1956
Pageant of Empire: The Glamour of the East, 1924
Commissioned by British Empire Exhibition
Printed by Vincent Brooks, Day & Son
Lithograph
39 ¾ x 24 ⅞ in. (101 x 63.2 cm)
Gift of Henry S. Hacker, Yale College, Class of 1965
B2005.20.14

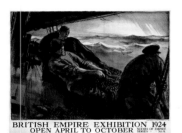

GERALD SPENCER PRYSE
1882–1956
British Empire Exhibition 1924: Scenes of Empire Series, No. 8. British Fisheries: Hauling In, 1924
One of a series
Commissioned by British Empire Exhibition
Printed by Vincent Brooks, Day & Son
Lithograph
39 ½ x 49 ¾ in. (100.3 x 126.4 cm)
Gift of Henry S. Hacker, Yale College, Class of 1965
B2005.20.11

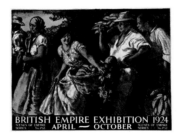

GERALD SPENCER PRYSE
1882–1956
British Empire Exhibition 1924: Scenes of Empire Series, No. P32. West Indies: Fruit Gatherers, 1924
One of a series
Commissioned by British Empire Exhibition
Printed by Vincent Brooks, Day & Son
Lithograph
40 x 49 ¾ in. (101.6 x 126.4 cm)
Gift of Henry S. Hacker, Yale College, Class of 1965
B2005.20.13

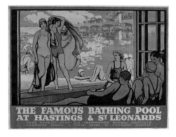

GERALD SPENCER PRYSE
1882–1956
The Famous Bathing Pool at Hastings & St. Leonards, 1934
Commissioned by SR
Printed by McCorquodale & Co.
Lithograph
39 ⅝ x 49 ⅞ in. (100.6 x 126.7 cm)
Gift of Henry S. Hacker, Yale College, Class of 1965
B2005.20.2

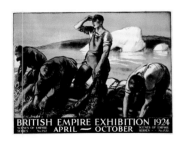

GERALD SPENCER PRYSE
1882–1956
British Empire Exhibition 1924: Scenes of Empire Series, No. P22. Newfoundland: Trap Fishing for Cod, 1924
One of a series
Commissioned by British Empire Exhibition
Printed by Vincent Brooks, Day & Son
Lithograph
39 ½ x 49 ¾ in. (100.3 x 126.4 cm)
Gift of Henry S. Hacker, Yale College, Class of 1965
B2005.20.12

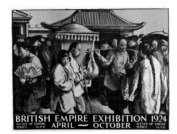

GERALD SPENCER PRYSE
1882–1956
British Empire Exhibition 1924: Scenes of Empire Series, No. P36. Hong Kong: Street Scene, 1924
One of a series
Commissioned by British Empire Exhibition
Printed by Vincent Brooks, Day & Son
Lithograph
39 ¹³⁄₁₆ x 50 ⅛ in. (101.1 x 127.3 cm)
Gift of Henry S. Hacker, Yale College, Class of 1965
B2002.22.11

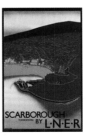

TOM PURVIS
1888–1959
Scarborough: Yorkshire by LNER, between 1923 and 1947
One of a series
Commissioned by LNER
Printed by Chorley & Pickersgill
Lithograph
39 ¹⁵⁄₁₆ x 25 in. (101.4 x 63.5 cm)
Promised gift of Henry S. Hacker,
Yale College, Class of 1965

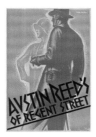

TOM PURVIS
1888–1959
Austin Reed's of Regent Street, ca. 1925
Commissioned by Austin Reed
Lithograph
29 ½ x 19 ½ in. (74.9 x 49.5 cm)
Promised gift of Henry S. Hacker,
Yale College, Class of 1965

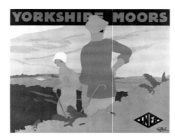

TOM PURVIS
1888–1959
Yorkshire Moors, 1930
Commissioned by LNER
Printed by McCorquodale & Co.
Lithograph
39 ½ x 49 ½ in. (100.3 x 125.7 cm)
Gift of Henry S. Hacker, Yale College, Class of 1965
B2008.26.8

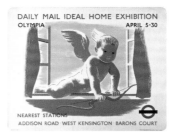

**REIMANN SCHOOL AND STUDIOS
OF INDUSTRIAL AND COMMERCIAL ART**
Daily Mail Ideal Home Exhibition, 1938
Commissioned by LT
Printed by the Dangerfield Printing Co.
Lithograph
10 x 12 ⁷⁄₁₆ in. (25.4 x 31.6 cm)
Gift of Henry S. Hacker, Yale College, Class of 1965
B2000.8.34

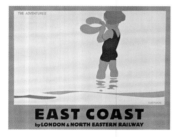

TOM PURVIS
1888–1959
East Coast: The Adventuress, 1928
Commissioned by LNER
Printed by J. G. Hudson and Co.
Lithograph
39 ½ x 49 ³⁄₈ in. (100.3 x 125.4 cm)
Gift of Henry S. Hacker, Yale College, Class of 1965
B2000.8.2

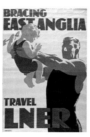

TOM PURVIS
1888–1959
Bracing East Anglia, 1931
Commissioned by LNER
Printed by the Dangerfield Printing Co.
Lithograph
117 ¼ x 77 in. (297.8 x 195.6 cm)
Gift of Henry S. Hacker, Yale College, Class of 1965
B2002.22.1

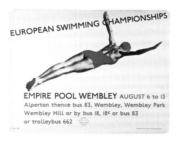

**REIMANN SCHOOL AND STUDIOS
OF INDUSTRIAL AND COMMERCIAL ART**
European Swimming Championships, 1938
Commissioned by LT
Printed by Waterlow & Sons
Lithograph
10 x 12 ⁹⁄₁₆ in. (25.4 x 31.9 cm)
Gift of Henry S. Hacker, Yale College, Class of 1965
B2000.8.36

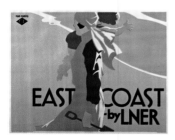

TOM PURVIS
1888–1959
East Coast by LNER, 1929
Commissioned by LNER
Printed by the Haycock Press
Lithograph
40 ⅛ x 50 ¹⁄₁₆ in. (101.9 x 127.2 cm)
Gift of Henry S. Hacker, Yale College, Class of 1965
B2006.24.9

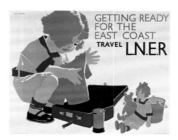

TOM PURVIS
1888–1959
Getting Ready for the East Coast: Travel LNER, 1937
Commissioned by LNER
Printed by Waterlow & Sons
Lithograph
Image: 38 ¾ x 49 ⅛ in. (98.4 x 124.8 cm)
Promised gift of Henry S. Hacker,
Yale College, Class of 1965

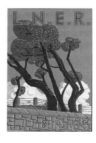

BETTY RITCHIE
LNER Service, 1934
Graphite pencil and gouache
19 ¾ x 13 ⁷⁄₁₆ in. (50.2 x 34.1 cm)
Friends of British Art Fund
B2007.8

PETER ROBERSON
1907–1989
London's Museums and Galleries, 1956
Commissioned by LT
Printed by the Baynard Press
Lithograph
40 1/16 x 25 in. (101.8 x 63.5 cm)
Gift of Henry S. Hacker, Yale College, Class of 1965
B1993.3.13

PHILIP ROBERTS
Country Markets, 1960
Commissioned by LT
Printed by the Baynard Press
Lithograph
40 x 24 15/16 in. (101.6 x 63.3 cm)
Gift of Henry S. Hacker, Yale College, Class of 1965
B2004.18.37

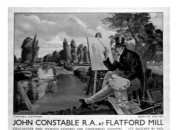

HENRY RUSHBURY
1889–1968
Constable Centenary: John Constable R.A. at Flatford Mill, 1937
Commissioned by LNER
Printed by the Haycock Press
Lithograph
39 1/8 x 49 13/16 in. (99.4 x 126.5 cm)
Gift of Henry S. Hacker, Yale College, Class of 1965
B2004.18.4

PETER ROBERSON
1907–1989
London Rovers, 1958
Commissioned by LT
Printed by Waterlow & Sons
Lithograph
40 x 25 in. (101.6 x 63.5 cm)
Gift of Henry S. Hacker, Yale College, Class of 1965
B1991.46.10

SHEILA ROBINSON
1925–1987
Royal London: Kensington Palace, 1953
Left panel of pair
Commissioned by LT
Printed by the Curwen Press
Lithograph
39 15/16 x 25 in. (101.4 x 63.5 cm)
Gift of Henry S. Hacker, Yale College, Class of 1965
B2004.18.35

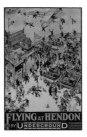

ANTHONY FREDERICK (TONY) SARG
ca.1880–1942
Flying at Hendon, 1914
Commissioned by UERL
Printed by Johnson, Riddle & Co.
Lithograph
38 3/8 x 23 1/2 in. (97.5 x 59.7 cm)
Promised gift of Henry S. Hacker,
Yale College, Class of 1965

PETER ROBERSON
1907–1989
Town and Country Houses, 1961
Commissioned by LT
Printed by Leonard Ripley & Co.
Lithograph
39 7/8 x 24 15/16 in. (101.3 x 63.3 cm)
Gift of Henry S. Hacker, Yale College, Class of 1965
B1991.46.2

LEONARD H. ROSOMAN
born 1913
Shell Guide to Midlothian, 1961
One of a series
Commissioned by Royal Dutch Shell Co.
Printed by Henry Stone and Son
Lithograph
29 1/2 x 20 in. (74.9 x 50.8 cm)
Promised gift of Henry S. Hacker,
Yale College, Class of 1965

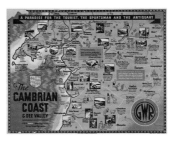

J. P. SAYER
The Cambrian Coast and Dee Valley, between 1923 and 1947
Commissioned by GWR
Printed by London Lithographic
Lithograph
40 1/4 x 50 in. (102.2 x 127 cm)
Gift of Henry S. Hacker, Yale College, Class of 1965
B2004.18.18

ROBERT SCANLAN
born 1908
When Did You Last See Your Picassos?, 1960
Commissioned by LT
Printed by the Baynard Press
Lithograph
39 15/16 x 24 7/8 in. (101.4 x 63.2 cm)
Gift of Henry S. Hacker, Yale College, Class of 1965
B1993.3.12

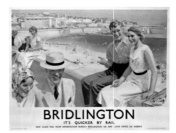

SEPTIMUS EDWIN SCOTT
1879–ca.1965
Bridlington: It's Quicker by Rail, between 1923 and 1947
Commissioned by LNER
Printed by Jarrold & Sons
Lithograph
39 9/16 x 49 3/4 in. (100.5 x 126.4 cm)
Gift of Henry S. Hacker, Yale College, Class of 1965
B2000.8.19

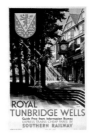

CHARLES J. M. SHEPARD
born 1892
Royal Tunbridge Wells, 1939
Commissioned by SR
Printed by the Baynard Press
Lithograph
39 x 24 3/16 in. (99.1 x 61.4 cm)
Gift of Henry S. Hacker, Yale College, Class of 1965
B2000.8.7

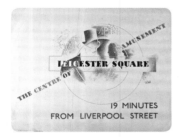

HANS SCHLEGER (ZERÓ)
1898–1976
Leicester Square: The Centre of Amusement, 1935
Commissioned by LT
Printed by Waterlow & Sons
Lithograph
Sheet: 9 7/8 x 12 3/8 in. (25.1 x 31.4 cm)
Gift of Henry S. Hacker, Yale College, Class of 1965
B2000.8.28

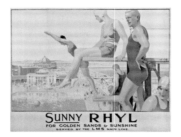

SEPTIMUS EDWIN SCOTT
1879–ca. 1965
Sunny Rhyl, between 1923 and 1947
Commissioned by LMS
Printed by S. C. Allen & Co.
Lithograph
39 3/16 x 49 1/16 in. (99.5 x 124.6 cm)
Gift of Henry S. Hacker, Yale College, Class of 1965
B2002.22.12

JOY SIMPSON
Local Museums, 1968
Commissioned by LT
Printed by Leonard Ripley & Co.
Lithograph
39 1/8 x 25 in. (99.4 x 63.5 cm)
Gift of Henry S. Hacker, Yale College, Class of 1965
B2004.18.36

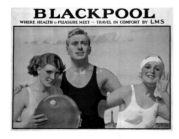

SEPTIMUS EDWIN SCOTT
1879–ca. 1965
Blackpool: Where Health and Pleasure Meet, ca. 1930
Commissioned by LMS
Printed by S. C. Allen & Co.
Lithograph
39 1/4 x 49 3/4 in. (99.7 x 126.4 cm)
Gift of Henry S. Hacker, Yale College, Class of 1965
B2001.16.2

SEPTIMUS EDWIN SCOTT
1879–ca. 1965
The Spirit of Coal: Gas Exhibit, after 1924
Commissioned by Wembley Stadium
Printed by Samson Clark & Co.
Lithograph
116 7/8 x 77 7/8 in. (296.9 x 197.8 cm)
Promised gift of Henry S. Hacker,
Yale College, Class of 1965

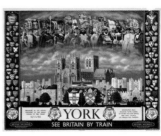

E. H. SPENCER
(possibly Herbert Spencer, born 1924)
York: See Britain by Train, after 1948
Commissioned by BR
Printed by Waterlow & Sons
Lithograph
39 7/8 x 49 7/8 in. (101.3 x 126.7 cm)
Gift of Henry S. Hacker, Yale College, Class of 1965
B2004.18.14

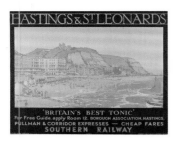

WALTER ERNEST SPRADBERY
1889–1969
Hastings and St. Leonards: Britain's Best Tonic, 1932
Commissioned by SR
Printed by Waterlow & Sons
Lithograph
40 x 49 ⅝ in. (101.6 x 126 cm)
Gift of Henry S. Hacker, Yale College, Class of 1965
B2004.18.3

HARRY STEVENS
1919–2008
Spring in the Parks, 1960
Commissioned by LT
Printed by the Baynard Press
Lithograph
40 x 25 in. (101.6 x 63.5 cm)
Gift of Henry S. Hacker, Yale College, Class of 1965
B1991.46.4

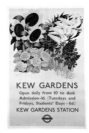

**ADA ELIZABETH EDITH (BETTY)
SWANWICK**
1915–1989
Kew Gardens, 1937
Commissioned by LT
Lithograph
40 ⅛ x 24 ¹³/₁₆ in. (101.9 x 63 cm)
Gift of Henry S. Hacker, Yale College, Class of 1965
B2000.8.17

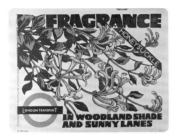

WALTER ERNEST SPRADBERY
1889–1969
Fragrance: Honeysuckle, 1936
One of a series
Commissioned by LT
Printed by the Curwen Press
Lithograph
10 x 12 ⁹/₁₆ in. (25.4 x 31.9 cm)
Gift of Henry S. Hacker, Yale College, Class of 1965
B2000.8.26

HARRY STEVENS
1919–2008
London Parks: In those Vernal Seasons of the Year,
1961
This poster is a duplicate of B2004.18.34
Commissioned by LT
Printed by the Baynard Press
Lithograph
40 x 24 ¹⁵/₁₆ in. (101.6 x 63.3 cm)
Gift of Henry S. Hacker, Yale College, Class of 1965
B1991.46.5

**ADA ELIZABETH EDITH (BETTY)
SWANWICK**
1915–1989
Wild or Savage, 1954
Left panel of pair
Commissioned by LT
Printed by the Curwen Press
Lithograph
39 ⅞ x 24 ⅞ in. (101.3 x 63.2 cm)
Gift of Henry S. Hacker, Yale College, Class of 1965
B1991.46.11

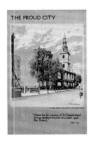

WALTER ERNEST SPRADBERY
1889–1969
*The Proud City: The Noble Fabric of the Church
of St. Clement Danes*, 1944
One of a series
Commissioned by LT
Printed by the Baynard Press
Lithograph
39 ⅛ x 24 ¾ in. (99.4 x 62.9 cm)
Gift of Henry S. Hacker, Yale College, Class of 1965
B2004.18.8

HARRY STEVENS
1919–2008
London Parks: In Those Vernal Seasons of the Year,
1961
This poster is a duplicate of B1991.46.5
Commissioned by LT
Printed by the Baynard Press
Lithograph
39 ¹³/₁₆ x 25 in. (101.1 x 63.5 cm)
Gift of Henry S. Hacker, Yale College, Class of 1965
B2004.18.34

BARBARA SWIDERSKA
born 1933
The Victoria and Albert Museum, 1967
Commissioned by LT
Printed by McCorquodale & Co.
Lithograph
39 ⁵/₁₆ x 24 ¹⁵/₁₆ in. (99.9 x 63.3 cm)
Gift of Henry S. Hacker, Yale College, Class of 1965
B1993.3.4

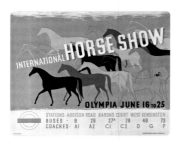

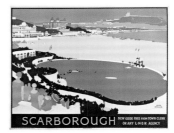

**S.Y. REIMANN SCHOOL AND STUDIOS OF
INDUSTRIAL AND COMMERCIAL ART**
International Horse Show, 1938
Commissioned by LT
Printed by Vincent Brooks, Day & Son
Lithograph
9 ¹⁵/₁₆ x 12 ⁷/₁₆ in. (25.2 x 31.6 cm)
Gift of Henry S. Hacker, Yale College, Class of 1965
B2000.8.31

FRED TAYLOR
1875–1963
St. Albans, Bus 84, 1916
Commissioned by UERL
Printed by Johnson, Riddle & Co.
Lithograph
29 ¹³/₁₆ x 19 ¹³/₁₆ in. (75.7 x 50.3 cm)
Gift of Henry S. Hacker, Yale College, Class of 1965
B2000.8.5

FRED TAYLOR
1875–1963
Scarborough, ca. 1923
Commissioned by LNER
Printed by Chorley & Pickersgill
Lithograph
39 ³/₄ x 49 ⁵/₈ in. (101 x 126 cm)
Gift of Henry S. Hacker, Yale College, Class of 1965
B2005.20.3

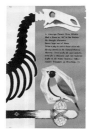

EDWIN CHARLES TATUM
1927–1991
Natural History Museum, 1956
Commissioned by LT
Printed by Leonard Ripley & Co.
Lithograph
39 ⁷/₈ x 25 in. (101.3 x 63.5 cm)
Gift of Henry S. Hacker, Yale College, Class of 1965
B2004.18.40

FRED TAYLOR
1875–1963
*By Tram from Hammersmith, Wimbledon or
Shepherd's Bush*, 1922
Commissioned by UERL
Printed by Vincent Brooks, Day & Son
Lithograph
40 ³/₈ x 25 in. (102.6 x 63.5 cm)
Promised gift of Henry S. Hacker,
Yale College, Class of 1965

FRED TAYLOR
1875–1963
The Empire Shop, 1927
Commissioned by Empire Marketing Board
Printed by Waterlow & Sons
Lithograph
19 ¹⁵/₁₆ x 30 in. (50.6 x 76.2 cm)
Promised gift of Henry S. Hacker,
Yale College, Class of 1965

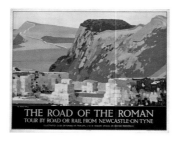

ROBERT TAVENER
1920–2004
Country Walks: Summer, 1958
Commissioned by LT
Printed by the Curwen Press
Lithograph
39 ¹⁵/₁₆ x 25 in. (101.4 x 63.5 cm)
Gift of Henry S. Hacker, Yale College, Class of 1965
B2004.18.23

FRED TAYLOR
1875–1963
The Road of the Roman: The Roman Wall, between
1923 and 1947
Commissioned by LNER
Printed by the Dangerfield Printing Co.
Lithograph
39 ⁷/₈ x 49 ⁷/₈ in. (101.3 x 126.7 cm)
Gift of Henry S. Hacker, Yale College, Class of 1965
B2000.8.3

HORACE CHRISTOPHER TAYLOR
1881–1934
To Summer Sales by Underground, 1926
Commissioned by UERL
Printed by Vincent Brooks, Day & Son
Lithograph
39 ⁷/₁₆ x 24 ³/₄ in. (100.2 x 62.9 cm)
Gift of Henry S. Hacker, Yale College, Class of 1965
B2006.24.6

HANS UNGER
1915–1975
Country Walks: Spring, 1956
Commissioned by LT
Lithograph
39 ¹⁵/₁₆ x 24 ¹⁵/₁₆ in. (101.4 x 63.3 cm)
Gift of Henry S. Hacker, Yale College, Class of 1965
B2001.16.5

HANS UNGER
1915–1975
The Tower of London, 1956
Commissioned by LT
Printed by the Baynard Press
Lithograph
39 ⅞ x 24 ¹⁵/₁₆ in. (101.3 x 63.3 cm)
Gift of Henry S. Hacker, Yale College, Class of 1965
B1993.3.6

HANS UNGER
1915–1975
Christopher Wren, Architect, Born 1632, 1957
Left panel of pair with *Christopher Wren, Architect, Died 1723*
Commissioned by LT
Printed by the Baynard Press
Lithograph
39 ⅝ x 25 in. (100.6 x 63.5 cm)
Gift of Henry S. Hacker, Yale College, Class of 1965
B2004.18.11

HANS UNGER
1915–1975
Christopher Wren, Architect, Died 1723, 1957
Right panel of pair with *Christopher Wren, Architect, Born 1632*
Commissioned by LT
Printed by the Baynard Press
Lithograph
39 ¾ x 25 in. (101 x 63.5 cm)
Gift of Henry S. Hacker, Yale College, Class of 1965
B2004.18.12

UNKNOWN ARTIST
(after Christopher Richard Wynne Nevinson, 1889–1946)
Now Back the Bayonets with Your War Savings Certificates, between 1914 and 1918
Commissioned by the National War Savings Committee
Printed by the Dangerfield Printing Co.
Lithograph
29 ⅞ x 19 ⅛ in. (75.9 x 48.6 cm)
Promised gift of Henry S. Hacker,
Yale College, Class of 1965

UNKNOWN ARTIST
To Ipswich, Lowestoft and Yarmouth, after 1929
Commissioned by Eastern National Omnibus Co.
Lithograph
30 ⅛ x 19 ¾ in. (76.5 x 50.2 cm)
Promised gift of Henry S. Hacker,
Yale College, Class of 1965

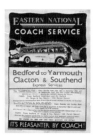

UNKNOWN ARTIST
Bedford to Yarmouth, Clacton & Southend, after 1929
Commissioned by Eastern National Omnibus Co.
Lithograph
29 ¹⁵/₁₆ x 19 ¹⁵/₁₆ in. (76 x 50.6 cm)
Promised gift of Henry S. Hacker,
Yale College, Class of 1965

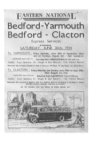

UNKNOWN ARTIST
Bedford-Yarmouth, Bedford-Clacton, after 1929
Commissioned by Eastern National Omnibus Co.
Printed by H. Clarke and Co.
Lithograph
30 ⅛ x 20 ¹/₁₆ in. (76.5 x 51 cm)
Promised gift of Henry S. Hacker,
Yale College, Class of 1965

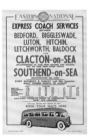

UNKNOWN ARTIST
Express Coach Services, Clacton-on-sea, Southend-on-sea, after 1929
Commissioned by Eastern National Omnibus Co.
Printed by Stafford & Co.
Lithograph
30 x 19 ⅞ in. (76.2 x 50.5 cm)
Promised gift of Henry S. Hacker,
Yale College, Class of 1965

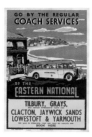

UNKNOWN ARTIST
Go by the Regular Coach Services, after 1929
Commissioned by Eastern National Omnibus Co.
Printed by Stafford & Co.
Lithograph
29 ¾ x 19 ¹⁵⁄₁₆ in. (75.6 x 50.6 cm)
Promised gift of Henry S. Hacker,
Yale College, Class of 1965

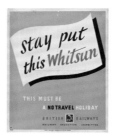

UNKNOWN ARTIST
Stay Put This Whitsun, between 1939 and 1945
Commissioned by BR
Printed by McCorquodale & Co.
Lithograph
25 x 19 ¹³⁄₁₆ in. (63.5 x 50.3 cm)
Promised gift of Henry S. Hacker,
Yale College, Class of 1965

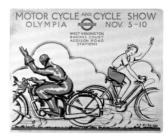

ANNA KATRINA ZINKEISEN
1901–1976
Motor Cycle and Cycle Show: Olympia, 1934
Commissioned by LT
Printed by the Dangerfield Printing Co.
Lithograph
10 ½ x 12 ½ in. (26.7 x 31.8 cm)
Gift of Henry S. Hacker, Yale College, Class of 1965
B2000.8.29

UNKNOWN ARTIST
Special Excursions to Race Meetings:
Westcliff-on-Sea Coach Services, after 1929
Commissioned by Eastern National Omnibus Co.
Lithograph
29 ¾ x 20 in. (75.6 x 50.8 cm)
Promised gift of Henry S. Hacker,
Yale College, Class of 1965

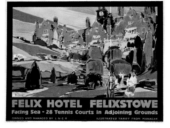

WILLIAM WALCOT
1874–1943
Felix Hotel, Felixstowe, between 1923 and 1947
Commissioned by LNER
Printed by the Avenue Press
Lithograph
39 ⅝ x 49 ⅝ in. (100.6 x 126 cm)
Gift of Henry S. Hacker, Yale College, Class of 1965
B2000.8.23

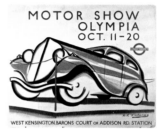

ANNA KATRINA ZINKEISEN
1901–1976
Motor Show: Olympia, 1934
Commissioned by LT
Printed by the Dangerfield Printing Co.
Lithograph
10 ¹¹⁄₁₆ x 12 ⅜ in. (27.1 x 31.4 cm)
Gift of Henry S. Hacker, Yale College, Class of 1965
B2000.8.25

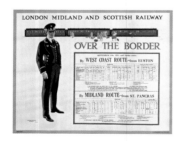

UNKNOWN ARTIST
Over the Border, 1931
Commissioned by LMS
Printed by McCorquodale & Co.
Lithograph
39 ½ x 49 ⁹⁄₁₆ in. (100.3 x 125.9 cm)
Gift of Henry S. Hacker, Yale College, Class of 1965
B2002.22.13

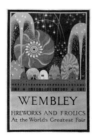

HAROLD SANDYS WILLIAMSON
1892–1978
Wembley: Fireworks and Frolics, after 1923
Commissioned by Wembley Stadium
Printed by the Dangerfield Printing Co.
Lithograph
117 ¾ x 78 ¼ in. (299.1 x 198.8 cm)
Promised gift of Henry S. Hacker,
Yale College, Class of 1965

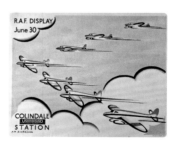

ANNA KATRINA ZINKEISEN
1901–1976
R.A.F. Display, 1934
Commissioned by LT
Printed by the Dangerfield Printing Co.
Lithograph
10 ¹⁄₁₆ x 12 ⁷⁄₁₆ in. (25.6 x 31.6 cm)
Gift of Henry S. Hacker, Yale College, Class of 1965
B2000.8.27

ANNA KATRINA ZINKEISEN
1901–1976
Richmond Horse Show, 1934
Commissioned by LT
Printed by the Dangerfield Printing Co.
Lithograph
10 7/16 x 12 1/2 in. (26.5 x 31.8 cm)
Gift of Henry S. Hacker, Yale College, Class of 1965
B2000.8.30

FRED MILLETT

London after Dark, 1968
(detail; see checklist, p. 159)

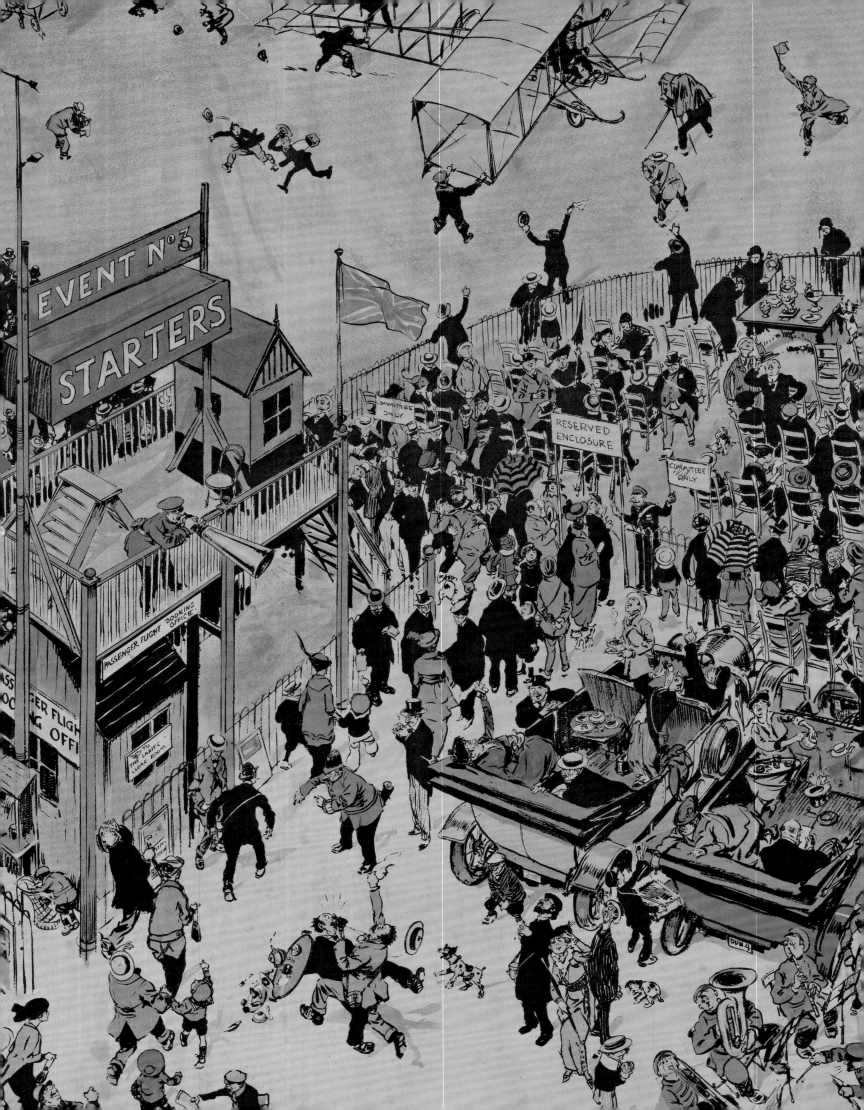

SELECTED READINGS

Antreasian, Garo Z., and Clinton Adams. *The Tamarind Book of Lithography: Art and Techniques.* Los Angeles: Tamarind Lithographic Workshop; and New York: Harry N. Abrams, 1971.

Barman, Christian. *The Man Who Built London Transport: A Biography of Frank Pick.* Newton Abbot, Eng.: David & Charles, 1979.

Baumhoff. Anja. *The Gendered World of the Bauhaus.* Frankfurt-am-Main: Peter Lang, 2001.

Bogart, Michele H. *Artists, Advertising, and the Borders of Art.* Chicago: University of Chicago Press, 1995.

Bownes, David, and Oliver Green, eds. *London Transport Posters: A Century of Art and Design.* Aldershot, Eng.: Lund Humphries in association with the London Transport Museum, 2008.

Bradshaw, Percy V. *Art in Advertising.* London: Press Art School, n.d. [1925].

Brooks, Michael W. *Subway City: Riding the Trains, Reading New York.* New Brunswick: Rutgers University Press, 1997.

Cohen, Ronald C., and Stephen G. McShane, eds. *Moonlight in Duneland: The Illustrated Story of the Chicago South Shore and South Bend Railroad.* Bloomington: Indiana University Press, 1998.

Cole, Beverley, and Richard Durack. *Happy as a Sand-Boy: Early Railway Posters.* London: HMSO, 1990.

————. *Railway Posters: 1923–1947.* London: Laurence King, 1992.

Commercial Art 1–5 (October 1922–June 1926); n.s., 1–23 (July 1926–December 1937). London: The Studio.

Cumming, David. *Handbook of Lithography.* London: Adam & Charles Black, 1904.

Design in Modern Industry: The Year Book of the Design and Industries Association, 1923–24. London: Ernest Benn, [1924.]

Design in Modern Life and Industry: The Year Book of the Design and Industries Association, 1924–25. London: Ernest Benn, 1925.

"Drawn on Stone: Something of the Life and Work of Thomas E. Griffits, Lithographer, Part I: Early Days," *The Pleasures of Printing.* London: Baynard Press, [March 1955]; "Part 2: The Mature Craftsman," *The Pleasures of Printing.* London: Baynard Press, [c. 1955].

Eckersley, Tom. *Poster Design.* London: The Studio, 1954.

Eskilson, Stephen J. *Graphic Design: A New History.* New Haven: Yale University Press; London: Laurence King, 2007.

Garland, Ken. *Mr. Beck's Underground Map.* Harrow Weald, Eng.: Capital Transport, 1994.

Gilmour, Pat. *Artists at Curwen.* London: Tate Gallery, 1977.

Green, Oliver. *Underground Art: London Transport Posters from 1908 to the Present.* London: Studio Vista, 1990; 2nd ed. London, Laurence King, 2001.

Griffits, Thomas E. *The Technique of Colour Printing by Lithography.* London: Faber and Faber, 1940, repr. 1944.

Halliday, Stephen. *Underground to Everywhere: London's Underground Railway in the Life of the Capital.* Stroud, Eng.: Sutton Publishing and the London Transport Museum, 2001.

Harris, Neil. "Designs on Demand: Art and the Modern Corporation." In Neil Harris, *Cultural Excursions: Marketing Appetites and Cultural Tastes in Modern America.* Chicago: University of Chicago Press, 1990.

Harrison, Charles. *English Art and Modernism 1900–1939.* New Haven and London: Yale University Press for the Paul Mellon Centre for Studies in British Art, 1981, repr. 1994.

Harrison, John. *Posters and Publicity.* London: The Studio, 1927.

Haworth-Booth, Mark. *E. McKnight Kauffer: A Designer and His Public.* London: Victoria and Albert Museum, 2005.

Hayward, Stephen. " 'Good Design Is Largely a Matter of Common Sense': Questioning the Meaning and Ownership of a Twentieth-Century Orthodoxy." *Journal of Design History* 11, no. 3 (1998): 217–33.

Hewitt, John. "East Coast Joys: Tom Purvis and the LNER." *Journal of Design History* 8, no. 4 (1995): 291–311.

————. "Posters of Distinction: Art, Advertising, and the London, Midland, and Scottish Railways." *Design Issues* 16, no. 1 (Spring 2000): 16–-35.

Holder, Julian, and Stephen Parissien, eds. *The Architecture of British Transport in the Twentieth Century.* New Haven and London: Yale University Press for the Paul Mellon Centre for Studies in British Art, 2004.

Hutchison, Harold, and James Laver. *Art for All: London Transport Posters, 1908–1949.* London: Art and Technics, 1949.

Jones, Sydney R. *Posters and Publicity.* London: The Studio, 1926.

Kauffer, Edward McKnight, ed. *The Art of the Poster: Its Origin, Evolution, and Purpose.* London: Cecil Palmer, 1924.

Kinross, Robin. "Emigré Graphic Designers in Britain: Around the Second World War and Afterwards." *Journal of Design History* 3, no. 1 (1990): 35–57.

LeMahieu, D. L. *A Culture for Democracy: Mass Communication and the Cultivated Mind in Britain between the Wars.* Oxford: Clarendon Press, 1988.

London & North Eastern Railway Magazine 1–37 (January 1927–December 1947).

London Transport Museum website, with archive of underground posters: www.ltmuseum.co.uk.

Middleton, Allan. *It's Quicker by Rail! The*

History of LNER Advertising. Stroud, Eng.: Tempus, 2002.

Miles, Betty. At the Sign of the Rainbow: Margaret Calkin James, 1895–1985. Alcester, Eng.: Felix Scribo, 1996.

Modern Publicity. London: The Studio, 1930–1984/5.

Modern Publicity 1937 and 1938: Commercial Art Annual. New York: William Rudge; London: The Studio.

National Railway Museum website: www.nrm.org.uk/home/home.asp.

Nava, Mica, and Alan O'Shea, eds. Modern Times: Reflections on a Century of English Modernity. London: Routledge, 1996.

Penrose's Annual (1914–1934) continued by Penrose Annual (1935–1976)

Penrose Annual (irregular) 1–74 (1985–82).

Pevsner, Nikolaus. An Enquiry into Industrial Art in England. Cambridge, Eng.: Cambridge University Press, 1937.

_____. "Patient Progress: The Life and Work of Frank Pick," Architectural Review 92 (August 1942). Repr. in Studies in Art, Architecture and Design vol. 2. New York: Walker, 1968, 190–209.

Pike, David L. Subterranean Cities: The Worlds beneath Paris and London, 1899–1945. Ithaca, N.Y.: Cornell University Press, 2005.

The Poster: An Illustrated Monthly Chronicle 1–6 (June 1898–December 1900). London: E. R. Alexander and Sons.

The Poster: An Illustrated Monthly Magazine Devoted to Poster Art and Poster Advertising (1910–30). Chicago: Poster Advertising Association.

Posters by E. McKnight Kauffer. New York: Museum of Modern Art, 1937.

Raffé, W. G. Poster Design. London: Chapman and Hall, 1929.

Richmond, Leonard, ed. The Technique of the Poster. London: Sir Isaac Pitman and Sons, 1933.

Rogerson, Ian. Barnett Freedman: The Graphic Art. Huddersfield, Eng.: Fleece Press, 2006.

Ross, Cathy. Thirties London: A City in the Jazz Age. London: Museum of London, 2003.

Saler, Michael T. The Avant-Garde in Interwar England. London: Oxford University Press, 1999.

Seddon, Jill, and Suzette Worden, eds. Women Designing: Redefining Design in Britain between the Wars. Brighton: University of Brighton, 1994.

Shackleton, J. T. The Golden Age of the Railway Poster. Secaucus, N.J.: Chartwell Books, 1976.

Sparrow, Walter Shaw. Advertising and British Art. London: John Lane, Bodley Head, 1924.

Suga, Yasuko. "Modernism, Commercialism, and Display Design in Britain: The Reimann School and Studios of Industrial and Commercial Art." Journal of Design History 19 (Summer 2006): 137–54.

Thirties: British Art and Design before the War. Exh. cat., Hayward Gallery, October 25, 1979–January 13, 1980. London: Arts Council of Great Britain, 1979.

Timmers, Margaret. ed. The Power of the Poster. London: Victoria and Albert Museum, 1998.

Twyman, Michael. Images en Couleur: Godefroy Engelmann, Charles Hullmandel et les Débuts de la Chromolithographie. Lyon: Musée de l'Imprimerie; Paris: Panama Musées, 2007.

_____. Printing, 1770–1970: An Illustrated History of Its Development and Uses in England. London: Eyre & Spottiswoode, 1970; 2nd ed., British Library, 1998.

Ward, Stephen V. Selling Places: The Marketing and Promotion of Towns and Cities, 1850–2000. London: Routledge, 1998.

Wilk, Christopher, ed. Modernism: Designing a New World , 1914–1939. Exh. cat. London: Victoria and Albert Museum, 2006.

Zega, Michael E., and John E. Gruber. Travel by Train: The American Railroad Poster, 1870–1950. Bloomington: Indiana University Press, 2002.

INDEX